EDWARD HOPPER

Light and Dark

Gerry Souter

Author: Gerry Souter

Layout:
BASELINE CO LTD
33 Ter - 33 Bis Mac Dinh Chi St.,
Star Building; 6th floor
District 1, Ho Chi Minh City
Vietnam

© 2007, Confidential Concepts, worldwide, USA
© 2007, Parkstone Press International, New York, USA
© Heirs of Josephine N. Hopper, licensed by the Whitney Museum of American Art,
 pp. 6, 9, 10, 12, 14-15, 17, 18, 21, 22-23, 24, 27, 28-29, 30, 33, 34, 36, 38-39,
 42, 45, 47, 50-51, 53, 54-55, 56, 60-61, 64-65, 67, 70-71, 73, 74, 76, 77, 79,
 80-81, 82, 85, 86-87, 115, 116-117, 123, 138-139, 146-147, 168-169
© Sheldon Memorial Art Gallery, pp. 218-219
© 2007, Lyonel Feininger estate, Artists Rights Society (ARS),
 New York/ VG Bild-Kunst, Bonn
© 2007, The Georgia O'Keeffe Museum/ Artists Rights Society (ARS), New York
© 2007, Charles Sheeler
© 2007, John Sloan

ISBN: 978-1-85995-420-1

Printed in Korea

EDWARD HOPPER

Light and Dark

Gerry Souter

ACKNOWLEDGEMENTS

The author would like to thank specifically Ms Carol Rusk, the Benjamin and Irma Weiss Librarian at the Whitney Museum of American Art, 945 Madison Ave., New York, NY 10021 for her kind assistance in helping us locate Edward and Josephine Hopper letters and other writings from the Frances Mulhall Achilles Library, Whitney Museum of American Art.

Another source that must be acknowledged is *Edward Hopper – An Intimate Biography* by Gail Levin (University of California Press, Berkeley and Los Angeles, California, 1995). Built primarily upon the diaries and letters of Josephine Nivison Hopper, accessible when Ms Levin was curator of the Edward Hopper Collection of the Whitney Museum of American Art back in 1976, the book is a model of well-written scholarship. Its precise documentation of the artist's life complements the many books written by Ms Levin about Edward Hopper's work.

The author would also like to thank the Chicago Art Institute Ryerson Library.

CONTENTS

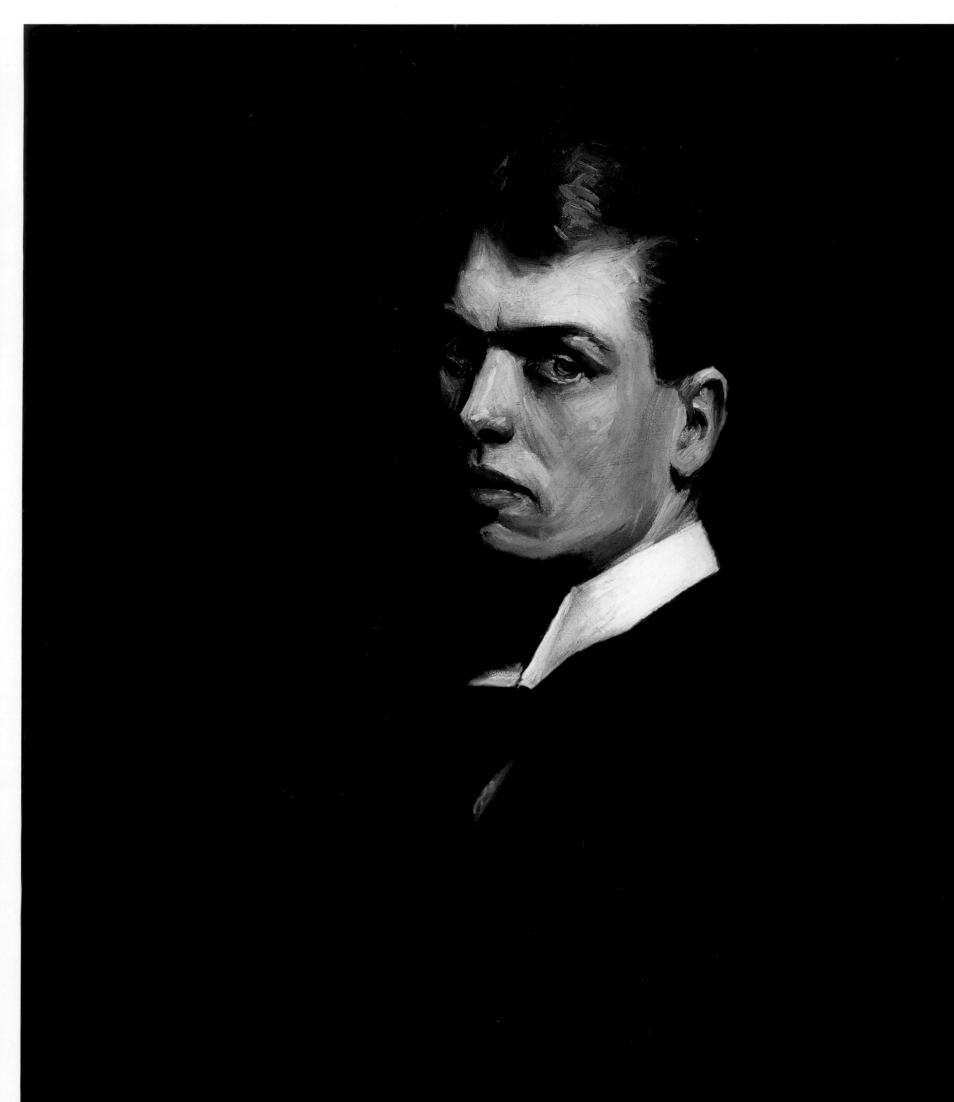

INTRODUCTION

Edward Hopper's realist creations in oil, watercolour and etchings earned him a degree of celebrity throughout America's interwar years from the 1920s to the 1940s. During the last twenty years of his life, the honours came, the medals, the retrospective exhibitions and the invitations to countless museum and gallery openings, many of which he turned down. He was a recluse, a captive of his overachieving upbringing, a prisoner of humiliating memories of early rejection, the tenant of his failing body and the sole occupant of a darkly silent philosophy that resonated with virtually anyone who confronted his work. Hopper's creative efforts discovered elements of the American scene that appear to be silent remnants left behind, or events about to happen. His work is his autobiography.

Edward Hopper and his wife, Josephine – in later years almost nobody thought of him without her and so they are linked in art history – were married for forty-three years. He stood six foot five inches and she topped out at five foot one inch with coppery red hair. Virtually everything in their life together orbited around his art. Josephine Nivison Hopper also had modest talent as an artist. Through her contacts, she helped him exhibit his first watercolours. Nevertheless, in Hopper's solar system there was room for only one artist – himself, the sun at its centre. Yet she insinuated herself into his self-absorbed world. Once they were married, with few exceptions, the only women appearing in Hopper's small repertory company were painted from Jo's nude or costumed form.

Besides modelling, in 1933 she began a relentlessly personal diary of their life together adding to a detailed record book of his work: its size, brand of paint used, canvas or paper, oil or watercolour, what gallery accepted it, and its selling price – less 33% gallery commission. With her own art career in tatters beneath the weight of his creative shadow and callous indifference, she bonded with him as clerk, diarist, house lackey, social prod, financial juggler and creative scold.

Drip, drip, drip, her constant flow of chatty encouragement wore down the resolve of his blockages, his inability to work, his cavernous depressions. She also knew how to push his buttons and twist the guilt knife. He saw no reason to stop reminding her of her second-class status in the household and as an artist. They splashed each other's psychological vitals with acidic scorn and calculated goading and then battered each other, drawing blood physically and emotionally. But their mutual dependence persisted.

Edward and Jo also had good times as they explored the eastern Seaboard beginning in the 1920s, stopping to sketch and splash on watercolour. They made friends of the people whose homes and boats and special places Edward drew and painted. They tramped together along the streets of New York where they had studied art and were part of the Greenwich Village artist scene.

From the 1920s to the 1960s they both embraced the realist American art movement as other painters and sculptors came and went. Hopper stood like a rock amid the chaos that welcomed, then rejected the Impressionists, dismissed, then lionised the Expressionists, Surrealists and other "ists" that bubbled to the surface. His work needed no manifesto, belonged to no school. A Hopper needed no signature and its value never dropped. Like bankable Alexander Calder and

> *The man's the work. Something doesn't come out of nothing.*
> — Edward Hopper
>
> *"If you don't know the kind of person I am*
> *And I don't know the kind of person you are*
> *A pattern that others made may prevail in the world*
> *And following the wrong god home we may miss our star."*
>
> Excerpt: *A Ritual to Read to Each Other*
> — William Edgar Stafford, 1914-1993

1. *Self-Portrait*, 1903-1906.

Oil on canvas, 65.8 x 55.8 cm.

Whitney Museum of American Art,

New York, Josephine N. Hopper Bequest.

Pablo Picasso, once he hit his own creative personal stride his paintings and etchings always found buyers. Hopper's two-dimensional world turned in on itself from unpopulated introspective compositions of hills, boats and houses to include a pensive collection of seeming allegories featuring a silent cast of drained characters, each captured with something yet undone, or done and now buried beneath regret, or just waiting to see what might come and change their lives.

From his birth in Nyack, New York in 1882, to his death at the age of eighty-five sitting in his chair in the New York City apartment-studio he occupied for fifty years, Hopper spent his eight decades in pursuit of light and shadow. He mastered executing their delineation of our lives and environment. Thanks to Josephine, his would-be browbeaten Pepys, busy, busy, busy beside him, we have a small and often vitriol-spattered window into his reclusive world. The pursuit is a rich journey through painful creative self-discovery and massive self-denial. We travel through the evolution of technical facility in a schizophrenic labyrinth snaking between commercial and artistic success fuelled by the need for recognition, underscored with self-loathing and ending in his lifetime among the immortals of fine art.

Many writers have taken this trip and for their discoveries and their scholarship, I am grateful. To the museums and institutions that hang his work and archive the papers accumulated by his long life goes more of my gratitude. I also owe much to my years as a student at the School of the Art Institute of Chicago where, brush in hand, I fought the lonely battle with my own demons. Every day I walked through the galleries on the way to my classes. Every day I walked past Hopper's *Nighthawks* (pp.198-199) and every day, when my mind wasn't occupied with the detritus of youth, I felt success as a painter slipping away. Only later I discovered that art is supposed to be painful if you do it right. Following Hopper's tortuous career prickles long dormant memories.

Each writer has come away with a slightly different Edward Hopper. Even though his paths are known, his acquaintances documented, his days and dates authenticated and his body of work is catalogued, what emerges is still an enigma. Hopper the man and artist remains a puzzle box with many hidden compartments and sliding panels. Located within the final secret space may lie a Rosetta Stone, a "Rosebud," a key to his workings. Since the only paths to the "why" of a creative artist lie in the trace elements left behind and what the artist chose to reveal, these scattered traces and choices cause curious writers to put on comfortable shoes and begin.

— Gerry Souter,
Arlington Heights, Illinois

"No one can correctly forecast the direction that painting will take in the next few years, but to me at least there seems to be a revulsion against the invention of arbitrary and stylised design. There will be, I think, an attempt to grasp again the surprise and accidents of nature, and a more intimate and sympathetic study of its moods, together with a renewed wonder and humility on the part of such as are still capable of these basic reactions."[1]

— Edward Hopper, 1933,
Notes on Painting (excerpt)

2. *Jo Painting*, 1936.

Oil on canvas, 46.3 x 41.3 cm.

Whitney Museum of American Art, New York,

Josephine N. Hopper Bequest.

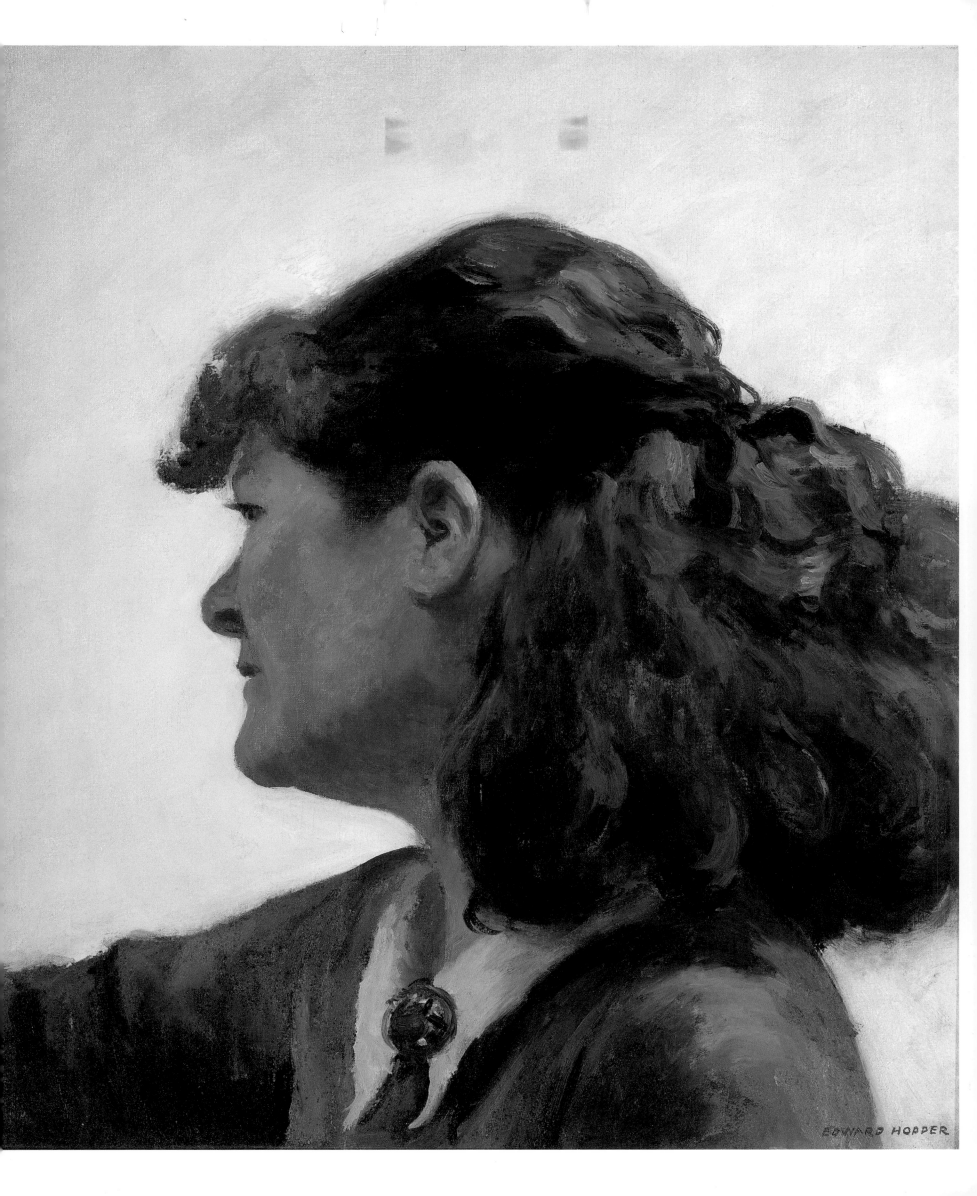

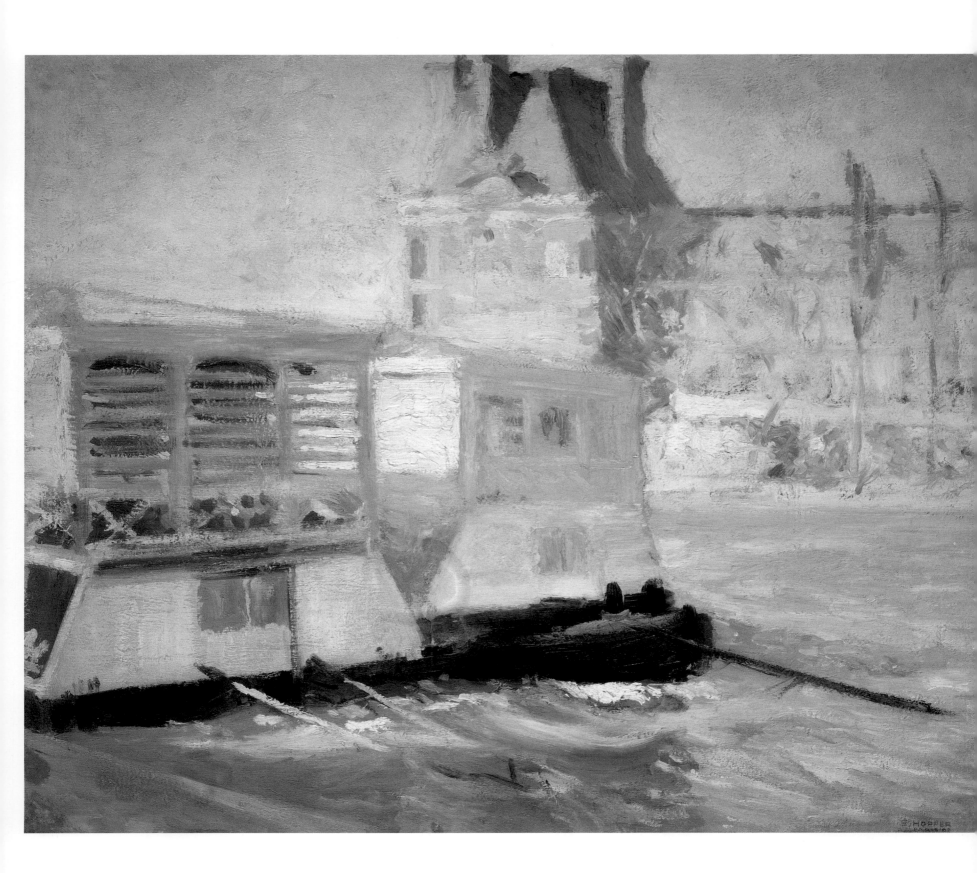

Emergence – A World of Light and Shadow

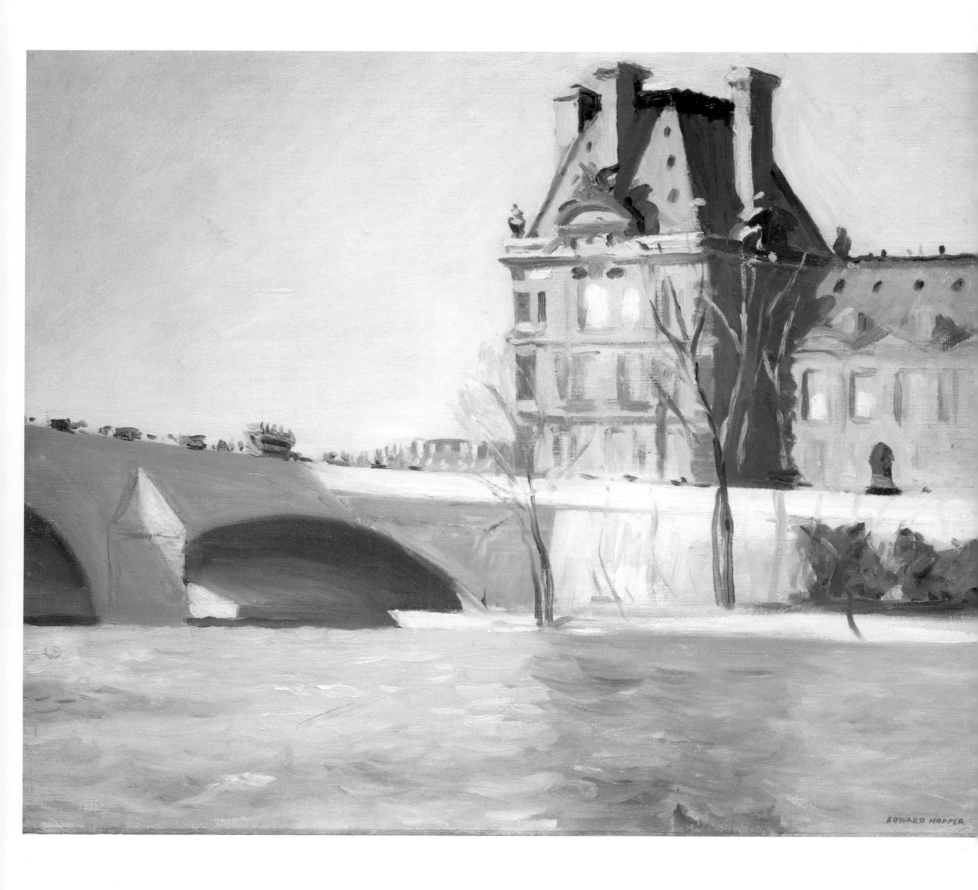

On 22 July 1882, Edward Hopper emerged into the middling-size prosperous town of Nyack, New York on the Hudson River. His mother, Elizabeth Griffiths Smith Hopper, was of English and Welsh stock, while his father, Garrett Henry Hopper, came from generations of English and Dutch ancestors. The elder Hopper tried his hand at sales and finally opened a dry goods store that failed to achieve any great success. Edward was the second child in the family, arriving two years after his sister, Marion.

While Hopper senior toiled amid bolts of cloth, cards of buttons and celluloid collars, Edward's mother kept her son and daughter supplied with creative tools targeting the theatre and art. An early prized possession for young Edward was a slate blackboard and chalk. He could draw and erase with impunity, but any particularly satisfying result lacked permanence. He began sketching and painting early, taking his sketchbook with him on frequent treks into the nearby countryside.

The Hopper home at 82 North Broadway belonged to Elizabeth's widowed mother, Martha Griffiths Smith, and was the site of Liz and Garrett's marriage in 1879. It was a rambling two-storey white frame house sheltered by trees and punctured by shuttered windows beneath deep-set eaves, decorated with cornices and belted with a corner porch across the front. To Edward, this place with its dark windows that revealed nothing of the lives lived inside represented home, personal solitude and a refuge during his early years. Its counterparts would appear repeatedly in his future paintings.

The fact that his father could not afford to move their family into a house of their own had to affect Edward's Victorian childhood during which men were expected to be the sole providers. His Grandmother Smith not only owned the house but also claimed the moral high ground in the community where her father, The Reverend Joseph W. Griffiths, had started up the Nyack Baptist Church back in 1854. The female side of the Hopper family provided for the family needs through rents and mortgage payments on other Nyack properties.

Edward and his older sister Marion attended private schools and came home to rooms cleaned by an Irish maid, and delivery boys bringing groceries and other purchases bought on account in town. His grades were above average throughout high school. One of his favourite subjects was French, which he studied and learned well enough to be able to read throughout his life.

At a time when the average grown man's height reached five feet eight inches, young Hopper at twelve years old already towered at six feet. He seemed to be all arms and legs, causing his friends to nickname him "Grasshopper". He loved jokes at other people's expense and often raged when he did not win at games. Many friends remembered his teasing, an annoying and persistent character flaw that stayed with him, often with a sadistic edge, into adulthood. Naturally shy, he peered over the heads of his classmates and always ended up in the back row in photographs.

Hopper spent puberty and adolescence wandering along the bank of a nearby lake where ice was harvested in the winter, sketching people, boats and landscapes. Yacht building flourished in Nyack and the boat docks along the river became hangouts for Edward and his friends. They formed the Boys' Yacht Club and piloted their sailboats with varying degrees of expertise. From those days, Edward carried with him a love of boats and the sea that lasted the rest of his life.

"My aim in painting has always been the most exact transcription possible of my most intimate impressions of nature. If this end is attainable, so, it can be said, is perfection in any other ideal of painting or in any other of man's activities."

— Edward Hopper

3. *Le Louvre et la Seine*, 1907.
Oil on canvas, 59.8 x 72.7 cm.
Whitney Museum of American Art, New York, Josephine N. Hopper Bequest.

4. *Le Pont Royal*, 1909.
Oil on canvas, 60.9 x 73.6 cm.
Whitney Museum of American Art, New York, Josephine N. Hopper Bequest.

5. *River Boat*, 1909.

Oil on canvas, 96.3 x 122.2 cm.

Whitney Museum of American Art, New York,

Josephine N. Hopper Bequest.

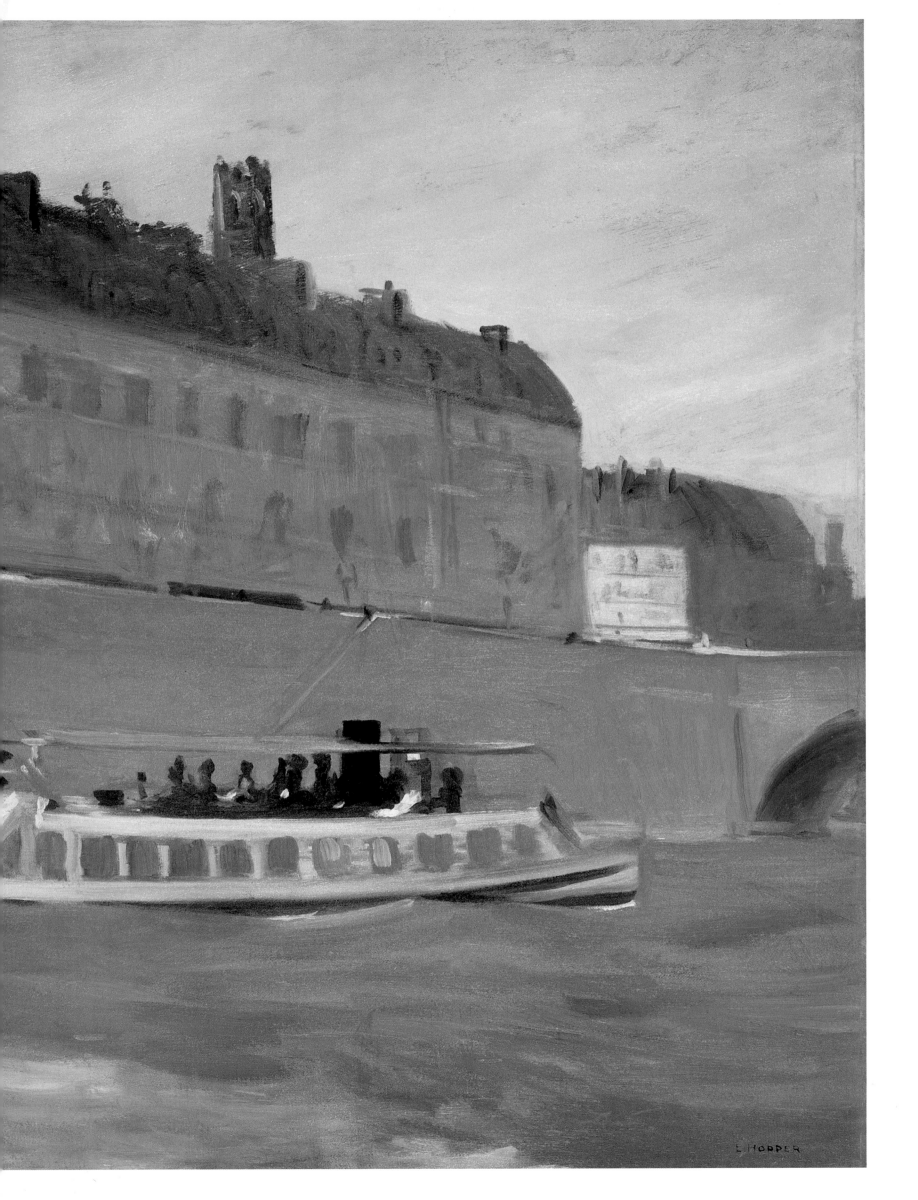

The railway had arrived along with electric light, paved streets and changed the complexion of the town, bringing more traffic, small businesses and a mostly Irish immigrant population. Elegant Victorian houses along the Hudson River belonged to wealthy industrial barons whose Dutch ancestors had amassed fortunes. His world was an idyllic boy's world at the end of the nineteenth-century.

Hopper's religious education in the Baptist Bible School was at odds with the freedoms of adolescence. He absorbed teachings on the rewards of a frugal life style and the righteous need to step back from the gratifications of lust and sex and other "immoral behaviour". Baptists had a strong belief in the hickory switch for bad conduct, but Edward, it seems, was rarely punished for his misdeeds. He was the young prince, the talented untouchable. Yet, his personality developed inward as if ashamed of his ascension in the face of his father's second-class situation within the upper middle-class success of the matriarchal Smith clan. This reticence and retreat into long silences later evolved into bouts of depression when his self-perceived skills failed him and the armour of his ego no longer appeared to sustain his ambition. Already he had developed a placid mask to hide behind and contain the demons of perceived inadequacy that dogged his career.

If Garrett Hopper bequeathed any legacy to his son, it was the love of reading. While the elder Hopper struggled with his business books and accounts, he was at home in his library with shelves groaning under English, French and Russian classic literature. Great social changes were occurring during the "Gay 90s" and the replacement of Victorian religious rigour by Edwardian free-thinking. From Turgenev to Victor Hugo and Tolstoy, Edward fled into books to discover words for the feelings that he could not disclose. He adopted his father's bookish salvation as a retreat and chose his most trusted friends from pages, not from life. Their quotes – often spoken aloud – became his surrogate responses.

By 1895, Hopper's natural talent was obvious in his technically well-executed oils. He relished details in his meticulous drawings of navy ships and the carefully-observed rigging of the racing yachts built in Nyack shipyards. He always came back to the sea and shore throughout his life, back to the big sky continuously redrawing itself in white on blue from opal pale to dangerous cerulean, and the surf-shaped rocks fronting long sweeps of dunes topped by hissing grasses. By 1899 he had finished high school and looked toward the big city down the Hudson, the centre of American art.

Hopper's mother saw to it that Edward and Marion were exposed to art in books, magazines, prints and illustrations. She spent a considerable sum on pencils, paints, chalks, sketch pads, watercolour paper, brushes and ink pens. While Marion preferred to pursue theatrical drama, Edward practised various art techniques, watching how light gave or robbed objects of dimension and how line contained shapes and directed the eye. He went to school copying weekly magazine covers created by the great illustrators of the time: Edwin Austin Abbey, Charles Dana Gibson, Gilbert Gaul and the sketches of Old Masters: Rembrandt and Jean-Auguste-Dominique Ingres.

Hopper absorbed all the fine examples and still retained a sense of humour as a safety valve to release some of the high expectations under pressure. His cartoons and lampoons remained with him as age further hardened his face to the world. Often they represented deeply felt emotions, but were tossed off with a laugh so as not to draw attention to the man behind the pencil.

6. *Ile Saint-Louis*, 1909.

Oil on canvas, 59.6 x 72.8 cm.

Whitney Museum of American Art, New York,

Josephine N. Hopper Bequest.

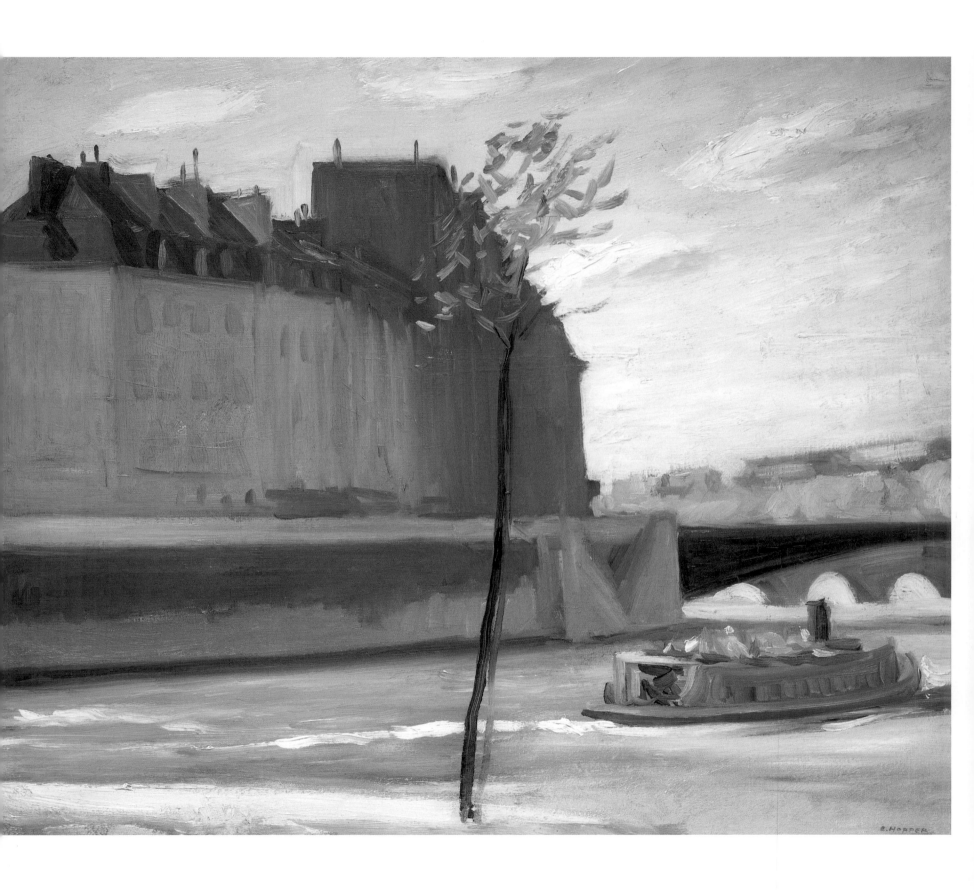

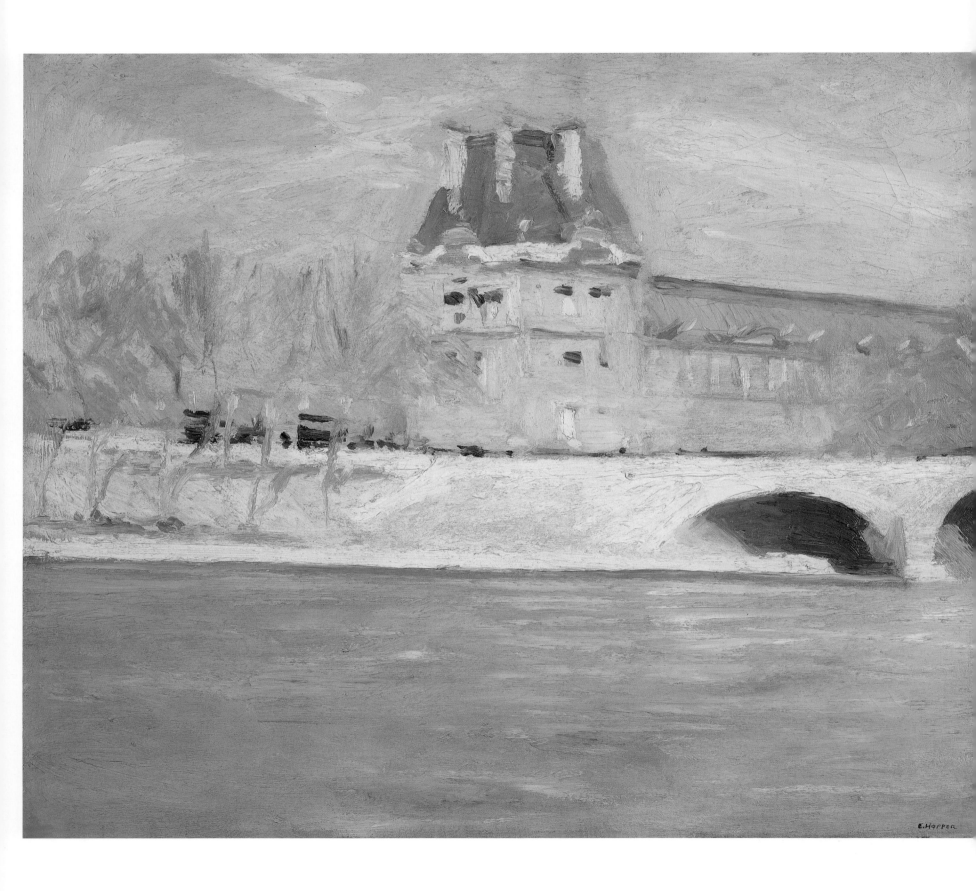

With his father's practical approval and his mother's profession-oriented encouragement, he decided to pursue a career as a commercial illustrator and enrolled in the New York School of Illustrating at 114 West 34th St.

Magazine and graphic poster illustration was in its "golden period" at the turn of the century. The mechanics of printing had embraced the photographic method of transferring the finished drawing to the printing plate with a half-tone screen. This reducing of the illustration to a series of dots allowed flexible sizing to any page dimension or cropping requirement. Freedom to employ a variety of media gave the artist a broad scope of interpretation.

Since there were so many magazines, advertisements, posters and stories to be illustrated, good illustrators who met deadlines and were literate enough to capture the core idea for the image were in great demand. There was good money in illustration. Publications and corporations who coupled their public identity to the work of these men prized those artists who reached the top rank. And it was a man's world. Regardless of talent, women were rarely accepted into the illustration schools. A woman's creative energies were best focused on producing happy, well-behaved children and a suitable home life for her husband. Their art was a hobby, a dabble, a device to keep idle hands busy. Edward Hopper was all right with that.

Enrolled on a monthly basis, he commuted daily from Nyack to New York, working in the classroom and at home on "practice sheets" devised by the school's "dean," Charles Hope Provost. These learn-by-rote copy sheets, originally designed as a correspondence school teaching aid, catered to the widest possible spectrum of would-be talent in order to corral the most tuitions. Hopper had already spent time after high school copying illustrations of his favourite artists and churning out original sketches of characters and scenes from literature. After a year of Provost's shallow instruction, Hopper raised his sights to study fine art as well as commercial illustration. His parents agreed to chip in the $15 a month fee and in 1900, his portfolio was impressive enough to be accepted at the New York School of Art where William Merritt Chase held sway.

Chase was a product of the nineteenth-century European academy system. He came from Williamsburg, Indiana, showed early artistic promise and found enough local patronage in St Louis to afford European study. His efforts placed him in the Royal Academy of Munich in 1872. His return to the United States in the late 1870s led art critics, reviewers and trend prognosticators to suggest he would become one of the great American painters. They were to be disappointed.

Chase's style was entrenched in European realism and his subjects lacked an "American" flavour. As the moral climate shifted toward a more uplifting fiction, away from the low and gritty reality of the late nineteenth-century American scene, so he shifted to the pose of the *flâneur*, a French term for a detached observer of life. Chase painted from life, but a moral, uplifting, civilised life that appealed to upper class art buyers and art students anxious to sell. His lessons in composition and his flawless technique were valuable to many of his students who went on to eclipse him: Marsden Hartley, Charles Demuth, Georgia O'Keeffe and Edward Hopper.

Another instructor who crossed Hopper's path was the young Kenneth Hayes Miller. While teaching at the New York school, Miller was developing his painting style that matured in the early 1920s. His lush urban paintings were referred to by one contemporary critic as an "attempt to make Titian feel at home on 14th Street and crowd Veronese into a department store."[2]

7. *Après-Midi de juin* or *L'Après-Midi de printemps*, 1907.
Oil on canvas, 59.7 x 73 cm.
Whitney Museum of American Art, New York,
Josephine N. Hopper Bequest.

He also pursued nineteenth-century painting tradition by giving weight and substance to his characters through a build-up of a layered pigment *impasto* beneath thin glazes of colour. Because Miller's subjects favoured the reality of the streets, Hopper preferred Miller to Chase's more refined fiction still rooted in the European academy.

By the time young Edward rose each day in Nyack for the train ride to Hoboken and the ferry trip to New York, he was a home-grown, virtually self-taught raw talent looking for direction. That talent quickly swept him to the head of Chase's illustration class where he confronted live models in costume and the heady excitement of "fitting in" with a roomful of working artists. His classmates were a rowdy lot of young men filled with pent up energy and looking for relief from the hours spent examining how a shadow moulds the shape of a cheek or working the edge of a charcoal stick to perfectly follow the swell of the model's thigh just above the knee. As the concentration was intense so was the release.

Many of these "boys" would become icons in the world of American art: George Bellows, Rockwell Kent, Guy Pène du Bois, C. K. "Chat" Chatterton, Walter Tittle and some, such as the poet Vachel Lindsay and the actor, Clifton Webb, who accepted their lack to drawing talent to become icons in the world of letters and the theatre. Hopper's pranks and teasing blended with the male atmosphere. His dry humour came in bursts and left its mark on those it touched. His original timidity hidden behind a substantial wall of reserve began to fade away as he grew more comfortable in the grungy studios where students scraped their palettes clean at the end of the day and left the gobs of colour spread on the walls and decorating the wretched caked and stratified easels.

There were also the "smells" of art: graphite, kneaded erasers, chalk dust, charcoal, linseed oil, glue, sizing, raw wood stretchers and drum-stiff canvas, the piquancy of sweat and turpentine, pig-bristle brushes and Conté crayons, white lead and varnish. The dried crumbs and powdered remnants ground their way into crevices of the easels, straddle boards and overturned chairs used as easels. Drips dried on work aprons, smocks and blotched shoes. This tactile evidence of creation was a tonic that focused the mind and calmed the tremor in the too-early-morning hand.

With an eye to paying the bills, commercial illustration and its practical applications still claimed a part of his training. His studies included classes with illustrators Arthur Keller and Frank Vincent Du Mond. He still envied the great commercial illustrators of his time and their ability to capture life on a page.

By the turn of the century, Impressionism had engulfed Europe with its gauzy, filmy play of light by the likes of Monet, Seurat, Pissarro, and Degas contrasted with the substantial shapes of Manet, Van Gogh, and Cezanne. As Chase sent Hopper and his classmates to the Metropolitan Museum of Art to study Edouard Manet, so did Hopper's next great influence, Robert Henri, who began teaching at the New York School of Art in 1902.

Henri (pronounced hen-RYE) studied in France under the slick technician and master of the romantic allegory, William Adolphe Bouguereau. Henri bolted from the *trompe-l'œil* style of meticulous rendition to the looser, broad stroke technique of the Post-Impressionists. He also sought to create a more rounded approach to the teaching process by including reading and discussion of writers in his drawing classes. Hopper, the chronic reader, was enthralled by Henri's shift of creative priorities. As Chase had preached art for art's sake, Henri stressed *art for life's sake*.

8. *Les Lavoirs à Pont Royal*, 1907.

Oil on canvas, 74.9 x 88.3 x 4.4 cm (framed).

Whitney Museum of American Art, New York, Josephine N. Hopper Bequest.

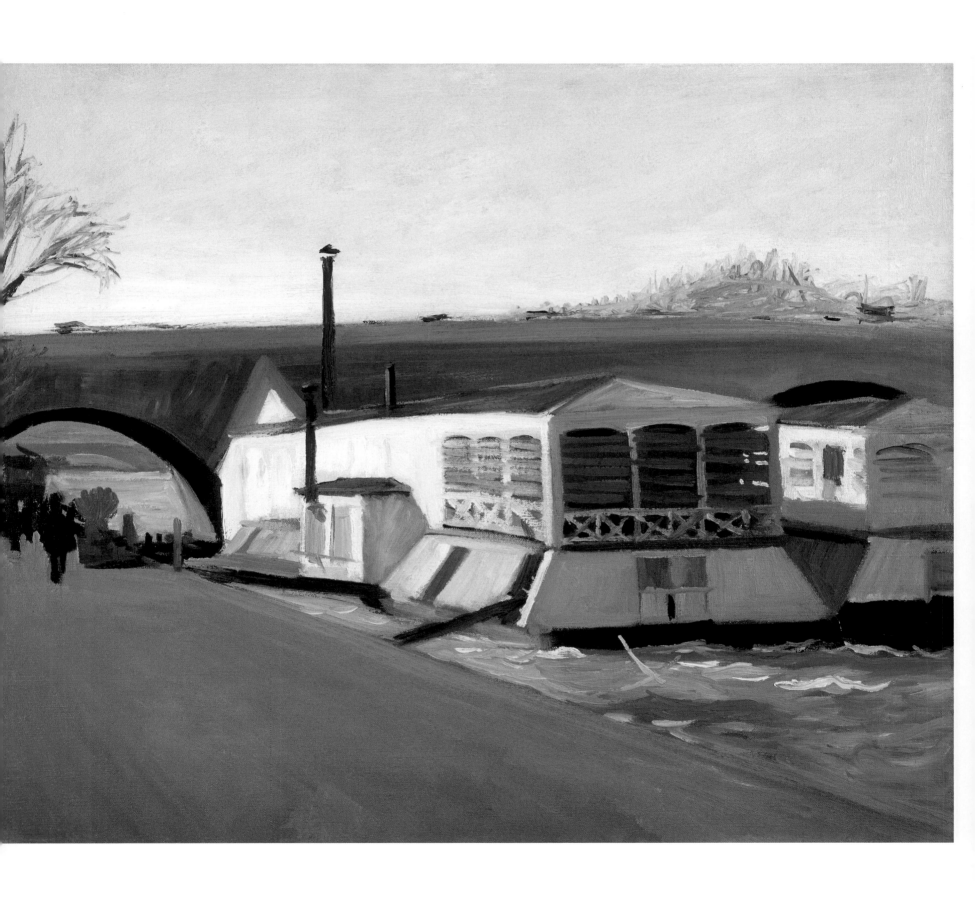

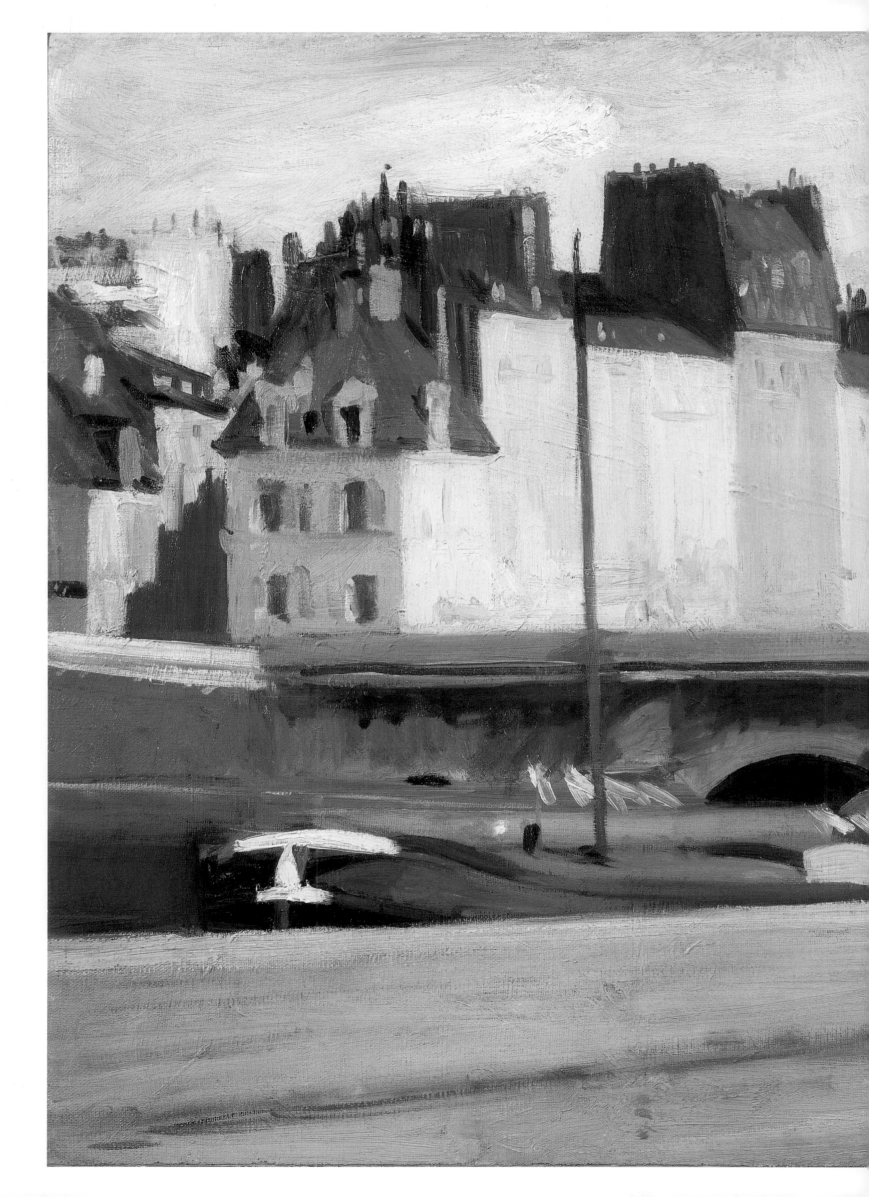

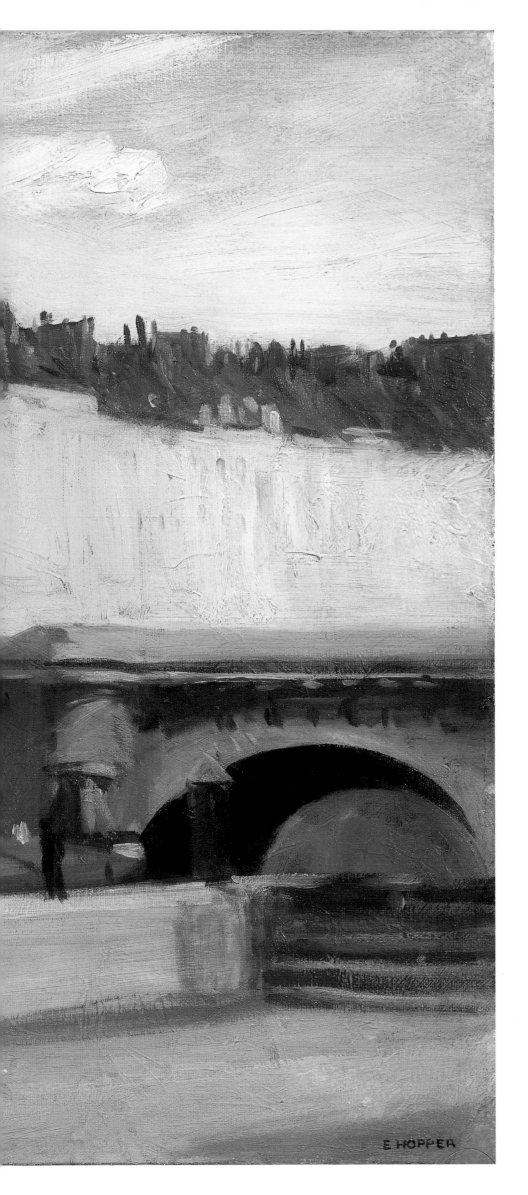

E HOPPER

9. *Ecluse de la Monnaie*, 1909.

Oil on canvas, 60.3 x 73.2 cm.

Whitney Museum of American Art, New York,

Josephine N. Hopper Bequest.

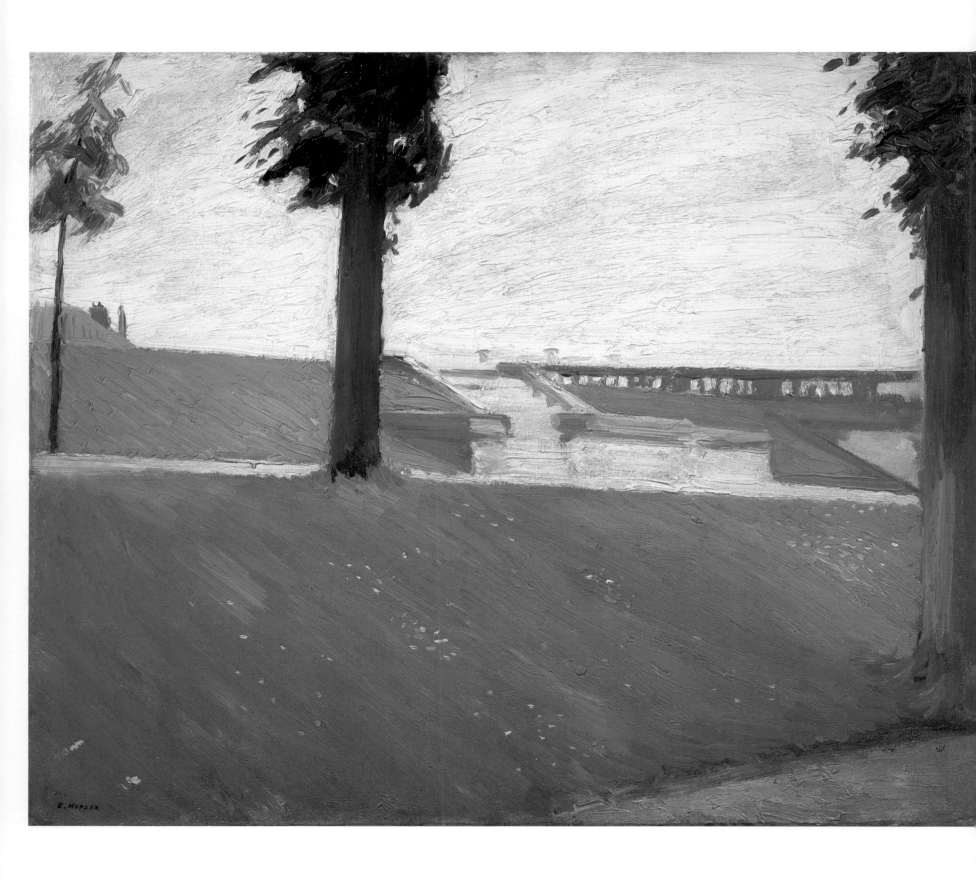

"Henri's class was the seat of sedition among the young," wrote Guy du Bois. Vachel Lindsay noted Henri demanded "…force, likeness and expression" in the students' portraits. [3]

Hopper's nude studies under Henri's tutelage between 1902 and 1904 reflect the models as solid shapes formed by light and shadow rather than linear creatures floating in their space. They have no identity in their faces, but each body is architecturally supported, its light-modulated surfaces yielding to gravity and individuality in every plane.

One by one, Hopper carved out these studies and one by one they received Henri's red daub of paint in the corner as a sign of approval. By 1905, Hopper had rejected Chase's still-lifes, his showboating lectures to the entire class from a hapless student's easel. Henri spoke quietly to each artist, his words to their ears. His demands that the students look beyond the confines of the studio to their own worlds produced some of Hopper's most predictive works from 1904 to 1906. These vertical compositions showing snapshots of country scenes presage Hopper's future minimalist approach, his high contrast use of light and deep shadow to block up masses and sweeten with eye-catching details. They lack, however, the maturity of his later work with these subjects.

Robert Henri's style of intense and personal criticism of student work, his engaging the artists to use their intellect as well as their brushes and paints, and his ruthless culling of unsuccessful attempts with two slashes of paint across the offending work made his sought-after praise even more valued. As for Henri's own painting skills, Hopper was a bit more sparing in his praise: "Henri wasn't a very good painter, at least I don't think so. He was a better teacher than a painter." [4]

But Hopper became a star student, winning a scholarship in life drawing and first prize in oil painting during one of the school's *concours* competitions. His education was spurred on throughout 1903 and 1904 by these prizes and the adulation that led to his teaching Saturday classes in life drawing, composition, sketching and painting.

By 1905 Edward Hopper looked out of his framed self-portraits from deep blue eyes shaded by uncompromising brows, down a well-shaped but not over-large nose. The mouth, however, begins to tell the story. It is a petulant mouth stretched wide with the thin upper lip pressed against a demanding, insistent slab of a lower lip. He saw himself without flattery and stamped the canvas with an implacable image. His restless and relentless nature drove him in many directions.

He began taking commercial illustration jobs to earn money on a part-time basis for the C. C. Phillips and Company Advertising Agency at 24 East 22nd Street. Student Coles Phillips founded the agency that lasted for a year until he closed it to freelance as an independent illustrator. Hopper produced some commercial work, but his heart wasn't in it. He had been a student for seven years and had amassed a considerable body of knowledge that now needed application. He had enjoyed instruction and praise from teachers who were polar opposites of each other.

While his technique had been improved and refined with a variety of media, his *thinking* about art had been profoundly affected. He now needed to know if his own personality, the sum of his experience, could be translated to the painted surface and find an audience. He searched for a motivational jump-start to his yearning to be a fine artist, a painter in the grand manner.

10. *Le Parc de Saint-Cloud*, 1907.
Oil on canvas, 74 x 86.7 x 2.5 cm (framed).
Whitney Museum of American Art, New York,
Josephine N. Hopper Bequest.

Paris, Impressionists and True Love

In October 1906 he chose the route most travelled by artists at that time, a journey to Paris, the world's cultural shrine. At the age of twenty-four, the tall boy from Nyack, New York went off to "see the The elephant". In that same month, as Hopper embarked for the French capital, Paul Cezanne died, his work only attracting attention in his later years. Of the mighty band of Impressionist and Post-Impressionist painters who had stood the art world on its ear, only Edgar Degas remained. He lived on in Paris, virtually blind, creating clay sculptures by touch. The public was unaware of him until after his death in 1917.

But the word had gone out and young men – and some persistent young women – with paint boxes and folding easels crowded the banks of the Seine with its bridges, the Latin Quarter and Montparnasse. They crowded the tables at the Dôme and Moulin Rouge. Prostitutes flourished. Pimps thrived and many young artists traded their talent for cheap wine and absinthe, holding down wire-backed chairs clustered around café tables littered with glassware and small saucers soiling paper table covers scratched with scribbled graffiti that would come to nothing.

Automobiles chugged and popped on spoked wheels announcing themselves with bulb-horns hooting at crossings. They added their few exhausts and their aroma of burning castor oil to the million chimneypots that sent charcoal and wood smoke into the miasma that hung above the city. Horse droppings littered the streets.

Pissoires and sewage wagons added their fragrance to each early morning, almost overwhelming the baguettes rapidly circulating in carts from bakeries to restaurants to be eaten before they turned to hard crumbly bird food. Paris was a rich stew of action, smells and grand architecture thickened with islands of leisured timelessness utterly foreign to any American brimming with the need to succeed.

On 24 October, Edward Hopper arrived at a Baptist mission at 48 rue de Lille, the Eglise Evangélique Baptiste run by a Mrs. Louise Jammes, a widow who lived with two teenaged sons. The New York Hoppers knew her through their church. As soon as Edward could manage he applied *gesso* ground to some 15" x 9" wood panels and set out with his paints and brushes. The colours in his box reflected the darker tones he had worked with under Henri's tutelage in New York: umbers, siennas, browns, greys, creams, cerulean blue. His eye immediately sought out the juxtaposition of geometric shapes.

Shafts and strikes of light on surfaces gave the images depth and a dynamic of expectancy. Where there were no people, it seemed as if someone had just stepped away from a window or the last of a crowd had just passed along the deserted bridge. After years of drawing from models at school and rendering gay young people for his commercial illustration jobs, people vanished from his work except as distant compositional objects – mere dabs of the brush or people-shaped objects.

On balance, when he was not painting in oils, he sketched the denizens of the Paris streets and created a collection of watercolour caricatures from the *demi-monde* and the lower depths of French society. These character types were not new to him. While at school he had rented a small studio on 14th Street. Prostitutes patrolled that area with insouciant assurance.

11. *Trees in Sunlight, Parc de Saint-Cloud*, 1907.
Oil on canvas, 59.7 x 73 cm.
Whitney Museum of American Art, New York,
Josephine N. Hopper Bequest.

12. *Le Pont des Arts*, 1907.

Oil on canvas, 59.5 x 73 cm.

Whitney Museum of American Art, New York,

Josephine N. Hopper Bequest.

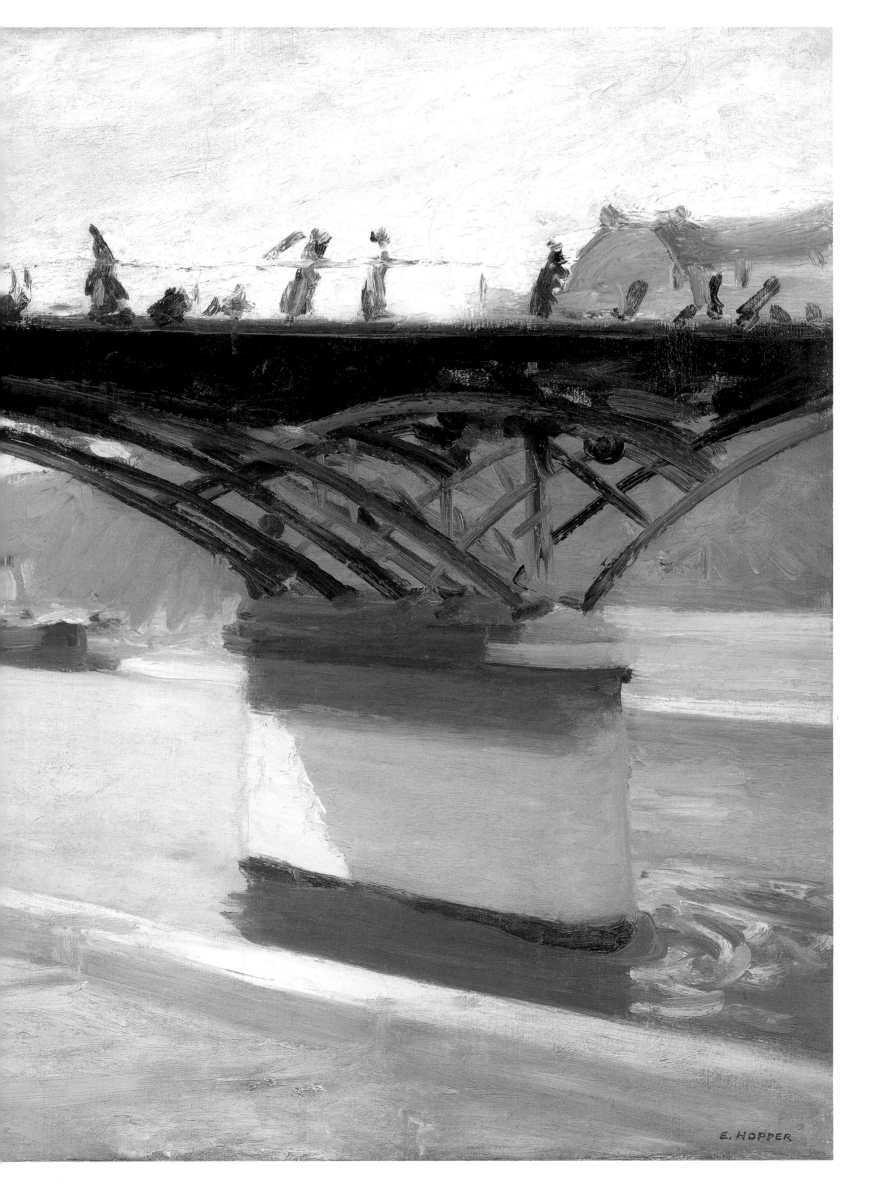

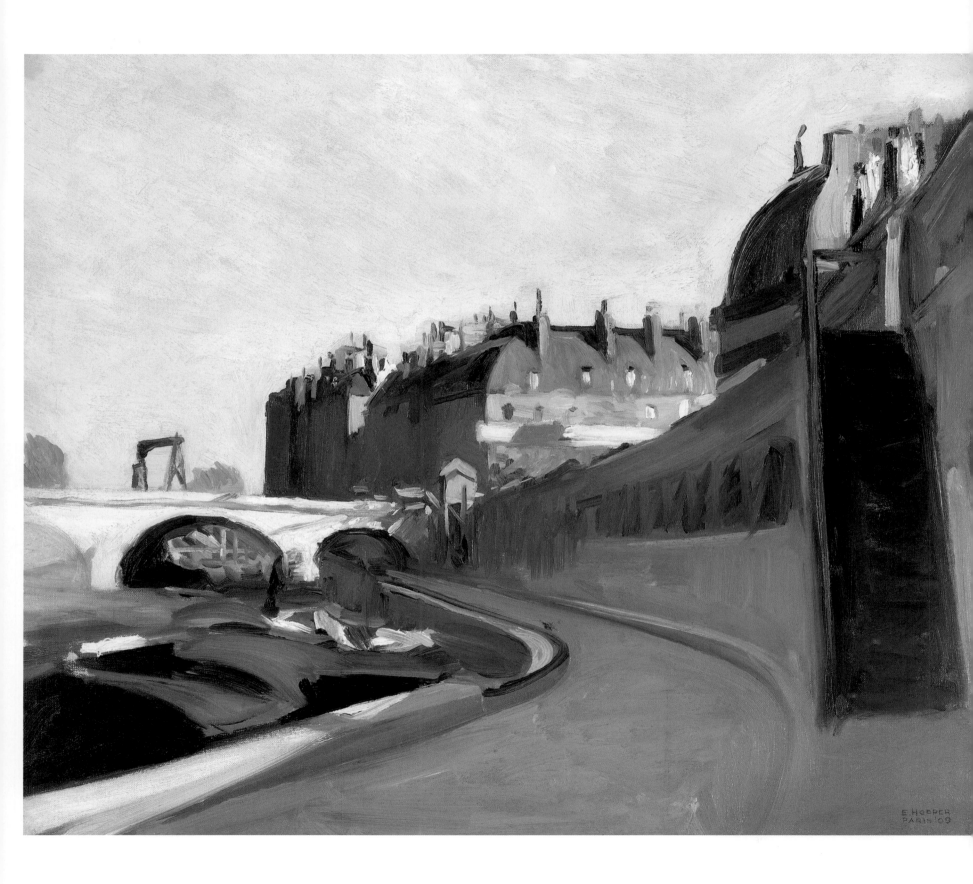

In his letters home he mentioned the grace of the French women and the stunted appearance of the men. After the grimy chaos of New York, however, Paris seemed clean and inviting. Dressed in his tailored suit, shirt and tie, and topped with a straw boater when weather permitted, he spent much time wandering in the parks, down the tree-lined paths of the Jardin des Tuileries, listening to bands play in the gazebos and watching children sail their boats in the fountain. While the Hoppers' home life had maintained a placid surface, and displaying emotions in public had been frowned upon, Paris must have seemed like an open candy store to the repressed young artist.

Hopper had little tolerance for the famous pavement cafes along the boulevard du Montparnasse and the boulevard Saint-Germain. There, in the words of Patricia Wells of the *New York Times*, "...the café serves as an extension of the French living room, a place to start and end the day, to gossip and debate, a place for seeing and to be seen. Long ago, Parisians lifted to a high art the human penchant for doing nothing."[5]

He did manage to sit in on some of Gertrude Stein's famous salons peopled with the Old Guard and the *avant garde:* novelists, painters, sculptors, poets and wealthy expatriates following "the season" and the parties. "I wasn't important enough for her to know me," he said later in an interview.

A few New York art students had preceded him to Paris and he used them to help him explore. Patrick Henry Bruce and his new wife were particularly helpful. They made sure he became acquainted with the impressionist painters who had broken out just twenty years earlier: Pissarro, Renoir, Sisley, Monet and Cezanne.

Pissarro he liked, Cezanne he didn't, dismissing the painter's work as "lacking in substance". Bruce and other artists in residence led the initiate marching through the galleries where the paintings of these masters glowed on the walls and through the Gustave Caillebotte Collection at the Luxembourg Palace where that artist had saved paintings once condemned.

As spring arrived and rain washed away the grime from the skies and puddled the streets, Hopper noticed the sudden luminosity, the light reflected into shadows, how bright the stone buildings appeared. The small oil-on-board studies he had made in the earth colours he had brought from New York were set aside as the sun suddenly suffused his work. Into a series of 25" x 28" canvases he poured light-bathed scenes of Paris and its suburbs, and followed the Seine and nearby canals where wash boats (laundry washing) tied up for customers.

In *Le Louvre et la Seine* (p.10), the great repository of art shimmers in gold beyond two wash boats tethered in the Seine. Terraced lawns in *Le Parc de Saint-Cloud* (p.24) are slabs of yellow-green pierced by up-thrusting tree trunks into a hot thick *impasto* sky.

The Impressionists loaded his palette with both hands when he produced *Trees in Sunlight* (p.27) at that same Parc de Saint-Cloud location. Here his brush strokes shortened up, becoming busy dabs of alizarin, both raw and mixed with zinc white. Trees became vertical slashes and swipes of thalo green and cadmium yellow. The indoor school studies faded away as he attacked his sky-lit subjects, painting from life.

The sketchy nature of these Paris oils and watercolours seemed to bubble through the architectural geometry of Hopper's developing style as though he was channeling the spirits of dead Impressionists. Sadly, the very "European" nature of the subject matter and its handling ran contrary to the gritty realism happening back in the United States.

13. *Le Quai des Grands Augustins, 1909.*
Oil on canvas, 59.7 x 72.4 cm.
Whitney Museum of American Art, New York,
Josephine N. Hopper Bequest.

14. **Claude Monet**, *Le Pont de l'Europe, gare Saint-Lazare (The Bridge of Europe, Saint-Lazare Station)*, 1877.
Oil on canvas, 64 x 80 cm.
Musée Marmottan, Paris.

By 1907 he was having a grand time, as letters from the widow Jammes revealed to Hopper's parents. He was a fine "mama's boy," enjoying good wholesome fun while ignoring the slovenly Bohemian art scene. And then he met the first true love of his life. Her name was Enid Saies.

"I went to dinner at an English chapel…with a very bright Welsh girl, a student at the Sorbonne, and we derived considerable amusement from the evening's programme, which consisted chiefly of sentimental songs with the h's omitted." [6]

She also boarded with the Jammes. Her parents, like Edward's, were very religious and she, like Edward, cared little for religion. Enid was not Welsh, but her parents were English with a house in Wales. Being very bright, fluent in French and other languages and a book lover, she must have dropped into Hopper's austere well-ordered life like a bombshell. She was also tall at 5 ft 8 in with dark brown hair and light brown, almost hazel eyes.

With her English accent, possibly spiced with a bit of a Welsh lilt, and her enjoyment of his awkward sense of humour and American habits, he became enraptured. Her studies at the Sorbonne had concluded and she was preparing to return to England in the summer. Worst of all, she had accepted the marriage proposal of a Frenchman ten years her senior.

Edward wrote to his mother that he wished to extend his trip to Paris into a tour of Europe as he was already in France. With parental assent – blindly given and not knowing his reason was the pursuit of Enid – Hopper packed and crossed the Channel to Dover and took the train to London.

There he trudged around the English capital, finding the Thames "muddy," the city "dingy" and the culture lacking the sparkle of France. Dutifully, he climbed the steps to the National Gallery and the British Museum. He wrote home that the food could not match the quality of that served in France. But nothing could match the love he had left behind and he made one final try to change that situation.

Hopper took Enid out to dinner. He sat with her in her parents' garden and, as she told her daughter years later, told her of his love and his desire to marry her. She remained true to her fiancé.

In the end, Hopper left London for Amsterdam, Haarlem, Berlin and Brussels on 19 July without unpacking his brushes or sketch pad. When he returned to Paris on 1 August 1907, the city had emptied because all its residents who are able to flee the August heat. And the City of Light held too many fresh memories. On 21 August he sailed for the United States, anxious to make use of his experiences and begin the campaign to make a name for himself in the world of fine art.

Later, Hopper wrote to Enid and she replied in depression over her impending marriage and reminding Edward of their great times together. "I've made a hash pretty generally of my life…oh, I'm so miserable…" [7] If this was a plea for Edward to come to her rescue, it fell on scorned ears. He was not used to rejection. She eventually abandoned her French suitor, married a Swede and raised four children. Back home in New York, Edward Hopper was discovering real rejection had many faces.

15. *Le Bistrot* or *The Wine Shop*, 1909.
Oil on canvas, 59.4 x 72.4 cm.
Whitney Museum of American Art, New York,
Josephine N. Hopper Bequest.

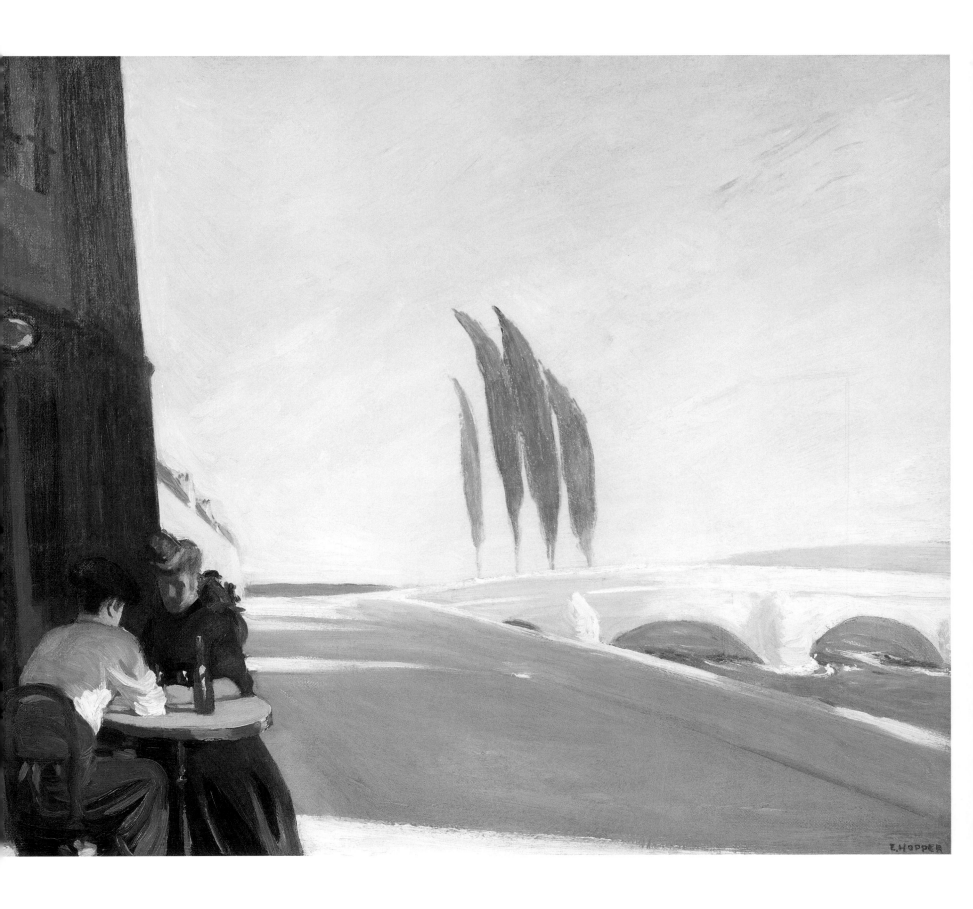

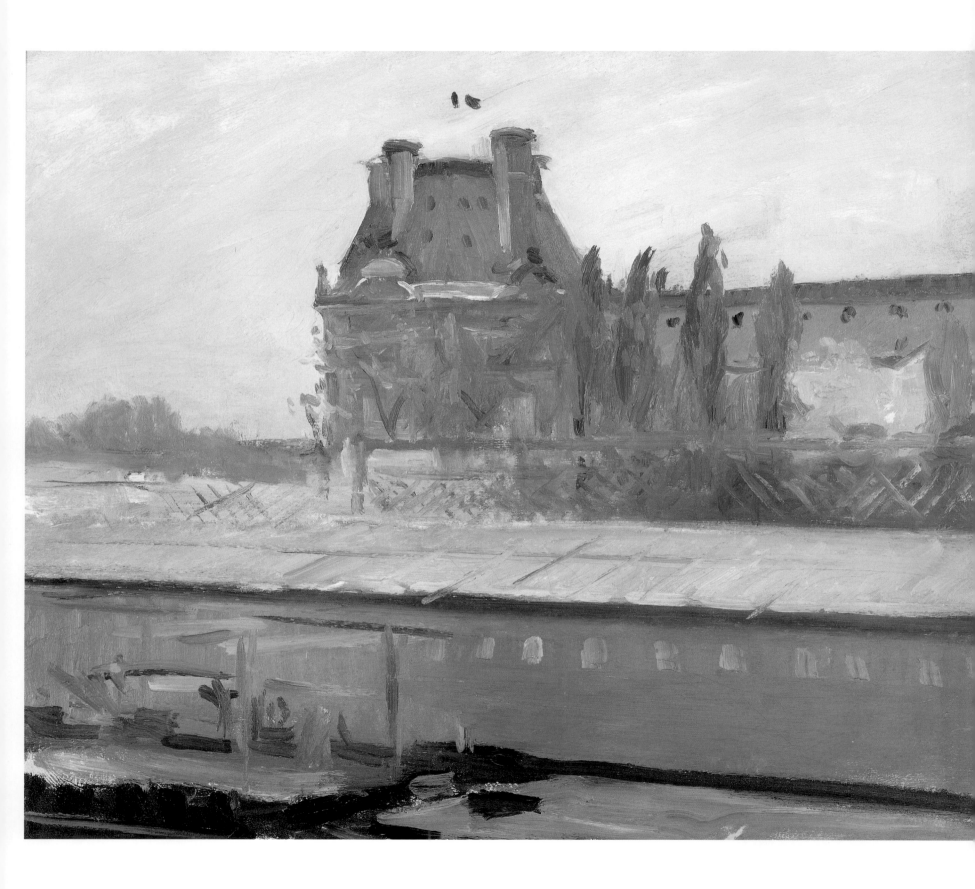

TURNING POINTS

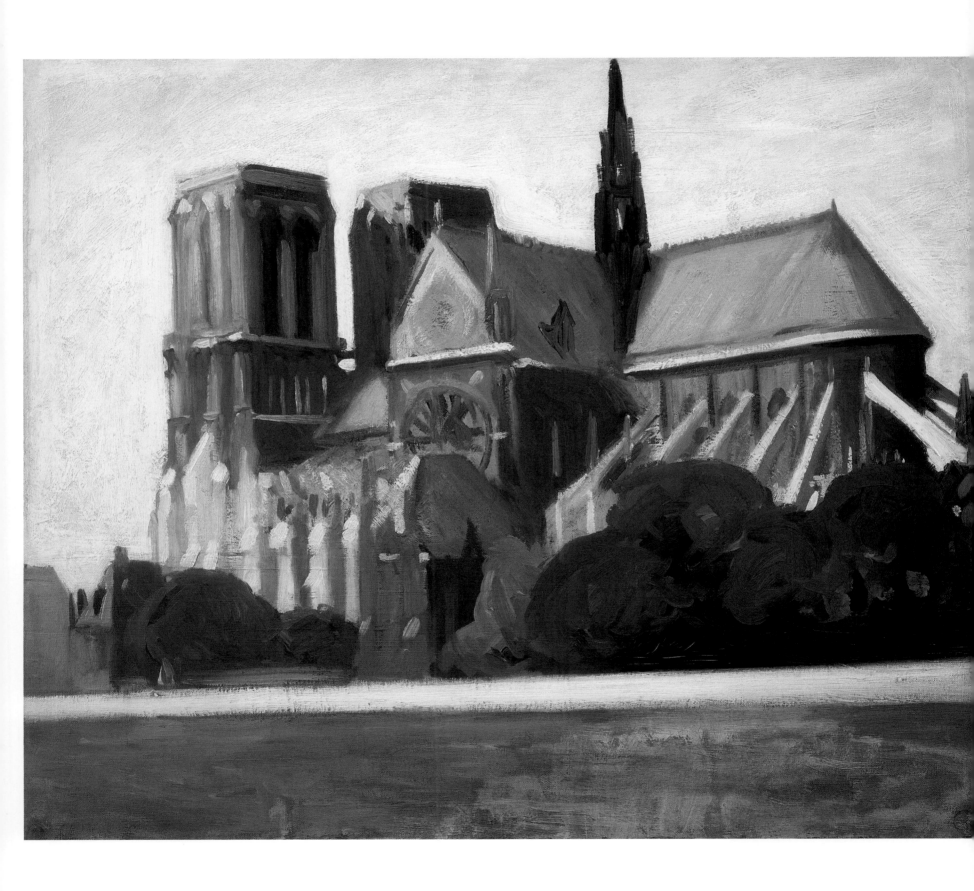

Return, Rejection and Flight

Romantic entanglements left behind, Hopper returned from Europe energised and ready to see his paintings on gallery walls. Regardless of personal problems brought on by his reserve and quiet nature and his dismissal of what he deemed to be distractions, his work had never let him down. He had spent seven years perfecting his technique, his eye for composition and hand for execution. The explosion of light and colour he had discovered in France had jarred him away from the sombre palette of Robert Henri, who had vaulted to success following his own tour abroad. Now, it was Hopper's turn to cash in.

Needing to become independent and remain permanently in the city, he faced the economic challenge of finding an apartment-studio and ready cash. Unfortunately only two months after Hopper stepped ashore in New York, on 16 October 1907, F. Augustus Heinze's scheme to corner the market in United Copper stock was exposed. The exposure revealed a network of interlocking directorates that included banks, brokerage houses and trust companies. This sudden revelation of bankers and stockbrokers in collusion came on the heels of the stock market plunge early that spring. This double hit fuelled a need among bank depositors to withdraw their money until matters were sorted out. That need resulted in runs on banks across the country. Since no bank keeps 100 per cent of depositors' cash on hand, the rush to empty bank accounts became the Bank Panic of 1907.

With the economy suddenly clapped in irons, disposable and investment income dried up. Even the wealthy snapped their purses shut, casting a jaundiced eye on investments that didn't translate into a proven return. The art world saw sales droop, commissions cancelled and shows of "promising artists, '....put on hold '...until further notice."

Hopper had no choice but to fall back on his skills as a commercial illustrator to earn money and maintain some semblance of independence from his family. This turn of events no doubt brought knowing smiles from the Smith-Hopper matriarchy in Nyack. He immediately sought out his pals from the art school to find wall space for his new work during this temporary set-back. In the meantime, his portfolio landed him illustration piece-work with the Sherman and Bryan Agency knocking out straw hat ads in stylish Art Nouveau designs that were the current rage. A frieze of chatting men in half-tone silhouettes behind the rendering of a straw boater was hardly innovative but they helped Hopper build some savings toward his real goal – a rapid return to Paris.

While Hopper slaved over his commercial drawing board, his mentor, Robert Henri, continued to create a buzz in the New York art world. With collectors and investors shying away from unknown American artists in favour of bankable Europeans – especially with the panic gripping America's finances – Henri felt that homegrown talent needed showcases and the stilted world of academic art needed shaking up.

Using his students as a base and trading on his own modest celebrity, on 3 February 1908 Henri opened a show of independent artists at the MacBeth Gallery at 450 Fifth Avenue. Besides his own work, he featured John Sloan, Ernest Lawson, George Luks, Everett Shinn, William Glackens, Arthur Davies and Maurice Prendergast.

Reviews for "The Eight" were lukewarm and in the *Evening Mail* the artists were relegated to "...a future that is never going to happen at all." This show did have impact beyond its original intent however. It was the first non-juried exhibition without prizes that was organised and selected by a group of artists. This type of exhibition became the model for one of the most famous exhibits in the history of Modern Art, the Armory Show of 1913.[8]

16. *Le Pavillon de Flore in the Spring*, 1907.
 Oil on canvas, 60 x 72.4 cm.
 Whitney Museum of American Art, New York,
 Josephine N. Hopper Bequest.

17. *Notre-Dame de Paris*, 1907.
 Oil on canvas, 59.7 x 73 cm.
 Whitney Museum of American Art, New York,
 Josephine N. Hopper Bequest.

18. *Valley of the Seine*, 1909.
 Oil on canvas, 66 x 96.2 cm.
 Whitney Museum of American Art, New York,
 Josephine N. Hopper Bequest.

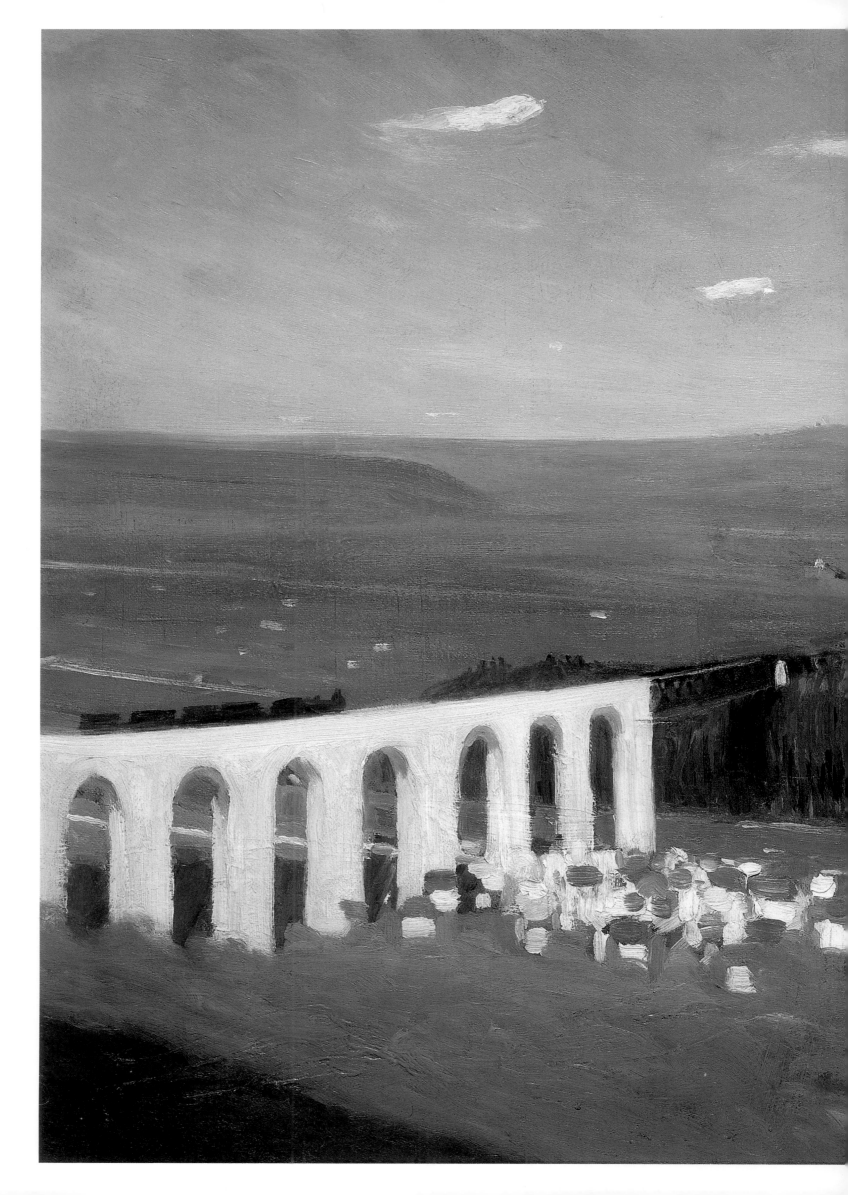

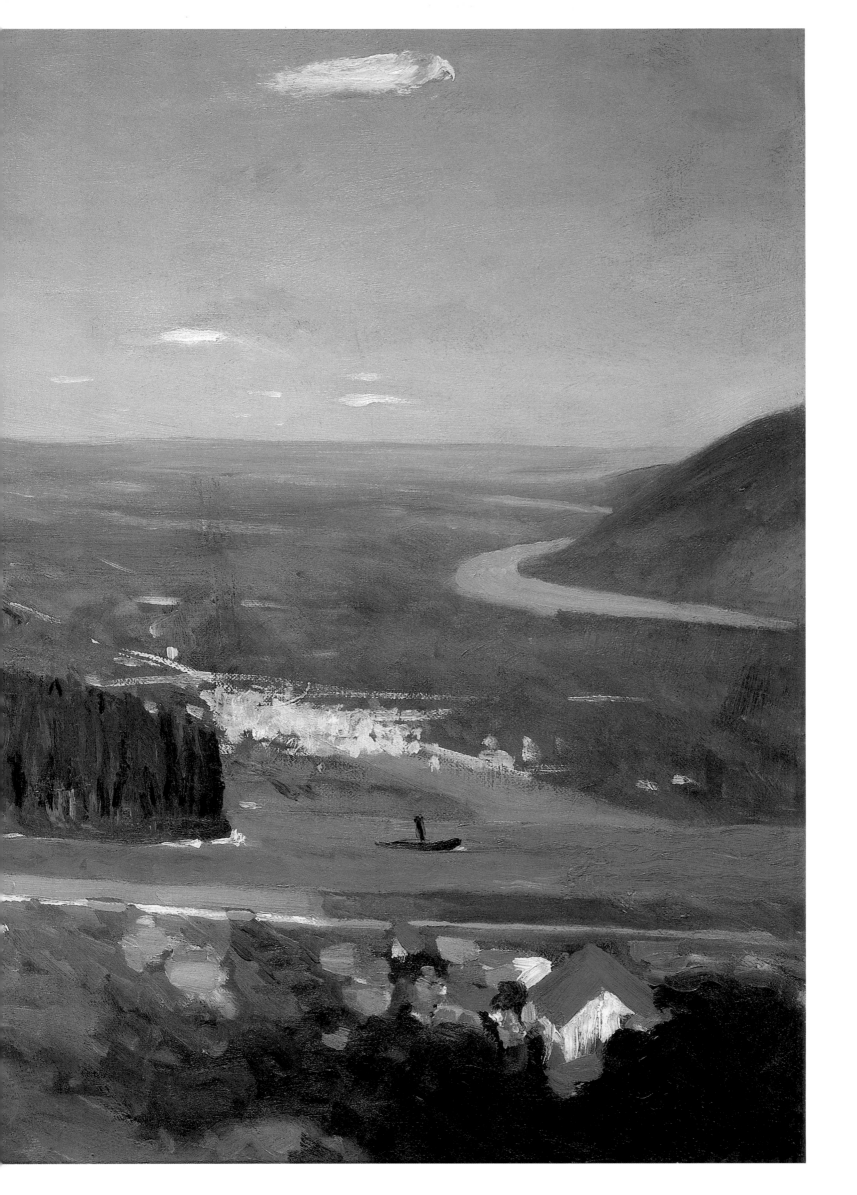

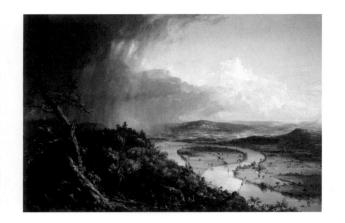

19. **Thomas Cole**, *View from Mount Holyoke, Northampton, Massachusetts, after a Thunderstorm — The Oxbow*, 1836.
Oil on canvas, 130.8 x 193 cm.
The Metropolitan Museum of Art, New York, gift of Mrs. Russell Sage.

20. *Macomb's Dam Bridge*, 1935.
Oil on canvas, 88.9 x 152.9 cm.
The Brooklyn Museum, Brooklyn, New York, bequest of Mary T. Crockcroft.

While Henri's show at the MacBeth Gallery confounded critics, another show had been in the works since 1906 titled *Exhibition of Paintings and Drawings by Contemporary American Artists*. Installed on the top floor of a building at 43-45 West 42nd Street, the show opened on 9 March to run until 31 March 1908. Created by New York School of Art students Glenn Coleman, Arnold Friedman and Julius Glotz, it featured fifteen artists; one of them was Edward Hopper.

Though the show purported to present the latest in striving for a "National Art," Hopper and three other artists showed French paintings. He offered *The Louvre and Seine* (p.10), *The Park at St Cloud* (p.24) and *Le Pont des Arts* (pp.28-29). Guy du Bois, Hopper's friend from school, hung *Gaîté Montparnasse*. Du Bois also became the mouthpiece for the group, using his media contacts to write articles and trumpet the group's success. He became a particular champion for Hopper over the years in a maturing friendship.

These young American painters, with Luks, Sloan, Glackens and Shinn at the core, had at last found wall space and were at least being noticed – if only to be ridiculed. They continued to follow Henri's lead, seeking out gritty urban subject matter in New York and rendering it in the dark palette of colours favoured by Goya, Manet, Velázquez and Frans Hals. Together, the young rebels were dubbed *The Ash Can School* of American painting. While urban realism was nothing new – Chase had been an urban Realist – the group's subject matter portrayed the bottom half of the city's population, the alleys, elevated trains, crowded streets, tenements and steamy waterfronts.

The subject matter and nature of Hopper's style abstracted him from the grim and gritty "Ash Can" painters. If critics mentioned him at all, his work was considered with a sniff "…European". He did, however, shift his interest to more "national" scenes, creating *Tramp Steamer* (p.46) (actually a British ship seen crossing the English Channel), *The El Station* (pp.60-61), *Railroad Train* (p.62) and *Tugboat with Black Smokestack* (p.47). His palette remained light and he subsequently fell out of favour with Henri. While Hopper disagreed with Henri, he was still drawn to his former teacher's example of going abroad over the summers. To that end, Hopper avoided late nights drinking with the boys and any living expenses beyond the basics. He cultivated a generally frugal lifestyle that would continue long after his reputation was made.

In March 1909 Hopper bolted from New York, arrived in Plymouth, England on the 17th, and headed directly for Paris via Cherbourg. Wasting no time, he presented himself at Mme Jammes' Baptist Mission at 48 rue de Lille. What he found was Mme Jammes near death at the hospital and his rooms in doubt. He was forced to pay money for an hotel room until his lodgings could be sorted out. On 28 April the elderly landlady who had mothered Edward during his first visit and wrote glowing letters to Elizabeth in Nyack about her wonderful "mama's boy", died of consumption. Mrs Jammes' sons now controlled the fate of Hopper's lodging. He ingratiated himself by showing up at her interment in the cemetery at Courbevoie, and the sons, in turn, let him keep his room. Edward mentioned her death in his letter home, but only as an obstacle to his convenience.

He wasted no time and set to work in familiar settings along the Seine and in the nearby French countryside. During this visit, his palette deepened and his brush strokes lost their choppy impressionist quality. *Le Pont Royal* (p.12) and *Le Pavillon de Flore* (p.34) are more substantial as structures, as is the *Ile Saint-Louis* (p.17), all three buildings located on the placid Seine. The *Louvre* looms in shadow beneath an approaching thunderstorm, reflecting the poor weather that seemed to dog this Paris trip. Whenever the sun showed, Hopper exploited its dimension-giving brightness on walls as in *Le Quai des Grands Augustins* (p.30), where the distant buildings leap into relief.

His technique became so secure that he used oils with a surety of stroke that found even greater expression with his later watercolours. The buildings, boats and bridges are sketched solidly into place with a minimum of fuss and disdain for details. The oils are the antithesis of his precise, linear

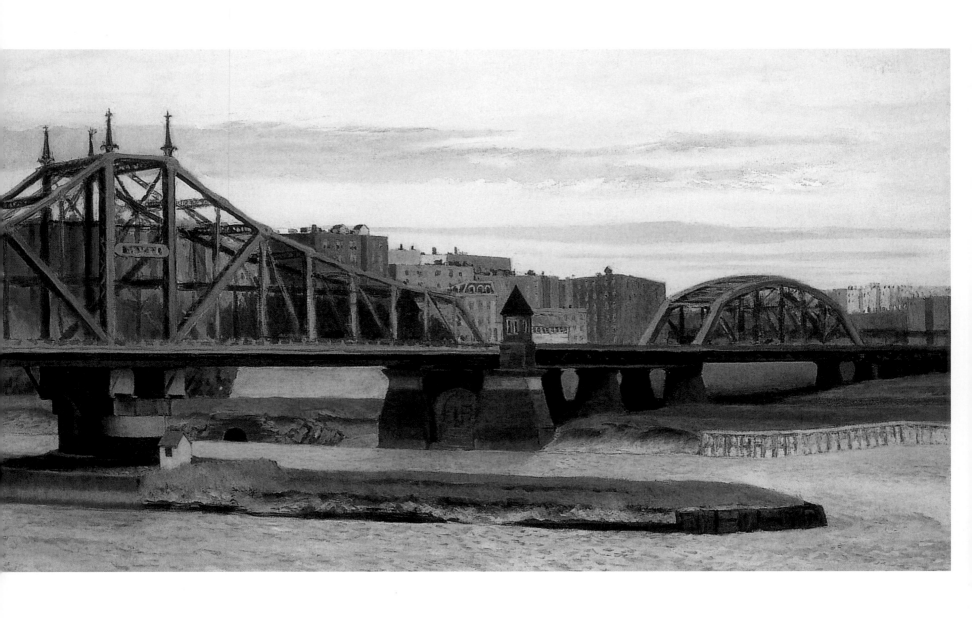

commercial illustrations. Where the illustrations are fussy, the oils reveal a minimalist skill confidently displayed. His jumble of angles and forms gracing magazine covers in dynamic display are absent from the conceit exercised in his simple oil compositions.

Hopper had become a master of painting and drawing and now searched for his voice.

Eventually, lack of money and overabundance of bad weather shortened his second visit to the City of Light and eliminated any further European exploration. He departed on 31 July aboard the Holland-American Line steamship *Ryndam* and arrived in Hoboken, New Jersey on 9 August 1909.

Once back in New York, Hopper drew from his memory and imagination three compositions he probably carried with him in his head from the French shores. Gail Levin in her seminal biography on Hopper[9] seizes a telling parallel between Hopper's *Valley of the Seine* (pp.38-39) and Thomas Cole's *The Oxbow* (p.40), an elevated view of the Hudson River where it loops back on itself forming a peninsula in the valley. In Cole's painting – shown at the Metropolitan Museum of Art in 1908 – a very detailed foreground of shrubbery and a moss-overgrown and lightning-shattered tree blend with an approaching storm that holds the eye in check. Beyond the brooding foreground and storm clouds, the bend in the river seen far below lies revealed in sunlight. Hopper grew up along the Hudson River and probably saw Cole's painting.

His *Valley of the Seine* is almost an homage, but he reverses the effect. Hopper plants a brilliantly sun-lit white railroad bridge opposite a wall of dark woods not unlike the Hudson's palisades. Behind the tall woods is a small town suggested by a scribble of brushwork that becomes roofs and walls. In the far distance, the Seine bends back upon itself recalling the looping Hudson in *The Oxbow*. To appreciate Hopper's masterly rendition of this scene, the viewer need only look closely at the canvas and realise how few brush strokes created all the central details. Hopper seems to be performing here, challenging academic and old world pastoralists on their own turf.

Le Bistrot (p.33), another post-Paris painting, captures a moment in time much as the Impressionists and Post-Impressionists accomplished. Seurat, Degas, Renoir all captured moments in lives, moments framed. This painting resembles a photograph, a "decisive moment" captured decades later by Henri Cartier-Bresson, Andre Kertesz, or Alfred Eisenstaedt, all of whom studied the great painters. Huddled at an outdoor table like extras on a stage set, two women share a bottle of beer. Beyond them, a lemon-yellow bridge and walkway beneath four dry wind-bent cypress trees look more like a backdrop about to be rolled up. Called from his imagination and memory, *Le Bistrot* remains a mythical place.

Summer Interior (p.67), also painted in 1909 in New York, is a near abstraction. A half-dressed nude sprawls next to an unmade bed. She's not anchored to the floor, but floats along with colour shapes representing a fireplace, a wall or shuttered door, the pale green carpet with a hot rectangle of window light pinned to it. The brown of the bed frame recedes, but all the other planes come forward giving the room a restless, unfinished appearance. The disconsolate girl is a leftover from an event having taken place in a lonely dreamscape. Like the couple in *Le Bistrot*, she has no identity. They are all symbols, the first in a long line of Hopper's haunted subjects.

Once again, Robert Henri's Ash Can artists organised a show to run from 1-27 April 1910 in a former warehouse on West 35th Street. This Exhibition of Independent Artists not only flew in the face of New York's art academia, it overlapped with the dates of a show at the National Academy of Design. The exhibition offered wall space to artists for a fee of $10 for one painting and – such a deal – only $18 for two. This bargain basement chance to show with some of the most well known of the Ash Can artists lured 344 entries. Among them was Edward Hopper.

Again, his pinch-penny existence limited him to a single entry and he chose *Le Louvre et la Seine*, an early French painting with its shimmering impressionist palette from 1907. Dragging out this retro

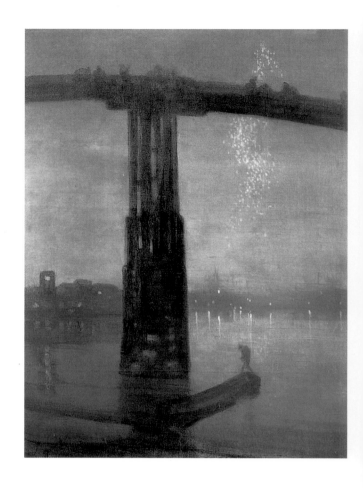

21. *Blackwell's Island*, 1911.

 Oil on canvas, 62.1 x 75.6 cm.

 Whitney Museum of American Art, New York,

 Josephine N. Hopper Bequest.

22. **James Abbott Whistler**,

 Nocturne: Blue and Gold-Old Battersea Bridge,

 c.1872-1875.

 Oil on canvas, 68.3 x 51.2 cm.

 Tate Britain, London.

work was almost an act of self-destruction. Almost any of his 1909 canvases would have at least showed his move towards a more personal aesthetic.

The show was well-reviewed and, once again, he remained invisible to the critics. Stubborn to the end, Hopper nursed his pennies and churned out commercial illustrations to earn cash for yet another expedition to Paris.

The RMS *Adriatic* docked at Plymouth, England on 11 May 1910, and a sober Edward Hopper disembarked knowing he had only his own finances and references to fall back upon. Once in Paris, he took a cheap room at the Hôtel des Ecoles in the Latin Quarter. But he remained only a week before following in Robert Henri's footsteps of the previous year and boarding the train to Madrid. He played the tourist, wandering through the sights and sounds, writing home and attending a "sickening" bullfight, of which one scene ended up considerably later in an etching.

The thrall of Europe had faded. The delights of Paris had diminished and his final trip abroad ended in departure from Cherbourg on 1 July aboard the *Cincinnati*, a steamer of the Hamburg-American Line. He had not found the financial and worldly success in foreign travel that Henri had discovered. The trips abroad had actually changed his life for ever, but, in 1910, facing a return to the rigour of New York, the endless grind of commercial illustration and hunting for an outlet for his brilliant skills as a painter, young Edward had no clue as to his future.

On his Terms

In the New York City Directory of 1911, Edward Hopper listed his occupation as "Salesman".[10] His contemporaries – fellow students and pals – were achieving success. As cash loosened up after the Bank Panic of 1907, even these relative unknowns were selling paintings and getting free ink in the press – favourable free ink from art critics looking for the next hot trend. Hopper, on the other hand, couldn't get arrested. He was "reduced" to trudging from one art and advertising agency to another with his portfolio, trying to peddle his skills as an illustrator to art directors he considered for the most part to be Philistines.

He thought this work to be demeaning and beneath him. The illustrator's market in the early twentieth century consisted of hundreds of popular magazines, niche market magazines, trade journals, advertisements, story illustrations and posters. New photographic printing processes gave the illustrators a wide range of tools with which to create evocative and dynamic renderings. However, the improvement in mechanics lagged behind the "rules" that governed subject matter and its presentation.

Youth ruled, stereotyped characters were expected for instant reader identification. Content was dictated as was composition to allow for logotypes, titles and products. Art directors had the option to treat his finished art as they pleased. They reversed pictures, removed beards, added moustaches, toned down backgrounds, added products and cropped out elements they considered superfluous. These were trespasses on his creative concepts, further rejections of his hard work at even this low level. Nevertheless, they paid the rent, bought oil paints and brushes and put food – such as it was – on the table.

One major problem confronted Hopper in this market-place. He was a very good illustrator. If he had wished to give up getting recognition as a fine artist, he might have eventually ranked with Gibson, Leyendecker, James Montgomery Flagg and N.C. Wyeth. As it was, even with his disgust at prostituting his talent, he was still in demand as a top "B-list" commercial artist. His ambivalence toward the illustrator's art form is noted in a collection of his illustrations.[11] Very rarely is anyone smiling.

23. *Briar Neck, Gloucester*, 1912.

Oil on canvas, 61.4 x 73.6 cm.

Whitney Museum of American Art, New York,

Josephine N. Hopper Bequest.

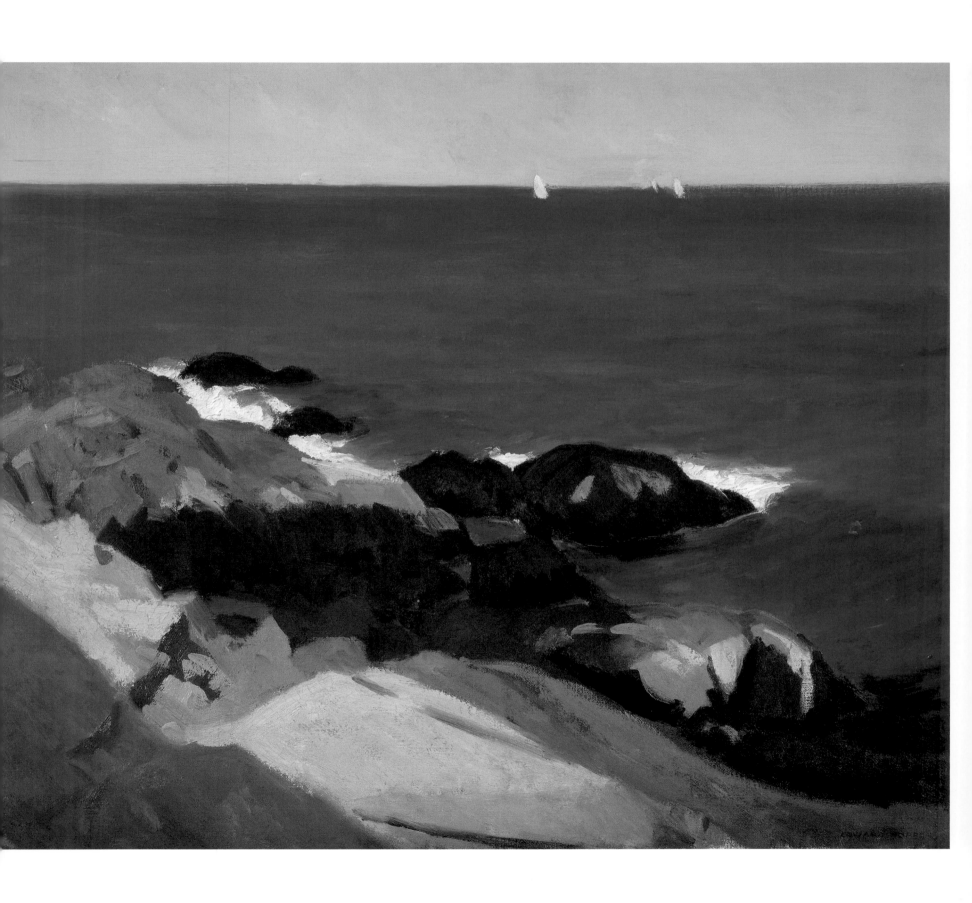

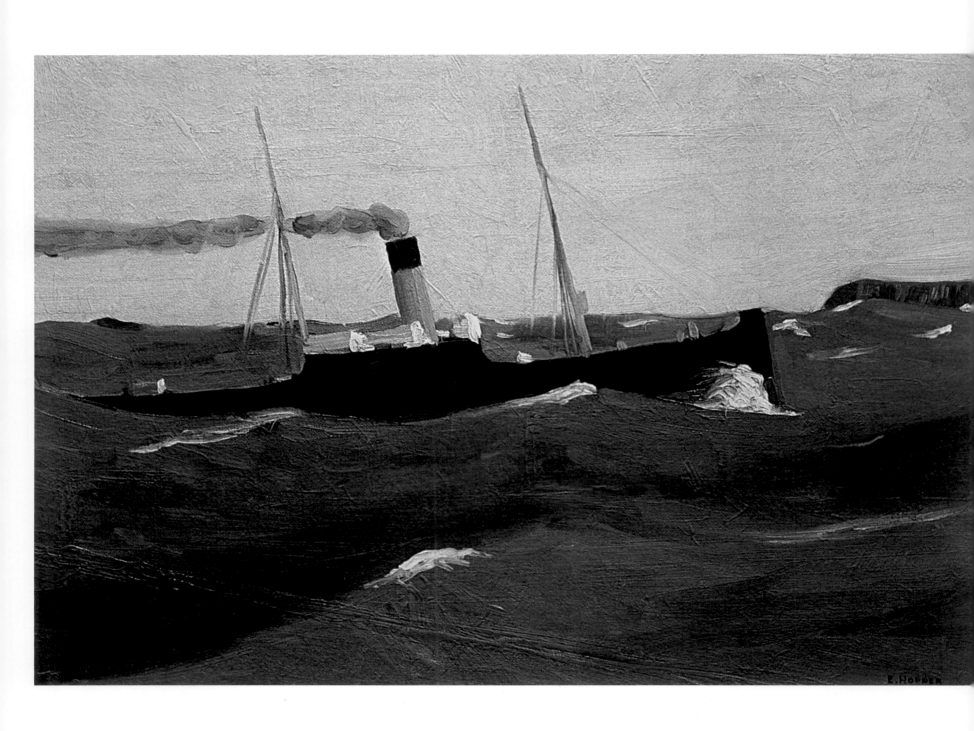

24. *Tramp Steamer*, 1908.

Oil on canvas, 51.1 x 74.1 cm.

Hirshhorn Museum and Sculpture Garden, Washington, D.C.,

gift of Joseph H. Hirshhorn.

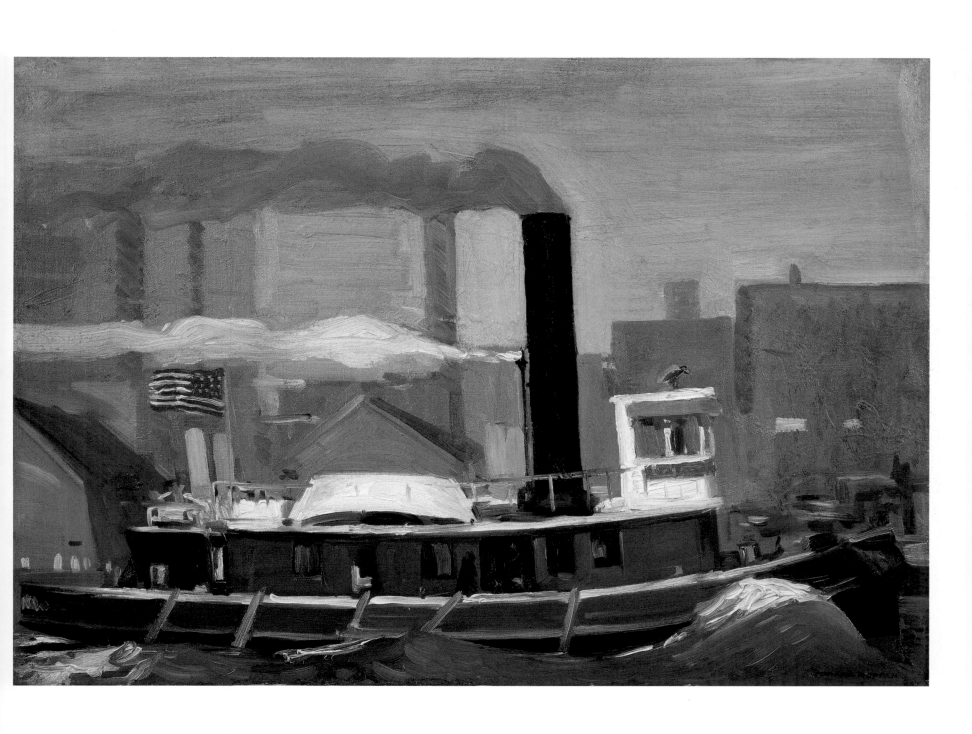

25. *Tugboat with Black Smokestack*, 1908.
Oil on canvas, 51.4 x 74.3 cm.
Whitney Museum of American Art, New York,
Josephine N. Hopper Bequest.

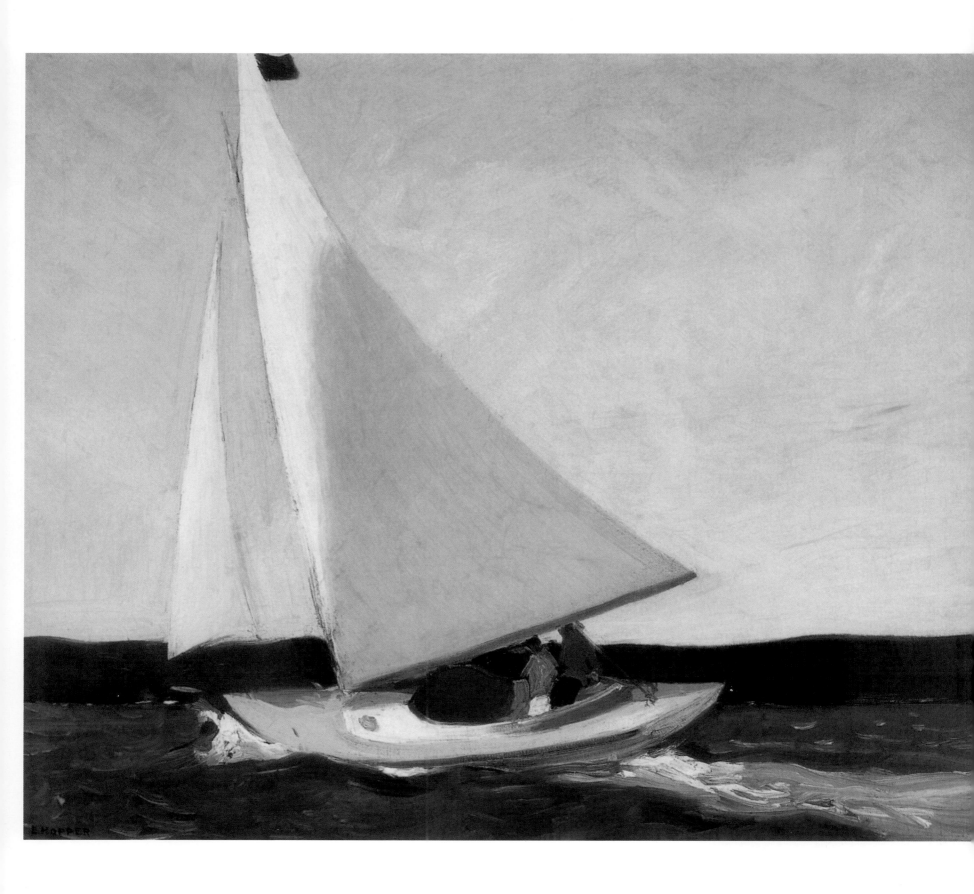

Illustrating for cash was also a thief of time. Normally a slow starter under any circumstances, Hopper's output of paintings dwindled to two in 1911. The oil *Sailing* (p.48) depicts a "Knockabout sloop rig – jib and mainsail taking up most of the canvas…" in Hopper's description. It is a subject painted from memory of his early days on the Hudson River. Again, using a minimum of strokes, the open cockpit sailboat is leaning hard over to port with its sails full, leaving a pale wake on an almost opaque sea. The sails and sky are heavily painted, covering a self-portrait that just peeps through to the naked eye if you are looking for it.

The other painting, *Blackwell's Island* (p.42) , is a dark and moody affair with a composition that recalls *Le Bistrot*, but with the opposite effect. Its provenance demonstrates Hopper's desire to crack the code and step into the limelight. Robert Henri had arrived triumphant from Europe in 1901 to settle in New York. From the window of his apartment on East 58th Street, he had a view of Blackwell's Island in the East River and painted a picture post-card winter scene complete with ice floes. In 1909, George Bellows, one of Henri's anointed stars, chose the island, highlighting the Queensborough Bridge with the busy Manhattan waterfront in the foreground. In 1910, Julius Golz – another Henri favourite – won critical praise at the Independents' Exhibition for his stab at Blackwell's Island.

Having moved from his studio among the hookers on 14th Street, Hopper had found space at 53 East 59th Street very near Robert Henri's studio. Henri and two of his acolytes had found success with Blackwell's Island and so, it appears, might Hopper. He was aware of James MacNeil Whistler, whose pictures were shown at the Museum of Modern Art in 1910, and chose an approach to the island that reflected Whistler's "Aestheticism."

Whistler's moody tonalism was in direct opposition to the Impressionists. In fact, Whistler's apparent move to the past, the *Nocturnes* (p.43), are closer in spirit to modern art than is Impressionism. The concentration in the *Nocturnes* on purely formal values of colour and line traces a direct descent to the development of abstraction in the early twentieth century. [12] His use of thinned oil paints applied spontaneously to create images from his memory must have especially appealed to Hopper.

In Hopper's *Blackwell's Island*, the scene is moonlit and composed in the manner of *Le Bistrot* with the bridge span occupying the left side of the canvas. A tug boat chugs in midstream beneath the Queensborough Bridge and lights wink on in houses scattered along both banks. A few stabs of zinc white create a single reflection of moonlight, grabbing the painting's almost geographic centre. It was with paintings such as *Blackwell's Island* as well as many of Hopper's later works that abstract painters acknowledged a kinship in use of colour, line and planes.

If Edward had entertained the idea that the much-painted *Blackwell's Island* would be his entrée into the more successful company of his former schoolmates, he missed his chance. Robert Henri decided to pick up the Independent Artists concept one more time and produced a series of unjuried shows at the MacDowell Club at 108 West 59th Street. He designed his new programme around exhibits of eight to twelve artists showing for two weeks at a time. Each group was responsible for the painters chosen to exhibit. Hopper was chosen along with Sloan, Glackens, Luks, Speicher, Leon Kroll and Henri.

The series of shows began in November 1911, and Hopper's turn to exhibit was scheduled for 22 February to 5 March 1912. The artists showing with him were Guy du Bois (Hopper's personal champion), George Bellows, Leon Kroll, Mountford Coolidge, Randall Davey, May Wilson Preston and Rufus J. Dryer. Hopper brought five oils to the exhibit's bare walls: *River Boat* (pp.14-15), *Valley of the Seine* (pp.38-39), *Le Bistrot* (p.33) (Americanised to *The Wine Shop*), *British Steamer* and – the only piece of "American" art – the jaunty little sloop, *Sailing*.

Guy du Bois, who must have invested quite a bit of personal vouching for Hopper to get him in after the last French debacle, was most likely stunned.

26. *Sailing*, 1911.

 Oil on canvas, 61 x 73.7 cm.

 Carnegie Museum of Art, Pittsburgh, Pennsylvania,

 gift of Mr. and Mrs. James H. Beal.

27. *Gloucester Harbor*, 1912.

 Oil on canvas, 66.5 x 96.8 cm.

 Whitney Museum of American Art, New York,

 Josephine N. Hopper Bequest.

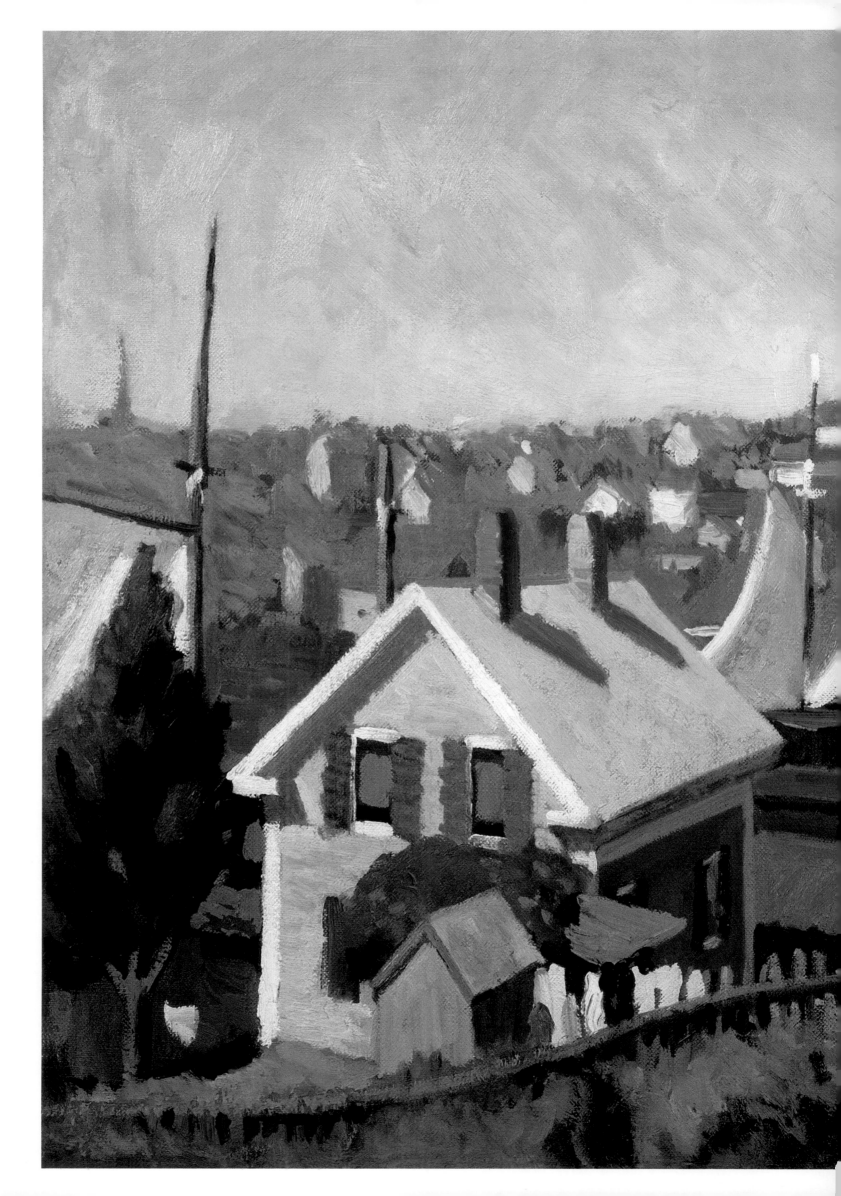

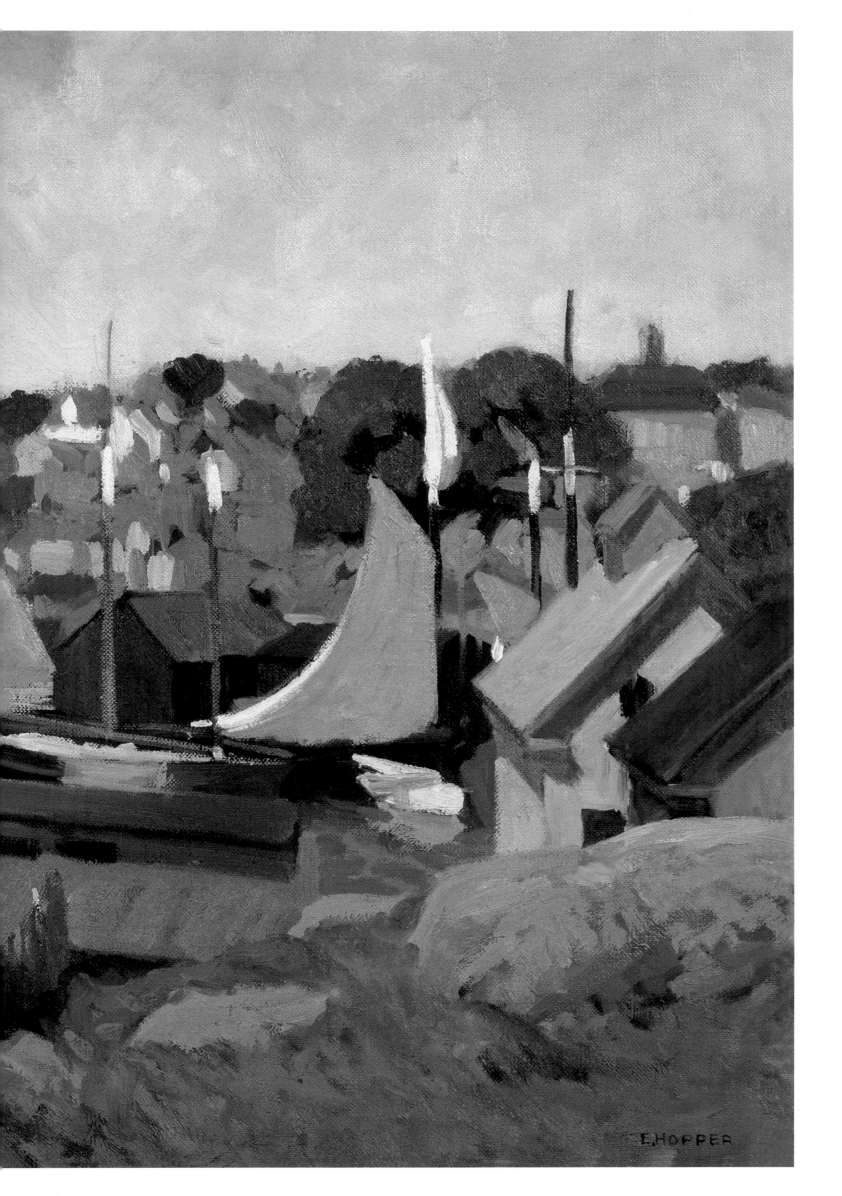

Once again, Hopper sold nothing and was rendered invisible by the critics. Once again, he trudged back home with his shopworn French pictures and began looking for illustration work. How is it possible for an intelligent, gifted person to keep pushing a product that nobody wants? He had already followed Henri's footsteps across Europe three times. He moved his studio to an address just down the street from Henri. He even painted the same subject as Henri. He had great friends and supporters among his former schoolmates. Moreover, the idea of schlepping his portfolio of illustration samples door to door hunting for jobs drawing pictures of suspenders, straw hats, debutantes, polo matches, deskbound bosses and muscular stevedores was anathema to him.

Edward Hopper wanted success but it had to come on his terms. After being the hero for the first twenty years of his life – the perfect son, the star pupil, the best prankster, the gifted technician – he needed to maintain that level of applauded accomplishment. The voice he had developed so far was one of minimals, of impressions. He joked late in his life about "still being an Impressionist" and that is probably what he meant. His was an art of suggestions rendered so deftly as to seem to be actually there. In addition, the emotion coming from the canvas regardless of subject matter seemed diaphanous, just out of reach, implied just as three swipes with the brush created a ship's hull and a scribble of zinc white and dabs of carmine created a French town with red roofs in the distance.

It was as if Hopper himself was an implied suggestion:

> *"Great art is the outward expression of an inner life in the artist, and this inner life*
> *will result in his personal vision of the world. No amount of skilful invention can*
> *replace the essential element of imagination."*

Changing Times

It must have been with a sigh of resignation that he once again took up his portfolio and plunged into the faceless crowds rushing along the pavements, dodging horse manure in the streets, being startled by the beep of horseless carriage horns and the hissing pop valves on steam cars. He endured the press of bodies on the electric trolley-cars that groaned and clanked towards yet another illustration job that he hated and needed.

There were plenty of jobs open to Edward Hopper. *System, the Magazine of Business* hired him and he began a long relationship with the publisher drawing men and women in office situations. The pay was good and he received enough assignments to consider venturing from New York to paint new subjects. He chose Gloucester, Massachusetts on the Eastern seaboard as his destination and gregarious Leon Kroll as his travelling companion.

The tall taciturn Baptist and the short gabby Jew worked hard all summer in and around the beaches and boat docks of the coastal town. Hopper was unusually productive, possibly egged on by Kroll's relentless good humour and prodigious output. Leon Kroll would return often to Gloucester, eventually becoming a fixture there until late in his life. The picturesque port drew artists from everywhere so Hopper found it difficult to set up an easel and not find himself intruding into someone else's scene.

His first time painting American scenes out of doors seemed to inspire him and he turned out *Gloucester Harbor* (pp.50-51), *Squam Light, Briar Neck, Tall Masts* (p.53) and *Italian Quarter* (p.123). Each one was carved out in bright sunlight with no gauzy atmospheric effects. Virtually no human figures are present, but their boats and houses and the thrusting masts of the moored ships suggest

28. *Tall Masts*, 1912.

Oil on canvas, 61.6 x 74.3 cm.

Whitney Museum of American Art, New York,

Josephine N. Hopper Bequest.

29. *American Village*, 1912.

Oil on canvas, 65.7 x 96.2 cm.

Whitney Museum of American Art, New York,

Josephine N. Hopper Bequest.

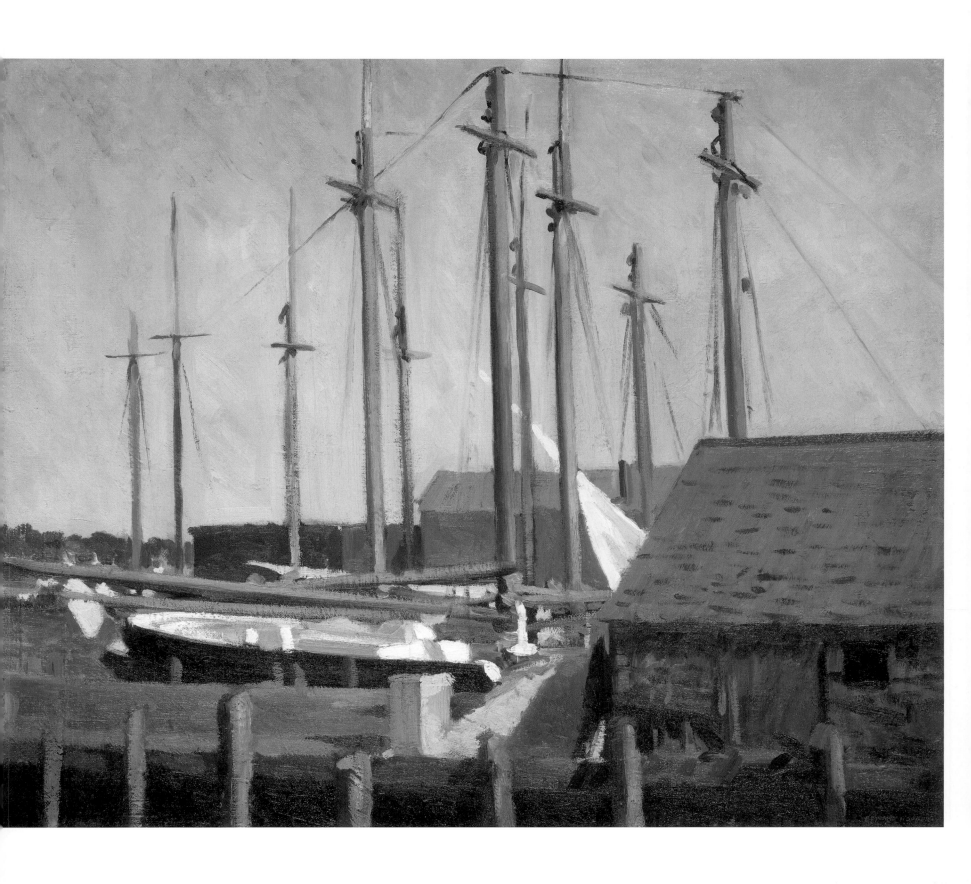

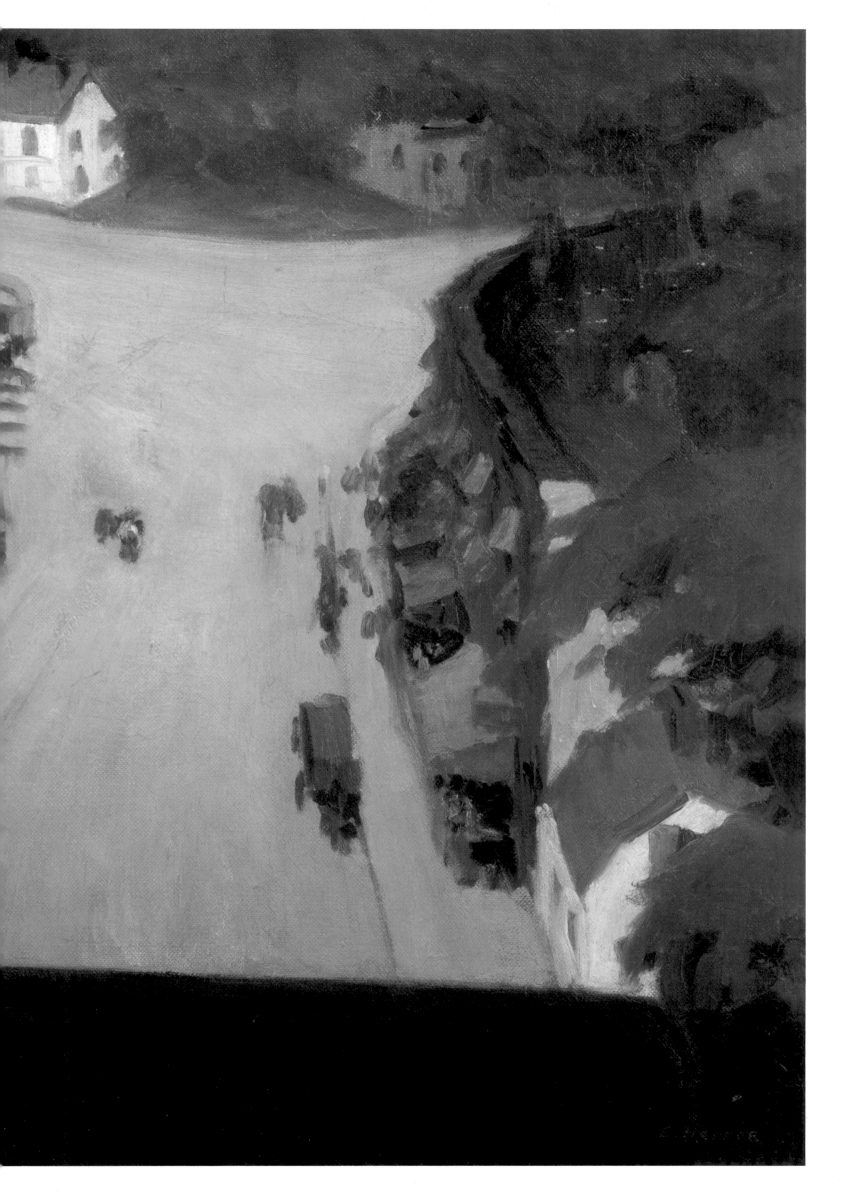

a busy population. A thick *impasto* of surf crashes against the rocks at Briar Neck anc large rocks litter the back alley of the Italian Quarter merging their hard-edged angles with the slanting roof eaves of the town's frame houses. *Squam Light* with its wind-scoured outbuildings perches above a beach with drawn-up dories. The white of the lighthouse and sun-bleached houses is laid on with thick strokes. The facility with which the painting is dashed onto the canvas suggests Hopper was enjoying himself. Only the always-changing sky seems to have been heavily worked until one of its many permutations remained behind.

On returning to New York, his mind was still lingering on the summer's activity while through the carriage window he watched small towns rush past. Back at home, he painted *American Village* (pp.54-55), an early evening look down from an overpass at a village street. The windows of its stone-front buildings are still shaded with individual awnings. Street level awnirgs hide the shopping populace from view. A quirk of the light singles out a white frame house and yellow trolley-car at the end of the main street, but the rest of the pavement activity is only suggested by strategic paint dabs as low clouds roll overhead before the arrival of a summer rainstorm.

Invigorated by his summer of painting, Hopper joined Kroll, George Bellows, eight other hopefuls and the ubiquitous Robert Henri back at the MacDowell Club. In January 1913, when the hanging was completed and the doors opened, Hopper had hung two paintings, *Squam Light* and *La Berge*, yet another of his Paris paintings of the Seine. He demonstrated an almost pathological unwillingness or inability to separate himself from his French work in the face of monumental indifference. Predictably, he sold nothing and was once again ignored by the critics.

Hopper dragged himself back to *The System, Magazine of Business* and added fiction illustration for the *Associated Sunday Magazine,* a Sunday supplement tabloid carried by major city newspapers. But a more bittersweet test of Hopper's resolve was still ahead, as judging was underway for inclusion in the February opening of a show to be held at 25th Street and Lexington Avenue in the cavernous hall of the 69th Regiment Armory. The 1913 Armory Show would turn the art world on its head and Edward Hopper desperately wanted be a part of the excitement. The opening of the Armory Show on 17 February 1913 tore into the staid American art scene with 1,250 paintings sculptures and decorative works by more than 300 European and American artists. From Marcel Duchamps *Nude Descending a Staircase* to the realist works of the American Ash Can School, there were no limits or boundaries. Critics rushed about seeking the high ground, moral, or creative or both, but mostly followed the popular line, or as one critic wrote:

> *"It was a good show…but don't do it again."*

Newspaper cartoonists had a field day with the abstract works.

Following a series of independent art shows in France, England, Germany and Italy, the *Association of American Painters and Sculptors International Exhibition of Modern Art* suddenly brought the works of "those people across the Atlantic" to the creatively constipated, conservatively conformist art scene that had dominated the United States for decades. It brought to light for a new broad segment of the public those American artists who also practised this lurid internalised alchemy of paint and canvas, or stone and chisel.

During the selection process, the Domestic Exhibition Committee was chaired by William Glackens, one of Henri's circle, part of the "Eight" show, who contributed regularly to the on-going MacDowell hangings. This committee managed to offend almost everybody by its original invitations for admission requiring originality and a "personal note" in each artist's work as part of the committee's guidelines. Hopper was not automatically invited to submit as in the past.

30. *Yonkers*, 1916.

Oil on canvas, 61.6 x 73.9 cm.

Whitney Museum of American Art, New York,

Josephine N. Hopper Bequest.

A backlash among American artists finally wedged open the door to submissions by uninvited artists. Hopper, hat in hand and no longer one of the favoured Henri clique, brought two of his 1911 oils, *Sailing* and *Blackwell's Island*. Only *Sailing*, the jaunty little sailboat, was allowed to be hung.

Unprecedented crowds shouldered their way into the Armory hall. Guffaws of laughter, gasps and curses punctuated the rumbling murmur of the crowd as they passed works by Kandinsky, Picabia, Matisse, Charles Sheeler, Georgia O'Keeffe, Brancusi, Everett Shinn, John Sloan. The walls were alight with colour and movement.

Like many of the American artists, Hopper surreptitiously hung about near his painting, looking for reactions, listening for comments. Nearby, his old instructor and leader among the classical Realists, William Merritt Chase, huffed and puffed aloud over the "rubbish" on exhibit. From the crowds trudging past, pointing and whispering behind their hands, stepped a textile manufacturer from Manhattan named Thomas F. Victor. He liked the picture of the sailboat, noted its price was $300, and being a successful manufacturer, offered $250. Hopper accepted and a show official affixed a "sold" ticket to the picture's frame.

Finally, Hopper had sold a painting, something created from his memory and imagination. The $250 sale price is equivalent to $5,000 in 2006 dollars.[13] This is significant money and a jubilant and revitalised Edward Hopper took the train home to Nyack to show his parents that he was finally on the fine art track to success. The legendary Armory Show closed on 15 March. Garrett Hopper, always lingering at the edge of frail health, died on 18 September 1913. Edward had vindicated himself to his father who, considering his own fruitless struggle for success, must have been very pleased for his son.

Edward Hopper had to take stock of his life at this juncture. Realistically, his sale of a painting was more a symbol of the door cracking open than an arrival, a confirmation of his long sought after success as a fine artist. He was past thirty years of age and had developed a facility with the painting medium that obeyed what he chose to place on the canvas. Abstraction and "modernism," as featured in the Armory Show, held no thrall for him. He had committed himself to realism and the painter's ability to translate his personality to the selection, presentation, addition and subtraction of elements in a given scene. Now he needed to flush away the past struggle and move on. To begin with, in November 1913, he began documenting his sales in an account book, carefully noting each acquisition of cash, no matter the source. In doing so he came to grips with the illustrative work that he needed to support his painting. His creative vocabulary was in hand and each canvas sold trimmed time from the purgatory of commercial illustration.

In December 1913 Hopper sought out a new and larger studio. He discovered Washington Square in Greenwich Village and a run-down Greek Revival style building at Three Washington Square North facing the park. It had been built in the 1830s and rehabilitated in 1884 for conversion to artists' studios. Previous artist tenants had included Thomas Eakins, Augustus St Gaudins and William Glackens. He moved into the fourth floor at the top of seventy-four steps into a crude lodging that had no private bathroom or central heating. A coal stove sat in one corner and a glorious skylight lit up the room and leaked during rainstorms.

Hopper's neighbours were artists of various stripes and one of them, Walter Tittle, had been a former Chase student with Hopper. Their friendship was rekindled and Tittle helped Hopper find illustration jobs. Like it or not, Hopper was dragged into the Bohemian artist scene that had infiltrated the Italian and Irish Greenwich Village neighbourhood, The Washington North building often rang with simultaneous parties that Hopper visited by simply climbing or descending the stairs. He had shunned the riotous behaviour of the Left Bank-Montmartre crowd in Paris, but the proximity and vitality of Greenwich Village gave him some relief from work if it did not inspire him.

31. *New York Corner (Corner Saloon)*, 1913.
 Oil on canvas, 61 x 73.7 cm.
 The Museum of Modern Art, New York,
 Abby Aldrich Rockefeller Fund.

32. *The El Station*, 1908.
 Oil on canvas, 51.3 x 74.3 cm.
 Whitney Museum of American Art, New York,
 Josephine N. Hopper Bequest.

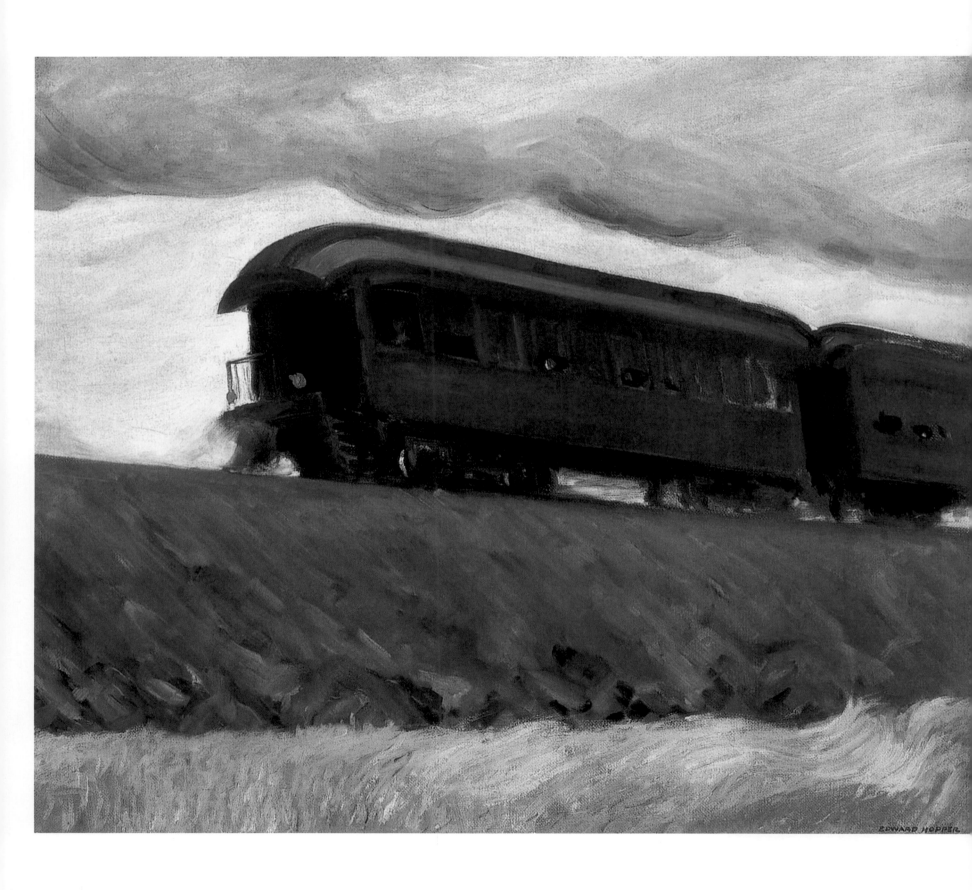

It is curious that Hopper, usually the tall man in the rear of the photograph separate from the crowd, continued to be sought out by his contemporaries. He was far from the most successful and hardly a gregarious yarn-spinner. His work had been juried out of their shows, or accepted grudgingly. He worked in their shadows, but rarely in their company. He seemed to be seeking a key to their success in the location of their subject matter. "The American Scene" had many possibilities to draw from, and yet Hopper chose to dog the tracks of these artists and then produced works that drew no reviews from critics and did not sell. In the growing vitality of the American art landscape he became the 6ft 5in invisible man.

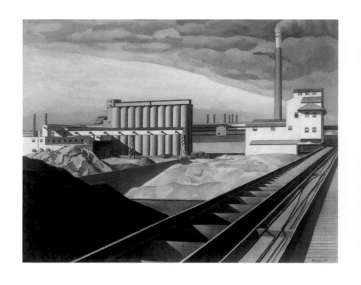

And yet he continued to be a fixture in their society. If he churned inside, he maintained a placid exterior. There was a dogged certainty about him that seemed to be supported by the brilliant technique he had demonstrated in Henri's classes and in the casual skills he so disdainfully showed off in his illustrations. His friends and supporters remained loyal throughout his life. During these early days, they seemed to be either patiently waiting for his eventual eruption into fame and recognition, or obtained some relief over the frail condition of their own groping livelihoods through *Schadenfreude*, watching the self-possessed Hopper fail repeatedly.

Hopper drew on their company, seeking if not approval then acceptance as he had received all his life from his mother and father, Jammes in Paris, Enid Saies, his instructors William Merritt Chase and Robert Henri, from his supporter Guy du Bois and from Thomas F. Victor, the Manhattan cloth maker who had liked his painting of the sailboat at the Armory Show. As an actor needs applause, an artist needs acceptance. Every rejection is a rebuke, a dismissal not just of the object but also of the personality behind the interpretation of the subject. During this period from 1913 to 1923, Hopper's apparent stoicism masked his fear of failure and baffled his contemporaries. At some point, something had to give and everyone wanted to be around when it happened.

World War I arrived in Europe and soon the United States was giving lip service to victory for the French and England as British war propaganda films were shown in big city movie palaces and nickelodeons. Hopper found some variety from the magazine fiction he illustrated after having to read some of the mediocre text. The U. S. Printing and Litho Company cranked out movie posters and each one paid Hopper $10 ($200 in 2006 dollars). He was also paid to sit through the silent melodramas, which he preferred to the pulp fiction of the time. Movies became a fascination for him that lasted the rest of his life. Even the free movies did not calm his irritation over the theatre marketing people who demanded changes in his drawings when his realistic renderings did not conform to the stereotypes the film moguls thought the public would accept.

After building up his relative wealth into the black, Hopper needed to blow off steam. An artist acquaintance, Bernard Karfiol, recommended the Maine seaport village of Ogunquit, a popular nesting place for New York artists who descended on it each summer like a flock of seagulls. For eight dollars a week, Hopper became a guest at the Shore Road boarding house favoured by the artist population and sat down with them to a communal supper table where he met a fellow resident, a short redhead named Josephine Nivison whom he had seen in Henri's classes. The instructor had, in fact, painted a full-length portrait of her costumed in paint smock gripping her palette and brushes titled *Art Student*. The village became a gathering place for many of Hopper's schoolmates and all the old stories blossomed to life around the dinner table and afterwards.

He plunged into a series of paintings in his usual 29" x 24" size canvases that again demonstrated his ability to make so much out of so little apparent effort. The coastal coves are revealed under a bright sun that bathes the bays creating deep shadows and flat blue seas beneath the anchored brush-swipe dories. Two paintings distinguish themselves from the sea-washed cliffs and coves.

33. *Railroad Train*, 1908.

Oil on canvas, 61 x 73.7 cm.

Addison Gallery of American Art, Phillips Academy, Andover, Massachusetts, gift of Dr. Fred T. Murphy.

34. **Charles Sheeler**, *Classic Landscape*, 1931.

Oil on canvas, 63.5 x 81.5 cm.

Mr. and Mrs. Barney A. Ebsworth Foundation, Saint Louis.

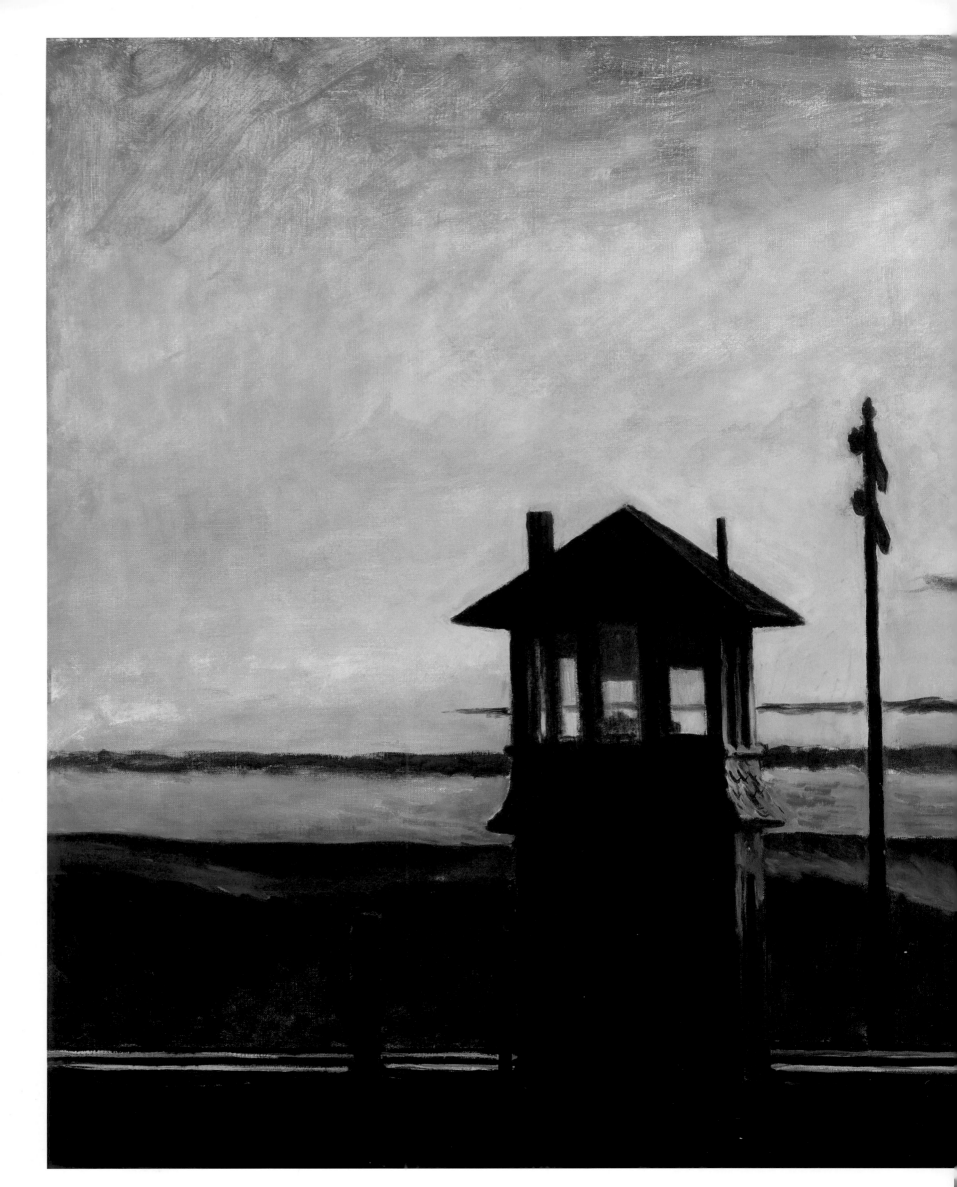

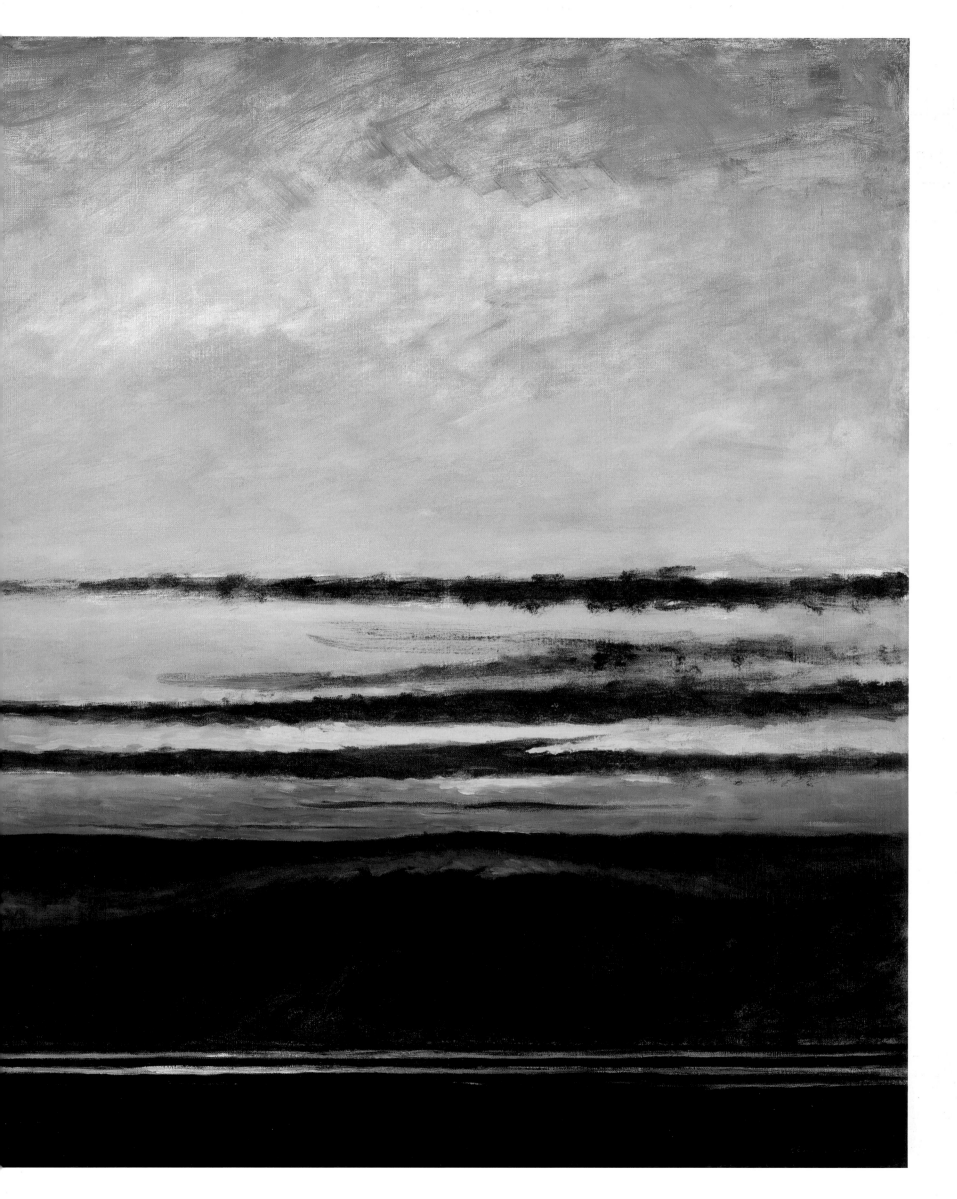

One is *Rocks and Houses* (pp.116-117) that sits beneath a stratus-cloud sky. In the somewhat flatter light, the houses with their deep eaves and gambrel roofs crouch behind an enormous rock, rounded with age and festooned with shrubbery at its base. The feeling is one of compression and melancholy. The houses are intruders on an ancient landscape. Another painting is *Road in Maine* (p.115), the simple view of a rural road winding back in an S-curve behind a rocky outcropping. Only the top part of the curve is visible as it disappears around the corner, its shoulder punctured by two utility poles. The light is sunny, the sky is clear, and yet the mood suggests something has just passed this way or is approaching. The theme would return later in his work.

Returning from Ogunquit he had quite a lot to show for his time away from the illustration trenches. Once back, he found different trenches waiting. His magazine clients had lined up a number of projects including imagined World War I scenes from *Everybody's Magazine* showing bloody and brutal combat action of which he knew nothing.

The Montross Gallery on Fifth Avenue above 49th Street proposed a show and Edward was invited. Full of optimism, he offered up his latest work, *Road in Maine*. Guy du Bois placed four of his own works and singled out his old chum Hopper's piece for comment in *Arts and Decoration Magazine* – of which he was editor. He used the terms: "austerity and baldness", citing elimination of detail in the extreme, the "wireless" telephone poles, the "bleak" country and pointing out the "barren" road. Sounding almost like a slap, du Bois saved the review at the end with the "warmth and colour that ring with sincerity and truth" and a parting pat on the back: "This is where the painter has returned more than he has taken away."

The left-handed effusiveness aside, du Bois' mention comes close to getting inside Hopper's head and seeing in its infancy what would become a primary drive in the artist's choice and rendering of future subjects.

Hopper did not find the experience amusing. He failed to sell the painting. He was also keenly aware of a previous show of Maine paintings by George Bellows who was singled out as "…following in Winslow Homer's footsteps…like Rockwell Kent."[14] Many of his former schoolmates were getting good press, advancing into sales and one-man shows – even if some were achieving success by being compared to already successful artists. Hopper did not desire to follow in anyone's "footprints".

Pressing on, Hopper presented himself at the MacDowell Club with two canvases in February 1915. The oil *New York Corner* (p.59) is, for Hopper, an explosion of human activity around the ornate gold and gilt façade of a corner saloon. Its composition is an academic balance of foreground, middle ground and background that is anything but lively. The figures are dressed in workers' black, trudging toward a newspaper kiosk that is also beneath the saloon's overarching portico. The effect – with the rounded pavement kerbs – is of carved figures on a moving platform forever circling across the face of an antique clock. It is Hopper's virtuoso ability to spike in elements of colour and light with simple brush dabs: the newspapers, the highlight on the foreground gas lamp, the gilt decoration above the door and the barber's pole that adds life to the urban solidity of the brick building and distant cityscape.

The second painting, *Soir Bleu* (pp.70-71) was revelatory both for the painter and for his audience. Besides the obvious fact that once again Hopper had again ploughed into French territory so ignored by previous critics, he played the French morality card in a United States teetering on the edge of its former Victorian traditions. After the turn of the century, the country began claiming that behaviour such as drugs, prostitution, lewd dancing, rude language, white slavery and racy literature or post cards had been "…brought here from Continental Europe", meaning France. Just before the horrors of modern warfare exploded across the fields of Flanders, the decadent French were

35. *Railroad Sunset*, 1929.

Oil on canvas, 74.3 x 121.9 cm.

Whitney Museum of American Art, New York,

Josephine N. Hopper Bequest.

36. *Summer Interior*, 1909.

Oil on canvas, 61 x 73.7 cm.

Whitney Museum of American Art, New York,

Josephine N. Hopper Bequest.

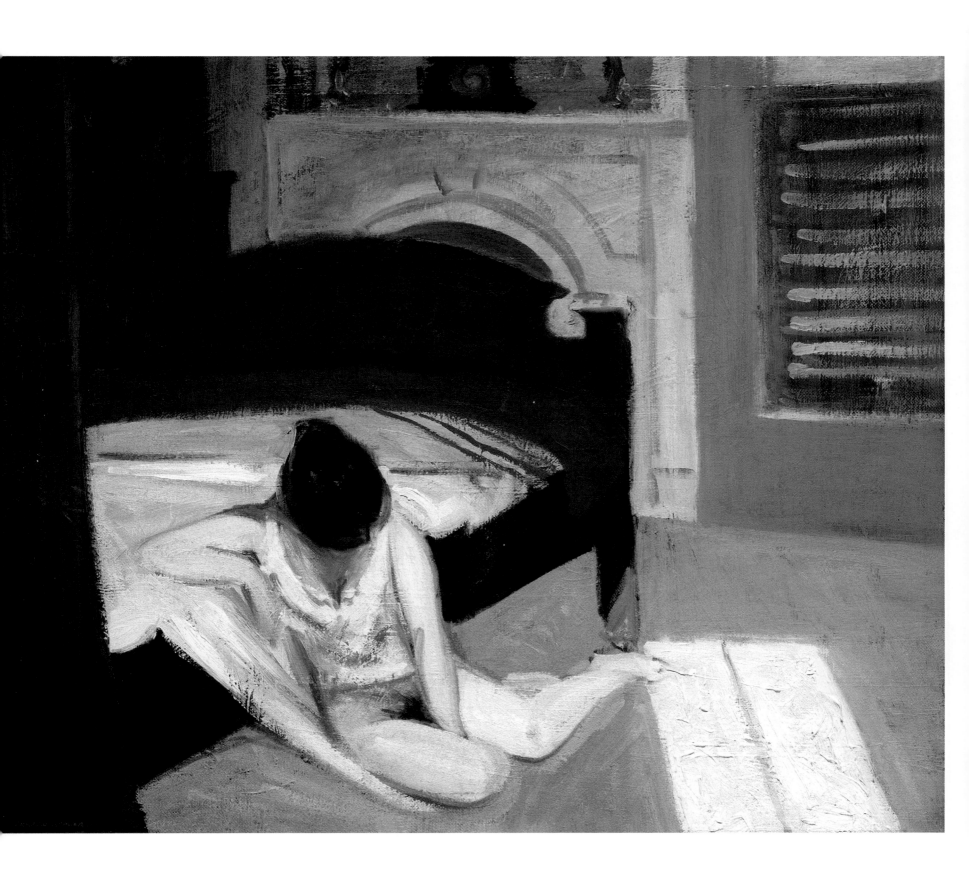

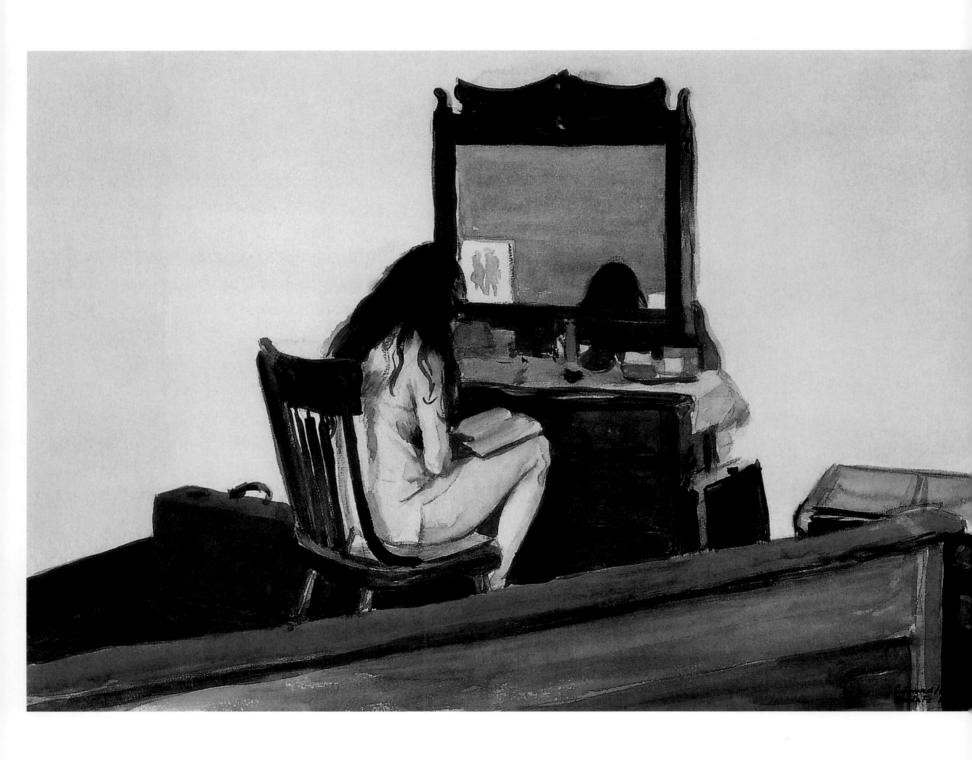

considered poor role models for American children – or adults for that matter. After all, wasn't a condom called a "French letter"?

Hopper's *Soir Bleu* was a huge three by six foot horizontal rectangle. It portrays a tough looking French *Maquereau* (street pimp) at one round table, a man in a beret and a soldier in conversation with an off-duty clown in full make-up smoking a cigarette at a second table, while at a third table two socialites in evening clothes with wine glasses pause in mid conversation. Above this collection stalks a woman in a dress cut low across the bodice. She wears heavy rouge, lipstick and eye shadow. Her gaze is settled above and beyond the people at the tables and her expression is both haughty and expectant. Above everyone hang Japanese lanterns that suggest a festive outdoor setting.

This appears to be a Hopper fantasy piece, coughed up from his sexually repressed past and in tune with the current Francophobia sweeping polite society where American families expected their daughters to be kidnapped from the local ice cream parlour into French brothels at any moment. He was familiar with the seated cast of characters based on experience from his three trips to Paris. Coming from his puritanical Baptist background, chances are that his first sexual experience was a fling with a French prostitute. The pulp press regaled its readers with tales of poor virgin girls lured to their ugly fate and young men of good family ruined by disease and blindness. The painting has a ring of truth in its characters and is the second time the story-telling of his illustration work had intruded into his personal art. It would not be the last.

The critics took notice of Hopper at last. His *New York Corner* was given passing grades all around, but *Soir Bleu* was fobbed off as a seedy collection "…of hardened Parisian absinthe drinkers". This view projected the debauchery of *demi-monde* life in Paris, the "modern Babylon." Francophobia trumped any value the painting might have had as a curiously moving character study. The ubiquitous Guy du Bois alone offered an insightful review citing, "Mr. Hopper…avoids show of enthusiasm and spends the language of art with an economy that one might compare to parsimony were it not so coldly judicious."[15]

Neither painting sold. *Soir Bleu* was pulled off its stretcher to be rolled up and discovered after Hopper's death. It was hastily labelled *Café Scene* until its provenance was discovered later.[16] French themes were at an end. He had endured about as much rejection as an artist can stand and the market for his personal work had diminished to virtual disappearance. He needed something to escape the self-defined "drudgery" of illustration art and set about to find it.

Searching Afield, Finding New Tools

Rent had to be paid, meals had to be bought – Hopper did not cook – and materials had to be purchased. The day to day nickels and dimes for the buses, trolleys and subway allowed Hopper to campaign his portfolio to new clients including *The Farmer's Wife* and *Wells Fargo Messenger* magazines. He had no telephone, so picking up and delivering in person was common. He wanted to repeat his success at Ogunquit during the summer of 1915.

The MacDowell crowd led by Bellows, Henri and Kroll had shifted their sights to Ogunquit this season and descended on the little port in the grand manner. They showed up with their wives and rented small summer cottages. Hopper continued to pass the potatoes and biscuits at a communal boarding house table. A dense fog dogged the coast during that summer so Hopper's former schoolmates used their funds to rent studio space, hire models and paint inside. Hopper bumbled around with his sketchbook trying to find outdoor material before it vanished with a change of off-shore breeze. The foggy summer of 1915 in Ogunquit was a disappointment.

37. *Interior (Model Reading)*, 1925.
 Watercolour and pencil on ivory paper,
 35.3 x 50.6 cm.
 The Art Institute of Chicago, Chicago, Illinois.

38. *Soir Bleu*, 1914.
 Oil on canvas, 91.4 x 182.9 cm.
 Whitney Museum of American Art, New York,
 Josephine N. Hopper Bequest.

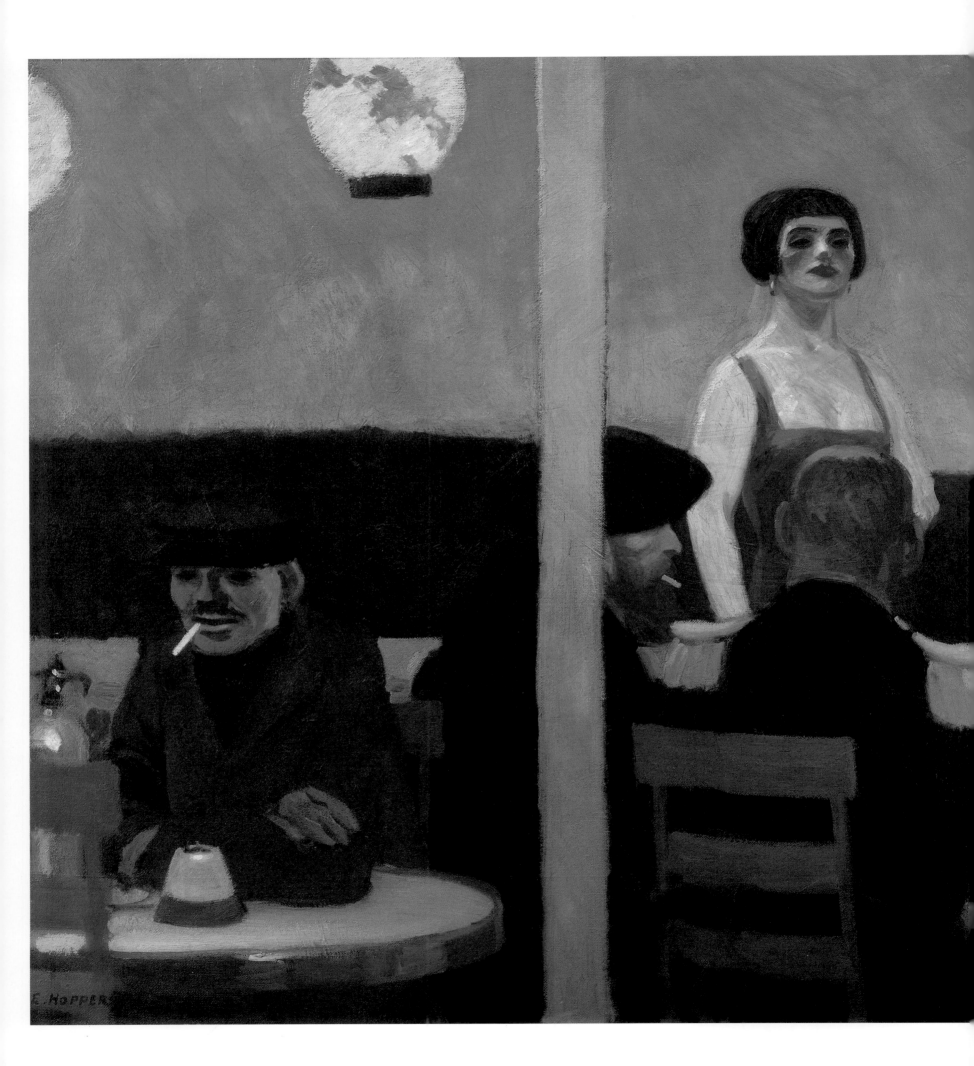

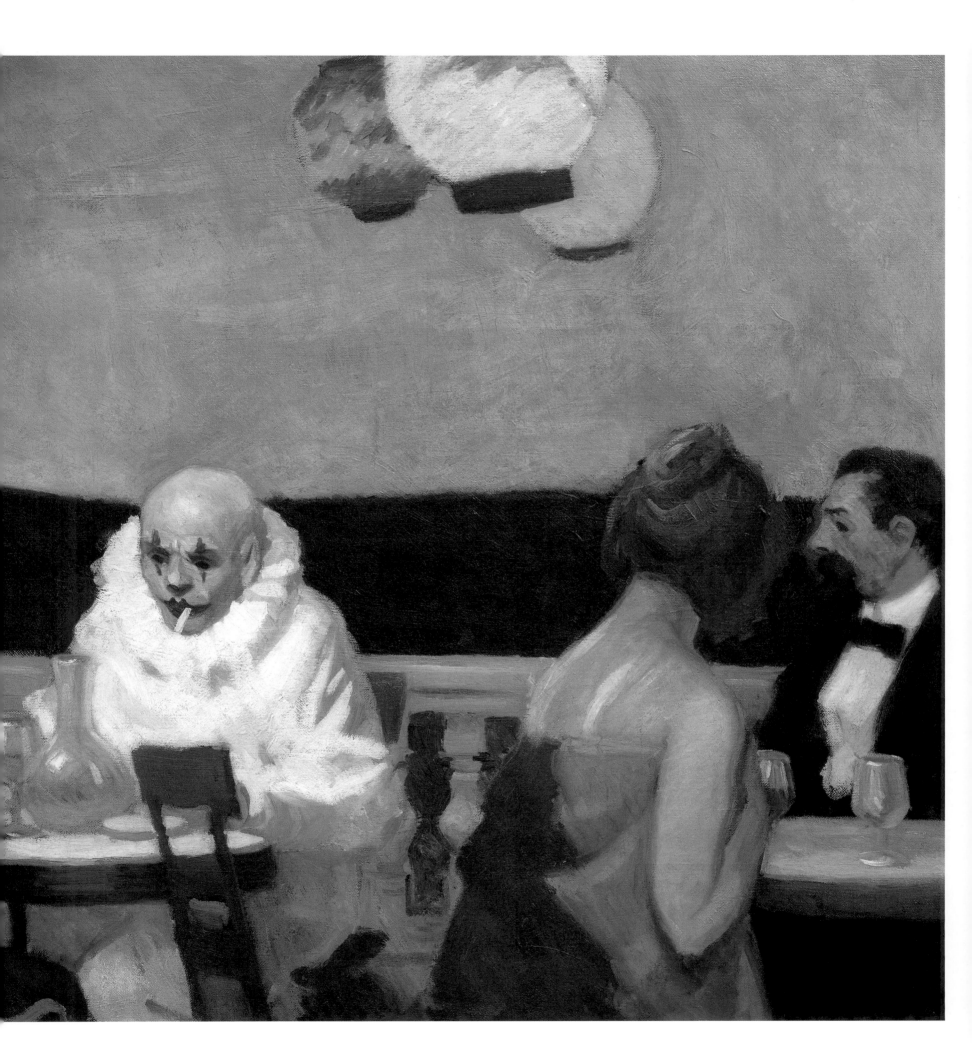

Desperate to avoid more illustration work, he decided to try teaching. C.K. "Chat" Chatterton taught art in a girls' school – Vassar College – so how hard could it be? Hopper had already done some teaching on Saturdays while at the New York School of Art. He printed up some cards and launched his new scheme.

DRAWING PAINTING ILLUSTRATION

Mr. Edward Hopper will give instruction in drawing, painting, illustration and the composition of pictures at 53 North Broadway, Nyack, New York on and after October and every Saturday morning from 9 to 12. Mr. Hopper was a pupil of Chase, Henri, K. H. Miller and others and is a former instructor of the Chase School. For terms address 53 North Broadway, Nyack, or 3 Washington Square North, New York.[17]

Holding classes in a room off his mother's parlour, Edward accumulated students, acquired a few plaster casts for student copying and convinced his mother to pose in her rocking chair when she wasn't passing out lemonade and cookies to the students. It was a horror, a nightmare, a purgatory. To keep from blowing his top, Hopper tried to see the humour in it. He printed another card in French which translated:

E. Hopper Firm, Founded in 1882

Firm E. Hopper

Objects of Art and Utility

Oil paintings, engravings, etchings, courses in painting and literature, repair of electric lamps and windows, removal and transportation of trunks, guide to the countryside, carpenter, laundryman, hair dresser, fireman, transportation of trees and flowers, wedding and banquet halls, readings, encyclopedia of art and science, mechanic, rapid cure for illnesses of the spirit such as flightiness, frivolity and pride. Reduced prices for widows and orphans, Samples on request. Demand the registered trademark.[18]

The MacDowell crowd along with C. K. Chatterton, Sloan and others assembled to set up a show of their recent work. While they had painted away on the Massachusetts coast with paid models and in their snug rented cottages, Hopper had loomed in and out of fog banks in search of subjects. He managed to tug *American Village* (pp.54-55) out of the stack in his studio along with a couple of Ogunquit paintings from the previous season. This show like the last was a disappointment and he sold nothing.

Fortunately, he managed to add colour covers to the work for both *Wells Fargo Messenger* magazine and a new trade magazine client *Morse Dry Dock Dial*, a shipping publication. These were some of his best and most "painterly" illustrations that showed off some striking design latitude over the hack work he'd become used to. His carefully attended account book showed an endless notation of single and double digit paydays: "1 line drawing - $8, 1 half-tone drawing - $35."

While slaving away at *Country Gentleman Magazine*, Hopper's agony over illustration became apparent to the magazine's editor, A. N. Hosking. To retain Hopper's good work and alleviate the artist's frustration, Hosking suggested a change of medium to loosen up the creative blockage. He thought Hopper ought to try etching.

Hopper had to be aware of the brisk American market for art prints as he began in 1915. Logically, he chose the etching medium for both its ability to render drawings permanently that he made in Conté crayon, and the possible economic considerations of actual sales – considering an etching plate can deliver many copies of the original rendering. The process also seemed to reinvigorate his creative excitement as he dredged up both scenes from his memories of France and the American seacoast, and sketches not yet turned into paintings.

39. *Les Poilus*, 1915-1918.

Etching, 23.6 x 26.7 cm.

Whitney Museum of American Art, New York,

Josephine N. Hopper Bequest.

E. HOPPER

Edward Hopper

To my wife Edward Hopper

74

The Acid Etching Process and Dry Point Etching

The etching plate from which prints are made is usually copper. Lines inscribed on the plate below the flat and polished surface hold the ink that is transferred to porous paper. An artist begins an etching by making a sketch in pencil or Conté crayon on a copper plate that is covered with a thin coat of wax called the "ground", and the sketch is transferred to the plate using an "etcher's needle" to cut through the wax to the copper below. Once the drawing is ready for etching, acid is applied to the surface and it "bites" into the plate where the lines are drawn through the wax, producing lines and crevices that correspond to the image drawn. By repeated masking of selected areas of the image, using wax and a painted-on lacquer or varnish, followed by re-application of the acid, lines of different depth and variations in tone can be created to build up the final result. Because the etcher has only to draw the design through wax, rather than wield a tool with sufficient force to cut into metal, it is possible for the work to "flow" much more easily than with engraving. The easy strokes of the needle, and the softness of line resulting from the work of the acid, combine to produce an appearance and tone in the finished print that bears resemblance to a fine pencil drawing. Not all of the drawing needs to be etched at the same time. Linear textures such as cross-hatching can be applied to an area, bitten with the acid and then masked with a covering wax application while another element of the image is etched through the ground. Each stage of this work is proofed with a print to check the result. This check print is called a "state," and many states may be printed until the final finished proof is complete.

Another method Hopper studied was dry point etching. This engraving form uses an etching needle upon a plate without the use of any acid. The needle used has more of a cutting edge than the rounded point used on the etching ground. In drawing the design, the needle cuts into the copper and leaves what is known as a burr ridge of copper on either side of the furrow. This burr gives the soft quality to dry-point etchings when they are printed.[19]

Being in control of the entire process was also important to Hopper, so he bought himself an old-fashioned flat-bed banknote press. From his friends C. K. Chatterton and the Australian illustrator Martin Lewis, Hopper picked up the rudiments of etching and began experimenting. He wanted only the whitest Umbria paper and the blackest ink for final prints. By his judgment, no truly black ink was available in the US so he had Frankfurt ink ordered from England.

Hopper continued to visit the galleries with friends, his neighbour Walter Tittle and former instructor, Kenneth Hayes Miller. He was particularly struck by the works of Manet, Pissarro, Sisley, Monet, Renoir and Degas whom he found at the Durand-Ruel gallery. Though quite a bit of his work seemed to owe something to Cezanne – especially the oils of rocks and sea done at Ogonquit and later at Monhegan Island – Hopper dismissed the connection. Curiously, those who fled from Hopper's eventual enthusiasm for etching fell all over themselves claiming credit for steering him to the medium once he developed some skills.

Through 1916, he toiled with the etching process while he worked – no more than three days a week – at commercial illustration. He never received the big commissions because of his inability to portray the fragile charms of pretty girls and his total lack of desire to please fussy art directors at the big magazines. His were the industrial clients, trade magazines and low end "pot-boiler" pulp fiction.

As 1917 opened, so did yet another opportunity present itself to show his work at an exhibition by the MacDowell crowd that travelled to Springfield, Ohio, Walter Tittle's home town.

Hopper added three paintings to the collection gathered together by the usual suspects, Henri, Kroll, Davey, Sloan, Chatterton, Bellows, and Andrew Dasburg, a painter on the fence between

40. *Evening Wind*, 1921.

 Etching, 33.7 x 40.6 cm.

 Whitney Museum of American Art, New York,

 Josephine N. Hopper Bequest.

41. **Edgar Degas**, *Nude Woman Combing her Hair*,

 c.1879-1885.

 Monotype, 31.3 x 27.9 cm.

 Musée du Louvre, Paris.

42. *Night in the Park*, 1921.

Etching, 33.7 x 37.5 cm.

Whitney Museum of American Art, New York,

Josephine N. Hopper Bequest.

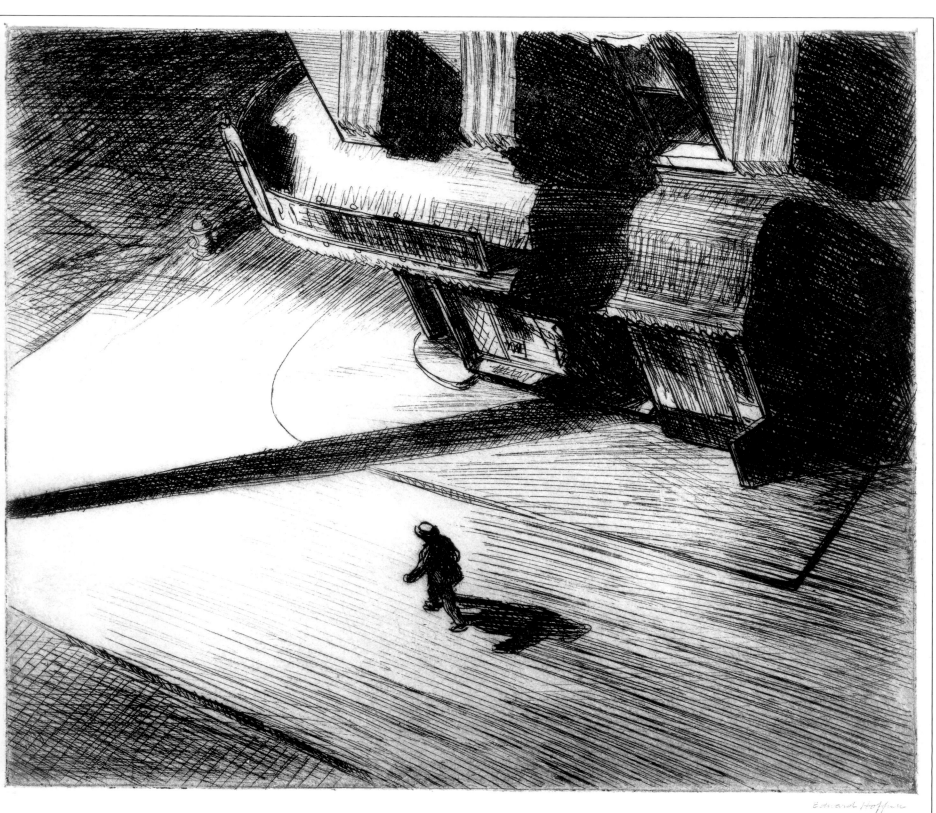

43. *Night Shadows*, 1921.

Etching, 24.4 x 27.9 cm.

Whitney Museum of American Art, New York,

gift of Gertrude Vanderbildt Whitney.

Cezanne and Cubism. Hopper's works bore no relation to each other, nor did they show any developing direction: A *Portrait of Mrs. Sullivan*, rendered in Henri's style, *Rocks and Sand* and a vivid busy street scene bathed in high sunlight, peopled with crowds of his brush-dab figures and featuring a yellow trolley-car, all yielded up with brushstrokes of thick *impasto* called *Summer Street*. The show featured "Prominent Paintings," but on the list of the prominent artists noted, Hopper was absent. When *American Art News* reviewed the show, it cited the exhibition as a collection of "…a group of clever painters of the Henri type." Hopper was mentioned among the "other painters represented".[20]

Edward Hopper had apparently reached the end of the line with his oil paintings as far as the current marketplace was concerned. His friendship with Walter Tittle continued to produce illustration assignments as Tittle's own reputation grew in that field. To keep his creative mind cooking while he turned out illustrations on autopilot to pay the bills, Hopper continued to hone his etching skills and hoped for an opportunity to show.

He drew an invitation to show at the *First Annual Exhibition of the Painter-Gravers of America*, an organisation founded to improve the quality of American prints. The founders of this group included George Bellows, whose printing medium was lithography, and John Sloan, who had been creating etchings of urban life since arriving in New York in 1904. Watercolourist John Marin had produced almost two thirds of his output of 180 etched plates between 1905 and 1913.[21] Julian Alden Weir, famed for his spontaneous dry point engravings, was a founder, along with Childe Hassam, who had won a chest full of gold medals for his paintings and print work as well as being a member of New York's fashionable artistic eyrie, the Salgamundi (a stew of many ingredients) Club. Being invited to show with this experienced collection of print makers might have been the result of campaigning by his chums Bellows and Sloan, since Hopper was hardly a prominent name as an etching artist. He submitted three small prints, and his other loyal chum, Guy du Bois, published one, *Les Poilus,* in *Arts and Decoration Magazine*, March 1917.

Seeing print-making opening up as another possible market for his work, Hopper felt comfortable enough to sub-let his studio and use some of his "pot-boiling" money to spend another summer at Monhegan. Traipsing along the wind-swept shorelines and boat-crowded bays, he once again exchanged pleasantries with the little red-headed girl, Josephine Nivison. Other friendships kindled included the painter Rockwell Kent and print enthusiast Carl Zigrosser, at the time an employee of Frederick Keppel and Co., where the American Painter-Gravers show had been held that spring. Zigrosser went on to become the Director of New York's Weyhe Gallery from 1919 to 1940 and the Philadelphia Museum of Art's Curator of Prints from 1940 until 1963. He was a passionate collector of prints and a prolific writer on the subject.

Rockwell Kent had been encouraged to visit Monhegan by Robert Henri, whom he knew from the New York school. Hopper was the same age as Kent and they must have recognised their shared interest in the sea and the timeless energy of nature. Also like Hopper, Rockwell Kent was a loner and shunned connections with the Post-Impressionists and the growing abstract expressionist movement. His lithographs remained in the Realist camp, closer to Hogarth and Constable than Monet or Cezanne. A fellow illustrator, Kent had a wide following of clients, and this led to a very accepting audience for his prints in the 1920s.

Hopper might have seen his own future in Kent's success as a print maker.

In the spring of 1918 the Chicago Society of Etchers called, requesting a submission for an exhibit at the Art Institute of Chicago, and Hopper sent along his recently published *Les Poilus* (p.73). Catering to American viewers, he changed the name to *Somewhere in France*. Meanwhile, he and the MacDowell Club crowd hung a show of drawings, watercolours and pastels. Hopper's prolific

44. *East Side Interior*, 1922.

Etching, 34.6 x 40.5 cm.

Whitney Museum of American Art, New York,

Josephine N. Hopper Bequest.

45. *American Landscape*, 1920.

Etching, 33.9 x 46.3 cm.

Whitney Museum of American Art, New York,

Josephine N. Hopper Bequest.

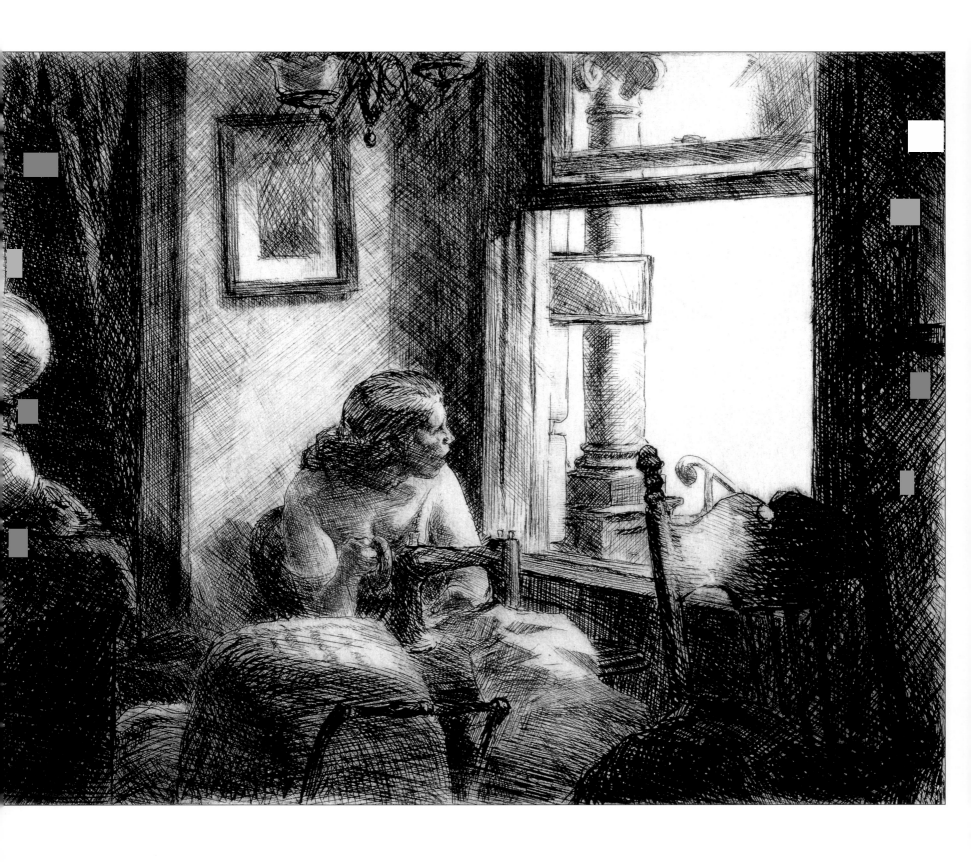

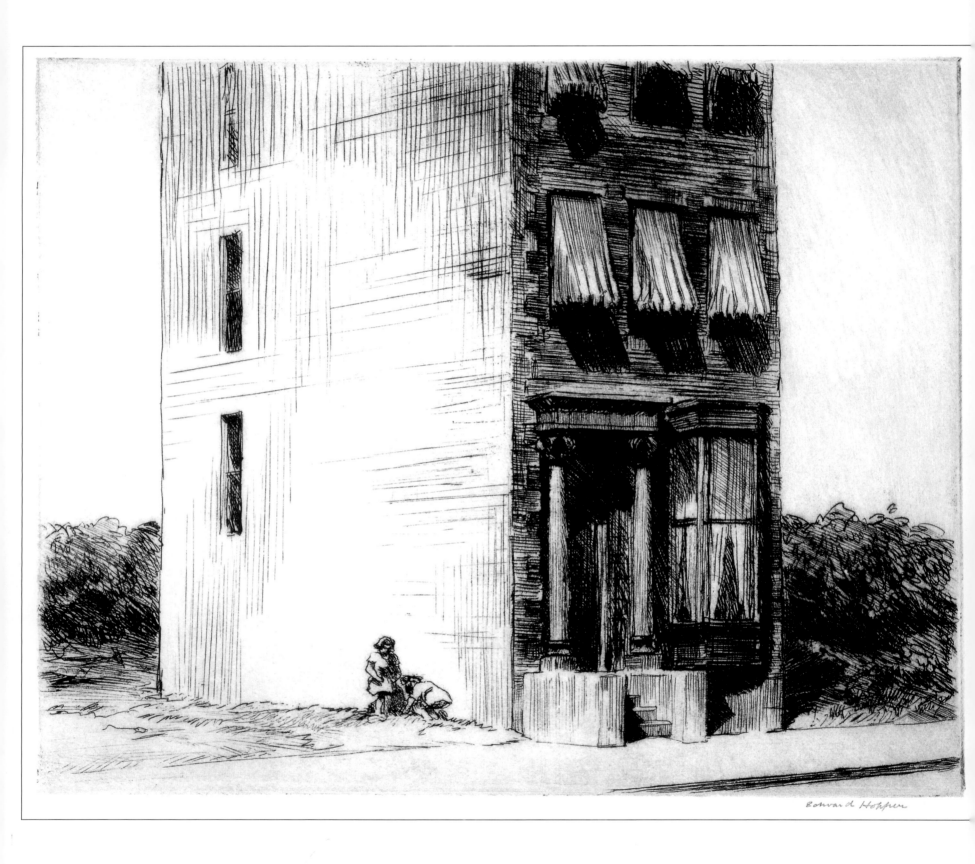

Edward Hopper

display of eight pieces included *Somewhere in France*, the *El Train*, *The Open Window* and *The Bull Fight* – a spectacle that had sickened him when he visited Spain. He chose to portray the least heroic aspect of the fight where the blindfolded horse with a picador aboard is gored by the bull while the lance is driven into the bull's shoulder. Guy du Bois, in a write up of the show for *Arts and Decoration Magazine*, curiously comments on Hopper's "decorative handling" of the subject and ignores his uncharacteristic portrayal of the agony of the gored horse, that cries out along the composition's horizontal linear arc. Strong emotion was an uncommon feature of any Hopper work.

As the war in Europe wound down, Hopper's reputation ramped up. He won a poster contest sponsored by the United States Shipping Board Emergency Fleet Corporation with a depiction of a steel worker defending himself with a long-handled hammer against the thrusts of bloody bayonets titled *Smash the Hun*. Besides winning the $300 top prize, the poster was published on the cover of the *Morse Dry Dock Dial Magazine* by editor Bert Barnes, who had suggested that Hopper enter the contest. That magazine made exceptional use of Hopper's design and story-telling skills, which helped open other illustration doors to publications such as *Scribners*, and colour covers for *Hotel Management Magazine*. Characteristically, Hopper put down most of this work as "…pretty awful".

Print making opened up new worlds for Edward Hopper as he consigned prints from his etchings to the Chicago Art Institute, the National Arts Club in New York and out west to the print makers of Los Angeles. When they sold, the prices were modest – less than $20 each – but his illustration work brought in enough to make worry-free and enjoyable the 1919 summer painting vacation to Monhegan Island with Guy du Bois and his wife Floy. With his friend Guy, Hopper had his own publicist. The etchings had given him fine art exposure. Illustration – regardless of his proclaimed self-loathing – provided reputation and money. He was now in his mid-thirties heading into the 1920's and, for once, going in the right direction.

Redemption in Black and White

Gertrude Vanderbilt Whitney, sculptor and art patron, had founded the Whitney Studio Club on West 4th Street in 1918. It was a popular haunt for the artists of Greenwich Village, where they could take their ease or show their work. Guy du Bois obtained a one-man show for himself in November 1918 and at once began campaigning for a Hopper show at the club. His entreaties were successful and the walls were scheduled for Hopper's work in January 1920. The show would be Edward's first one-man presentation and the first time his paintings had been on display anywhere in three years.

Also showing at the Whitney Club was Hopper's former drawing instructor, Kenneth Hayes Miller, filling his space with female nudes. Both the prestigious club and the naked ladies drew critics. Miller's nudes solicited suitably artistic observations and those critics who were familiar with the arc of Hopper's career to date were stunned. He had dredged up every old French chestnut he'd been showing since his last trip to Paris. By this time, Edward Hopper had been recognised for his American scenes in etchings and patriotic illustrations. Of the sixteen oils hung at the Whitney Social Club, eleven were of Paris: *Le Pont-Neuf*, *Notre-Dame de Paris* (p.36), *L'Aprés-Midi de printemps* (p.18), *Juin, Le Parc de St Cloud* (p.24), *Le Quai des Grands Augustins* (p.30), *Le Bistrot* (p.33), *Le Pont des Arts* (pp.28-29), *Le Louvre et la Seine* (p.10), *La Cité, Les Lavoirs* (p.21). The remaining five were studies from Monhegan and the Massachusetts seacoast.

Du Bois was flabbergasted and in his review did his best to write around the dusty old French warhorses, but even his finely-minted and carefully-selected words were a feeble defence of an

46. *The Lonely House*, 1922.

Etching, 33.9 x 42.4 cm.

Whitney Museum of American Art, New York,

Josephine N. Hopper Bequest.

opportunity well and truly missed. None of the paintings sold. The critics jotted down polite comments about the American artist who painted French pictures and wandered off to try the club's buffet lunch.

Hopper absorbed the rejection of his poorly-timed nostalgia and pressed on, going to sketch at nights at the club, continuing his illustration work, pulling prints from his plates and contemplating the next summer's painting trip. By now, his frugal life style, arduous work ethic, voracious reading habit and absence of social life had left him a skeletal balding wraith resembling a repatriated prisoner of war rather than a reasonably successful B-list illustrator. He wore pince-nez glasses, clothed his tall gangling body in a three-piece suit, and during the winter lugged a scuttle of coal up the seventy-four steps to his studio to feed the pot-belly stove. If life became really tight, he could always take the ferry and the train back to Nyack for a home-cooked meal and a night in his old bed. "Grasshopper" was thirty-eight years old and needed a drastic change in his life.

The etching press in the corner of his studio apartment continued to press prints from his current crop of copper plates and he shipped them to various galleries and museums on consignment. He noted their pitifully small selling prices in his account book. He earned $1,594[22] in 1920 ($15,884 in 2006 currency) which, after deductions for rent, materials, transportation and something he called "bad debts", he had $614.20 ($6,120) left over to live on. The average American in 1920 earned about $100 a month and an assembly line worker in a Model T Ford factory earned $1,800 a year. Edward was paying his way, but hardly living large.

Fortunately, following the war the United States was enjoying a boom in agriculture, manufacturing, transportation and entertainment. While Europe struggled with a "lost generation" of wage earners, rebuilding and high inflation, the United States became the world's breadbasket and technology leader. In the big picture, this meant there was more disposable income for the burgeoning middle and upper-class to invest in art and decoration for their new homes. Fine art display had a nouveau-riche cachet to cash in on.

Hopper's press continued to churn. Some of his most interesting and famous etchings from the early 1920s were *American Landscape, Evening Wind, Night Shadows, Night on the El Train, The Lighthouse* and *The Lonely House*. Each points toward a direction for his art and the paths he would follow.

American Landscape (pp.80-81) is a story of homecoming told in 1920 as a milk herd is driven across a line of railway tracks towards a farmhouse and the cowshed. A wall of woods catches the last of the setting sun, as does the lead cow on the tracks and the upper storey of the frame house. The sky is bald and still carries summer heat. This could be nowhere else but America, with progress cutting across the once open prairie like a knife-edge, but life carries on as it has for a hundred years. Hopper's use of line is vigorous, suggesting more than simply reproducing the shadows, the light and dark masses that divide the composition into unequal thirds. Cropping out the emptiness on either side of the centrally placed action destroys the story of the wide open landscape.

Blowing curtains react to the *Evening Wind* (p.74), Hopper's 1921 etching from a Conté crayon sketch. The assurance gained during his continued attendance at sketching classes with nude models shows as the young woman kneeling on the bed that faces the window has weight and solidity. She faces away from us towards an empty view. The room is small and cheap, with a pitcher and bowl on the sideboard. Has she heard or seen something? Why does she need to go to bed in daylight – and naked in front of an open window? There are so many questions that raise so many possibly ambiguous symbolic interpretations. One of the delightful skills that Hopper developed – to the agonising frustration of future art writers – was the ability to expose the grindings and whirrings of his own internal fantasy engine in such a way as to invite the viewer to unload his own psychological

47. *The Lighthouse, (Maine Coast)*, 1921.

Etching, 39.3 x 43.6 cm.

Whitney Museum of American Art, New York,

Josephine N. Hopper Bequest.

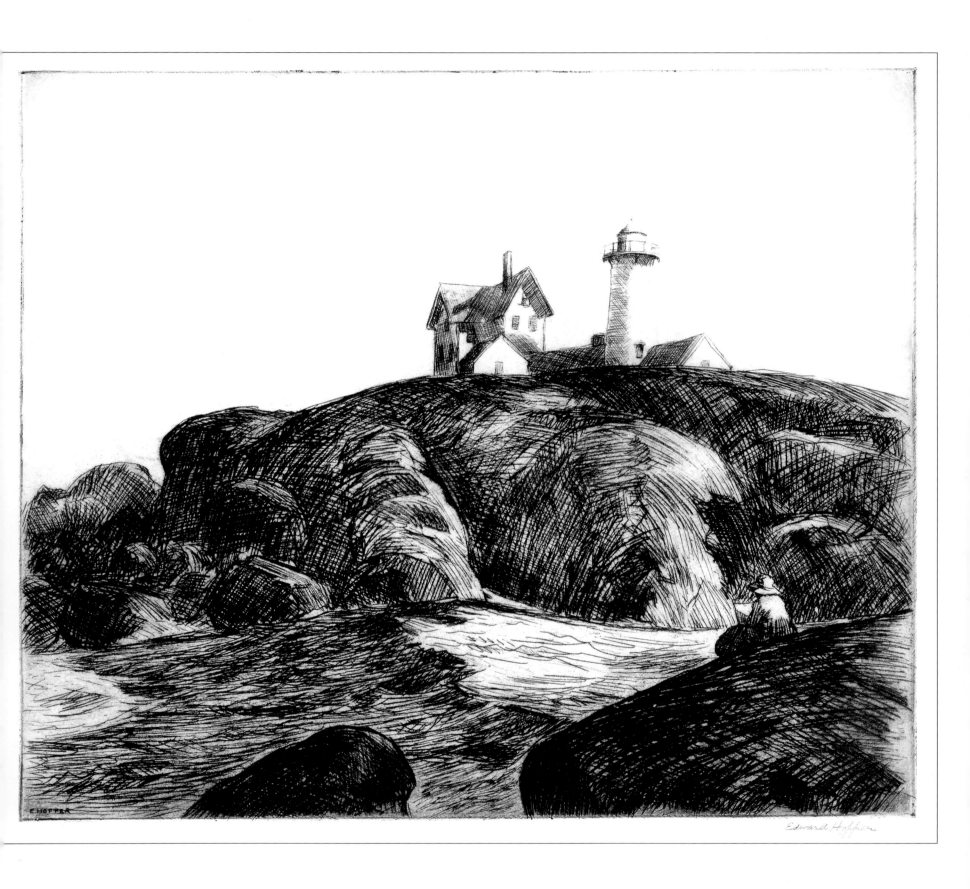

E HOPPER Edward Hopper

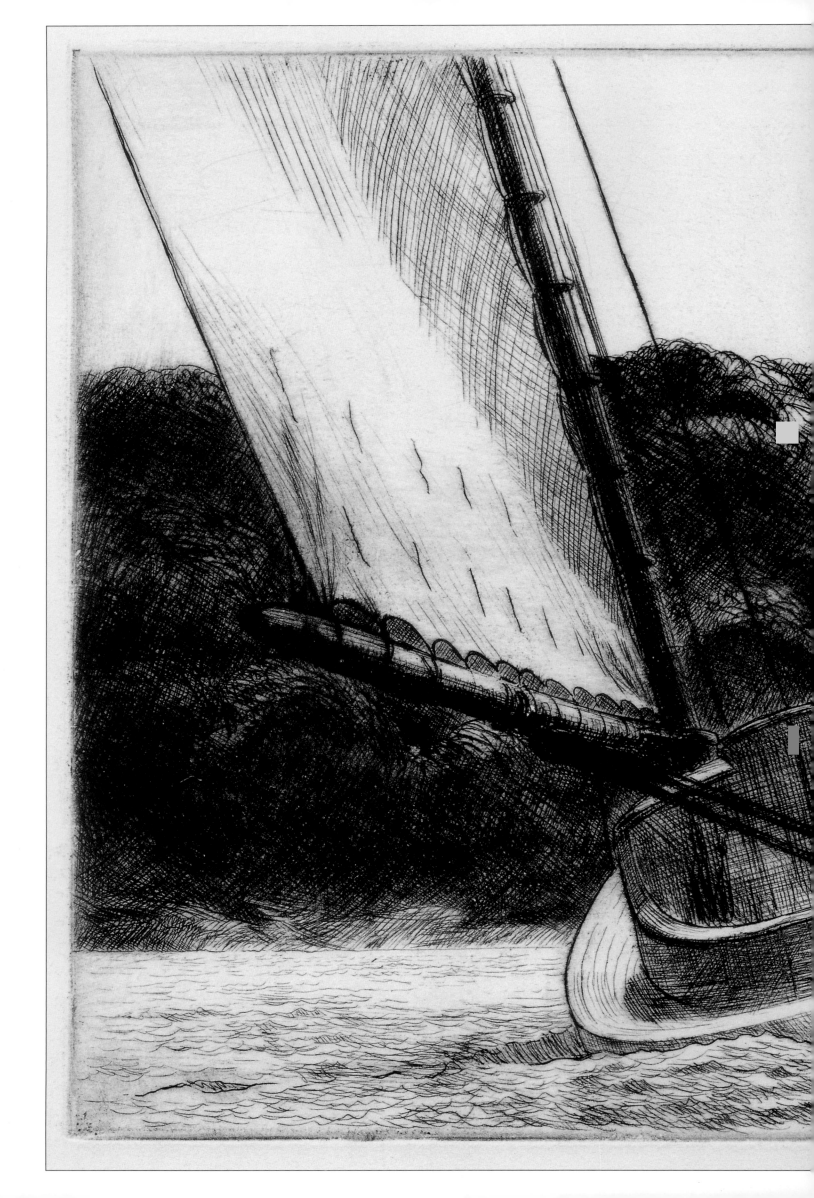

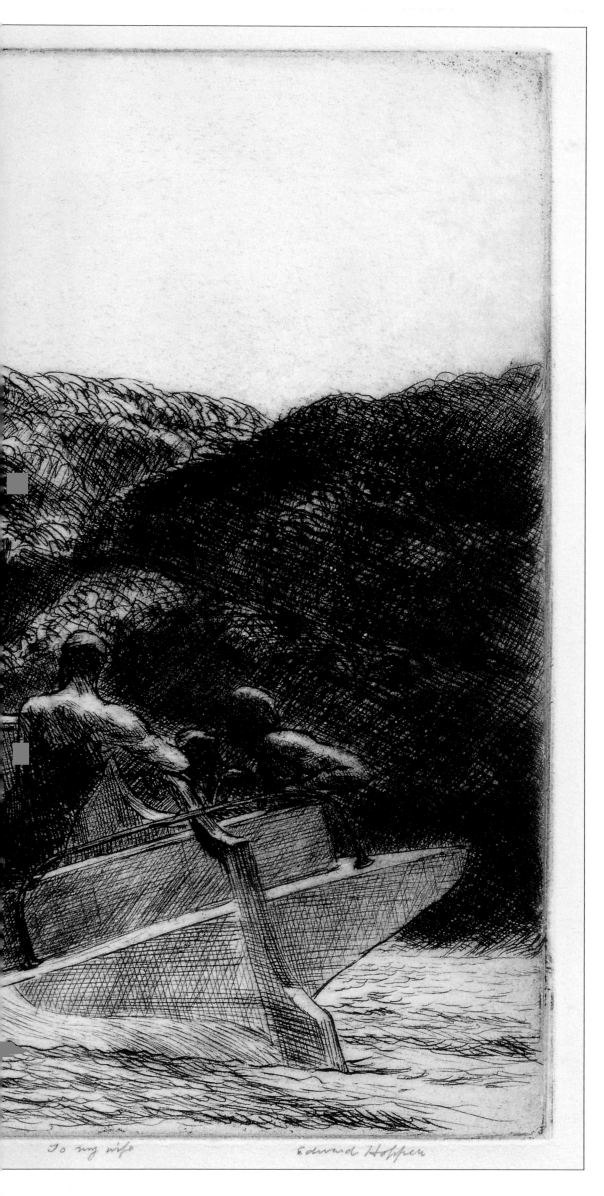

To my wife *Edward Hopper*

48. *The Catboat*, 1922.

Etching, 33.9 x 40 cm.

Whitney Museum of American Art, New York,

Josephine N. Hopper Bequest.

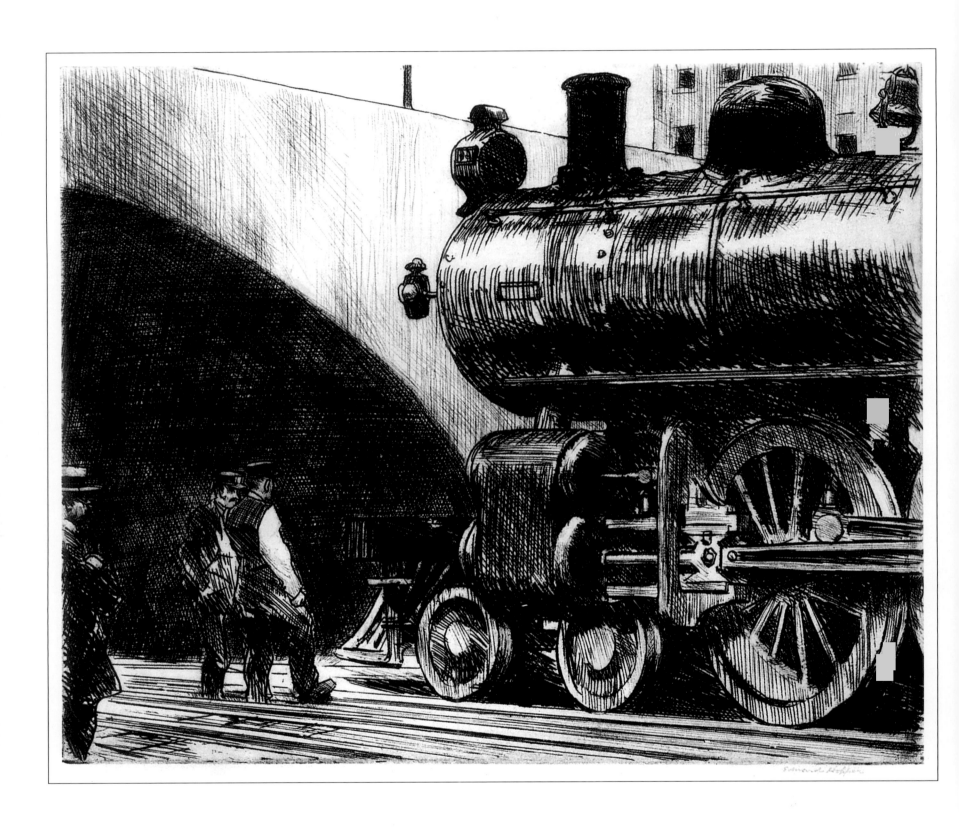

baggage on the print or painting before him. More than once Hopper fended off searching analytical questions about the "content" of his work. In one letter he answered:

> *"There is little to tell about it. It was entirely improvised from memories of glimpses into rooms seen from the streets in the East Side in my walks in that part of the city. No implication was intended with any ideology concerning the poor and oppressed. The interior itself was my main interest – simply a piece of New York, the city that interests me so much, nor is there any derivation from the so-called 'Ash Can School' with which my name has at times been erroneously associated."* [23]

Let them bring what they wanted to his work, he was finally, a few dollars at a time, making money with his prints and placing them in galleries and shows: Brooklyn, Chicago, Los Angeles, Canada – and even in the spring and winter shows of the snooty National Academy of Art. He was even compared to one of the Academy's darlings, the redoubtable printer and collector of gold and silver medals for his efforts, Childe Hassam.

In the autumn of 1921, feeling confident, Hopper placed three prints with the important and influential dealer Frank K.M. Rehn on consignment with a 33% commission attached. One of Rehn's clients was the prestigious Salmagundi Club, whose membership was a Who's Who of the New York art scene. Hopper had visited Rehn at the suggestion of an old schoolmate, Edmund Graecen from William Merritt Chase's classes, who went on to become President of the Grand Central School of Art in Eastport, Maine. Hopper showed up at Rehn's gallery with a selection from – what else – his dog-eared collection of French paintings. Rehn recognised the immaturity, the impressionist palette, and the pronounced aura of picked-over goods and rejected the lot. As Hopper stood amid the ruins of his presentation, a *Tribune* art critic happened to stop by and extolled the virtues of Hopper's prints hanging on the Academy's walls. Frank Rehn knew Hopper had something but not exactly what, so he accepted some Hopper prints on consignment.

Hopper's trips to Europe had allowed him to see the original prints of Rembrandt. His etchings produced during the 1920s reflect the Dutch master's bold use of light and line, revealed in such works as *The Three Crosses* in its fourth state etched in 1653.[24] Hopper pursued that ideal with his etchings, and while never achieving Rembrandt's luminosity or subtlety, he did manage to learn enough skills to give his stories a look of completeness that needed no further words. The etchings of the Dutch master, however, had been conceived with as much importance as his oil paintings. Hopper's prints, while they carried his stamp of strong design and symbolic reality, appeared to owe their existence to their appeal to art museum curators and galleries. They represented a mix of story-telling with the first real glimpse of his deeply personal vision revealed in black and white. With their modest financial return, they also became the loss-leaders for his eventual sales as a painter.

Hopper, at this time, was never far away from an agenda. His artist peers had all achieved varying degrees of success as printmakers besides their work with oils and watercolours. Following the pattern he had established on arriving in New York, Hopper once again emulated them. His growing success as an illustrator and poster artist gave him a platform for his etching, an *entrée* into the world of fine art and the acceptance he sought so desperately.

Both his *El Train at Night* and *Night Shadows* (p.77) reflect his roots in illustration. They are very human tales, one of intimacy and the other of fear. Either could be an illustration for a magazine, a major part of Hopper's *oeuvre* at the time. The man and woman in the El Train coach at night are lost in their moment and oblivious to us the voyeurs. Their intensity is surrounded by Hopper's gift for fussy details – the dangling hand straps, the uneven window shades that slid in tracks, the open

49. *The Locomotive*, 1923.

Etching, 20.2 x 25.1 cm.

The Museum of Modern Art, New York,

gift of Abby Aldrich Rockefeller.

windows drowning their conversation in the noise of the wind and the steel wheels clacking over rail joints. The carefully seen coach interior forms a stage for their small tightly-focused drama.

Night Shadows (p.77) reveals a man hurrying somewhere under the watchful dead eyes of a closed corner saloon not unlike the one in his painting, *American Corner*. The man enters the fringe of a bright light that blasts into the composition from the left, lighting the storefronts and casting a long shadow of an unidentified pole onto their façades. The harsh angle of the shadow and the intensity of the light leave the man exposed and vulnerable, not knowing what's beyond the shadows. Like *El Train*, this etching invites interpretation of the story.

The Lighthouse (p.85) and *The Lonely House* (p.82), on the other hand, require no residual explanation. They are complete as images and reflect very American places. The lighthouse and the lighthousekeeper's home and outbuildings perch on a rocky coast seen at low tide. The landscape is wind-scoured, and Hopper captures the brutal weight of the boulders squatting as they have for aeons and aeons of wave upon wave shaping their rounded shoulders and creating tidal pools between their thick gripping fingers of stone. The salt-blasted buildings appear isolated and frail, clinging to the shore at the sufferance of nature.

The Lonely House is almost a living thing, as if an elephant's foot had plunged down into the centre of the composition. This 1923 etching shows a terraced house carved from its flanking fellows like the last slice of cake on the plate. The building has a brooding personality as an end in itself with a gaping portico and framed parlour windows beneath a striped brow of awnings that completely deny light to the inside rooms Every bit of identity has been loaded onto the stone and columned façade of this house, as the rest – where the people live – stands slab-sided and naked in the high sunlight. The two small children who play against the bare wall in the searing sunlight are reduced to insignificance. Hopper's enjoyment of houses and simple structures for their own sense of place and as receptacles for his oddly personal vision had begun to take shape.

Throughout 1922 and 1923 both his etching and the discovery of his voyeuristic visions, peering into windows and freezing the inhabitants inside in postures that seemed checked in mid-gesture, had an appeal. *Evening Wind, East Side Interior, New York Interior, The Bay Window, Moonlight Interior*, all used the theme of women observed by the unseen artist. By this time, candid photography had become possible using small cameras, fast film and high energy developers, opening up the unconscious foibles and postures of people to scrutiny as though plucked from life. His etchings captured this same photographic "seized moment", but added the artist's freedom to suffuse every detail with personal symbolism, to create the viewpoint and to place every element within the frame.

Hopper had spent his entire life observing from the back row as he gradually towered above his playmates and school chums. His drawing gift and puritan upbringing had also cast him in the role of observer, set him apart from the action, the give and take of his peers, the braggadocio talk of sex and use of rough language. Art, like acting, is a refuge for the shy person. An artist puts his inner feelings and fantasies onto a page, canvas or block of stone as an actor becomes someone else on stage or in front of a camera to speak of things and do things that may be against the nature of the character's creator.

Hopper had discovered a small company of characters in his etchings and later in his paintings, mostly women at first, possibly because they were still a mystery to him with their two-faced mask of loving acceptance and amputating cruelty. These artistic creations in his etchings resonated with his peers and those who believed they knew him as voyeuristic glimpses beneath Hopper's shell. Critics saw in his work a fresh approach to a medium that had become more than a bit stuffy so as not to scare away middle-class clients with a few spare dollars to invest in real art. A criterion of

50. *Night in the El Train*, 1918.

Etching, 19.1 x 20.3 cm.

The Philadelphia Museum of Art,

purchased by the Thomas Skelton Harrison Fund,

Philadelphia, Pennsylvania.

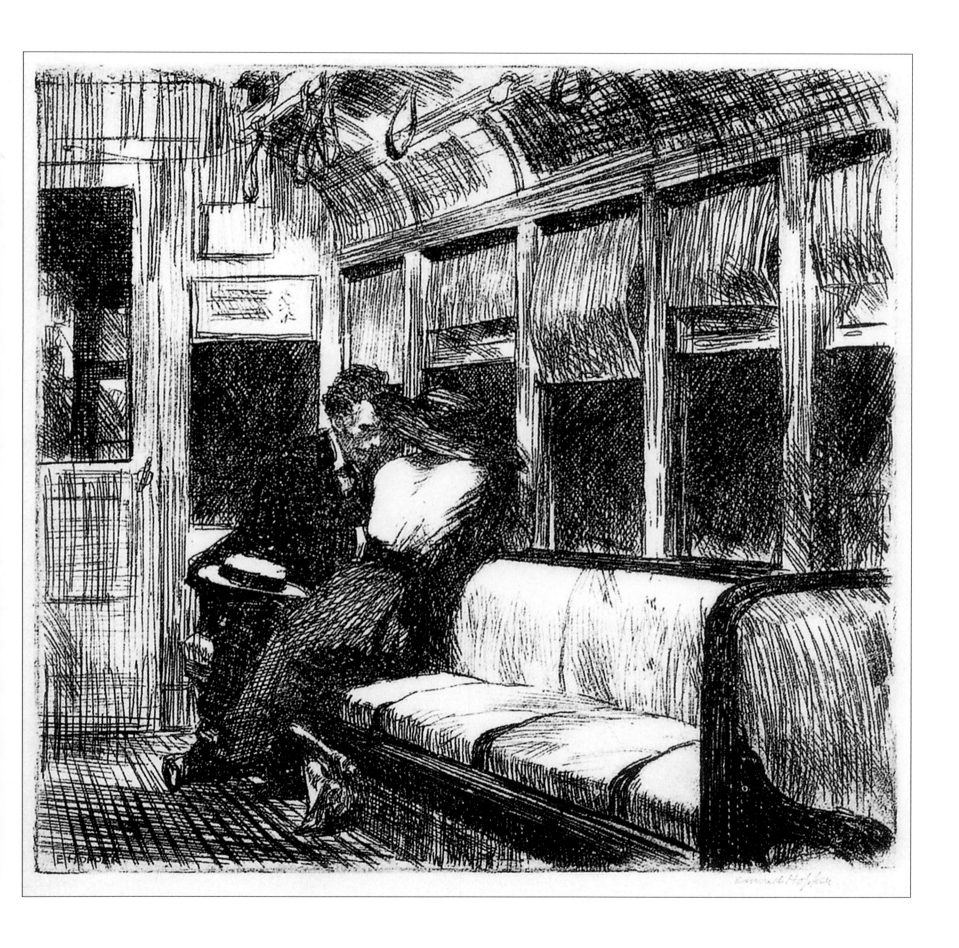

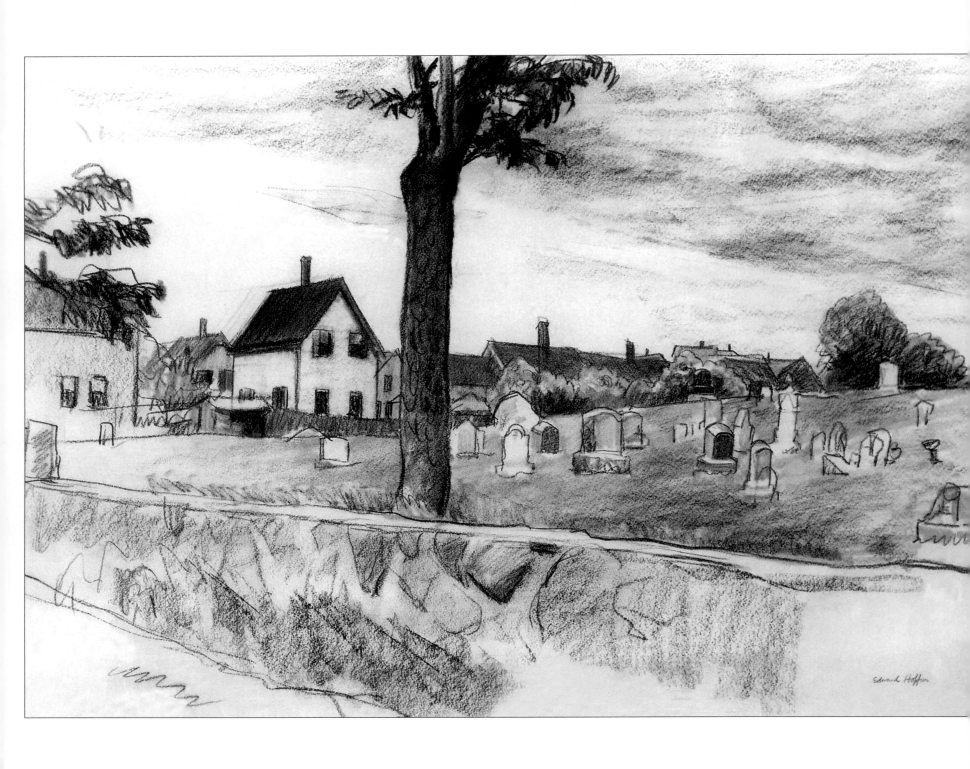

excellence embraced by the Academy and numerous salons rewarded slickness of technique, bucolic scenes, regurgitated allegories, sentimental nostalgia, embalmed still-lifes and pale imitations of some of the more *outré* stylists from Europe. Hopper's etchings – as would his later paintings – caused viewers to pause, suppose and fill in the blanks before and after the moment depicted.

In 1923, the last year Hopper seriously pursued etching, he sent off simultaneous submissions of the print, *East Side Interior* (p.79) to the Art Institute of Chicago and to the Los Angeles Museum. To his surprise, both came away winners, earning the Logan Prize of $25 from the Art Institute and the Mr. and Mrs. William Alanson Bryan Prize of for Best American Print offered by the Print Makers Society of California. On receiving this news, Hopper contacted Carl Zigrosserf, print curator at the Weyhe Gallery, and jacked up his prices, pushing *Evening Wind* (p.74) to $22 and *East Side Interior* (p.79) to $25.

If there was a peak year for Edward Hopper, it was 1923. He stopped etching, rediscovered watercolour, and found his future wife for starters. After what is surmised from scanty documentation to be a brief affair with a model, Jean Chéruy, that ended towards the end of 1922, Hopper braced himself for another summer painting session on the east coast. His newfound success as a printmaker provided much of the mental and some of the monetary wherewithal to make the trip. Gloucester was celebrating the 300th Anniversary of its founding in 1623, and was buzzing with art world hype as two organisations, the conservative North Shore Arts Association and the radical Gloucester Society of Artists, were mounting opposing shows. The conservative show was juried whilst the radicals promised their exhibition would be "open to all".

While this clatter and batter of palettes and brushes offered to spice up the usual painters' outing, Hopper also realised that he had dealt with his solitary existence for forty-one years in July. He wasn't good at social functions, but one-to-one he could be a delightful companion to someone he felt worthy of his interest.

Josephine Verstille Nivison was a fixture in the Bohemian Greenwich Village art scene. She worked hard at her chosen craft and, as previously said, had been portrayed by Henri. Her personality was outgoing and gregarious, which was complemented by her compact five-foot one height topped with a bobbed head of coppery red hair. Her most interesting facial feature was a nose that turned up at the end, giving her an elfin look.

Born on 18 March 1883 in Manhattan, her early life was one long round of peripatetic apartment-hopping, surviving close-quarters living with a fat and noisy aunt, an unsuccessful pianist father, Eldorado Nivison, who gave music lessons, and her mother, Mary Ann, whose Gaelic blood constantly simmered. Amid the chaos of her family life, Josephine devoured books as both a defence and an escape from reality. At Normal College in New York, she earned a Bachelor of Arts degree and studied French for six years and Latin for five, besides reading her way through a considerable helping of classical literature. Like her parents, she was always on the boil, full of energy and hunting for new outlets from theatricals to drawing and painting.

After a time in academic drawing classes, Josephine baulked at continuing, and jumped to the New York School of Art and the radical teachings of Robert Henri. He became her teacher and mentor, expanding the art instruction to include his particular life philosophy. She plunged into portraiture and embraced not only his philosophy but his painting style as well. In 1906 she left school to begin teaching boys' classes at Public School 188 on New York's Lower East Side and then to PS 64, where she stayed throughout the spring of 1912.

The era of submissive wives was wilting beneath the surge of empowerment as more women attended college, earned degrees in the professions and insinuated their way into the workplace. In Josephine's chosen art world – even among the radical Bohemian crowd – women artists were

51. *Cemetery at Gloucester*, c. 1920.
Black Conté crayon, 35.6 x 53.3 cm.
Collection Mrs. Lester Avnet, New York.

52. *Adam's House*, 1928.
Watercolour, 40.6 x 63.5 cm.
Wichita Art Museum, Wichita, Kansas,
Roland P. Murdoch Collection.

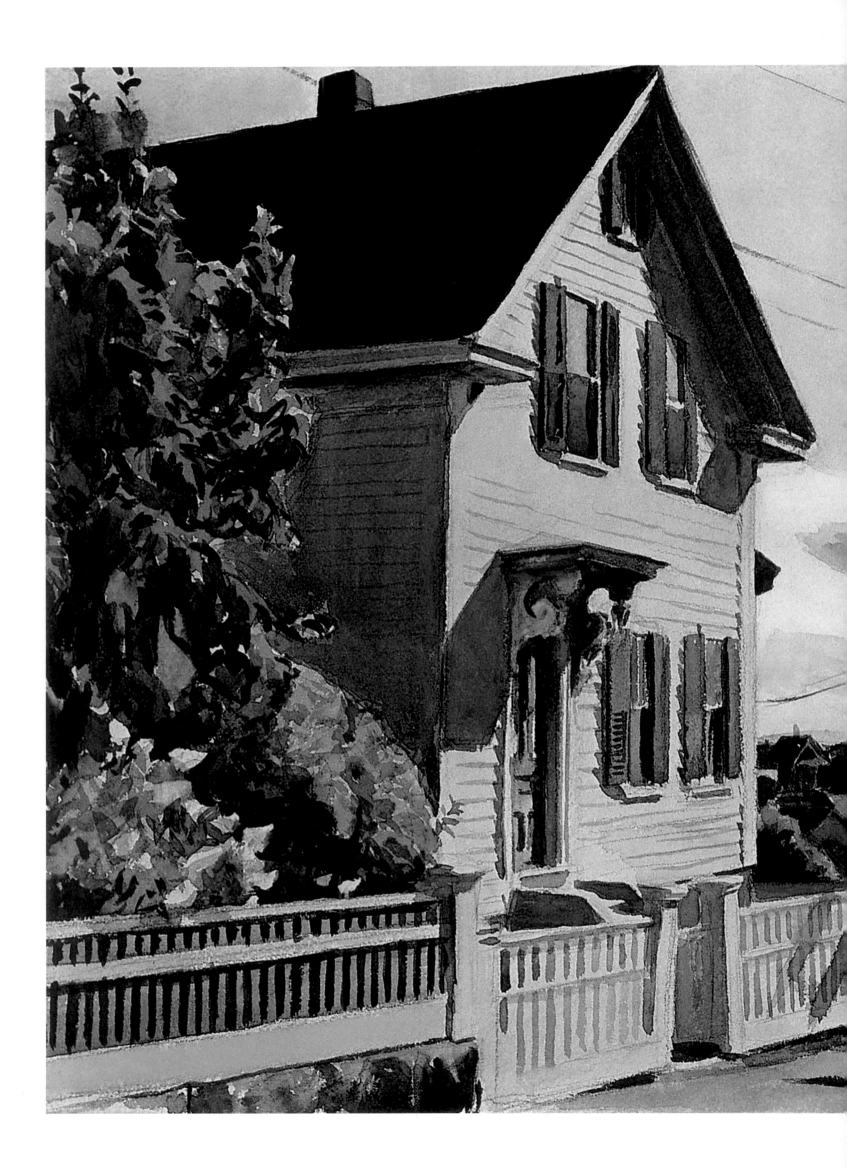

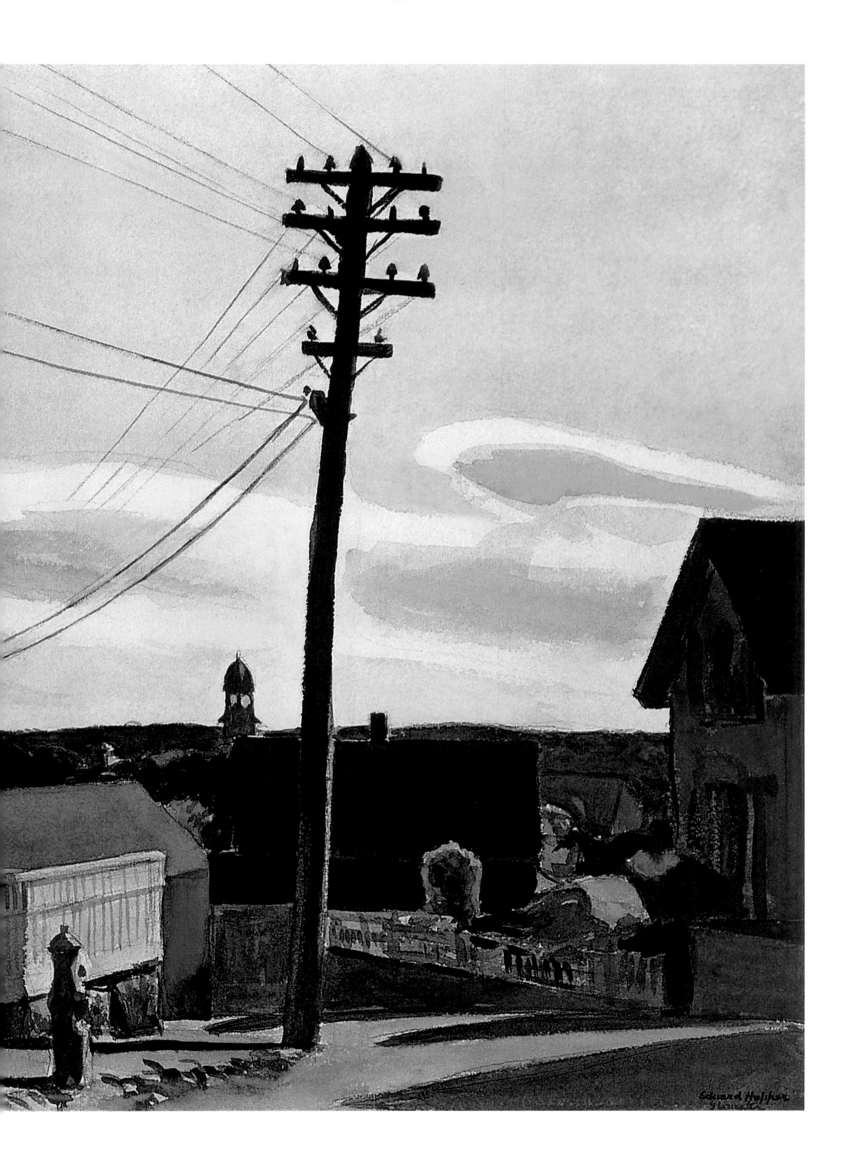

tolerated, but not invited to exhibit with the "serious" men. Their art, while possibly admired for its facility, was considered frivolous, good enough for a hobby but lacking in intellectual fortitude. Painters of the rank of Mary Cassatt and Georgia O'Keeffe were thin on the ground. Josephine's female peers chose to band together for their shows.

Josephine enjoyed her liberty from her parents and at the age of thirty moved into the top floor of an old house at 30 West 59th St with a voice student, Susie Belden, for a room-mate. Fully committed to the artist's life, she dogged Henri wherever he exhibited or lectured. Her drawings appeared (without compensation) in the radical magazine *The Masses* edited by Max Eastman, and she knew his feminist wife, Ida Rauhs. Jo acted in various theatre companies, mostly without pay as she was still teaching for a yearly salary of $1,080.

Summers were set aside to follow her painter pals up to Ogonquit and the Maine seacoast villages to work in watercolours, get together and have a good time. She frequently ran into Hopper during these trips.

As the end of the Great War drew close in 1918, she volunteered to go overseas and help wounded and disabled men returning from the trenches. At thirty-five, her alternative motivation was checking out the American doughboys for husband material. She took leave of absence from teaching, settled her affairs and shipped out to perform occupational therapy for U. S. servicemen aboard the *U. S. S. Sierra* docked at Bordeaux. Later, she worked in Brittany and finally in Brest. By December 1918 she was sick with bronchitis and was sent home to Boston, where it was determined she was "…temperamentally and physically unfit for the service", according to the Chief Nurse. In June 1919, she went back to New York, where she was discharged. Jo Nivison returned to no job and no studio, and was desperate to start again.

She managed to find a studio in a house next to the Church of the Ascension in Greenwich Village and from there tried to establish herself as an artist while working as a teacher at the Willard Parker School for sick children. There she contracted a mild form of diphtheria. Later, she tried teaching at New York's PS122 School for boys, but was physically and mentally not up to the job. Claiming her bad health had been caused by teaching at Willard Parker – and not having been informed of the health risks – she won a lifetime disability payment determined by her annual salary of $1,750.[25]

She then had a financial base for pursuing her career as an artist. Josephine started off by chopping seven years off her age – from thirty-six to twenty-nine – as listed in the census, and moving into new digs on the top floor of Vanderbilt Studios on 9th Street in the Village. Surrounded by other artists, she loved what she called "Titmouse Terrace".[26] Along with her new studio and breathing space to work and study, she also acquired Arthur the Cat, a long time faithful friend.

Accompanied by Arthur, she resumed summer painting trips to Provincetown, Monhegan and the Maine coast. Jo produced dozens of watercolours and enthusiastically joined the social season, getting her health back and making new friends with her infectious personality and seemingly boundless energy. Her work found wall space at the Belmaison Gallery of Decorative Arts in a show with an interior theme. She hung a watercolour, *Provincetown Bedroom*. Also featured was one of Hopper's etchings, *East Side Interior*. She showed watercolours of flowers in another show on the same walls as Charles Sheeler, Walter Tittle, Joseph Stella and Charles Demuth. By December 1922, the catalogue of a show where she hung with major artists including Modigliani and Picasso stated, "The watercolours of Nivison add a gay note of colour". She was starting to make her mark, and she must have felt that her trip to Gloucester in the summer of 1923 would be full of creative promise.

53. *Talbot's House*, 1926.

Watercolour, 40.6 x 50.8 cm.

Private collection.

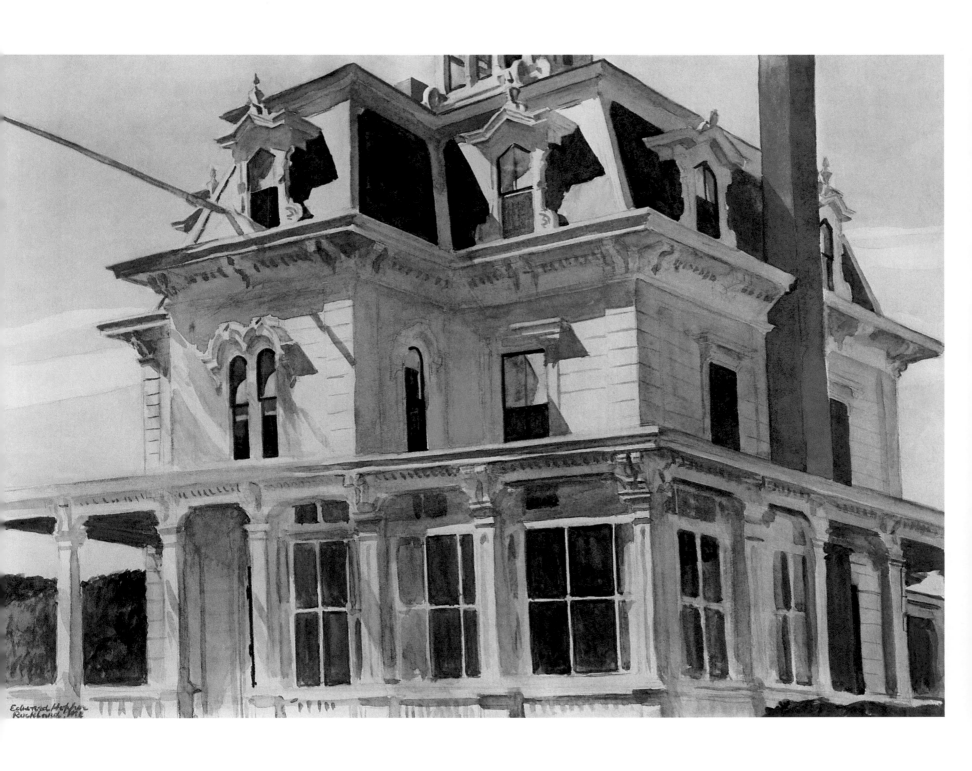

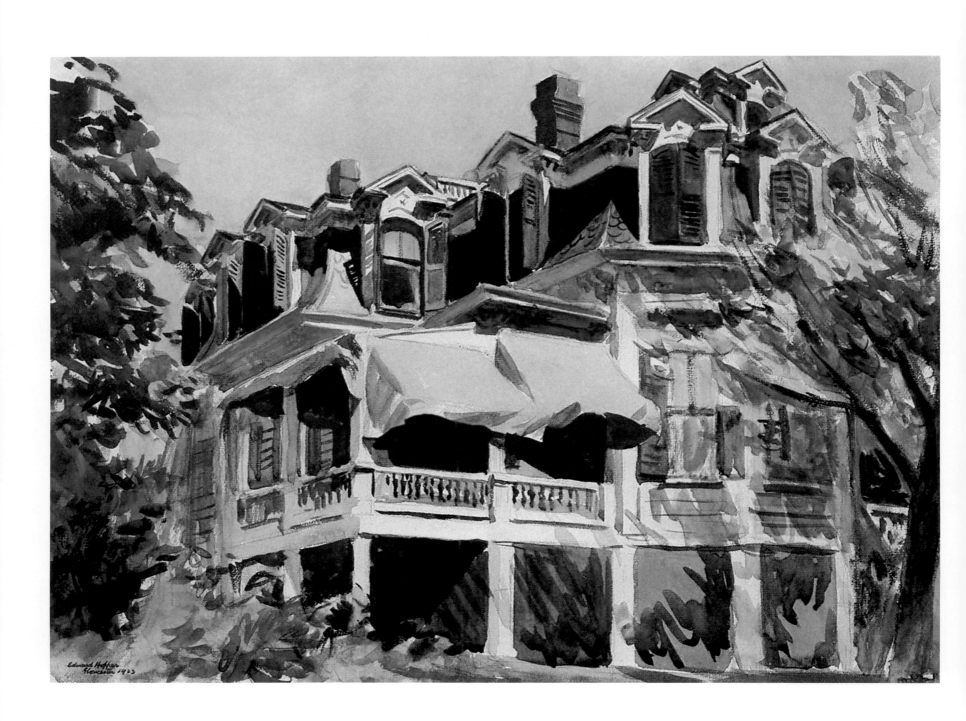

LOVE, MARRIAGE AND WATERCOLOUR

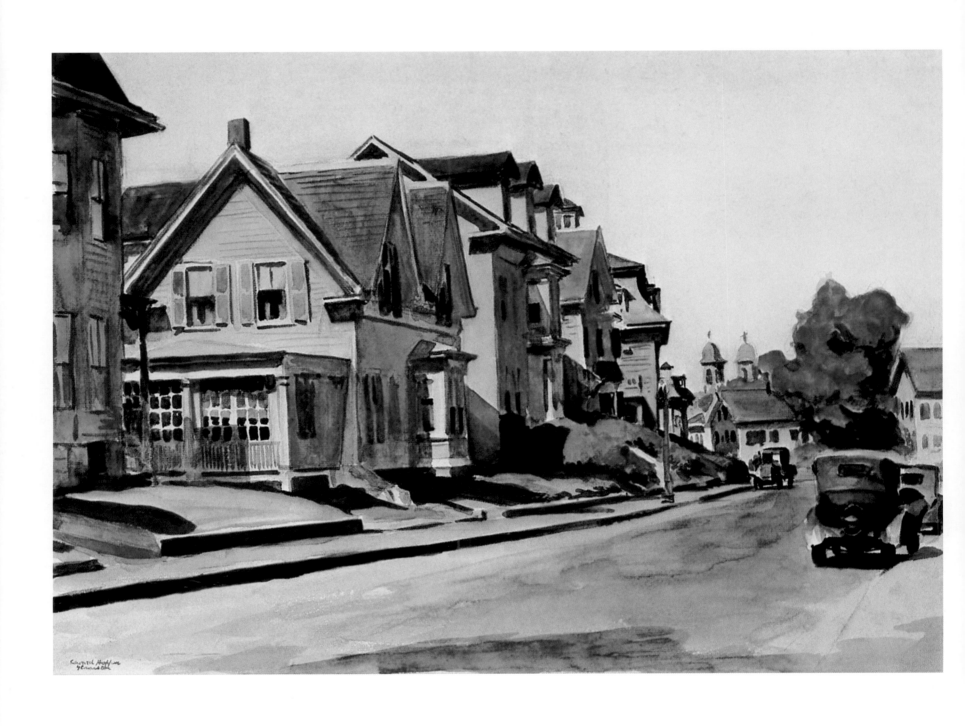

dward Hopper was also on a high. His etchings had boosted him up to a level with his peers, and frequent shows of his prints caused a demand for more. He had reached the ripe old age of forty-one and had spent the last twenty years living alone in Manhattan. His failed affairs with Enid Saies in Paris and Jean Chéruy in New York had dimmed prospects to find a soulmate, but his career seemed well in hand as he unpacked his bags in Gloucester in July 1923.

He had seen the short redhead before in Gloucester, Monhegan and other New England artists' haunts, usually with a group of other painters he knew or recognised, and usually she was talking or laughing. One day, he caught her attention.

"Hey, I saw your cat yesterday," he said.[27]

Josephine, who had brought Arthur with her to Gloucester, sized up the "long, lean and hungry" Hopper, admitting to herself that she found tall men interesting. Soon their easels were side by side and they were making regular early morning trips together. Hopper demonstrated his *savoir-faire* one morning as waves crashed against the boulders of Bass Rock by reciting one of Verlaine's love poems – from a book given to him by Jean Chéruy – in the original French. When he stopped, Jo picked up the French verse without missing a beat.

Hopper also had to notice her facility with *plein air* watercolour – painting begun and finished outdoors under natural light. For the first time since he'd roughed in some watercolour Parisian caricatures back in 1906, he considered the medium for his personal work. Until the summer of 1923, Hopper had used watercolours only for his commercial illustration jobs. With the publishers' increasing use of photo-engraving colour processes, Hopper's frequent assignments had allowed him to master the medium.

As with etching, Edward Hopper had to be aware of the increasing market for watercolours. Institutions such as the Brooklyn Museum, Worcester Art Museum, the Museum of Fine Arts in Boston and the Cleveland Museum were building significant collections of American watercolours: Since the brilliant work of Winslow Homer and John Singer Sargent in the nineteenth-century, and luminescent pointilism of Childe Hassam and John Marin's fluid semi-abstractions following his first one-man show in Alfred Stieglitz' 291 Gallery back in 1909, watercolour had attained maturity.

Breaking out his Windsor-Newton tubes and soft sable brushes, Hopper went to work alongside Josephine, becoming almost competitive in his enthusiasm. Painters were everywhere seeking out harbour views, seashores and dashing waves. While Hopper and Josephine did their share of facing well-worn visions, trying not to put their easels' feet in the exact three holes of a previous artist in the sandy soil, Hopper preferred moving inland and closely observing the old houses that seemed to grow from the rocks.

Tearing himself away from his natural love of the sea, he concentrated on the houses built by families who had lived off that sea. With peaked and mansard roofs, the houses rose above cobbled streets and sand-clogged roadways, their framework simple and salt-wind scoured. From elegant structures with gingerbread trim to jumbles of shacks heaped for convenience, their colours were vivid. Whitewashed sides glared searing white in the sun. Dormers jutted from slanting roofs, their peaks lost beneath deep-shadowed eaves. Turned mouldings flowed into porches and balustrades, their joints thickly smooth with generations of layered paint. Red-brick chimneys pierced the rooftops, thrust up like fingers from many fireplaces. Everywhere curtains and shutters hid the private interiors from artists' prying eyes, keeping the town's real world aloof with some remnant of dignity. Hopper could have been looking at his white frame homestead in Nyack, New Jersey, multiplied and transmogrified.

54. *The Mansard Roof*, 1923.
 Watercolour on paper, 33.2 x 46.2 cm.
 The Brooklyn Museum, New York.

55. *Prospect Street, Gloucester*, 1928.
 Watercolour on paper, 35.5 x 50.8 cm.
 Private collection.

Eastern Point Light was the first watercolour Hopper completed in that summer of 1923. The lighthouse and its homely keeper's house topped with a bell in a white cradle are bathed in early morning pink and lavender that suffuses all the colours into pastels, with the delicate iron grillwork of the catwalk around the lamp housing picked out in stark black. The architecture is a structural actuality while, in contrast to his treatment of seacoast rocks in his etching *The Lighthouse* from this same year, the rocks are less tangible, the grassy area is puddled into place wet-in-wet to seek its own edges. The tower itself thrusts up and dominates the insubstantial shore. The very looseness of his technique belies the precision required to convey a solid plane with a single brushstroke correctly loaded with just the right amount of watered pigment.

He created his blocked-in framework casually for *The Mansard Roof* (p.98). With the structure lightly pencilled in and using the untouched paper for white, Hopper dashed in the gallimaufry of dormers, shutters, eaves and chimney pots that comprised the top floors. Below that jumble, bright yellow awnings inflated and retracted with the sea wind shaded a second floor porch and threatened to tear free. The feeling of gusty wind was further enhanced by sketchy shadows from the surrounding trees that lashed across the house's framework.

Hopper hauled his easel to Gloucester's Italian Quarter where the gaudy houses trimmed in sienna stood amid clutter and heaps of rubbish. Hardly picturesque, the quickly-sketched houses showed their weather-beaten age, and it is easy to imagine the wind whistling between the clapboards. The speed with which he worked must have left Jo Nivison breathless. These subjects were not the stuff of the pictorialists, tripping over themselves to paint the obvious Gloucester scenes. Hopper cut loose with virtuoso watercolour technique tied to a colour-pure truth that caught the character of these plain homes as if they were portraits of individuals, setting them solidly between earth and sky, some more defiant than others, showing grey timber beneath peeling paint.

In *The Portuguese Church*, only the distant towers of the eponymous subject appeared on the far side of a wooden fence that protected a child's playgound. A foreground utility pole anchored the right side of the frame. This image is photographic in its composition with its clearly seen relationship of elements, splashed into life in the same way as a camera shutter reveals the scene to the film plane. This curiously cropped ordering of reality foretold future canvases featuring bridges and urban scenes that Hopper had not seen yet with these new eyes, but recognised after his revelations in Gloucester during the summer of 1923.

He returned to New York energetic and excited with at least seventeen successful watercolours. Josephine had a similar collection, and both of them had come to realise that they had been courting each other. On arriving home, Jo found an invitation from the Brooklyn Museum to hang six of her watercolours in a show it was mounting of American and European watercolours. Prior to the 1923 summer adventure, curators had visited her to look at some work of another artist that was in her care and saw her pieces. At that time, she had also recommended her neighbour Edward Hopper. He had achieved some reputation as an etcher, but not as a watercolourist. He brought some of his work to show them.

As a result, the organisers of the Brooklyn Museum show selected six of Hopper's Gloucester pictures that they hung next to a more mixed grouping from Josephine which included a rendering of Arthur, her cat. After opening day, critical praise was heaped on Hopper for his "vitality and force" that was "exhilarating." Making his work "…one of the high spots of the show." This time it was Nivison's work that went unnoticed. Besides this critical recognition, Hopper discovered that he had sold eighteen etchings. The Brooklyn Museum bought *The Mansard Roof* for $100, the first painting Hopper had sold since *Sailing* at the Armory Show of 1913. Later, two watercolours went on the walls of a Cleveland Museum show and he won two prizes worth $25 each.

56. *House by the Railroad*, 1925.

Oil on canvas, 61 x 73.7 cm.

Given anonymously to the Museum of Modern Art, New York.

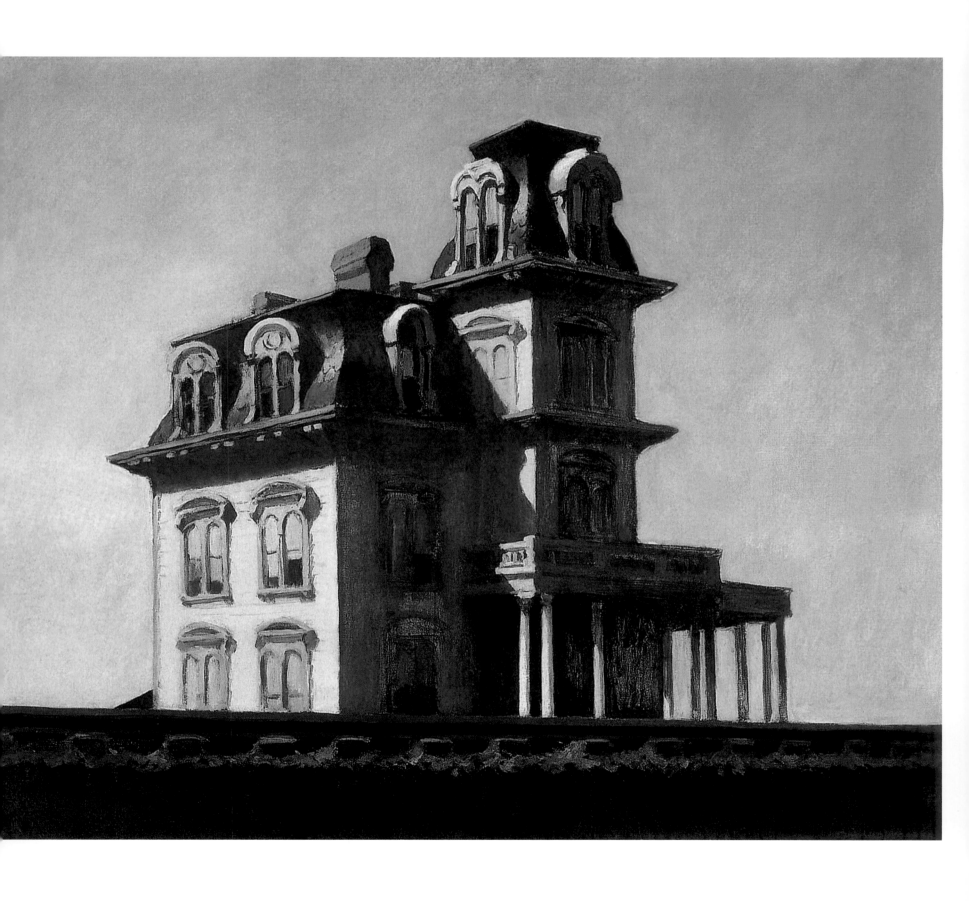

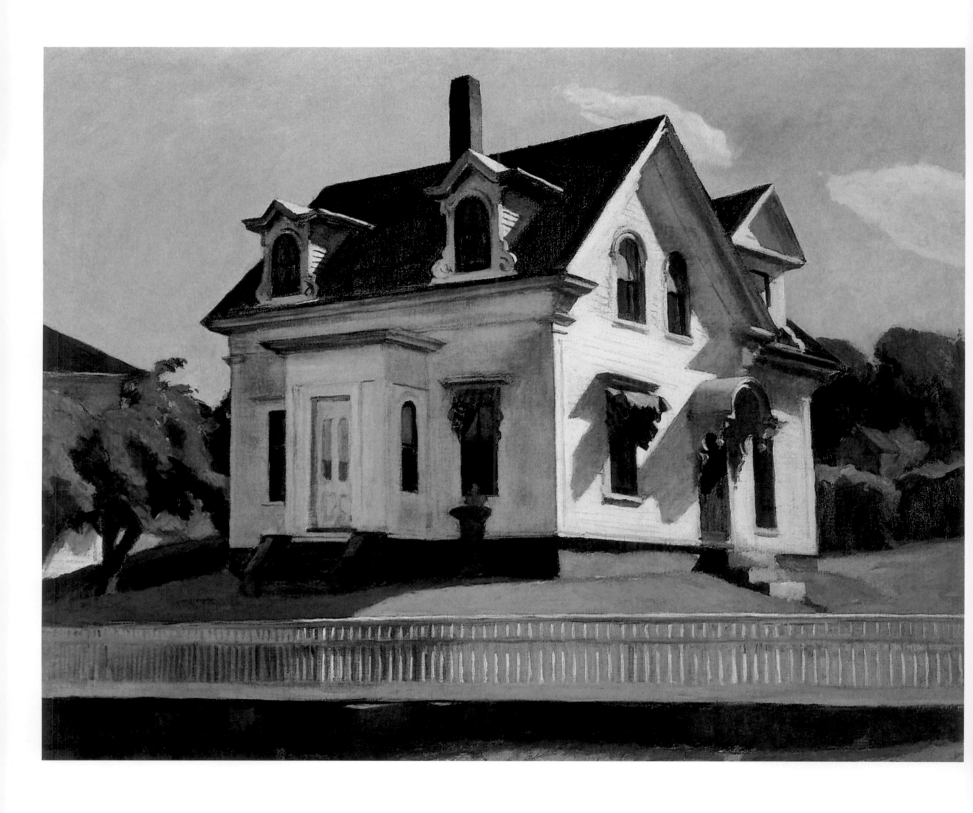

This surge in his artistic career was still not enough to offset the income he made in 1923 from his commercial illustration, but it was a start. During this time of frantic lugging of picture portfolios up and down stairs between their two studios and grabbing bites to eat at restaurants strengthened Nivison's and Hopper's personal bond. They exchanged *billets-doux* in French and he drew funny little cartoons for her as they frequented a local Chinese chop suey parlour that he featured in a later painting.

Feeling vindicated, Hopper entered the 23rd International Exhibition of the Carnegie Institute in Pittsburgh. Predictably and defiantly, he hauled out one of his Paris paintings, *La Berge*, made on the banks of the Seine, and, predictably, the judges bounced it. He was told to fetch the painting from a warehouse or be charged for its storage. His reaction to that latest rejection of his French adventures is unknown, but the painting has since disappeared.

Edward and Jo had some long talks during the spring of 1924 concerning their summer painting destination. Josephine longed to revisit Provincetown and the lively art colony at Cape Cod. Edward, however, was on a roll and wanted to return to Gloucester and pick up where he had left off. The discussions led to an argument – an escalating sequence of events that would become commonplace in their forty-year relationship – that resulted in another summer at Gloucester, but as man and wife.

On 9 July 1924 they pounced upon poor Guy du Bois to come with them and be Edward's best man at their wedding ceremony. He had other plans, he didn't want to and he was especially wary when they told him they first needed to find a minister to officiate. His protests were drowned out in their enthusiasm and the trio began hunting for a church – any church – that would perform the rites. It didn't help that Edward's proclamation of faith ended at "Christian" despite his strict Baptist upbringing. Josephine was an unenthusiastic Episcopalian. Guy finally impressed upon them his need to go home to Connecticut, gave them his blessing, and departed. Resolute, Edward and Josephine tramped on for many blocks until they entered the vestibule of the *Eglise Evangélique* to be greeted by The Reverend Paul D. Elsessor of the French Huguenot Church.[28] Nothing could have suited them better. The ceremony proceeded in French and they became husband and wife.

Some time later, when Edward trotted his bride before the assembled Hoppers and Smiths back in Nyack, Elizabeth's and as-yet unwed Marion's disapproval was palpable. No-one, in their eyes, would ever measure up to marrying their young Prince Edward. They remained in Josephine's later correspondence as "that loathsome breed." Jo only had Arthur the cat for family and Arthur seemed happy with the arrangement. Hopper, on the other hand, kept a grudging distance from Arthur, considering the cat a rival for Jo's affections and attention. The closeness of cohabitation – though Jo kept her 9th Street studio for an additional year after their marriage – and new status as husband and wife brought Josephine hard up against Edward's reclusive and off-putting social habits. Whenever she introduced him to her wide circle of friends in the Village art colony, her ebullience shattered into shards against Silent Ed's glacial stoicism. Mostly, he avoided her friends.

According to her diaries, she arrived at the marriage bed a virgin. Despite her associations with the racy artist crowd that loved to party and sleep around, her knowledge of sex was extremely limited. Hopper on the other hand, apparently freed of any moralistic codes of good Baptist conduct or biblical sins of the flesh, discounted any sensitivity he might have had to her first and subsequent sexual experiences with him. He even forbade her from discussing sex or seeking information among her married female friends, considering it "gossip" that was no-one else's business.

On their wedding night Hopper carried with him the Victorian baggage of male sexual domination and simply and directly took her, preferring, as her diaries shouted, "…attacks from the rear!"[29] For Jo, sex became a marital duty rather than a true exchange of affection.

57. *Hodgkin's House, Cape Ann, Massachusetts*, 1928.
Oil on canvas, 71.1 x 91.4 cm.
Private collection.

In all of their other shared experiences, however, Jo and Edward did enjoy the same need to work, the same frugal life style, and the love of travel to discover new subjects for their paintings. She weighed her discovery that Hopper's "strong silence" masked a deep vein of moody, selfish insecurity against his emerging recognition as a talented artist together with her own escalating career as a painter – a rising tide lifts all boats – and decided that the shared good things were more valuable. They packed their bags to catch the train for Gloucester.

After their arrival at Mrs. Thebaud's boarding house near Bass Rocks, where Hopper had first recited the poems of Verlaine to Jo above the wave-dashed beaches of Little Good Harbor, he set off to revisit some previous locations. Hopper found the Haskells' House he had painted in 1923 from the rear. This time, he moved his easel down to the front at street level. He painted the dormer-studded, eave-shaded mansard roof above bay windows and colonnaded entry porch as it rose high above him on a stepped grassy lawn.

Again, shadows from the late morning sun provided structure. Two utility poles that might have been eliminated as too homely added height and depth to the frame. Each plane of the complex house was defined with a precise brush stroke carrying an equally precise load of water and pigment. Picked-out details of the ornate wrought iron work across the dormer rooftops added delicate touches to the multitude of volumes below. Details were sketched in with quick strokes of a fine brush as the perspective and imposing weight of the structure had already made Hopper's statement.

Seeking new viewpoints, Hopper climbed aboard a buttoned up and battened down trawler to produce *Funnel of Trawler*. At first, the composition was a jumble of shapes, lines and shadows until the hulls of the seine boats on deck beneath their tarpaulins became clear. Then the shivs with their rigging-out tackle were recognised and finally, the great dark lump at the picture's centre became the trawler's iron funnel braced with steel cables just aft of the below-decks skylight at bottom centre. The unfamiliar compositional dynamics of this painting became a device Hopper used again and again. It was, like his *Portuguese Church* watercolour of 1923, almost photographic in its selection of elements within a frame where shift of placement, or elimination of any one element would destroy the work's effect.

Hopper's ability to force the viewer's eye to seek out the fundamentals in a painting takes that eye for a walk up a hill in *Rocks at the Fort*. Here, beneath a flat and overcast sky, rocks merged by ages with grasses and soil marched up from an unseen shore toward a pinnacle. A man with his dog shares the peak with a dark planked house. The other plain houses that shared this plot seemed more like continuations of the shore because of the looming foreground, their faded pastel colours and jumbled relationship to each other.

Reviews of these Gloucester houses almost universally referred to them as ugly, fusty, hideous, disagreeable and then rhapsodised how Hopper managed to abstract beauty from their architectural horror. At a time when the spare international architecture style typified by the German *Bauhaus* style that followed the Great War was gaining a foothold, all "bourgeois" details, eaves, cornices, decorative details of any kind, were shunned. Therefore once again the reviewers and critics brought their own trendy baggage to Hopper's work. But with Hopper's confidant execution, the antique, disagreeable beasts became nostalgic beauties on the watercolour page.

As in 1923, Edward Hopper returned from Gloucester, Massachusetts with a portfolio crammed with new watercolours and, trotting next to his long strides like a happy puppy, Mrs. Edward Hopper lugged her own sheaf of paintings. Guy du Bois intercepted them as they tried to determine which dealer would get first pick. Du Bois suggested his own dealer, C. W. Kraushaar Art Galleries.

John Kraushaar took one look at the watercolours and shook his head. "Too stark," he said.

Once again Hopper bent down and gathered up another steaming pile of failure. This time,

58. *Light Battery at Gettysburg*, 1940.

Oil on canvas, 45.7 x 68.6 cm.

Nelson Gallery-Atkins Museum, Kansas City, Missouri,

gift of the Friends of Art.

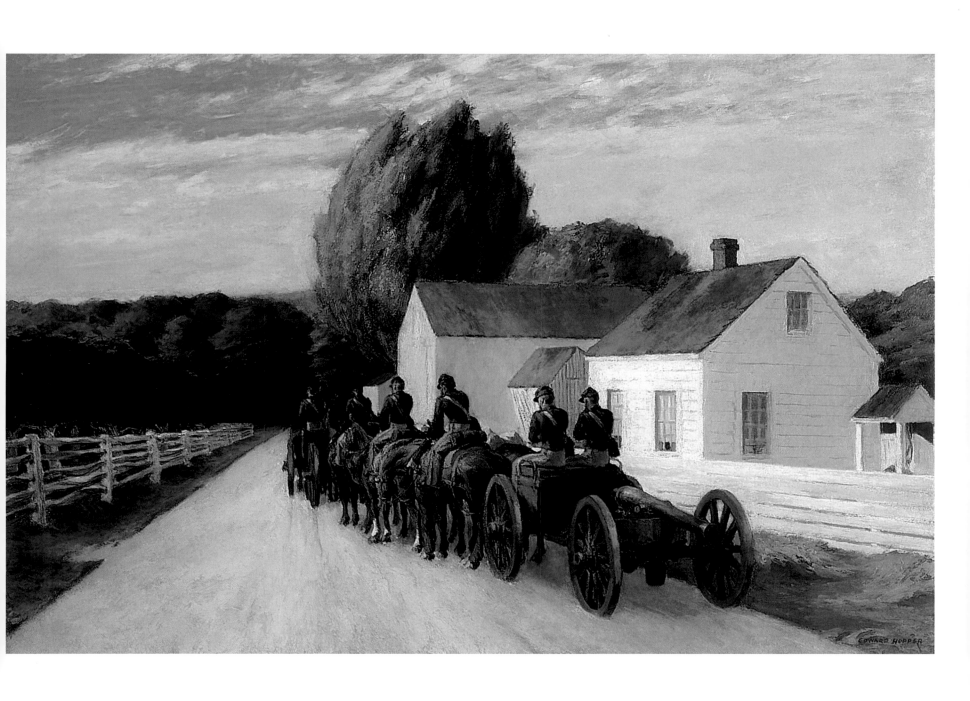

107

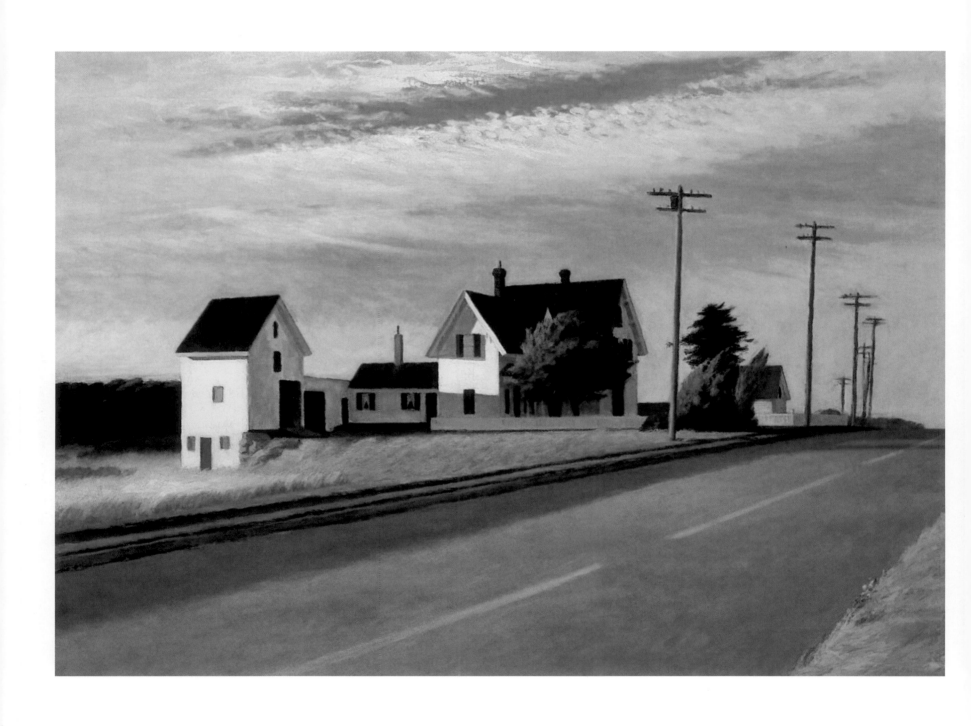

59. *Route 6, Eastham*, 1941.

Oil on canvas, 68.6 x 96.5 cm.

Swope Art Museum, Terre Haute, Indiana.

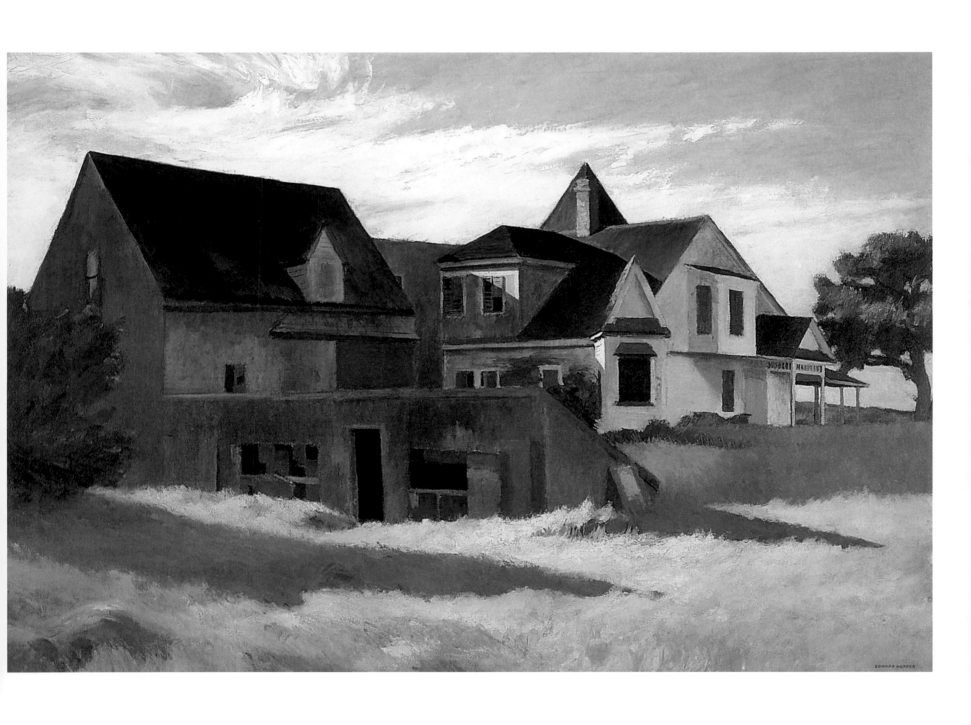

60. *Cape Cod Afternoon*, 1936.

Oil on canvas, 86.3 x 127 cm.

Carnegie Museum of Art, Pittsburgh, Pennsylvania.

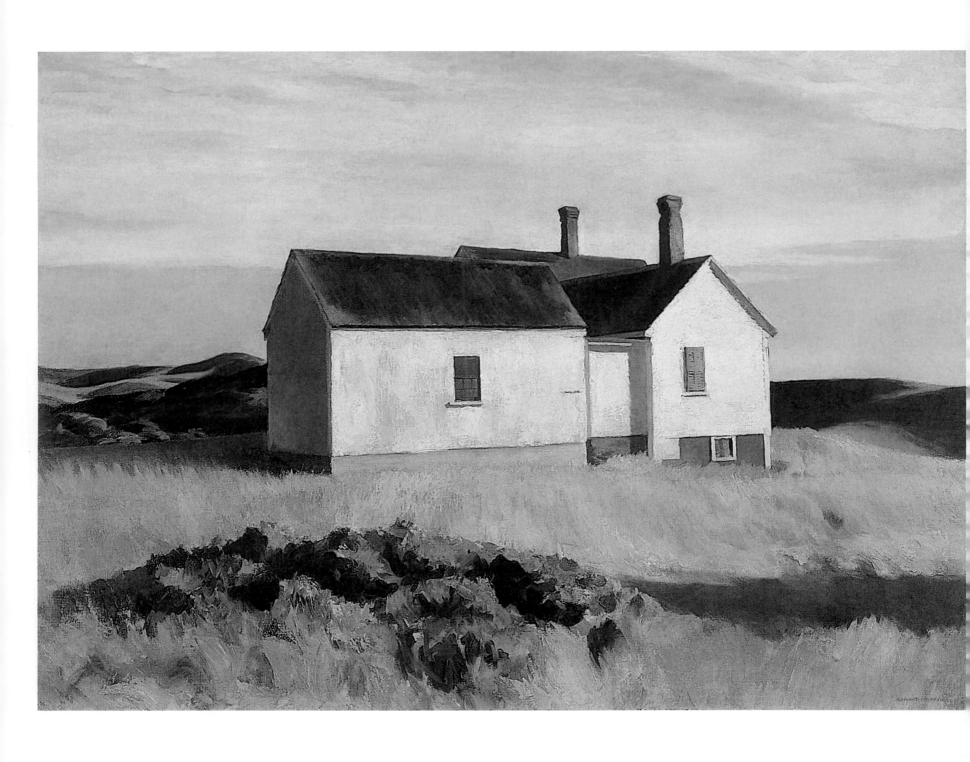

however, he recalled a gallery owner who had dismissed his French paintings, but eventually accepted four of his etchings. Frank Rehn had moved his gallery into a larger space at 693 Fifth Avenue. He was about to hang a new autumn show, *Ten American Painters*, featuring the work of Leon Kroll, William Merritt Chase, Abbot Handerson Thayer, Childe Hassam and others. Best of all, Rehn had become a sought-after dealer/agent over the past year, especially for American painters whom he promoted to the exclusion of all others. Hopper wandered in with his wad of rejected watercolours.

Rehn was on his way out to get some lunch and asked Hopper to spread the paintings out in the back room and he'd see them when he got back. As Rehn pottered around getting ready to leave, Hopper began laying out the paintings. A customer browsing the gallery peered down at a representation of a Victorian house. "That looks just like my grandmother's house," the customer said. Rehn immediately separated the man from some cash and sent him out of the door with the Victorian House watercolour. Forgetting about lunch, the gallery owner surveyed the Gloucester paintings and warmly welcomed Hopper into the Rehn family of artists.

Late in October 1924 the Rehn Gallery opened *Recent Watercolors by Edward Hopper* showing sixteen paintings. They all sold at $150 each. In one swoop his income from that art sale almost equalled his total income for 1923. A critic from the *New York Sun* newspaper, Henry McBride, received a note from Hopper, announcing the show, a rare stroke of marketing for the artist. Responding, McBride wrote:

> *"In the etchings this artist noted that however squalid the slums might be they still had the power to suggest beauty to an artist…In the present series of watercolours the same feeling enables him to be forcefully eloquent upon the hitherto concealed beauty of some supposedly hideous buildings built during the Garfield administration. The dwellings, in fact, are hideous and people of sensibility were quite justified in shuddering when they passed these relics of a dark era in American history upon the streets of Gloucester, although now that an artist has known how to extract beauty from them there will not be a temptation to view them with affection. Mr. Hopper was not as savage to Gloucester as Mr. Burchfield was to Salem, Ohio. He does not mock. He does not rant. He merely joins, and with more vehemence than most, in the cult that has restored the mid-Victorian forms to our hearts."* [30]

New York Times art critic called the exhibition, "…the most significant…" show Rehn had hung since opening his doors a year earlier.

Charles Burchfield, an already established artist, found himself frequently compared to Hopper since they both painted old houses, boats and other similar subjects. Burchfield's subjects were from Ohio, his birthplace state, and he showed influences of both the Fauve palette and Impressionism. He was about eleven years younger than Hopper. At the age of thirty-seven he received a one-man show at the Museum of Modern Art. Later in Hopper's career it was suggested Hopper began painting old houses after seeing Burchfield's watercolours. Hopper denied the connection though he did like the younger man's work.

As the 1920s raised their skirt hems, downed bootleg booze, dumped bigger engines into bigger automobiles and plucked jazz from Negro gin joints and speakeasies to headline for High Society, everyone talked about speed and modernism, about Art Deco design and Frank Lloyd Wright, the new architect of prairie style dreams. Strip away the Neoclassical, the Greek Revival, the weighted down European influences, the stodgy and overstuffed, any reminders of the fat cat corruption and graft of the late nineteenth-century before Teddy Roosevelt cleaned house and now "Silent Cal" Coolidge presented an equally stripped-down presidency.

61. *Ryder's House*, 1933.
Oil on canvas, 91.6 x 127 cm.
Smithsonian American Art Museum, Washington, D.C.,
bequest of Henry Ward Ranger through the National
Academy of Design.

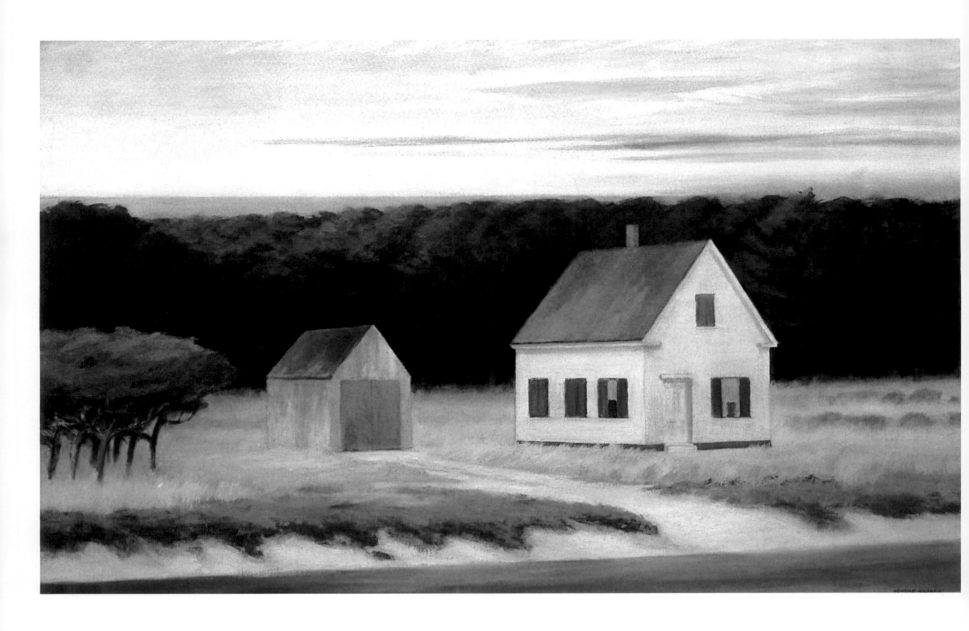

It was time for the dissonance of the Cubists and Modernists to lead the avant garde where line, colour and movement existed solely for themselves without the limitation of reality or anchor of recognisable subject matter. An example is Wassily Kandinsky's work that had passed from representation to abstraction from the early 1900s to the 1920s. Other artists rejected reality and joined the retreat from subject matter to codify pure expression.

Hopper and the other Realists were clearly in danger of becoming anachronisms. However, his pictures began to sell – to a degree that Rehn was thrilled when a customer returned a Hopper watercolour. That picture joined three others for a November show in Chicago by the Chicago Arts Club. Demand exceeded supply. The Bostonian collector John Taylor Spaulding bought four watercolours from Rehn's 1924 Hopper show. This wealthy connoisseur of fine art assembled collections of paintings by Renoir, Cezanne, Degas, Toulouse-Lautrec and Degas to hang with American painters Henri, Bellows, Kent and the master Winslow Homer. It was alongside Homer that Hopper's watercolours were displayed.

Socialite-collector Elizabeth Cameron "Bee" Blanchard helped wealthy friends decorate their fashionable New York homes. She bought three of Hopper's watercolours from the Rehn show and eventually owned nine of the paintings. Later, she became a frequent correspondent with Josephine.[31]

Etchings no longer carried the burden of his fine art sales. His paintings had taken over. Hopper's watercolour *Portuguese Church* showed in Chicago and Cleveland exhibitions. He also sent an oil painting done in 1923 titled *Apartment Houses* (p.205) to a Pennsylvania Academy of Fine Arts exhibition and another oil from 1922, *New York Restaurant* (p.203), had its debut in a show at the

62. *October on Cape Cod*, 1946.

Oil on canvas, 66 x 106.7 cm.

Collection of Loretta and Robert K. Lifton.

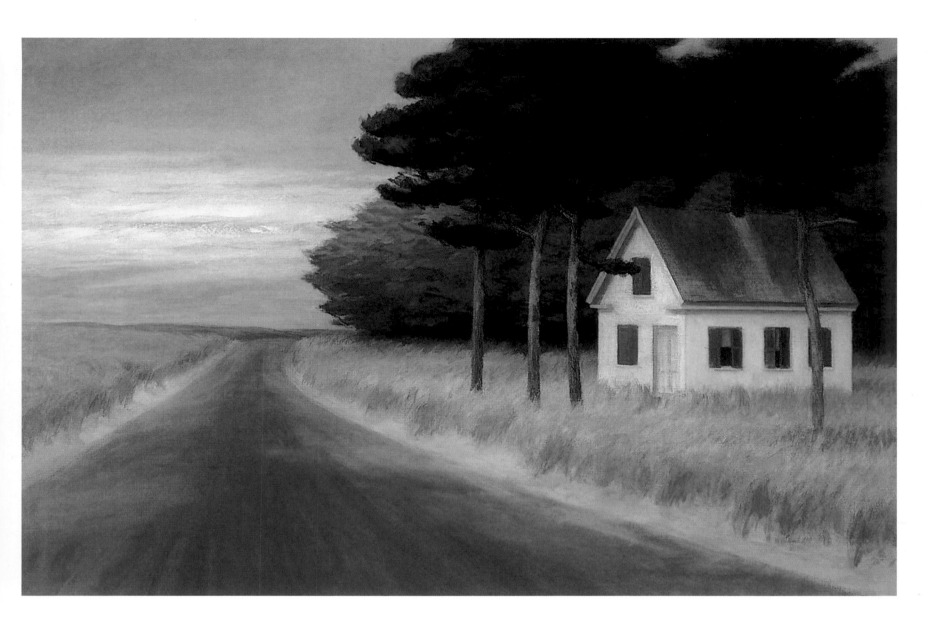

Cleveland Museum. These two oils were important because they echoed his etching subject matter and approach being scenes glimpsed, remembered and reassembled later in the studio.

Apartment Houses appeared to be a shutter-click of life seen from the window of a passing elevated train or from a window on the other side of an atrium. A plump blonde housewife changed the sheets on a bed in a corner bedroom. Behind her is another wall of windows only a few feet away. The walls were stucco over brick and the windows were sash pull-downs. The furnishings were middle class, a bureau with a round mirror on top, an upholstered chair and a picture on the far wall – nothing to say this is anything other than what it appears to be. But maybe it was a sick room. Maybe someone had died there and this hired girl was cleaning up the room. Sun streamed through the window behind her suggesting the room was at the top of the building. As he had done with his etchings, Hopper's use of story-telling scenes in his paintings seems to have grown from his addiction to the silent cinema and its voyeuristic melodrama. Following his movie poster work during and after the Great War, he regularly attended the many cinemas that had sprung up all over Manhattan. Each audience member sat safely in the dark watching other people on the screen bare their souls, laugh, fight, make love and experience tragedy. Eventually, film directors adopted Hopper's stark lighting and use of shadows to create the *film noir* movies of the 1940s and 50s.

Stylistically, the *film noir* was distinguished by its stark *chiaroscuro* cinematography lit for night with an obsessive use of shadows, and, most importantly, it explored the rotten underside of the American city, the place "…where the American dream goes to die".[32]

63. *Solitude*, 1944.

Oil on canvas, 81.3 x 127 cm.

Private collection.

New York Restaurant was the same kind of slice-of-life. A woman sits at a table with her back to us. She partially obscures the man with whom she is dining. A waitress in a white apron attends the table to their left while in the background other people are possibly examining the menu while waiting for a table. It is winter. Her coat is draped over the back of her chair and another coat and hat are on a rack to the right. The man wears a business suit and a tense expression; she affects a cloche hat and a fur piece around her neck. They have a window table next to a plant sending leaves up off a single stem. All the elements are there to create a small drama. The man could be hiring or interviewing the woman as he carves his steak. They are in deep conversation. The possibilities are endless.

The year 1924 was a magic time for Edward Hopper. His work sold out and its projected sales arc told him he could finally quit commercial illustration. He had shown sixteen watercolours in a back room of the Rehn Gallery and dominated the *Ten American Painters* in the gallery's featured display space. George Bellows – one of the "Ten" – even bought *Haskell's House* and *House in the Italian Quarter* for his own collection. Hopper must have viewed that purchase with a quiet smile since Bellows had risen high and fast in the American Realist art scene while Edward had been struggling to find himself.

He came home to a nice wife at the end of the day and had a companion when he wanted one. She had recently begun to help him organise his sales in a cloth-bound book-keeper's ledger that was very useful. Though Jo began it in 1924, she used his own account record and questions to start her listing with the etching *Evening Wind* (p.74) back in 1921. She listed his one-man shows and exhibitions of small groups of his paintings or etchings. With each entry, Hopper furnished a small thumbnail sketch of the work in Conté or ink. A bit at a time, Josephine's value to him increased. Hopper was not prepared for the recognition he so desperately sought. With the public's increasing awareness of him and his art – at least the public who mattered, those who bought art – came social and professional obligations.

Robert Henri and his equally successful chums, George Bellows, Leon Kroll, Guy Pène du Bois, John Sloan, Ernest Lawson, George Luks, Everett Shinn, William Glackens, Arthur Davies and Maurice Prendergast, had learned the value of self-image and promotion. While Hopper dogged their tracks, seeking walls, dealers and buyers, he had no intention of relinquishing any of his privacy. Mrs. Josephine Hopper became both his publicist, introducing him (cautiously) to friends who might display or buy his work, and his watch-dog, screening his contacts with the outside world and keeping pests at arm's length.

Though she was fiercely protective of his hours spent at the easel and kept the habits of his private life from the public at large, she was a gossip with those whom she considered to be close friends. Her letters and private diaries go on and on with running descriptions of Hopper's daily eccentricities, his bewildering stubbornness, the stream of negative comments on her work and every time their vitriolic exchanges came to slapping and biting, kicking and screaming, battles available to all her neighbours through the thin walls of Three Washington Square.

Hopper enjoyed reading the critics who tried to stuff him into a "school" or define his work and how he made obviously hideous buildings appear beautiful – or at least acceptable. He had never "joined a cause" or "been the exponent of a theory" and was definitely not a "group artist." Hopper was where he wanted to be with money in his pocket, future sales on the horizon and the wind at his back.

New Victories, New Adventures

8 January 1925 started the year with the death of George Bellows from a ruptured appendix. Virtually the entire art community turned out for the funeral and Hopper in particular was deeply

64. *Road in Maine*, 1914.

Oil on canvas, 61.6 x 74.3 cm.

Whitney Museum of American Art, New York,

Josephine N. Hopper Bequest.

65. *Rocks and Houses, Ogunquit*, 1914.

Oil on canvas, 61.6 x 74.3 cm.

Whitney Museum of American Art, New York,

Josephine N. Hopper Bequest.

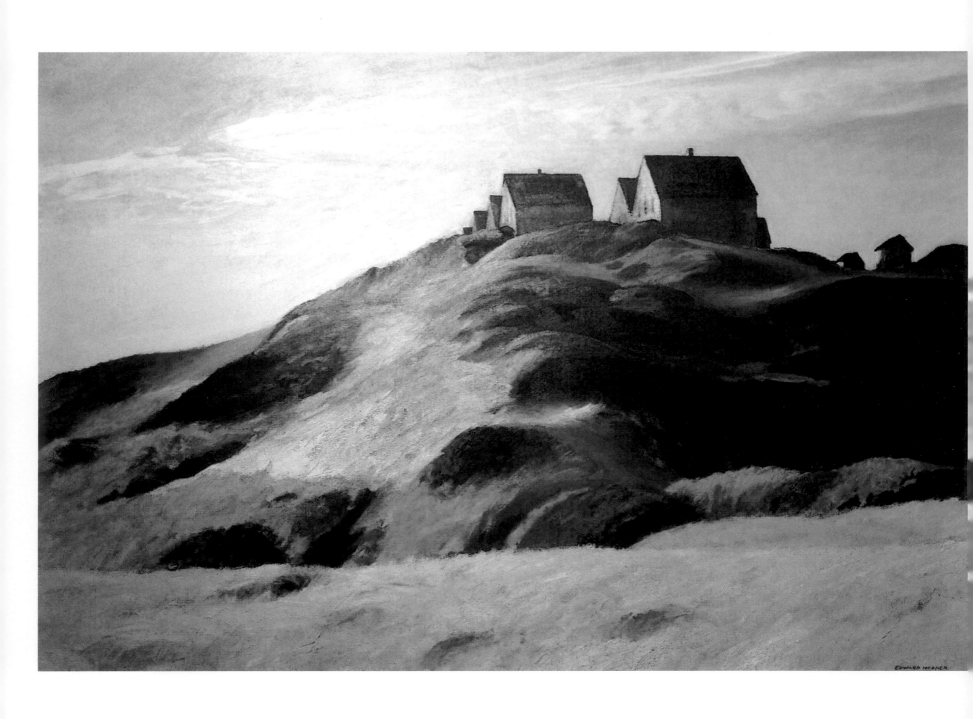

moved. He painted a desolate watercolour titled *Day after the Funeral* setting a tone of sombre despair unique to his developing style. Bellows' untimely death came at a time when Hopper's star was rising, but, ironically, also made Hopper keenly aware of his back marker status compared to the rest of Henri's clique. Private dealer E. P. "Ned" Jennings had just sold fifteen of Hopper's etchings to the Metropolitan Museum of Art. Bellows had received a one-man show of his work at the Museum back in 1911.[33]

Hopper had little time for reflection, however. In March 1925 the oil, *Apartment Houses* that he'd sent as an exhibit at the Pennsylvania Academy of Fine Arts was purchased by that institution for $400 – or $340 ($3,872 in 2006 dollars) to Hopper less the Rehn Gallery's fifteen per cent commission.

Two months later, the Whitney Studio asked him to show in their tenth Annual Exhibition at the Anderson Galleries. Hopper reached back into his stack of canvases and dug out those efforts that had met with yawns in previous showings, *New York Corner* painted in 1913 and *Yonkers (City Street)* (p.56) finished in 1916. His latest work resided with Rehn.

Josephine continued to exhibit her work under her maiden name and submitted two paintings, *A Tree* and *Taste of Boston*, to the Whitney show. A turning point in her life both as a wife and an independent artist occurred when Arthur the cat disappeared. After a fruitless search, she gave up and at the same time decided to give up her Ninth Street studio where Arthur had lived away from Hopper, who disliked the cat. She lugged her canvases to Three Washington Square's basement storage area and took up full-time residence in Hopper's studio apartment. Since the studio was Edward's domain, she set up her easel in the kitchen. To show her work, she had to haul the pieces up from the basement. Besides the cool if not hostile reception Hopper gave when introduced to her friends and mentors, Jo must have sensed his growing attitude of dismissal towards her independent career.

Hopper had little time for her forebodings. His friend and personal publicist, Guy du Bois, had sold his house in Westport, Connecticut and sailed for Paris with his wife Floy to set up long-term housekeeping. With Guy gone and possibly feeling burned out with Gloucester and the north east, Hopper chose a radical swing out west by train from June until September. Arthur's departure facilitated the decision, and they departed via Niagara Falls and Chicago to Santa Fe, New Mexico, wedged into a single sleeping berth to save money.

Once again, Hopper followed his colleagues' lead. Robert Henri, George Bellows, John Sloan and Randall Davey had all made the western pilgrimage. Henri and Bellows had made a trip to Santa Fe in 1917 and Henri became a frequent visitor until 1922. By 1919 Santa Fe had a growing reputation among east coast artists. Sloan and Davey talked their wives into a cross-country excursion from New York in a 1912 Simplex touring car. This was no small accomplishment in 1919 considering the lack of amenities such as water, fuel, lodging and roads. They brought with them a letter of introduction from Robert Henri.

Sloan eventually returned to spend thirty summers in Santa Fe, living and painting in a studio on Garcia Street in the Canyon Road neighbourhood. In 1920 Davey made a permanent home in Santa Fe in a restored sawmill built by the US Army in 1847 on a large tract of land. He remained on that property painting until his death in 1964.

Hopper set foot on Santa Fe soil and disliked everything about it almost immediately. Despite his desire to explore new visuals, his disconnection from the familiar scenes of Gloucester and the north east seashore was uncomfortable and he wandered off from the hoards of dusty tourists buying Indian pots and jewellery off blankets in the town square and sought out the sun-baked side streets. He came upon an eerily familiar scene and rendered it in watercolour.

66. *Corn Hill*, 1930.

Oil on canvas, 73.6 x 109.2 cm.

The Marion Koogler McNay Art Institute,

San Antonio, Texas.

67. *The Camel's Hump*, 1931.

Oil on canvas, 81.9 x 127.6 cm.

Munson-Williams-Proctor Institute, Museum of Art,

Utica, New York, Edward W. Root Bequest.

68. *Hills, South Truro*, 1930.

Oil on canvas, 69.5 x 109.5 cm.

The Cleveland Museum of Art, Cleveland, Ohio,

Hinman B. Hurlbut Collection.

Titled *St. Francis Towers*, it might well have been called *Portuguese Church II*. The painting's similarity to his 1923 watercolour was remarkable. The church's two towers resided behind a courtyard and a low adobe wall in the foreground. A utility pole rose asymmetrically to the right, casting its shadow on the wall. The wall of an adobe house anchored the left side of the frame. Both paintings put the religious buildings at a distance behind fences and walls, possibly reflecting Hopper's revolt against his Baptist upbringing.

Still seeking subjects that stirred him to activity, he took his paints to the small railway yard near Santa Fe station. There he found Denver & Rio Grand Western ten-wheeler locomotive number 177, an elderly branch line steamer with a cold boiler. He painted *D & R.G. Locomotive* lovingly under a sunny sky with respect for its details from the cowcatcher crossbeam to the steam line snaking past the Andrews trucks beneath the engine's coal tender. His watercolour brush expertly suggested these heavy iron and steel details with stabs of colour and shadows that typified his industrial portraits of ships, bridges and railways to come.

Houses in Santa Fe appeared more like forts than the delicately-detailed and ornately-decorated houses of seaside Maine and Massachusetts. These New Mexico desert homes were all hand-hewn beams and thick adobe brick walls with high ceilings and tile roofs. The colonnaded porch that wrapped around the front of *Ranch House, Santa Fe* was a practical no-nonsense addition built to shade the windows.

It is exhausting to imagine Hopper trudging through the orange dust and wheel-rutted mud and manure of back alleys seeking out fenced corrals, sun-dried old sheds, baked streets lined with adobe houses and staring at the near-by mesas and sparsely vegetated hills hoping to find inspiration. The process to avoid the obvious sea-faring scenes and portray the sublime and garrulous architecture had worked in Gloucester. In Santa Fe there was no sea, no salt air to invigorate, just *el viento caliente* during the day and the chill desert winds at night.

Of all the watercolours produced in Santa Fe that summer, *St Michael's College, Santa Fe* came closest to his Gloucester paintings as it spread across the frame with blue sky, a mansard roof studded with white tiles and punctured with multi-pane windows spreading on either side of a gambrel-roofed dormer thrusting forward with a balcony balustrade. Beneath the eaves above the tall and shuttered French windows of the second floor, with a few brush swirls he suggested the fussy supporting European quoins or brackets. A full line of balusters crossed the second floor, paper white and shadowed grey. Deciduous trees shaded the front yard. Statuary and wrought iron fencing were implied. The painting was distinctive, with its familiar European details, and yet it disappeared from Hopper's work until bequeathed to the Whitney Museum after his death. He finished it, but there was no resonance for him, no truth exchanged with the viewer. He lost interest.

Back in the quiet of their room, Hopper persuaded Jo to sit for a watercolour in front of the bureau mirror. Her back was to the bed and the easel and she was flanked by their suitcases. Her hair spread in tangles down across her shoulders. She wore a long-sleeved shirt and nothing more. The title, *Interior*, was later changed to *Model Reading* (p.68) by Hopper to suggest what would become another of Jo's future tasks in his painting career.

Besides working on their tans, being led on the obligatory horseback rides into the hills and spending days roaming the area on foot, output brought back from the Santa Fe trip was meager, totalling only thirteen paintings. But if he needed a triumph for the year, he produced his very last commercial illustration job, three drawings for *Scribner's Magazine* for a story published later in February 1927 titled *The Distance to Casper*. He had cut loose the safety net.

69. *Italian Quarter, Gloucester*, 1912.

Oil on canvas, 61.4 x 73.3 cm.

Whitney Museum of American Art, New York,

Josephine N. Hopper Bequest.

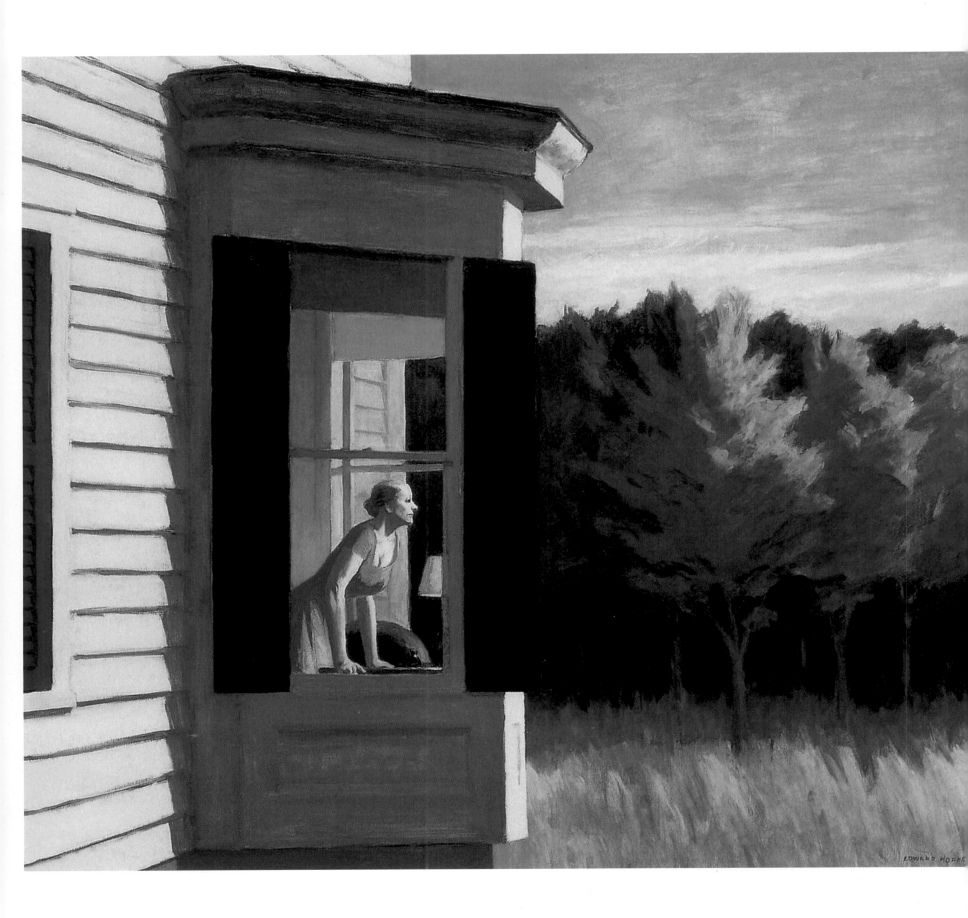

As if to cleanse themselves of the arid western vistas, Edward and Josephine's return to New York also heralded renewed visits to their beloved theatre – an addiction they both shared. Broadway glowed with theatre marquees as the number of stage plays being performed on any given night passed the 250 mark. Jerome Kern, George Gershwin and Oscar Hammerstein created their signature productions, *American in Paris, Show Boat* and *Funny Face* with Fred and Adele Astaire. The Hoppers finally had the wherewithal to buy tickets to the legitimate stage and their favourite silent films. The Oscars were presented for the first time in 1927 and *Wings* won Best Picture. Al Jolson, Mary Pickford, Rudolph Valentino, Clara Bow, Richard Arlen and Charlie Chaplin filled the seats. Edward even saved the ticket stubs, compiling quite a collection over the years.

Every mornin', every evenin' Ain't we got fun? Not much money, oh but honey' Ain't we got fun? Radio listeners could enjoy the *Grand Ole' Opry* transmitted from Nashville, Tennessee. Victrolas churned out hits like *I'll be With You in Apple Blossom Time* and *I'm Just Wild About Harry* while flappers and jazz-babies danced the *Charleston* and the *Black Bottom*.[34]

In this charged atmosphere, Edward Hopper painted one of his most famous signature images, one that would crystallise his style and philosophy into a single, haunting statement. He titled it *House by the Railroad* (p.103).

The painting, like most of his significant pieces, was produced from his imagination in the Washington Square studio, but its elements are all drawn from his observations along the east coast communities where sea-faring men made their fortune. Grand homes were the measure of a man's success and architects of the Victorian era demanded a free hand in revisiting extravagances of the past. The painting's centrepiece is a magnificent French Second Empire house with swooping mansard roofs that feature projecting dormers with paired arch windows beneath elaborate curved hood moulds. The main house joins a projecting pavilion with a balustrade above a colonnaded front porch. Hopper must have been transported back to the banks of the Seine looking across at the Louvre when he first saw these houses. The hugely overstated trim and turnings had become an architectural joke by the mid 1920s, but here, the grand old mansion carries its dignity in empty space, an aged dowager jealously holding on to her pride of place.

A straight-edged slice of steel rails cleanly decapitates the old house from its patch of land. Glazed windows stare out on scenes no longer familiar. This tragic portrayal of one art form overridden by another, of elegance abandoned for efficiency, is quintessential Hopper, the man who quit rural Nyack for New York City. He would find this theme often both with future architecture and the cast of characters who would come to take up residence in his canvases.

Another oil, painted earlier in 1924 and titled *New York Pavements* (p.235), brings Hopper firmly back into his city milieu presaging a series of urban architecture canvases during the mid to late 1920s. Like *House by the Railroad* an old building dominates the canvas, its roots deep in the cement as emphasised by the sheer weight of the horizontal stone blocks that form its Richardsonian façade. A colonnaded portico extends out to the pavement like the drawbridge and portcullis of a castle. The windows are set deep in their stone embrasures.

A wind is blowing down this street as it is in many Hopper paintings. Here, a window shade arcs inward and a curtain flutters back into darkness. On the pristine pavement, a nurse's dark blue headpiece streams behind her as she pushes her charge in a black pram. Hopper's feeling for weight and structural solidity gives the building a weary patience with a dangerous edge like an ancient toad under a porch waiting for a fly to come within range. The painting invites the viewer to tell its story.

70. *Cape Cod Morning*, 1950.
Oil on canvas, 86.7 x 102.3 cm.
Smithsonian American Art Museum, Washington, D.C.,
gift of the Sara Roby Foundation.

Hopper sent this pair of oils to an exhibit for non-members at the New Society of Artists' Seventh Exhibition held at the Anderson Galleries in January 1926. A *New York Sunday World* reporter dusted off his Presidents-as-Adjectives descriptive style:

"...his final apotheosis of a Grantian or a Garfieldian house deserted by everything except the railroad tracks that run across the bottom of the canvas and also a portrait of a McKinleyan New York apartment house with a blue-veiled nurse wheeling a baby carriage. Mr. Hopper does not intend to be caught being aesthetic, not if he knows the time in which we are living."[35]

Lloyd Goodrich, then a young critic, proclaimed *House by the Railroad* as:

"...the most striking picture at the exhibition...Without attempting to be anything more than a simple and direct portrait of an ugly house in an ugly place, it succeeded in being one of the most poignant and desolating pieces of realism we have ever seen."[36]

Much later, Goodrich wrote, "When I first saw Edward Hopper's *House by the Railroad* in 1926, I felt that a new vision and a new viewpoint on the contemporary world had appeared in American Art."[37]

That "new vision" was gaining interest among critics who had considered Hopper to be an up-and-coming American Realist scenic painter when in February he hung *Sunday* in Rehn's exhibition titled *Today in American Art*. Originally scheduled to be painting titled *Hoboken Façade*, Hopper had specifically taken the familiar ferry to that New Jersey location and came away with something much more profound.

In *Sunday* (p.128), a bald man wearing a collarless white shirt with gaudy sleeve garters sits smoking a cigar. Behind him is a row of old shop fronts, one empty and the other with its shades drawn. The street is bathed in bright sunlight. The critics unloaded all their personal baggage on this painting as though seeing previously unrecognised depths to Hopper's work. They characterised the seated figure as "helpless" and "pathetic," an "old bartender...planted in bored dejection on his doorstep."[38] A flurry of Hopper's "Americanism" and the "Americanness (sic)" of "...a worker, clean-shirted and helplessly idle." The *Brooklyn Eagle* noted, "Out of such commonplaces has Hopper created beauty as well as injected humour and an astute characterisation of place and type."[39]

If all this recognition was not enough for Hopper, the Boston Arts Club asked him to exhibit in February, and he had the opportunity to see five of his French pictures hung together, *The Louvre* (p.10), *Le Pont des Arts* (pp.28-29), *Le Quai des Grands Augustins* (p.30), *Ecluse de la Monnaie* (pp.22-23) and *Notre-Dame de Paris* (p.36). But Jo exhibited a watercolour, *Guinney Boats*, under her new name, Josephine Hopper. After lugging paintings from show to show during the winter, he spent a chilly spring haunting Lower Manhattan rooftops with his watercolours. In 1925, Hopper had painted the watercolour *Skyline, Near Washington Square*, the top two storeys of a tall brownstone near his Washington Square Building. The brownstone's façade is encrusted with Victorian cornices, brackets, arched and square window moulds picked out with heavy shadows. The sides are whitewashed brick seared with sunlight. It is strongly reminiscent of his earlier etching *The Lonely House* (p.82). Here, though, the inclusion of rooftop furniture in the foreground gives an indication of the distant building's height. The feeling of isolation is even greater.

In 1926 he returned – and would return often over the years – to rooftop vantage points, finding the same curious beauty in chimneys, water tanks, ventilators and ironwork as he had discovered among the fishing-fleet boats on the east coast. He painted a number of these: *Rooftops, Manhattan Bridge* (p.98) and *Lily Apartments* and *Skylight* among them. Four watercolours were deposited with Rehn as Edward and Jo fled the city for their comfortable New England seashores.

As Edward and Jo settled into their painting routines following the train ride from New York, Rehn showed the haunting oil, *House by the Railroad* to collector and heir to the Singer Sewing Machine fortune Stephen Clark. Rehn had contacted Clark in 1924, suggesting Hopper's latest watercolours were "...the best of their kind since Homer."[40] Clark bought the painting for $600 ($6,872 dollars in 2006).

71. *Pennsylvania Coal Town*, 1947.

Oil on canvas, 71.1 x 101.6 cm.

The Butler Institute of American Art, Youngstown, Ohio.

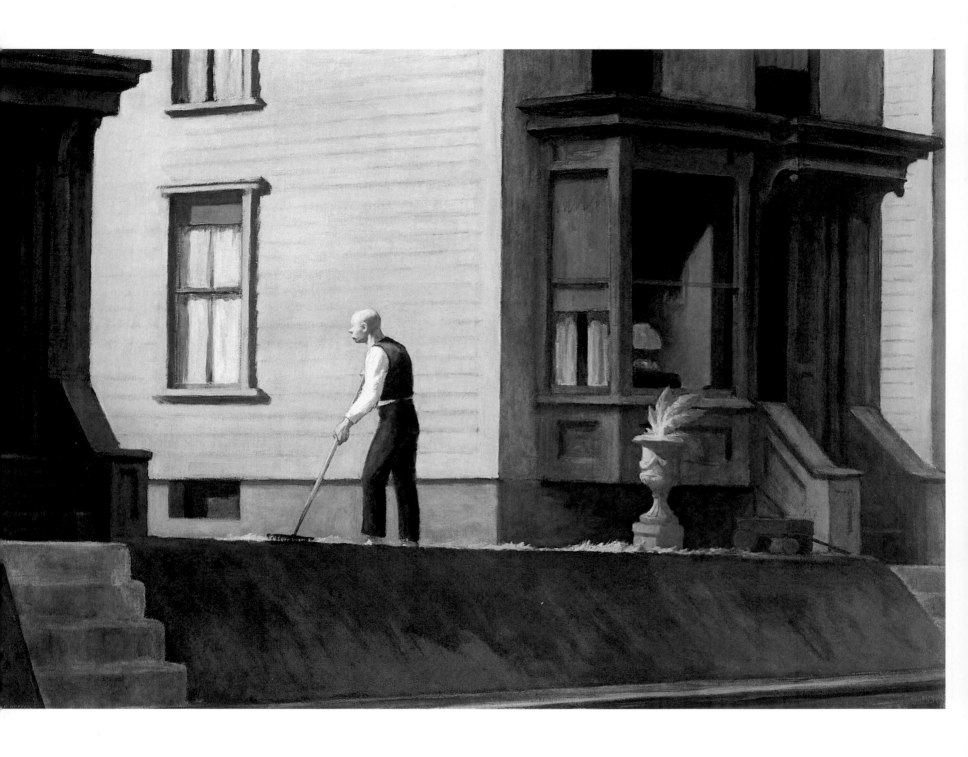

127

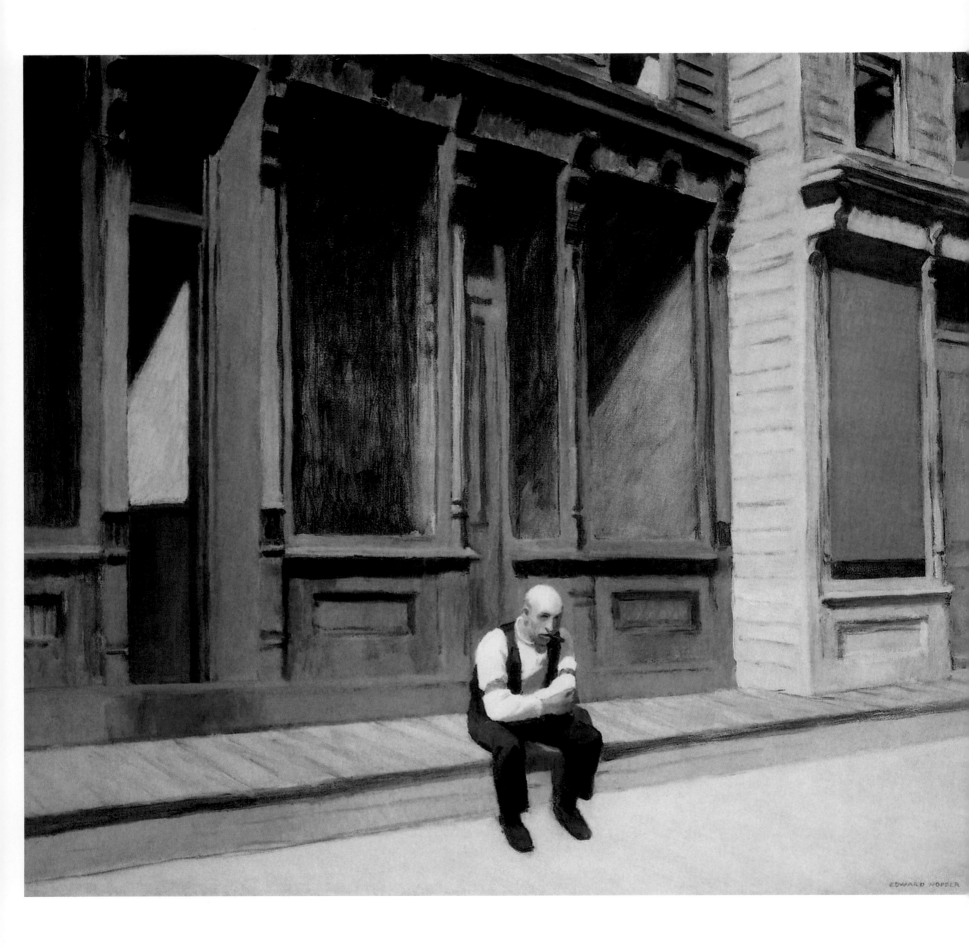

After briefly exploring Eastport and Bangor, Maine, the Hoppers arrived in the tumbledown fishing town of Rockland, and Edward plunged into one of his most rewarding and prolific periods. He lost himself among the antique houses and storage buildings, the rough landscape and other leavings of eras long past.

One unusual watercolour, *Civil War Campground*, taps into Hopper's love of history. A vista that most Realist artists of the time would have seen as devoid of any redeeming qualities is translated with attention to both design and symbolism. During the early days of the Civil War, Maine had been among the first to answer President Lincoln's call for volunteer regiments. It was on this Tillson's Hill that ten companies of troops assembled and bivouacked before marching off to add their names to the roll call of 73,000 soldiers who came from the "Pine Tree" state. Somewhere on the hill, a stone tablet marks the occasion.

Hopper portrays a golden grassy hill ridge, beyond which a house roof is visible and the gully then rises to the distant forested crest of a far hill. Three thick utility poles – often a Hopper compositional device – thrust up from the golden ridgeline. They carry telephone circuits, demonstrated by their small glass insulators, as the future leaps across what is now history. Hopper had always left his poles devoid of wires, but here he lightly sketches them in against a bald sky.

Besides bearing witness to times gone by, Hopper returned to his railway imagery in *Railroad Crossing*. This is an example of dynamic brushwork and composition rendering a simple scene into a deeply realised layering of light from the gravel road that crosses the tracks to the vigorous dark writhing forms of trees that almost obscure the shops and buildings at the bottom of the hill. All lines lead the eye in a rush toward the left of the composition as though a train has just raced through. A railway warning sign on the left – minus one arm – points us back into the picture. Trains hurry past this community, never pausing to look back.

More typical is *Haunted House*, a boarded-up storehouse among other storehouses that holds its hundreds of smells in layers of detritus left behind as ghosts from thousands of cargoes stowed in its cavernous interior. Painted quickly amid the wind-stirred golden grass, the cluster of abandoned, peak-roofed storehouses form a group that is valuable now only for its salt-scoured lumber used as panelling in rich men's dens.

Down near the shore Hopper found beached beam trawlers: *Beam Trawler Osprey* and *Bow of Beam Trawler Widgeon* waiting for dismantling and the cutter's torch. Once this community was redolent with the sharp miasma of fish and coal-fired steam and heard the clank of iron winches and the squeaking heave of bulging hemp nets. Now the shore stinks of old trawlers' rust, long rotted fish scales and puddled oil underfoot. Capstans are silent; hawse holes in the eyes of the ship empty and sightless. Hopper's love of the sea and the irresistible tug of nostalgia helped render these bloodless fossils in dignified nuances of decay.

Usually, Hopper worked close to where he lodged, but seeing with fresh eyes and confidence shorn of the grim financial reality waiting back in New York, he was more peripatetic, wandering further afield between the shore and Maine hills. He painted alone, preferring to separate himself from Jo as he had from the score of other painters tramping the rocky coast. She became a chatty distraction he intended to avoid.

He paused in front of the *Talbot's House* (p.97) and squeezed it into his page, cropping high – slicing off the rooftop widow's walk – low and on both sides, bulking up the brilliant whitewashed stone and brick Second Empire house with its dormered mansard roof, projecting eaves and colonnaded wrap-around porch.

Hopper also produced a rare interior – possibly on a rainy day – displaying an ornate living room organ with its cushioned stool sitting on a patterned rug next to a richly wooded claw-foot chair and

72. *Sunday*, 1926.

Oil on canvas, 73.7 x 86.4 cm.

The Phillips Collection, Washington, D.C.

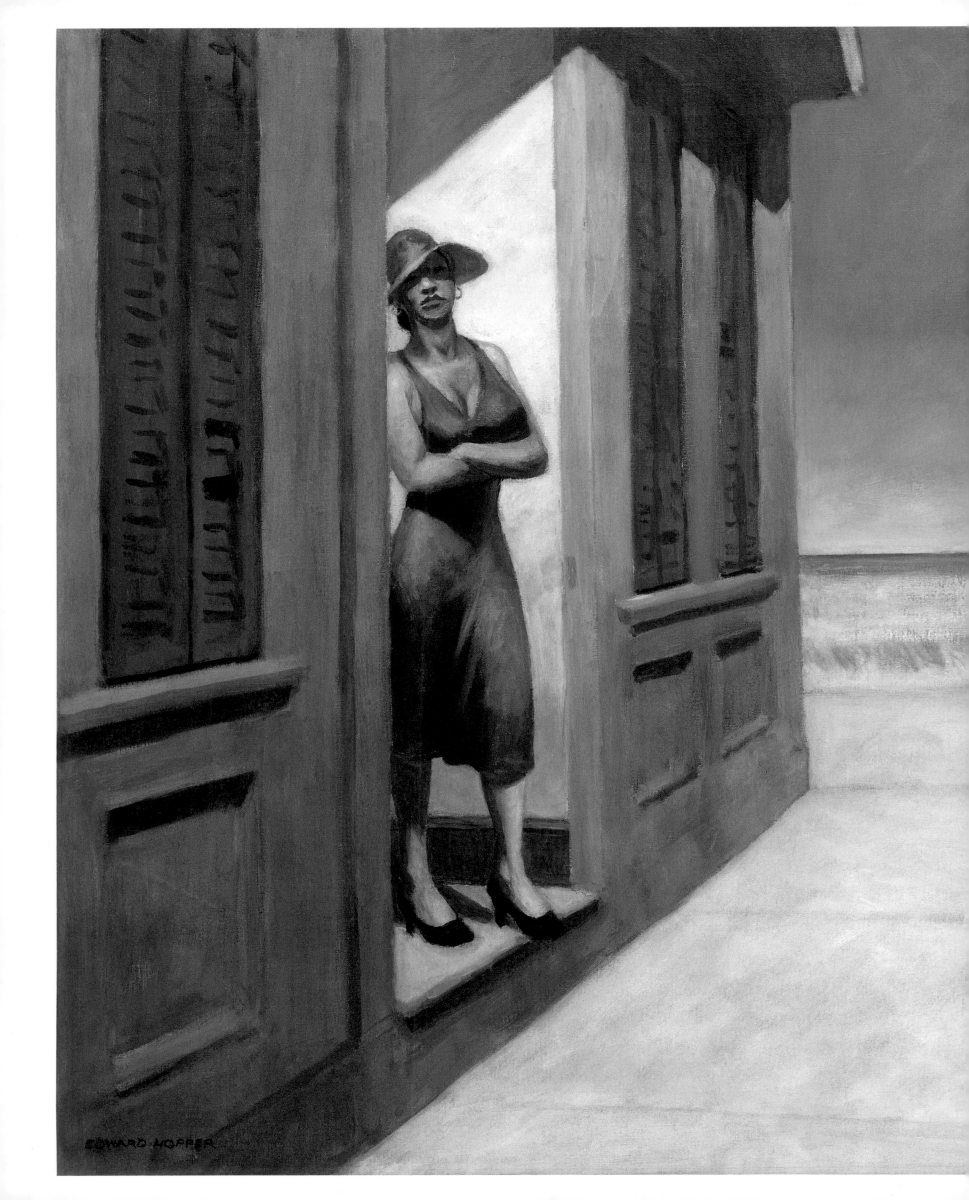

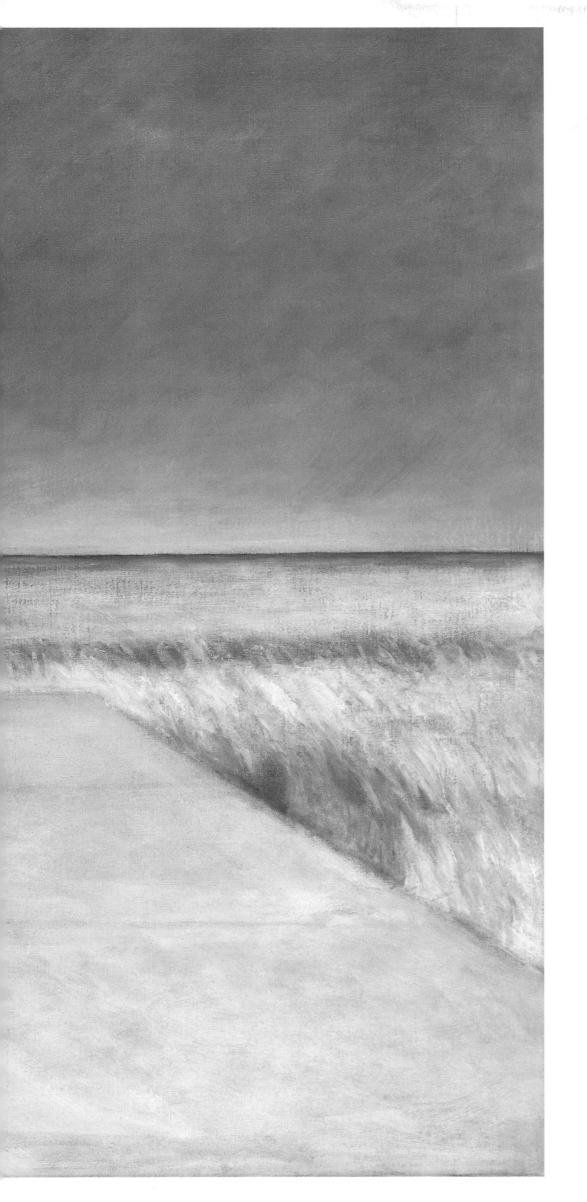

73. *South Carolina Morning*, 1955.

Oil on canvas, 77.6 x 102.2 cm.

Whitney Museum of American Art, New York,

given in memory of Otto L. Spaeth by his family.

table topped with a marble slab and an enamelled oil hurricane lamp. A brass music stand loaded down with favourite compositions – no jazz – waits next to the organ in *Mrs. Acorn's Parlor*.

Edward and Jo finally returned to Gloucester where they remained until it was time to go back to New York in the autumn. Hopper's suitcase was crammed with thirty watercolours and the oil *Gloucester Street*. This depiction of houses along Church Street at the corner of Pine might have been rendered in watercolour, but Hopper chose oil and the casual sketched effect of his previous watercolours disappears. The brisk immediacy of light and dark forms with suggested details becomes a timeless actuality of real houses with basements and closets and pantries in the rear, pans on the stove and secrets in upstairs bedroom drawers. The houses see everything passing on the street below through their window-riddled façades.

On arriving back in New York Hopper discovered a long time fan of his work, the Washington collector Duncan Phillips, had purchased *Sunday* for $600, the oil that had allowed critics such a psychological house cleaning. In his writing of *Brief Estimates of the Painters*, the somewhat befuddled Phillips pegged *Sunday*'s location as being a "Midwestern town", dismissing Hopper's having painted it in Hoboken, New Jersey. Phillips had that confidence of decision that some men – such as Teddy Roosevelt – used to great effect. Phillips used his to dismiss all evidence to the contrary and misplace Hopper's locations. He also proclaimed the watercolour *The Locomotive* (p.88) to be the product of romantic California light when it was actually painted in New Mexico. But his cheque was good and both Hopper and Rehn were thankful for that.

With the windfall of new paintings from his prize artist, Rehn decided to produce a one-man show of Hopper's most recent work in an unprecedented volume on St Valentine's Day, 14 February 1927. To take full advantage of this opportunity, Hopper began a push to finish several oils he had been working on in his studio. To meet the schedule, Josephine had to scramble as well.

Besides bringing Edward's sales account up to date in the green ledger book she had begun and mounting her own summer watercolour efforts, she had to strip off and sit in an arm chair for Hopper's *Eleven A.M* (p.214). Then she threw on a hat and coat and peered into a coffee cup as the sole visitor to *The Automat* (p.197). For *The City* (p.171), Hopper once again took to his roof and used a fussy Victorian pile across the street as the centrepiece for a bleak look at a corner of Washington Square that is both denuded of trees and stripped of its usual crowds. A distant wall of flats seals off escape from the Square and watches everything through hundreds of window eyes.

Each of these three paintings takes a cue from *Sunday*, revealing some internal conflict brewing with the central character. Even the old building seems to look out – as did the *House by the Railroad* – on a landscape no longer familiar. Hopper is dividing his interior character studies into two groups. In *Apartment House*, we stand outside as voyeurs, glimpsing a ritual through a window, cut off from participation. In *Eleven A.M.* and *The Automat*, we are unseen ghosts in the same space, sharing the same walls, but unable to reach out. This dichotomy would continue as Hopper drew on a story-telling ability likely gained through years of illustrating other writers' stories. Commercial illustration, the work he hated, gave him the tools to ask his own questions through his virtuoso command of the painting medium.

The St Valentine's Day show at the Rehn Gallery was a success as far as getting Edward his share of free ink among New York's nationally syndicated critics.

"Edward Hopper Adds to his Reputation" crowed Henry McBride's column headline in the *New York Sun*. To the *New York World*, Hopper suddenly appeared "…much more modern…" than his previous conservative pigeonhole allowed. The "Dean of American Art Critics" of the *New York Herald Tribune* for thirty-six years, Royal Cortissoz chose to politely harrumph his way through

74. *High Noon*, 1949.

Oil on canvas, 68.6 x 99.1 cm.

The Dayton Art Institute, Dayton, Ohio,

gift of Mr. and Mrs. Anthony Haswell.

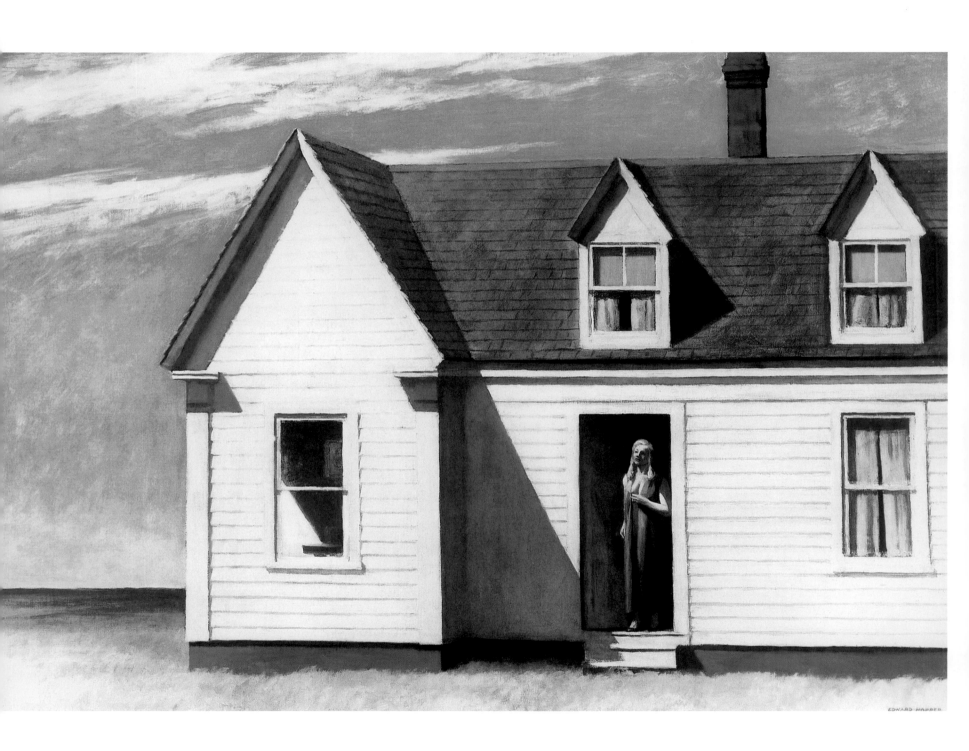

75. *Cape Cod Evening*, 1939.

Oil on canvas, 76.2 x 101.6 cm.

Collection of Mr. and Mrs. John Hay Whitney,

National Gallery of Art, Washington, D.C.

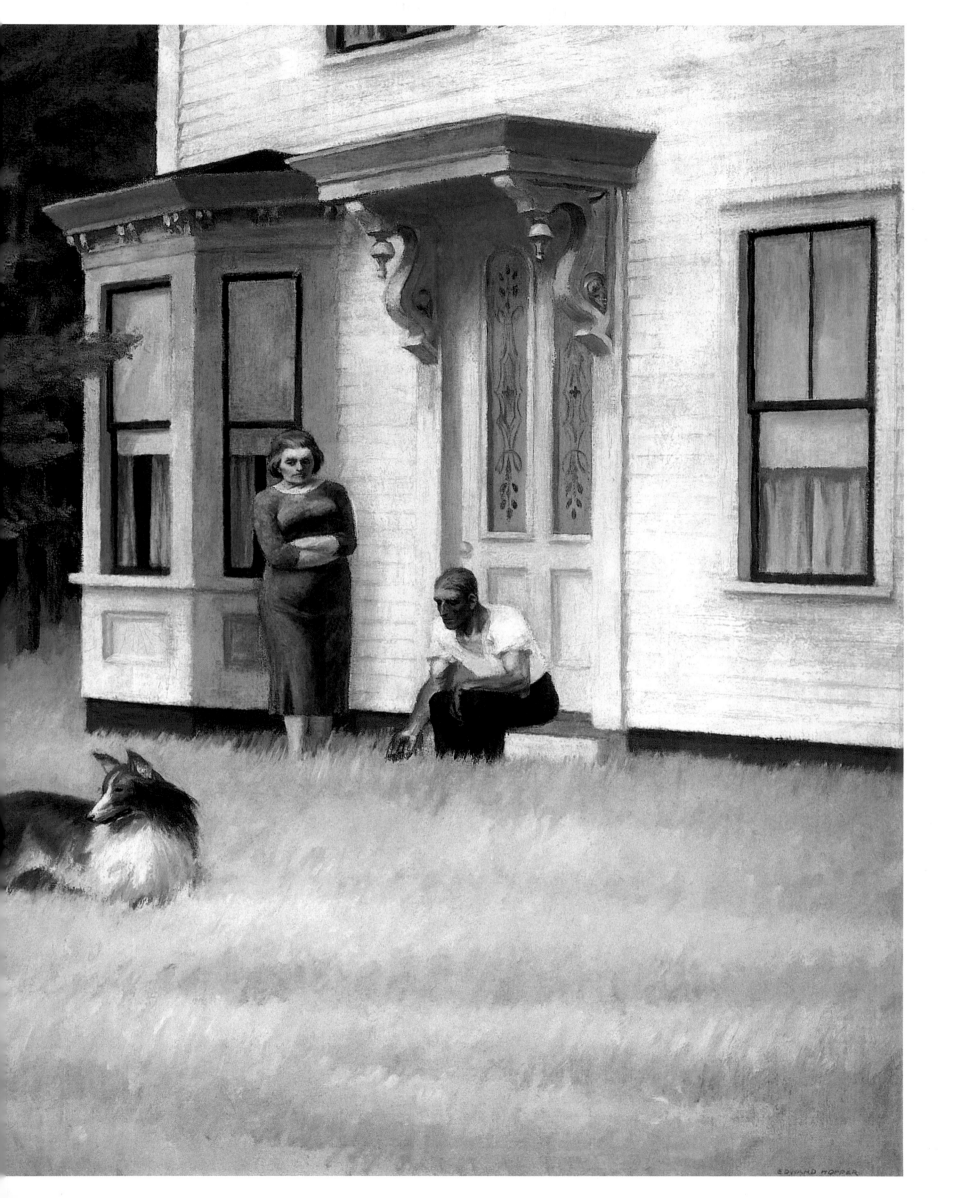

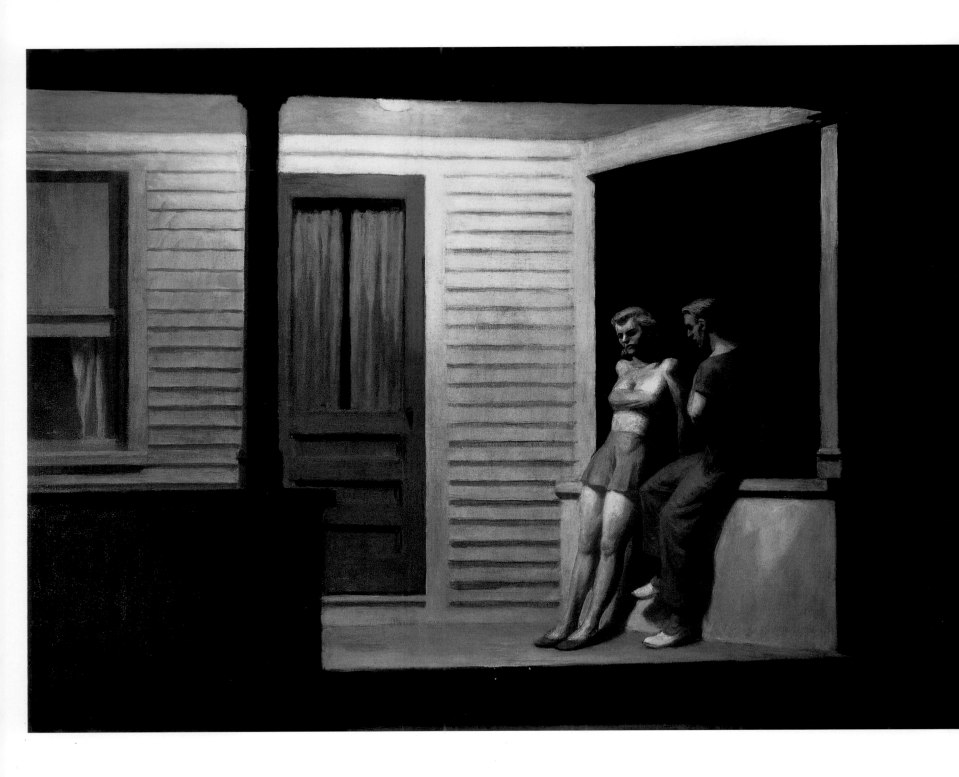

Hopper's multimedia display of four oils, twelve watercolours and a number of etchings as though treading through a minefield:

> " (Hopper) … uses various mediums with varying success… He is a proficient etcher… He paints well, sometimes in watercolour… The oils are disappointing for the same reason that makes some of the watercolours unsatisfying, the touch is heavy, almost dragging. In both mediums, Mr. Hopper suffers from seeing his subjects with a terribly prosaic literalness. 'The artist,' said Whistler, 'is known by what he omits.' This one makes a kind of dogged statement of fact, giving every detail the fullest possible view."

As Hopper gritted his teeth over critics' stylised analyses of his work and thrusting him head first into "The American Scene" club of painters, Josephine sent off a watercolour titled *Boats* to the Whitney Studio Show. She used her latest professional name, "Josephine N. Hopper".

This signature-in-the-bottom-right-corner identity problem dogged her as Edward's star rose and she became known as "Hopper's wife". This same problem pursued the husband/wife painters Diego Rivera and Frida Kahlo. As Rivera's commissions for murals and his prestige grew, Frida became known as "one of Rivera's wives" when any of her introspective works were hung. Jo's friends told her she was making a mistake not to use her maiden name and her middle name "Verstille" was very French in keeping with her "happy" impressionist style.

If shared identity was a sticking point, their mutual love of the theatre resulted in another oil painting delivered up to Rehn in March 1927 titled *Two on the Aisle*. Here, a formally-clothed couple prepare to sit down in their expensive on-the-aisle seats only one row back from the orchestra. The "aisle" referred to, however, is at the far right of the stage next to the ground floor boxes. In one of the box seats, a lone woman reads her programme. The design and colours bring you back to the balding man in the tuxedo removing his coat as he surveys the house. His expression seems to be uncertain. Did he overpay for expensive seats to see a poorly attended flop? His wife seems resigned to the situation.

Though *Two on the Aisle* (p.228) was apparently Jo's idea, Hopper continued the theatre theme in a number of future works.

In April, flush with critical appraisals, particularly those of Lloyd Goodrich who had replaced the absent Guy du Bois as his primary cheerleader, Hopper contributed an article in *The Arts Magazine*. Though aimed at praising the work of fellow "Americanist" John Sloan, Hopper took advantage of the offer to present some points of his own now that he had earned his audience's attention. Hopper wrote:

> "John Sloan's development has followed the common lot of the painter who through necessity starts his career as a draughtsman and illustrator: first the hard grind and acquiring sufficient technical skill to make a living, the work of self-expression in spare time, and finally the complete emancipation from the daily job when recognition comes. This hard early training has given to Sloan a facility and a power of invention that the pure painter seldom achieves."

In this paragraph, Hopper has described his own climb up the ladder and, as much as he would ever admit, laid the skills learned as an illustrator at the door of his own success. That "facility and power of invention" are as much a part of his toolkit as his Windsor Newton paints.

76. *Summer Evening*, 1947.

Oil on canvas, 76.2 x 106.7 cm.

Collection of Mr. and Mrs. Gilbert H. Kinney.

77. *Second Story Sunlight*, 1960.
Oil on canvas, 101.9 x 127.5 cm.
Whitney Museum of American Art, New York,
purchased with funds from the Friends of the Whitney
Museum of American Art.

Further on he comments that

> "…*certain artists of originality and intelligence, who are no longer content to be citizens of the world of art, but believe that now or in the near future American art should be weaned from its French mother. These men in their work are giving concrete expression to their belief. The 'tang of the soil' is becoming more and more in their painting…*" [41]

Gail Levin, Hopper's foremost biographer, notes in her book *Edward Hopper – An Intimate Biography* that Hopper's reference to "him" and "he" and "these men" reflects his belief that allowed "…no creative role for women, including his wife. His attitude toward women typifies most male artists of his generation. He was consistent in his disparagement of women artists in general, viewing them mainly as dilettantes who painted flowers, dabbled in other trivial subjects and caused trouble for men in the profession." [42]

Josephine's idea for the painting *Two on the Aisle* brought home her inspirational role in the partnership when Frank Rehn sold the oil for $1,500 ($16, 890 in 2006 dollars) – the highest price yet paid for an original Hopper oil. Her input also launched a series of theatrical theme paintings over the years that would last until Hopper's final painting.

Flush with money and ready to launch himself back to work, but with more mobility and freedom to track down subject matter and more time to paint with less trudging about, he bought a used 1925 Dodge car. It was boxy, with four doors, a flat roof, headlights inboard of the front wings, a three-speed transmission and four-cylinder engine. A friend in Nyack taught Edward how to drive while Jo sat in the back seat, giddy and excited, waiting for her turn at the wheel. That would never come. According to Darwinian assumptions of the time, backed by pseudo-scientific fact, women as a whole were unfit to drive due to their emotional instability, physical weakness and intellectual deficiencies. Relegated to the back seat, Jo fumed. Over the next twenty years, this Neanderthal concept of male superiority behind the wheel and Edward's fierce defence of his prerogatives provided fodder for furious battles sometimes degenerating into punching, kicking and biting. After all, Edward rationalised, the car was purchased to advance *HIS* art, so he called the tune.

On the Road with Ed and Jo

Loading down the Dodge with their suitcases, paints, brushes, easels, turpentine, linseed oil, oil paints, watercolours, canvas, stretchers, Conté crayons, pencils, kneaded erasers, paper, fixative, varnish, food basket, thermos, books, cans of oil, brake fluid, funnel, siphon, tool kit, extra fan belts, spark plugs, petrol can, grease gun, length of stout rope and maps, the Hoppers set out on their road trip to Maine. With Edward at the controls, the Dodge chugged along highway US 1 at forty-five miles per hour. They paused in Ogunquit to visit C. K. "Chat" Chatterton, an old art school chum of Edward's and a successful painter from Henri's "Ash Can" and "The Eight" crowd. They had shared studio space and a similar background, Chatterton being from Newburgh, New York just up the Hudson River from Nyack. Chatterton's wife, Antoinette, made the Hoppers welcome and kept Jo company while C.K. and Edward caught up on their stories of student nonsense and struggle.

The Hoppers covered 320 miles and found themselves near Portland at the lighthouse named "Two Lights" on Cape Elizabeth, Maine. Dating back to 1828, two stone towers about 300 yards apart had provided one constant light and one flashing beacon. In 1924 the US Coastguard decommissioned the western tower, leaving the 65-foot cast iron eastern tower built in 1874, the keeper's house and a fog horn station that sounded every sixty seconds in foggy conditions.

78. **Lyonel Feininger**, *Sailing Boats*, 1929.

Oil on canvas, 43 x 72 cm.

The Detroit Institute of Art, Detroit, Michigan.

79. *The Long Leg*, 1935.

Oil on canvas, 50.8 x 76.2 cm.

Virginia Steele Scott Foundation, Pasadena, California.

80. *The Lee Shore*, 1941.

Oil on canvas, 72.1 x 109.2 cm.

Private collection.

Lighthouses had been a favourite subject since Hopper's art school days, but the magnificent structure at Two Lights seemed to obsess him. Its tower was beautifully proportioned with a double deck around its circumference and tall windows protecting its rotating lenses and mirrors. The keeper's house had strictly non-functional gingerbread decoration beneath its eaves. Various sheds and other outbuildings had been added as needed, addition upon addition tumbling over the hillside. For Hopper, the location was like a magnet that drew him back over the years. During the summer of 1927 he painted three elegant watercolours of the light and its buildings.

Light at Two Lights (pp.146-147) is a composition that truncates the tower to show its concrete base, a section of the clapboard tunnel that connects the tower to the house for use in bad weather, a bit of roof peak, a tree and a scraggly bush. Combining natural and geometric forms in a flawlessly complete arrangement, the result resembles a student's assignment. Two other *Light at Two Lights* (pp. 150-151) watercolours explore the property revealing views of the tower – still trimmed – and the outbuildings in pleasing compositions under blue and bald skies. Hopper's ability to be faithful to textures and nuances of colour in shadows add an almost photographic quality to these paintings reminiscent of Charles Sheeler's "precisionist" paintings, but retain the demanding fluidity of the watercolour medium.

In 1929 Hopper created two oils from the Cape Elizabeth location, the lighthouse and the coastguard station down at the beach. The difference between the oils and watercolours is stunning. While the watercolours are spontaneous and filled with exploratory and relevant detail that gives each surface its own character, the oils seem carved from hard-lit masses, solid geometric forms exposed to a bright low sun. The reality of the buildings and their function and habitation has been replaced by the reality of the painting, the intrusion of the artist's will and power to transfer an intellectual subtext to pristine objects.

Compare these to the pair of oils, *Lighthouse Hill* and *Captain Upton's House*, painted in 1927 while the subjects were still fresh and exciting regardless of the selected medium. These two paintings retain the watercolours' freshness. In *Lighthouse Hill*, Hopper lets the shadows define the scene in horizontal shapes creating a rolling sea of grass beneath the house and tower that ride its crest. *Captain Upton's House* keeps the character of the rambling built-on structure with its decorated eaves, but with the opacity of oil paint and the skill of Hopper's brushwork, which he must have relished as the painting took shape.

As Hopper painted, Josephine – on foot – looked after finding accommodation for the night, locating places to eat and searching for public and private utilities to serve more basic needs. At one point, their toilet shared a shed with a bucket of lobster bait – chopped fish allowed to rot. She also managed to paint a few watercolours.

Eventually they took a turn through Portland where Hopper painted the watercolour, *Custom House, Portland* while crouched in the car during a downpour. This new use for an automobile became a natural extension of its value through the years. Hopper's growing confidence with the vehicle led to side trips through Connecticut and Vermont producing more watercolours to add to the heap of new work he deposited at Rehn's gallery in mid-October. From there, he drove Jo to Nyack and put the Dodge up on blocks during the winter.

As Rehn priced each of Hopper's new watercolours at $250, Josephine dropped off a short stack of her latest work at the Whitney Studio Club gift shop to sell for between $5 and $50 each.

Back at the Washington Square studio, Rockwell Kent had replaced Walter Tittle as Hopper's neighbour. Tittle, in keeping with his success, moved on to more fashionable digs uptown. Kent was a polar opposite of his droll, straight-laced neighbour. Another one of Hopper's former classmates, Kent lived with his new wife and the children of his former marriage in an apartment on a lower floor. He drank despite Prohibition and managed a successful career unencumbered by creative self-loathing brought on by mingling commercial illustration and other projects for hire with his painting and printing. Hopper could only harrumph and continue to lug coal in a scuttle up the seventy-four

81. *Ground Swell*, 1939.

Oil on canvas, 91.4 x 127 cm.

Corcoran Gallery of Art, Washington, D.C.,

William A. Clark Fund.

82. **Winslow Homer**, *Breezing Up (A Fair Wind)*, 1873-1876.

Oil on canvas, 61.5 x 97 cm.

National Gallery of Art, Washington, D.C.,

gift of the W.L. and May T. Mellon Foundation.

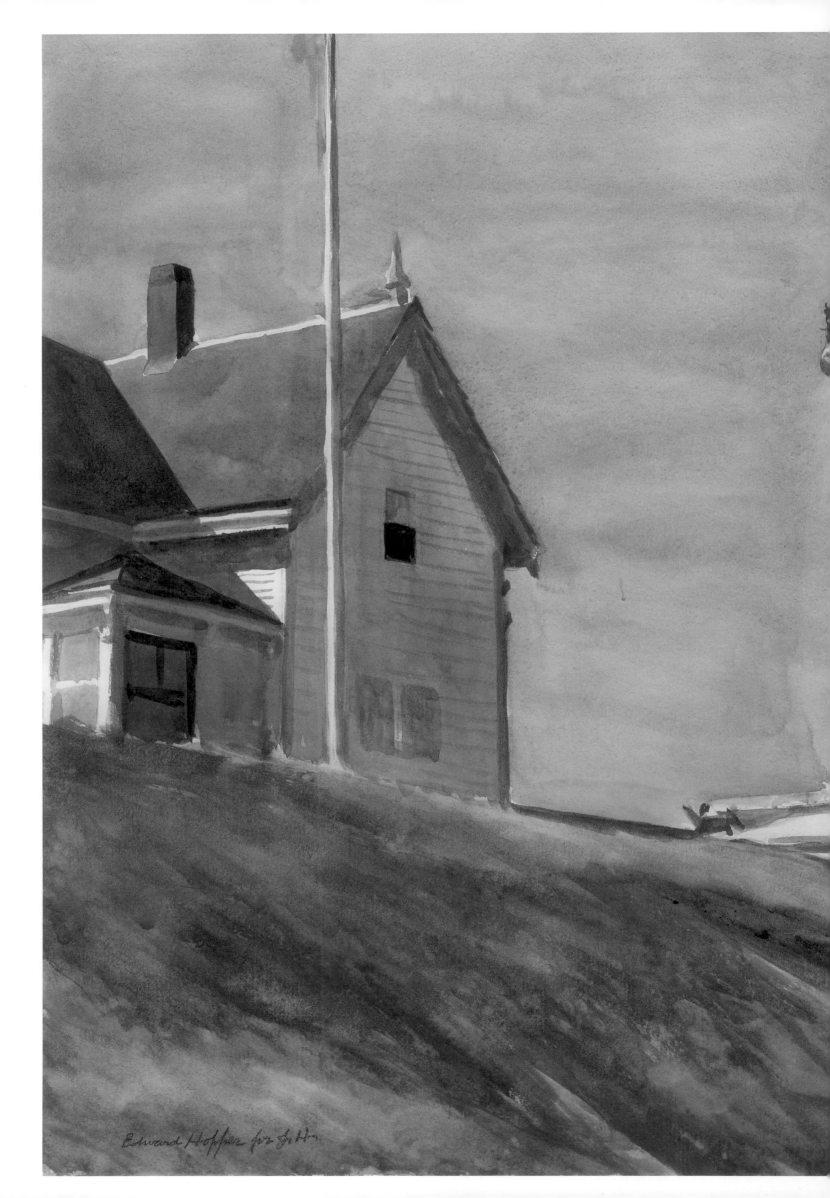

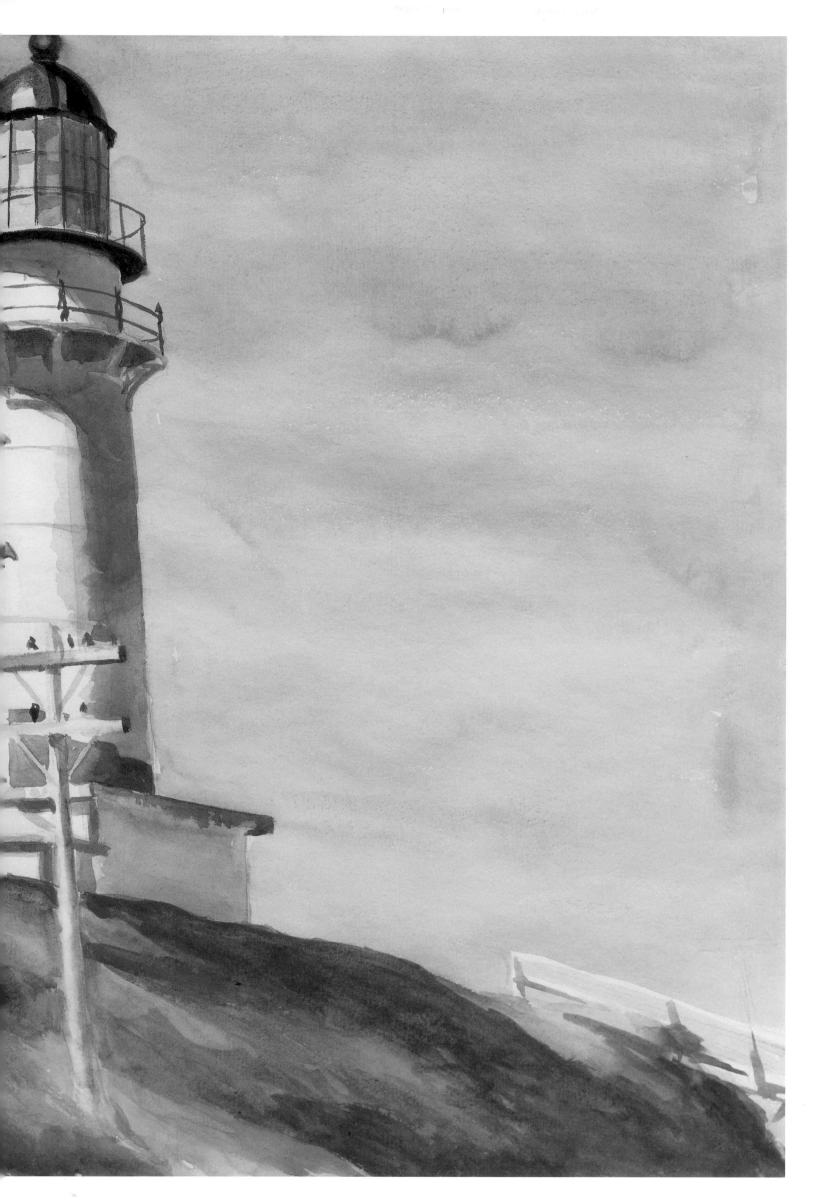

stairs to his pot-belly stove and busy himself painting a line on the floor of his studio space beyond which Josephine was forbidden to tread.

On the easel in this no-tread zone was a painting titled *Drug Store* (p.177) that Hopper was trying to finish before the end of the year. If driving around the east coast to find new subject matter was a departure, this painting also represented a creative shift. Hopper prowled the streets and elevated trains at night, peering into lighted windows. *Drug Store* was a representation of Silbers Pharmacy with its lighted window display announcing "Prescription Drugs" and the over-the-counter inducer of bowel movements, *Ex Lax*.

This corner drug store casting its interior light across a clean slab of pavement and causing half-shadowed doorways is an island in darkness, a purveyor of goods and services with its penny weighing-scale out front. Having just cast off his commercial shackles, Hopper chose to punch up his night ramblings with signage guaranteed to offend somebody. Offence was not long in coming. Suggestions by friends and Rehn's customers seemed to demand editing, so Hopper used watercolour to turn the "x" into an "s" to become "Es Lax".

The Boston lawyer John T. Spaulding, who had bought some of Hopper's watercolours, put down $1,500 for *Drug Store*. Its edited sign was pointed out and the lawyer-collector demanded that the original "Ex Lax" be restored, which Hopper accomplished with some water and a sponge. Meanwhile, an image of the altered painting had reached the offices of Ex Lax and they gave Edward free use of their product's name, but, alas, no free samples.

As 1927 ended, so did Hopper's romance with printing, or at least etching. On 15 January 1928 he took his copper plate in hand and scratched a dry-point image directly into the metal. Two women look down past the aisle steps toward the theatre stage. He titled it *The Balcony*. Two weeks later he created another dry point, *Portrait of Jo*. With those two dry-point etched prints, he closed the door on that part of his career that had kept his creative reputation alive when he could not give away his paintings. Always the marketing realist, Hopper's watercolours sold for a higher price and were one-off examples of his work, not copies from the plate. The antique banknote printing press remained in the corner of his studio for the rest of his life, relegated to the job of hat rack for his battered old fedora.

Beginning in 1928, Hopper created "Captain Ed Staples", an imaginary person who, in various guises, appeared again and again along with a repertory cast of characters standing in for real people in Hopper's haunting oils of urban and bucolic angst.

"Staples" is likely a composite character created from various New Englanders the Hoppers had met in their travels. Josephine claimed that "Ed" was "…dreamed up by E. himself".[43] This fictitious man in black waistcoat and trousers and long-sleeved collarless shirt standing in front of a bay window clapboard house, ankle-deep in grass, seemed to represent "everyman" to Hopper's mind: hands in pockets, unsure of what's expected, ready for a funeral or a wedding. His face, or his cousin's, would appear at roadside petrol stations, in a diner, in offices and apartment rooms. He is the fiction side of Josephine, Hopper's model for all females in his canvases. The original *Captain Staples*, however, had a short life. The painting was destroyed in a railway crash returning from a Cleveland Museum exhibition. His progeny would live on.

The routine had been established and would vary little over the ensuing years. From October to May Hopper worked on oils and put on his public face to write, attend shows, give interviews and deal with Jo's various agendas. From June to August they took to the road, travelling up to New England or heading west as far as Mexico, or south to Charlotte, South Carolina. 1928 was the last care-free summer before the Stock Market crash of 1929 and the start of the Great Depression. Though their own finances were hardly affected since they had no stock or bond investments, the *nouveau riche* who had been building collections with Stock Market income began disappearing from the galleries.

83. *Light at Two Lights*, 1927.

Watercolour on paper, 35.2 x 50.8 cm.

Whitney Museum of American Art, New York,

Josephine N. Hopper Bequest.

84. *Five A.M.*, c. 1937.

Oil on canvas, 63.5 x 91.4 cm.

Wichita Art Museum, Wichita, Kansas,

The Roland P. Murdoch Collection.

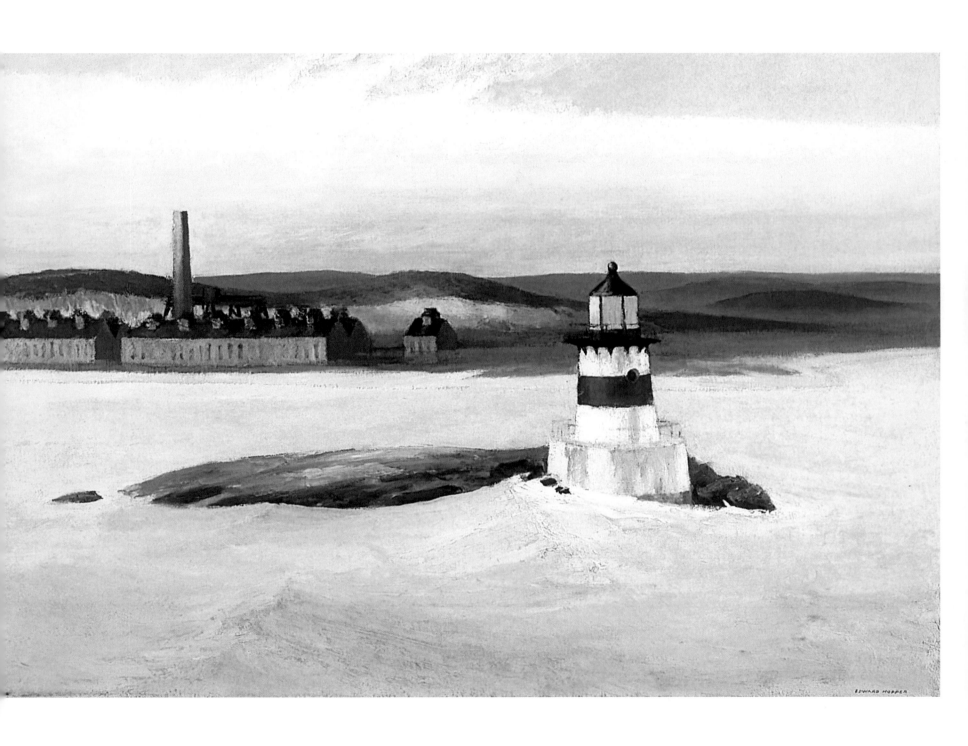

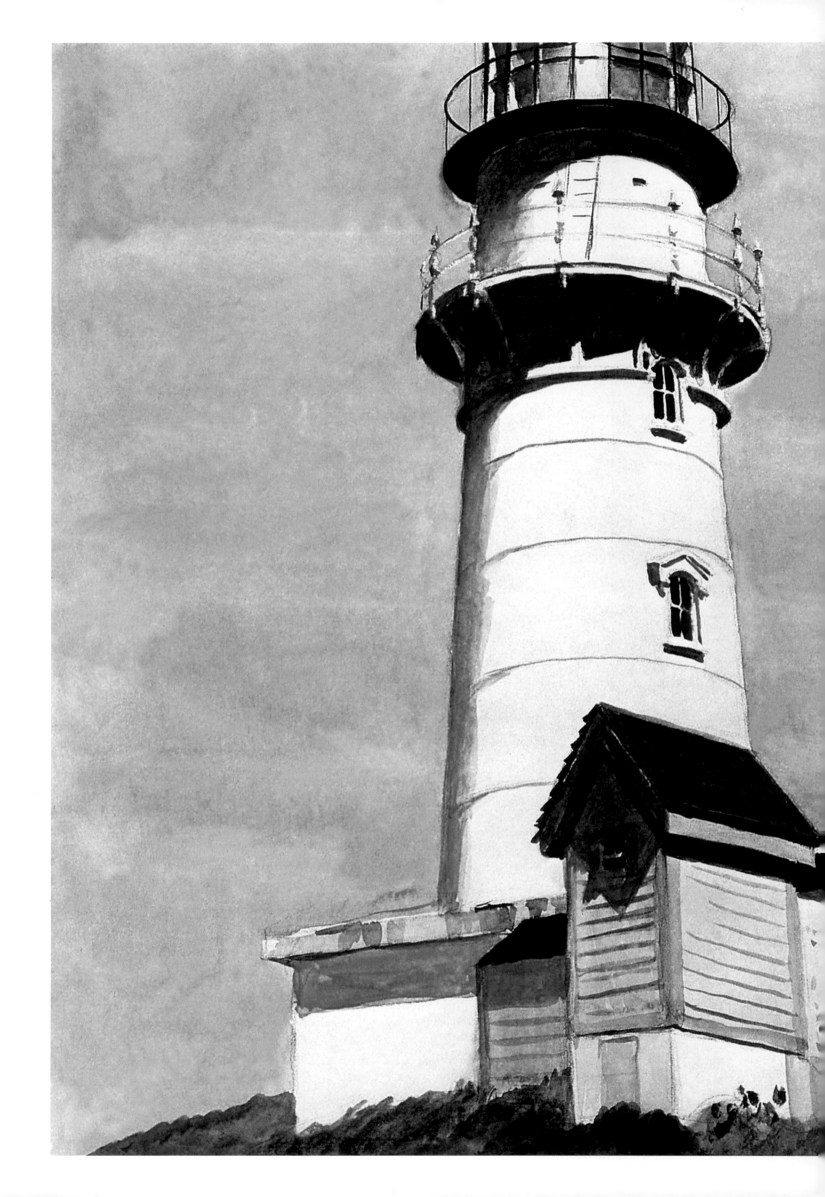

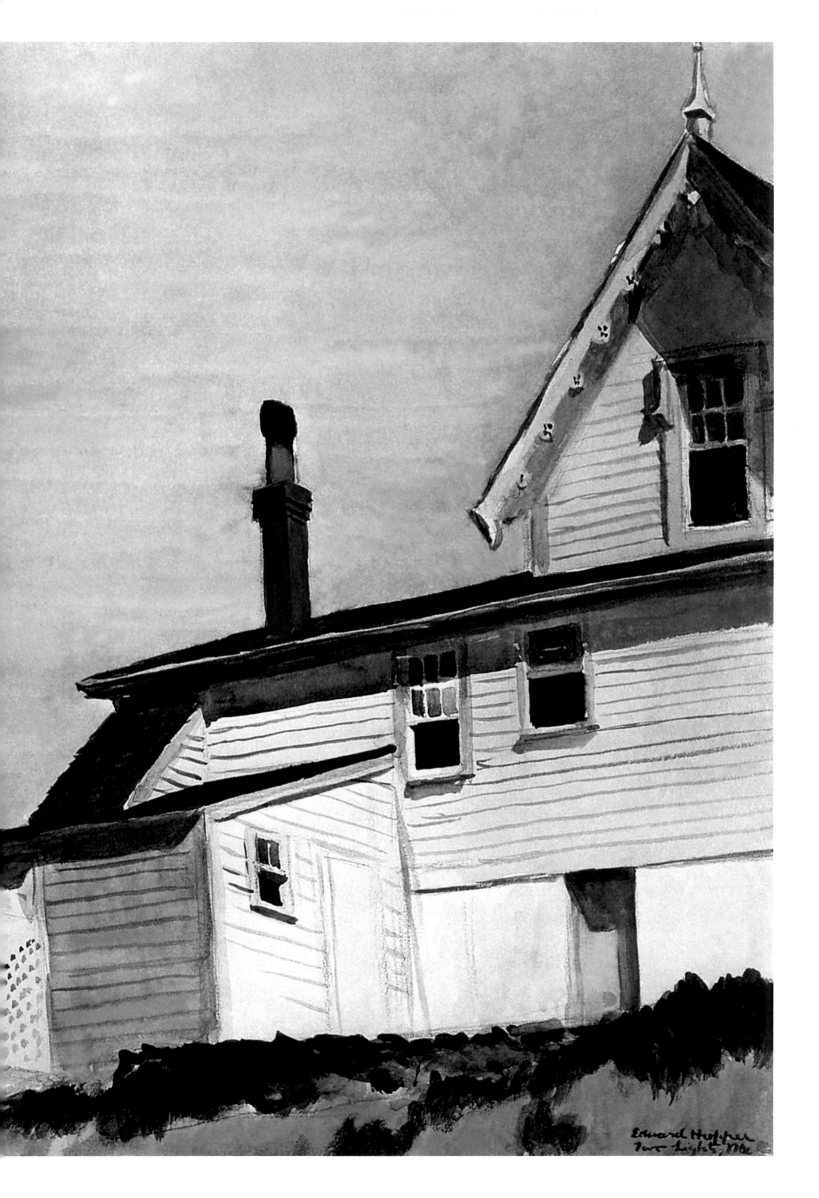

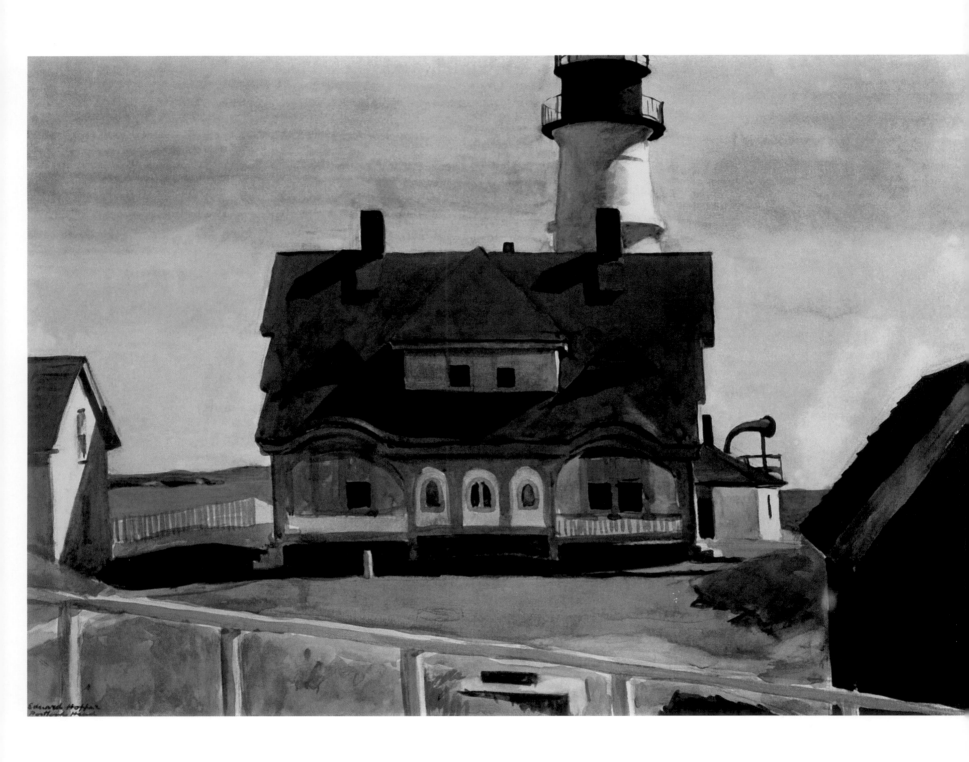

As with the Hoppers' travel and studio routine, little changed in their lifestyle since they had always lived such a frugal existence. Neither cared about fashion statements. They wore their clothes until they were threadbare at the knees and elbows or the linings wore out. Josephine did not mend, sew, knit or crochet. She did make rag rugs from clothes beyond saving. Her mother taught her that skill. Food came from restaurants or cans since Jo didn't cook. They drove each car they owned after the Dodge until it collapsed and then bought another used car and drove it into the ground. In good times or bad, the Hoppers continued on, buying their painting supplies, working at their easels, attending plays or seeing movies, Jo talked and Edward didn't even pretend to listen. Jo said that talking with Edward was the same as dropping a rock into a deep well, never hearing it hit the bottom.

But as 1928 began with chill winds and the stove glowing against the wall. Hopper finished the *Williamsburg Bridge* (p.164), a scene he discovered from the pedestrian walkway of that bridge across the East River. Two matronly apartment buildings with ornate, far-reaching cornices beetle out above the sidewalk. They are part of a façade of similar structures, but are one storey taller. The painting resulted from a Conté sketch that was then stripped of many details including extra ironwork and a fire escape. This exorcising of details became Hopper's way of thinning out his scenes to the essentials of design. A lone figure of a woman sits on a window ledge overlooking the street. Her lifestyle can be imagined.

Giving the painting the feeling of a drive-by photograph, across the bottom of the composition Hopper has left in the guard rails along the bridge walkway. He wants us to see the scene as he interprets it and to also know literally how he found the scene by leaving in an element that he might have easily cropped out.

Hopper's care in what to include within the frame is demonstrated more clearly in the painting *Washington Bridge Loop* that was delivered to Rehn's Gallery on 17 April 1928, according to Jo's record book. The canvas measures 35 x 60 inches and represents considerable tampering with the perspective and spatial relationships of the original scene. Charcoal and lithographic crayon sketches show the original view of the structure's ironwork, signal bridge and power pylons, the farrago of buildings jumbled together in the background and a single street lamp in the foreground.

According to Hopper's own writing – a rare disclosure considering his usual close-lipped nature when it came to his art – the width of the canvas was a decision he came to in service of design. He intended the width to suggest the content extending past the painting's margins, or "…great lateral extent…to make one conscious of the spaces and elements beyond the limits of the scene itself." This is an odd statement on so many levels, especially considering the spatial distortions that give this picture its unique depiction of an otherwise unexceptional scene. His pronouncements on art – and especially his art – did get better as he grew older. Hopper was a voracious reader, as confirmed by Josephine who endured his long silences and immersion in literature. Writing came hard to him, but his contemporaries clung to his words like jewels because they were so rare.

The preparatory sketches do show how much he distilled the scene, pared away distracting details and left the architectural masses behind. He also stretched the three basic planes across the exaggerated width of the scene. Finally, as with the woman in the *Williamsburg Bridge* window, he placed a small striding male figure in a drab overcoat and worker's cap into the shadows at the painting's left side.

In 1939, when the sketches and the painting became part of a teaching exhibition at Andover Academy, Hopper invoked an Oz-like "Ignore that man behind the curtain" disclaimer to the exhibit organiser, Charles Sawyer.

"The preliminary sketches would do little for you in explaining the picture. The colour, design, and form have all been subjected, consciously or otherwise, to considerable simplification."[44]

85. *Light at Two Lights*, 1927.
Watercolour, 35.6 x 50.8 cm.
Collection of Bount, Inc., Montgomery, Alabama.

86. *Captain Strout's House, Portland Head*, 1927.
Watercolour on paper, 35.6 x 50.8 cm.
The Wadsworth Atheneum, Hartford, Connecticut.
The Ella Gallup Sumner and Mary Catlin Sumner Collection.

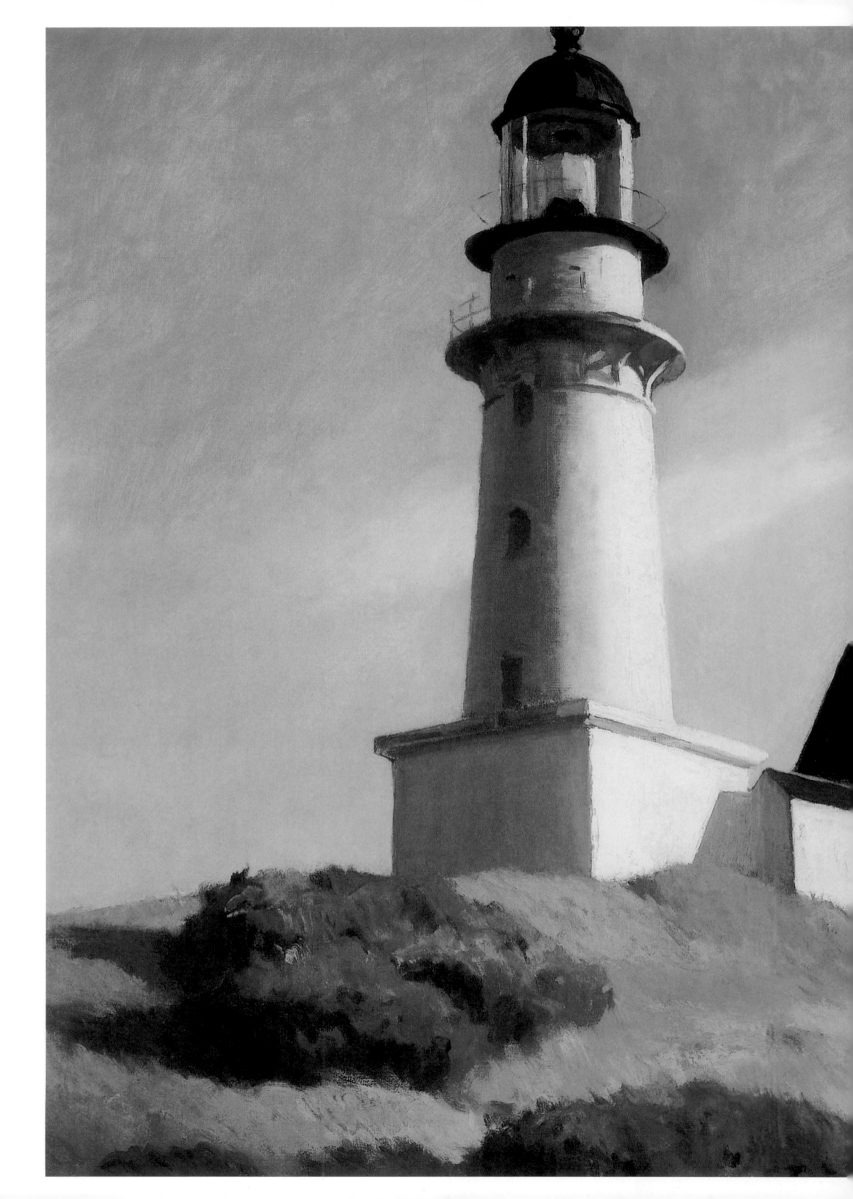

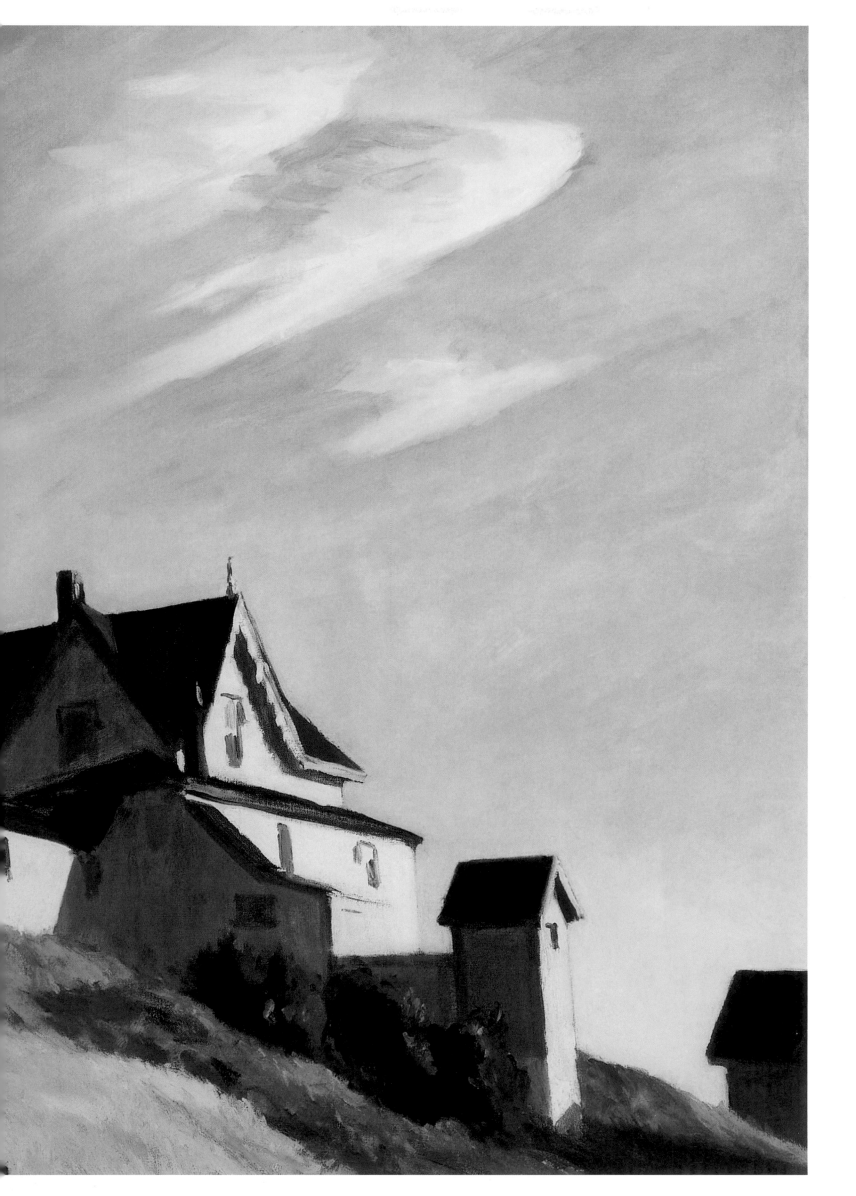

The sketches are, in fact, a treasure trove for the art educator trying to glimpse behind Hopper's creative process. This is hardly a unique response since most creative people are loath to display the cogs and gears churning away behind the machine. Art historians and teachers can only be thankful that so many of Hopper's preparatory drawings and studies survived thanks to Josephine Hopper.

At this time Edward Root, son of Theodore Roosevelt's Secretary of State, Elihu Root, made a particularly astute observation of Hopper's place in American Art. Already an enthusiastic collector of Charles Burchfield's work – a painter much compared to Hopper – Root saw an exhibition of Hopper's watercolours at a show mounted by Frank Rehn for the Art Society in Utica, New York. In a newspaper article, Root listed Hopper's skills:

> *"…his feeling for the brilliant sharply-defined iconic appearance of the American landscape; his sense of architectural surfaces which enables him to give a stronger suggestion of mass in his pictures of buildings than the buildings themselves are able to give; his ability to eliminate the unessential from each and every part of his picture; his instinct for the effective utilisation of the elements of design; his ample, deliberate, but nonetheless emotional method of laying on his paint; his feeling for the quality and carrying power of the paint itself."* [45]

In this long paean of praise Root managed to encapsulate much that made up Hopper's appeal. Compared to the other contemporary artists painting in the same *oeuvre*, American Realism, Hopper was totally unique. He belonged to no school as Childe Hassan clung desperately to American Impressionism. Hopper used no palette created by someone else as did Charles Bellows who claimed he "…had no sense of colour". He was no slave to photographic realism as was Charles Sheeler, nor did he abandon his grasp of realism to the mental and psychological gymnastics of Modernism, and he maintained no clique of devoted followers as did Robert Henri. Hopper admired the work of Burchfield, Kent, Bellows and Sloan, and now in their turn they were following his rapidly rising star.

Despite the frenetic activity in New York but true to their routine, the Dodge headed north-east once again and rumbled to a halt in Gloucester, Massachusetts on 28 June 1928. This time Hopper uncapped his Rembrandt oil paints and attacked the familiar countryside with an opacity around which flowed luminous grass – like a current of water around the modelled rocks in *Cape Ann Granite* and as golden tufts in the foreground of *Freight Cars, Gloucester*. In *Freight Cars* a beam shores up the vertical utility pole against the seacoast wind. The bare bones of a home-made snow plough and Tuscan red steel boxcars with dreadnought ends rest on their stub rail sidings in front of warehouse roofs all piled in front of the distant Catholic church steeple under a harsh late afternoon sky. The scene is rich in necessary detail and yet spare in applied paint, suggesting more than simple delineation.

On another note, a light-hearted portrait of *Hodgkin's House* on Cape Ann seems barely attached to the ground as wing-like eaves above deeply-moulded roof dormers and wind-ripped awnings on the bottom floor carry the theme of constant breeze on the exposed hillside. This 1850s creation, dubbed "The Bird House" seems to rely only on the sturdy rank of fencing across the bottom of the composition for protection against the elements.

From Hodgkin's House, Edward and Jo drove north to Ongonquit to visit G. K. Chatterton and his wife Antoinette at their summerhouse once again. Chatteron, like Hopper, was experiencing a surge in his career leading to many shows and recognition of his work over the next twenty years. To Chatterton's surprise – especially considering the joyful reunion of their last visit – a mood of depression had descended upon Hopper.

87. *The Lighthouse at Two Lights*, 1929.
Oil on canvas, 74.9 x 109.9 cm.
The Metropolitan Museum of Art,
New York, Hugo Kastor Fund.

88. *Rooms by the Sea*, 1951.
Oil on canvas, 74.3 x 101.6 cm.
Yale University Art Gallery, New Haven,
Connecticut, bequest of Stephen Carlton Clark.

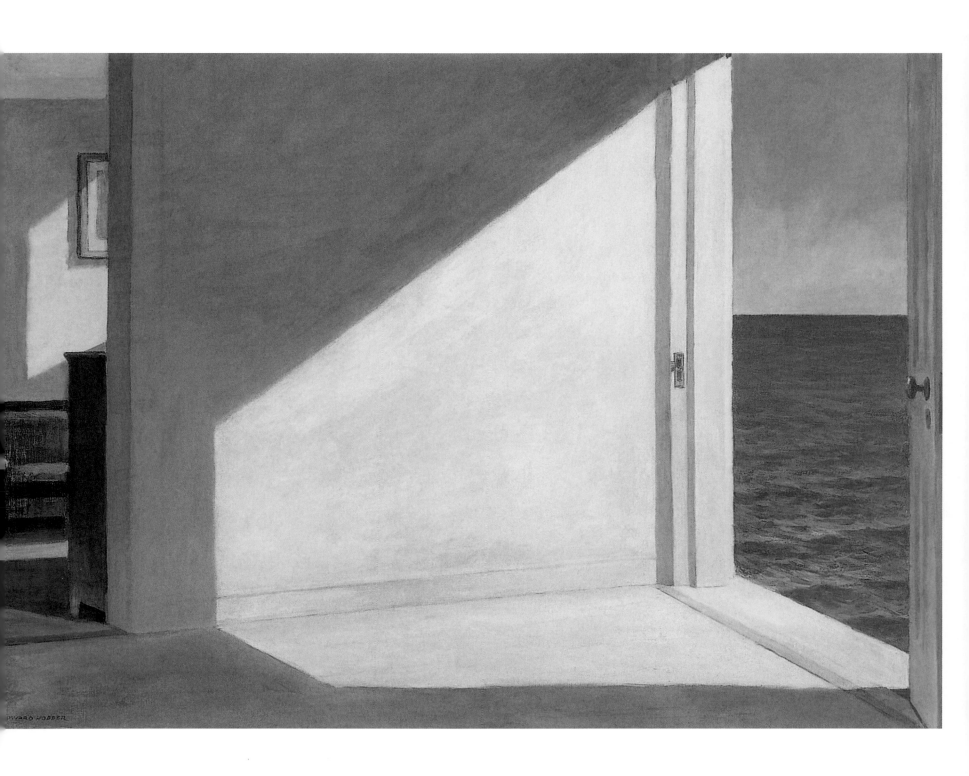

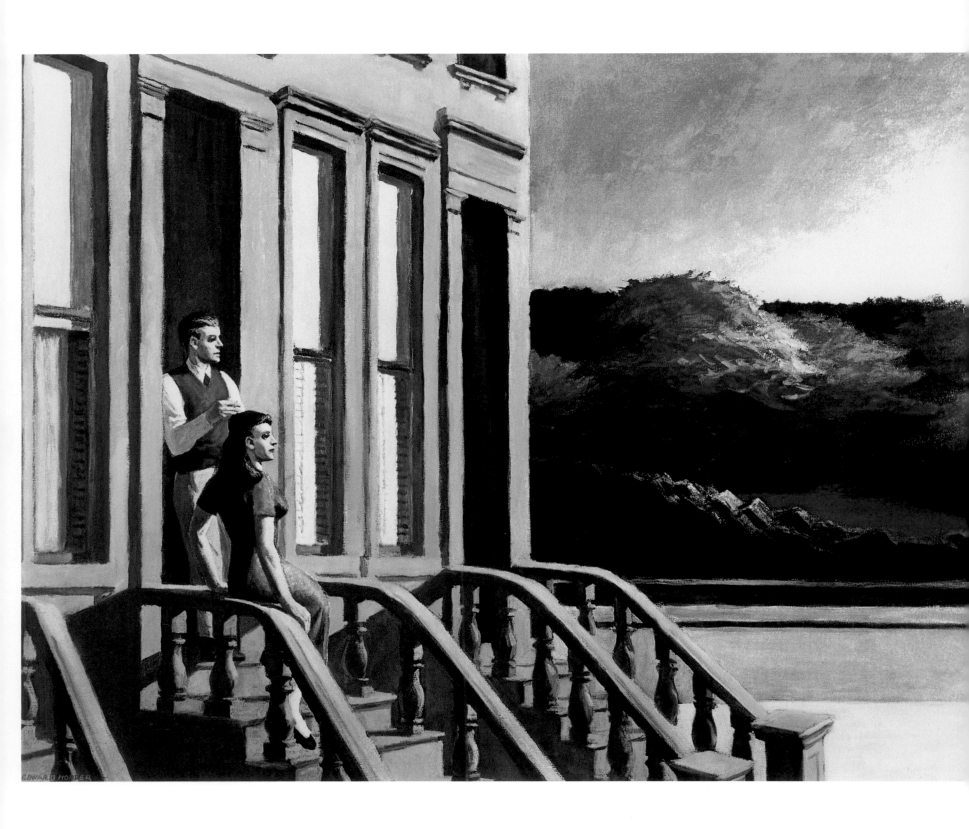

Chatterton recalled at the age of ninety-one in an interview with Canadian journalist Alexander Ross on 12 May 1971, "He (Hopper) was quite depressed, because it was the middle of summer and he hadn't done anything. And I said, 'What's the matter, anyhow? Plenty of stuff here to do, isn't there?' He said, 'I can't find it.' So we got in the car and drove around and we came to a spot that looked like the kind of thing he would do. We stopped and looked at it… nope, didn't interest him. Wasn't quite right. Something about it wasn't right…"

Though some of his most famous paintings remained in the future, these moods of depression over unfulfilled expectations and an inability to work became crushing impediments to Hopper's output. His creative production had now settled into an unflagging routine, but many factors – his physical health, his relationship with Josephine, his internal demons – began to break down the resolute wall he had erected.

After arriving back in New York in late September, Hopper discharged his summer painting efforts at Rehn's gallery and began sketching studies for a new painting in the same wide format as the *Manhattan Bridge Loop*. He planned another visit to *Blackwell's Island* (p.42), this time in daylight as opposed to his bridge abutment view of the island at night beneath the moon that he painted in 1911. These black and white drawings are meticulous to the point of writing out the colours he planned to use. The final oil rendering lays the island dead centre across the canvas between a pale blue and smog-ivory sky and a roily river worked and overworked into a busy wet texture. A V-shape of cirrocumulus clouds notches the upper centre above the foreboding buildings.

Renamed "Welfare Island" in 1921, the prison buildings held dangerous criminals ranging from the infamous "Boss" Tweed in 1874 to Arthur Simon Flugenheimer who became the brutal "Dutch Schultz" and claimed ownership of the Bronx by 1928. As the painting was being completed, the very dangerous Mae West, who added sexual improvisation to her first stage play, *Sex,* served ten days.

Hopper's "Island" is a grim compilation of penal servitude and public welfare architecture embedded in the narrow strip of land. Alleviating the blocks of workhouses, prison cells and charity beds is a white motorboat churning past, almost off the right side of the canvas. As with his other New York architecture paintings, a touch of humanity invades the otherwise stripped and edited urban scene.

Another aspect of these scenes is the conscious or unconscious voyeurism people practise when they ride the elevated train at night or peer unseen at apartment windows across the street. Vignettes of life pass windows with the shades up and curtains not drawn. These vignettes are often without context, inviting interpretation of what is taking place – quite like looking at a Hopper painting. He began this theme of outside-looking-in with *Apartment Houses* (p.205), painted in 1923 and picked it up again in *Night Windows* (p.206).

This 1928 oil depicts a woman in a red slip bending over in the centre of three windows of a corner apartment. The night is warm, as a curtain flutters outside an open window. Though a red table lamp burns in the opposite flanking window, the room is brightly lit from a centre ceiling fixture. The woman seems to be inviting strangers and her neighbours in for a show. While much noble literary and artistic attribution can be called up to explain this painting's genesis, we can also call on Hopper's sexual repression, his desire to place nude and semi-nude women in front of open windows and the suggestion of heat or a hot night – his ubiquitous fluttering curtains – as reasonable motivations.

The year 1929 found the Hoppers and the rest of the nation prosperous and drugged with success. With another one-man show opening at Rehn's on 21 January that brought considerable critical approbation, Hopper's total income in his ledger book for 1928 came to $8,486 ($98,804 in 2006 dollars). He and Jo had cash for their beloved theatre tickets and splurged occasionally at a better restaurant. But for the most part Jo still bought their clothes at Woolworths and Sears, dinner at home came out of a can and into a pot and Edward still lugged a scuttle of coal from the basement bin up the steps to their pot-belly stove.

89. *Sunlight on Brownstones*, 1956.
 Oil on canvas, 75.6 x 101 cm.
 Wichita Art Museum, The Roland P. Murdock Collection,
 Wichita, Kansas.

90. *People in the Sun,* 1960.
 Oil on canvas, 102.6 x 153.4 cm.
 Smithsonian American Art Museum, Washington, D.C.,
 gift of S.C. Johnson & Son.

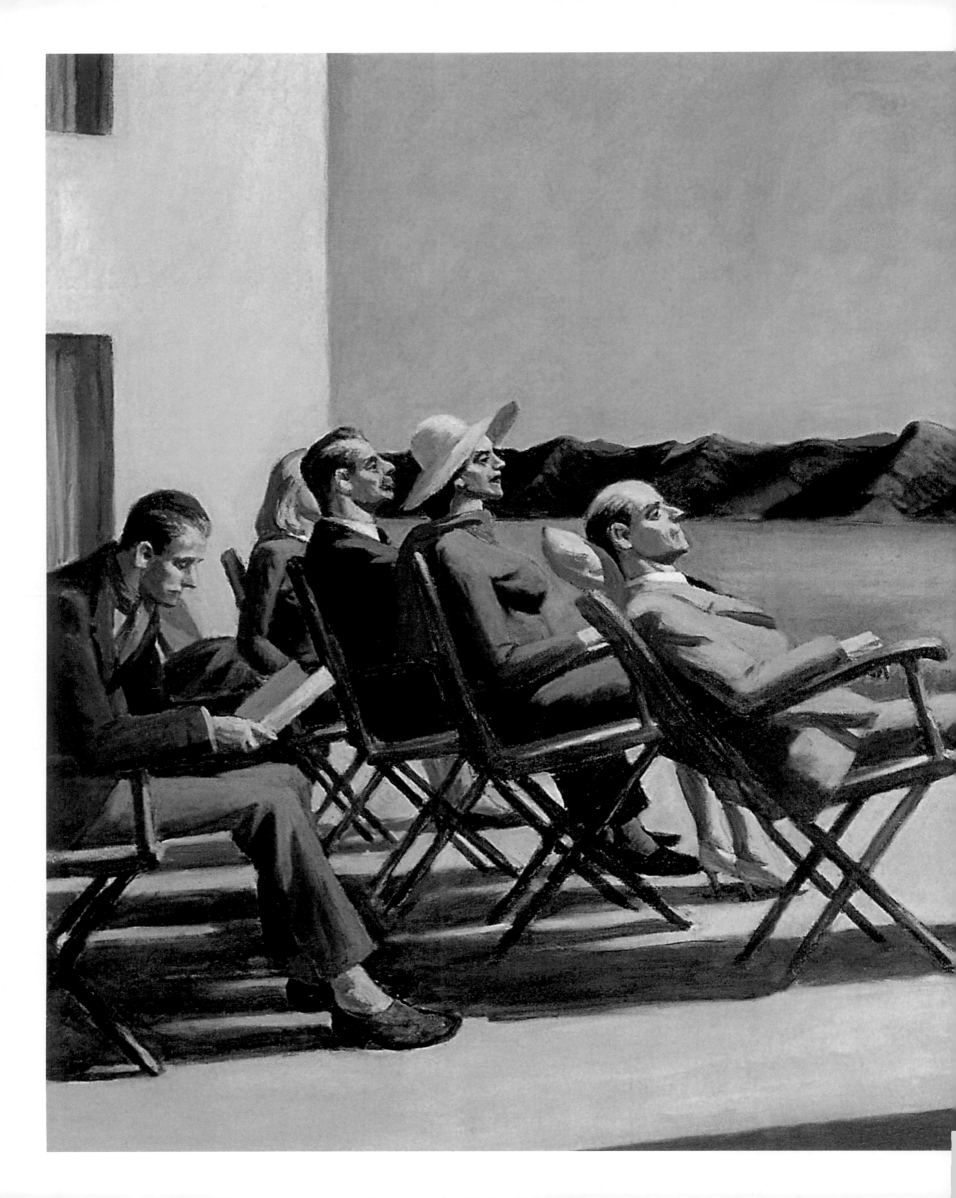

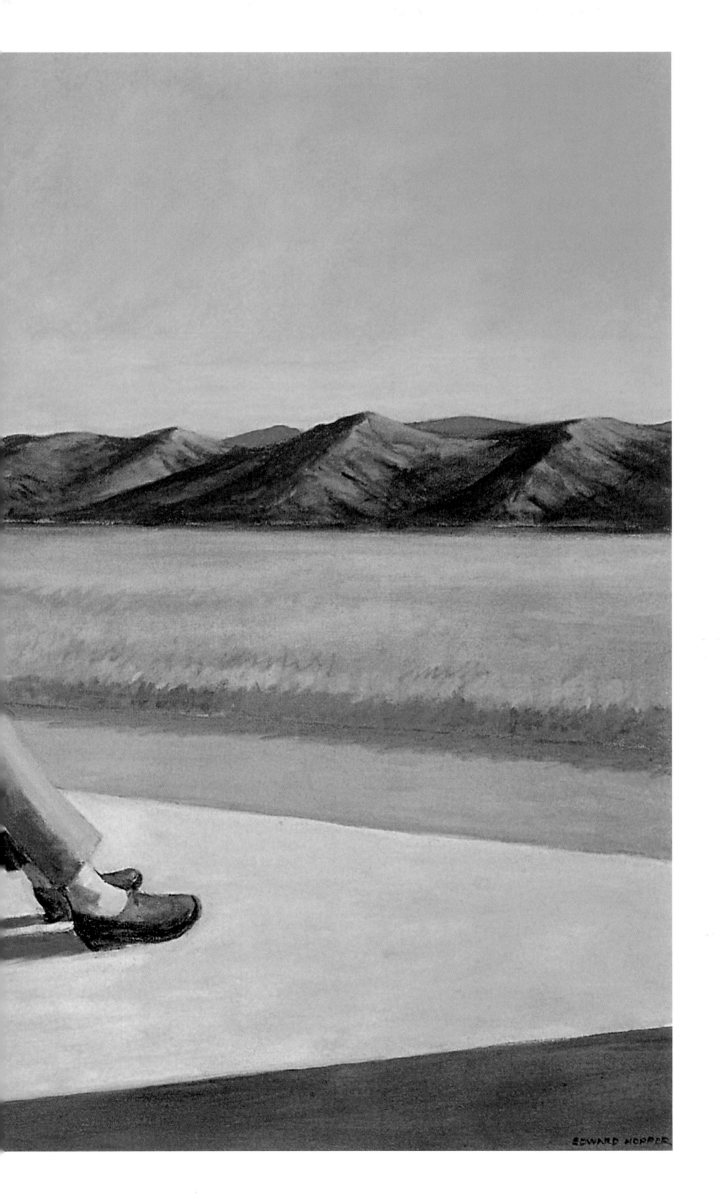

An example of their frugal lifestyle appeared in the 1929 painting, *Chop Suey* (p.200), a representation of a cheap second-floor Chinese restaurant they frequently visited on Columbus Circle. Jo had to scramble to pose for all three women seated at the tables. With that oil stashed at Rehn's, the Hoppers broke with tradition and instead of heading for the north-east, on 1 April they aimed their faithful Dodge south toward Charleston, South Carolina – the latest "in" community, according to writers and artists.

Hopper unpacked his watercolours as Jo settled them in a top-floor room at a boarding house owned by the widow Gertrude Wulbern Haltiwanger. For all its picturesque charm, Hopper found Charleston a bit of a let down. He was a Civil War buff and managed to see many of the battlefields, and gazed across the bay at Fort Sumter, but not many good paintings came from the location.

After touring Virginia through the Shenandoah Valley and visiting the Gettysburg Battlefield in Pennsylvania, the Hoppers returned to New York. They had no intention of summering in the stifling city and soon were off to Maine. As usual, the seashore breezes and lure of the quaint New England towns invigorated them. They arrived at Cape Elizabeth and once again Edward faced the remaining lighthouse at Two Lights. He painted an oil with the same title as the original watercolour painted in 1927 and repeated the process with the Coastguard station down at the beach. Both these paintings have been discussed earlier and most of Hopper's energy during this summer campaign was focused on producing watercolours to add to Rehn's ready supply. He was hard at work on 22 July when a copy of *Time* magazine announced the death of Robert Henri. Though Henri had helped him energise his intellect as applied to his art, as Hopper matured Henri's style and palette did not linger long. Also, Hopper had often found himself on the outside looking in at the virtually sycophantic collection of artists who gathered around Henri the impresario as he arranged shows for their work. Hopper said later, "It took me ten years to get over Henri. He wasn't a very good painter. At least I don't think so. He was a better teacher than a painter."[46]

The summer road trip produced two oils and a dozen watercolours and ended back in New York in September just in time to watch some of the great wheeler-dealers of the Stock Market buying binge decorate the pavements beneath the tall windows of their brokerage houses. *Black Thursday*, 24 October, 1929 signalled the crash that began choking the life out of America's economy.

Hopper experienced a foretaste of what was to come when he finished the *Railroad Sunset* (pp.64-65), one his most striking oils. The quality of atmospheric light that dominates this canvas recalls the Luminist painters who came from the nineteenth-century Hudson River school. Its use of almost impressionist short brush strokes to convey a progression from deep red sunset to the purple vault of the evening sky reminds us of the extreme tools Hopper often employed when showing skies and water – elements which often gave him fits. Possibly, the blood-red sunset searing the sky behind a lone railway pointsman's shack alongside an empty mainline track carried too much subtext for once wealthy executives who soon were selling apples on street corners for five cents each. The painting excited no interest. Hopper's earnings for the year finally totted up to $6,211 ($72,716 in 2006 dollars). Though his income dipped an equivalent of $25,000 in today's money, his prestige rose markedly when he was included in *Paintings by Nineteen Living Americans*, a show hung by the Museum of Modern Art, its second exhibition in its first year. He had been officially launched into the rarified air of the top echelon of American painters.

Over the next twenty years Edward Hopper's creative star rose and his personal life endured the harsh demands of the limelight. Life with Edward became a greater trial for Josephine as she literally clawed herself some creative space. Crippled by depression and his poor physical health, Hopper's output declined, but many of his greatest paintings lay ahead.

91. *Seawatchers*, 1952.

Oil on canvas, 76.2 x 101.6 cm.

Private collection.

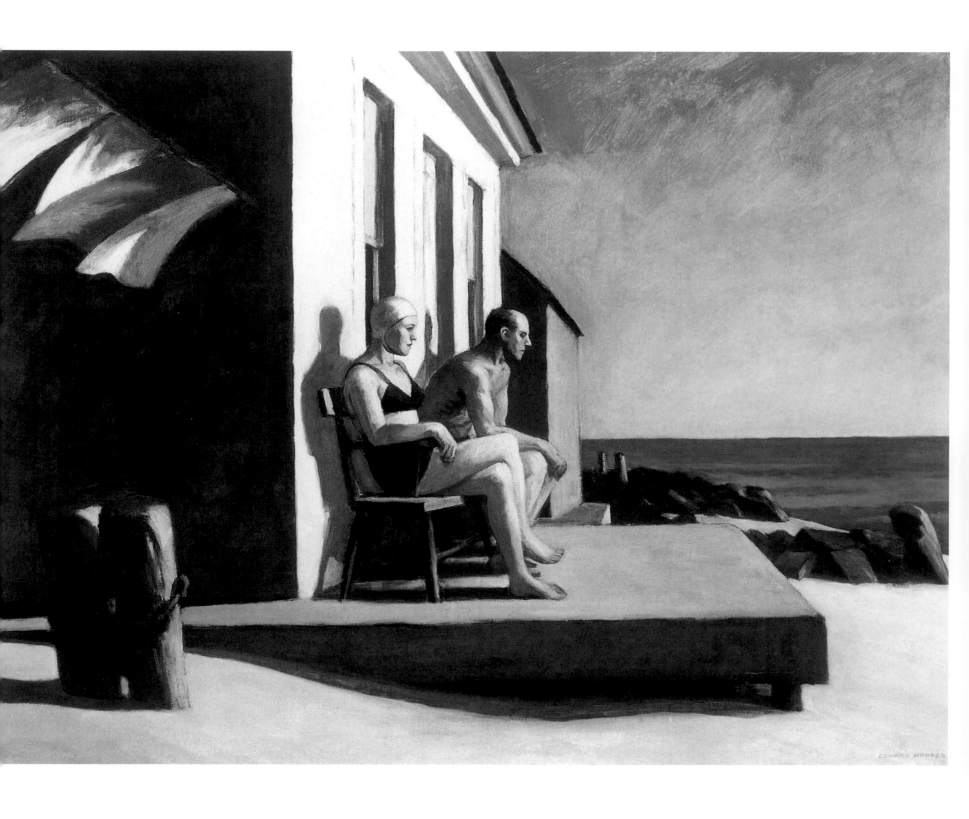

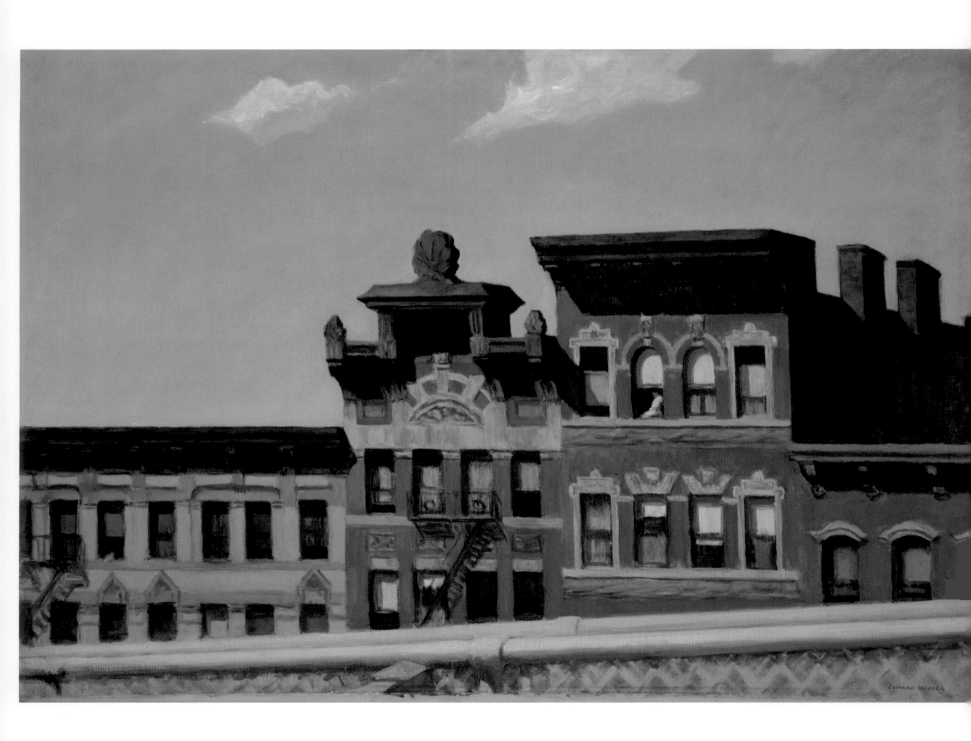

LIVES OF A GRAND OLD ICON

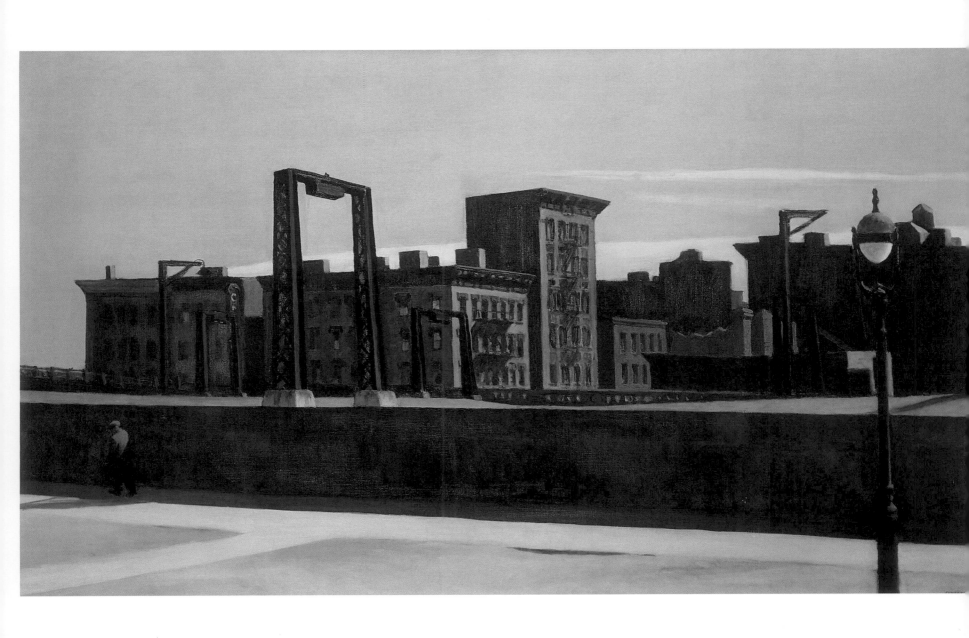

Rise and Decline

As the winter of 1930 gripped New York City – both its environs and its ravaged financial district – Edward Hopper basked in the glow of his pot-belly stove and the news that the Museum of Modern Art had acquired his *House by the Railroad* (p.103) as its first piece in the museum's permanent collection. The future rested on his easel in the form of another wide canvas, this one a row of Seventh Avenue shops – its original title – painted in low sunrise light and barren of any shoppers or residents of the upstairs apartments. Titled *Early Sunday Morning* (pp.174-175), a figure once resided in a window (like in his painting *From Williamsburg Bridge*), but he later painted it out. It is a thinly-painted oil with only a dab of flake white on the barber's pole globe for relief. The painting was purchased by the Whitney Museum of Art for $3,000 and became one of his signature works of art.

The Arts Magazine published a glowing review of the painting only to be rounded upon by Josephine who, after thanking them for their kind words, suggested the engraver should be put in jail together with the editor of the article who messed with Hopper's picture selection. Fuming, Hopper wrote to Forbes Watson, the editor,

> *"I have just learned of a damn fool letter that my wife sent you regarding The Arts portfolio on my stuff. Please disregard it, it being entirely female and unofficial and I blush to the seat of my pants when I think of it."* [47]

In June 1930, the Hoppers toured to Cape Cod for a change and ended up in the small isolated community of Truro, Massachusetts. They rented a little house – they called "Bird Cage Cottage" – on a large farm owned by the village postmaster, A. C. Burleigh Cobb. Surrounded by windblown hills and grassy dunes amid plots of scrub bushes with nary a tree in sight, the pair loved their sea air-scrubbed wilderness.

Only five hundred people called Truro home when the Hoppers visited. Edward plunged into a flurry of watercolours. Traipsing through "Burly" Cobb's farm buildings, he recorded the subtleties of the chicken coop, followed Burly to his job at the post office and later, when Burly fled home, there was Edward's easel and Burly's house being rendered. The *South Truro Church* drew Hopper to it with its stark lines, almost pagoda-like bell tower roof and its classic Greek front attached to the high-ceilinged meeting house. The battered graveyard alongside added to its image of isolation.

Corn Hill (p.118) rose in a series of lumps covered with golden and green grass capped by a cluster of plain houses with scarcely an eave or dormer among them. Looking out across the rolling *Hills, South Truro* (p.121) in the low sun made the houses appear as if they were sunk in the troughs between waves on a green and gold sea. The restless wind always blew, continually scouring the transient landscape. There Hopper laboured in the same location each day to catch the same nuances of light and, as the sun dipped, the same clouds of mosquitoes boiling up from stagnant ponds in the marshes. Jo often painted from the front seat of the Dodge and then prepared their meals by lantern light.

Since there were no restaurants nearby, Truro demanded more domestic duties from Jo, but she discovered she was competent in the kitchen. They had their own pump and a kettle to boil clothes for the laundry which Edward accepted as his chore. Their clothes required no ironing, they accomplished their morning ablutions in a bowl and the privy was out back. This primitive existence in a little house of their own rooted them to the place. Hopper's energy returned from its low ebb of the previous summer.

As the 1930s produced bank failures, business failures, foreclosures and bankruptcies, Edward Hopper's paintings of American places became icons of a rock-solid America on which a new future would be built. On another level, his interpretation of these places and the vast silences that seemed

> *"The term 'life' as used in art is something not to be held in contempt, for it applies all of its existence, and the province of art is to react to it and not to shun it. Painting will have to deal more fully and less obliquely with life and nature's phenomena before it can again be great."*
>
> — Edward Hopper

92. *From Williamsburg Bridge*, 1928.
 Oil on canvas, 73.7 x 109.2 cm.
 George A. Hearn Fund,
 The Metropolitan Museum of Art, New York.

93. *Manhattan Bridge Loop*, 1928.
 Oil on canvas, 86.4 x 152.4 cm.
 Addison Gallery of American Art,
 Phillips Academy, Andover, Massachusetts,
 gift of Mr. Stephan C. Clark.

94. *Rooftops*, 1926.
 Watercolour on paper, 32.7 x 50.5 cm.
 Whitney Museum of American Art, New York,
 Josephine N. Hopper Bequest.

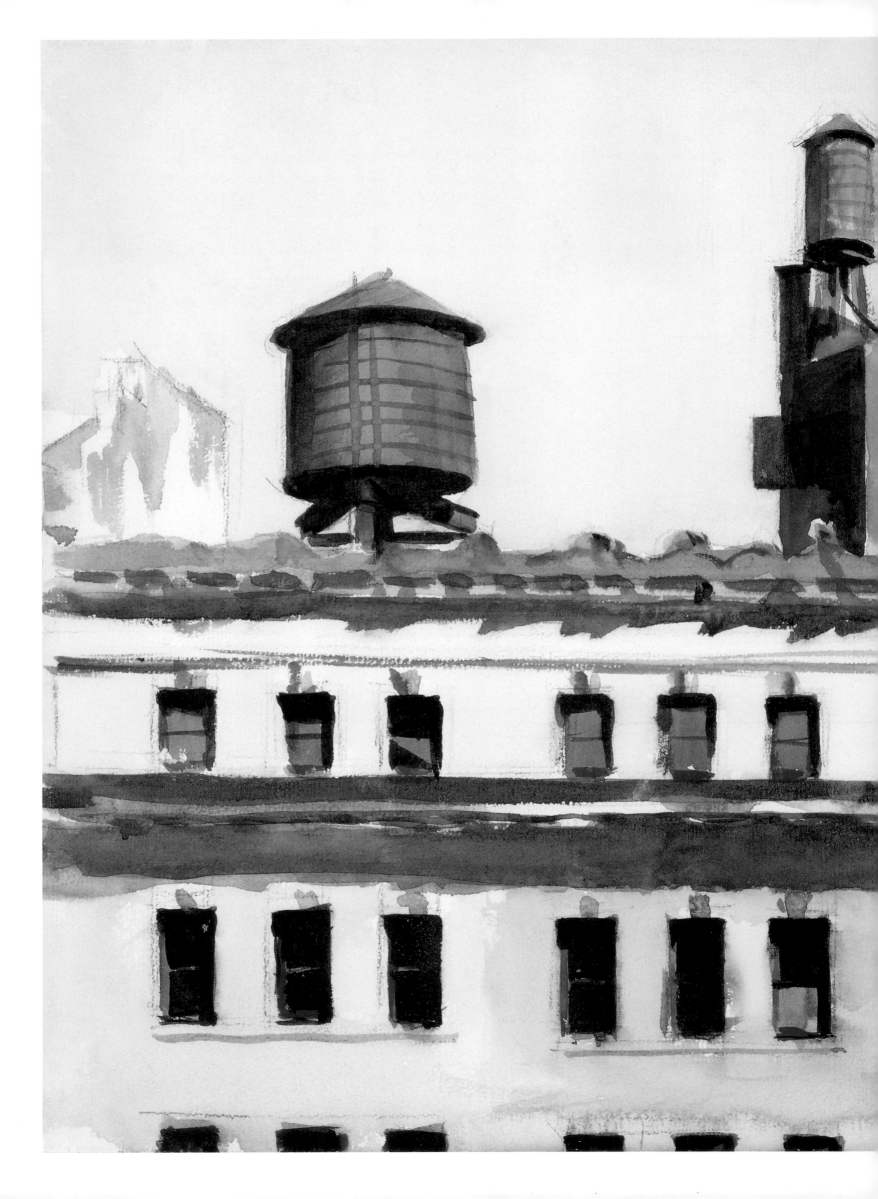

95. **Georgia O'Keeffe**, *Street, New York I*, 1926.

Oil on canvas, 122.2 x 75.9 cm.

The Georgia O'Keeffe Foundation, Santa Fe, New Mexico,

gift of the Burnett Foundation.

96. *The City*, 1927.

Oil on canvas, 71.1 x 91.4 cm.

University of Arizona, Museum of Art,

Tucson, Arizona.

to surround them and their inhabitants also gave art writers, critics and journalists considerable grist for their interpretative mills.

For example, Hopper delivered *Table for Ladies* (p.202) to the Rehn Gallery on 6 December 1930. Hopper had painted a waitress arranging a fruit basket in the window of a restaurant. As was their custom with some paintings, the Hoppers named the players. "Olga" the waitress is blonde and buxom and she bends forward above two raw chops in a bed of lettuce facing a row of yellow cantaloupes. Behind her "Anne Popebogales," (or the well-fed girl from *Automat,* p.197*)* plays the part of the hostess at the check-out counter, while the couple from *Two on the Aisle* – "Max Scherer and his wife Sadie" – occupy a table. The colours are rich and warm, and Hopper's stock company seems at home in this psychiatric playpen of implied and imagined meanings. The cantaloupes' relationship to "Olga's" ample breasts got the most ink among critics and writers. It sold for $4,500 to the Metropolitan Museum.

Du Bois, meanwhile, published a monograph on Hopper that reinforced the tangle of repressed feelings beneath the painter's thinly-applied paint.

"In America since the advent of Freud inspired demand for sensuality in life and art, Puritanism has been more generally derided than ever and a good many painters led away from it into byways where they must, because of temperamental exigencies, be lost. Hopper, in direct contradiction to these weaklings is so deaf to all faddish chatter that he can without strain, with no stunting exercise of will, remain himself."[48]

With du Bois's help, Hopper became understood as the silent repressed puritan going his own way in pursuit of forbidden fantasies deeply encoded into his images with paint applied in thin-washed strokes to even deny the viscosity of its own sensuous texture. Hopper loved it.

The 1930s also revealed several departures from past projects. His oil paintings became more people oriented, created in his mind and on the studio easel. A large work – 60 x 78 inches – finished in 1930 and titled *Barber Shop* again called a healthy young woman to centre stage, this time as a manicurist. According to Hopper's biographer Gail Levin, this painting owes its subject matter to a barber-shop painting by John Sloan in 1915. Sloane's work is a jovial genre illustration featuring a manicurist, her customer and the clubby men's atmosphere of the shop. Hopper's bored manicurist reads a magazine by bright yellow window light in a step-down shop below pavement level. Its composition is classic, divided into diagonal thirds by the shaft of light and a worn banister that is impossibly low considering the stair tread heights. Outside on the street, the angled barber's pole follows the diagonals in red, white and blue.

The theme of domestic alienation weaved its way through these years in Hopper's work as well as his situation with Josephine. Her career as a painter had been sublimated almost out of existence by his rising star. She was bitter and ignored as was the woman in a red dress in Hopper's oil *Room in New York* (pp.218-219).

The woman prepares to strike a piano key as the husband; home from the office in shirtsleeves reads his evening paper. She is dressed for going out. He is tired from work and the striking key will intrude on his peaceful solitude. Many paintings will revisit this theme as Jo's demands escalated.

When the painting was displayed at the Whitney Museum in 1932, the art critic of the *Herald Tribune*, Royal Cortissoz, could only harrumph and stamp his foot like a commuter who has missed the last train:

"Witness the *Room in New York* by Edward Hopper. The theme is pure banality and what the artist wreaks himself upon is simply the exact registration of fact.... That photographic spirit which Mr. Hopper embodies is all over the place, perceptible in the pictures of experienced painters like John Sloan, Kenneth Hayes Miller and Walt Kuhn and dominant among scores of the younger men."[49]

Cortissoz still viewed Hopper as an upstart compared to painters who were less "modern" and pledged to "beauty" such as the ubiquitous American Impressionist, Childe Hassam, whose career was beginning a precipitous downward slide. The conservative critic failed to understand that Hopper was now virtually critic-proof since his arrival at the top of the New York art scene. In March 1932, the prestigious National Academy of Design had elected Hopper to associate membership. For decades the Academy had been considered a pinnacle of recognition and achievement. Hopper declined the membership. The academicians had treated him badly when he needed support and now he cut them and made no further comment. His silence when presented with a fine opportunity to rag on the dusty opinions of the conservative art establishment made art news headlines and garnered considerable positive publicity. Having earned $8,728 in 1931 (or almost $115,000 in 2006 dollars), Hopper kept his own counsel and Jo trotted alongside pouring out her domestic and professional discontent to friends in long rambling letters. To Bee Blanchard she confided,

"For the female of the species, it's a fatal thing for an artist to marry; her consciousness is too much disturbed. She can no longer sufficiently live within herself to produce. But it's hard to accept this."[50]

And yet she stayed with him and did for him and was in the passenger seat of the Dodge when they headed north-east to Cape Cod and their Truro retreat each summer. And for all his grumpy silences, he didn't hesitate to dash up a hillside to rescue one of Jo's canvases that had been swept off its easel by the gusty winds. Edward seemed to thrive in the barren scrub while Jo needed people around her. He accepted his fiftieth birthday on 22 July 1932 with equanimity bolstered by success, while she anticipated her own natal day in eight months with the dread of someone who realises her creative life has been truncated and her social life repressed. Josephine had become more an acolyte in the service of Edward Hopper than a companion and partner to "Eddie" her husband.

Even before he left for the 1932 campaign in Truro he had complained about that "awful" Cape Cod and its barren landscape as another fit of depression descended on him. He painted once they were there, but then slipped away again, claiming he couldn't "…get hold" of anything. When Jo suggested a move to Vermont, he chose to remain steeped in boredom in Truro rather than put up with facing new surroundings.

As soon as he returned to New York, Hopper hurried up to the roof before the weather changed and painted *City Roofs*. Reminiscent of his watercolour, *Roofs of Washington Square* executed back in 1926, this work displays his masterly manipulation of shapes and colour to create an almost abstract composition using chimneys, ventilators, skylight covers and part of the multi-storey building across the street. Modernists of the period must have pointed trembling fingers at the work and triumphantly shouted "Aha! Hopper is becoming one of us!" They would have been wrong, as would the Surrealists, Dadaists, Expressionists, and even the *Der Blaue Reiter* group – all of whom at one time or another claimed him as part of their philosophical circle.

With money coming in almost as fast as he could paint, Hopper made a bold move. He moved into a larger studio in the same building that also boasted a separate bedroom in the back. This little room would also double as Jo's studio.

The year 1933 brought Jo an inheritance from her uncle Harry Woolsonwood which gave them enough wherewithal to purchase a permanent summer home. That same summer had been a waste of time for Hopper, producing no new paintings as he drove to Charlestown, New Hampshire, then north along the St Lawrence River and finally down through Gloucester to their rented cottage in Truro. Then it rained for days. Only three watercolours came from the entire adventure. Its wet and wretched outcome helped the Hoppers decide to build a permanent summer home on land they bought in Truro.

Alfred H. Barr Jr, the first director of the Museum of Modern Art, had assembled a one-man retrospective of Hopper's work for 1933. Hopper was becoming a fixture at that museum as he was

97. *Dawn in Pennsylvania*, 1942.
Oil on canvas, 61 x 111.7 cm.
Private collection.

98. *Early Sunday Morning*, 1930.
Oil on canvas, 89.4 x 153 cm.
Whitney Museum of American Art, New York,
purchased with funds from Gertrude Vanderbilt Whitney.

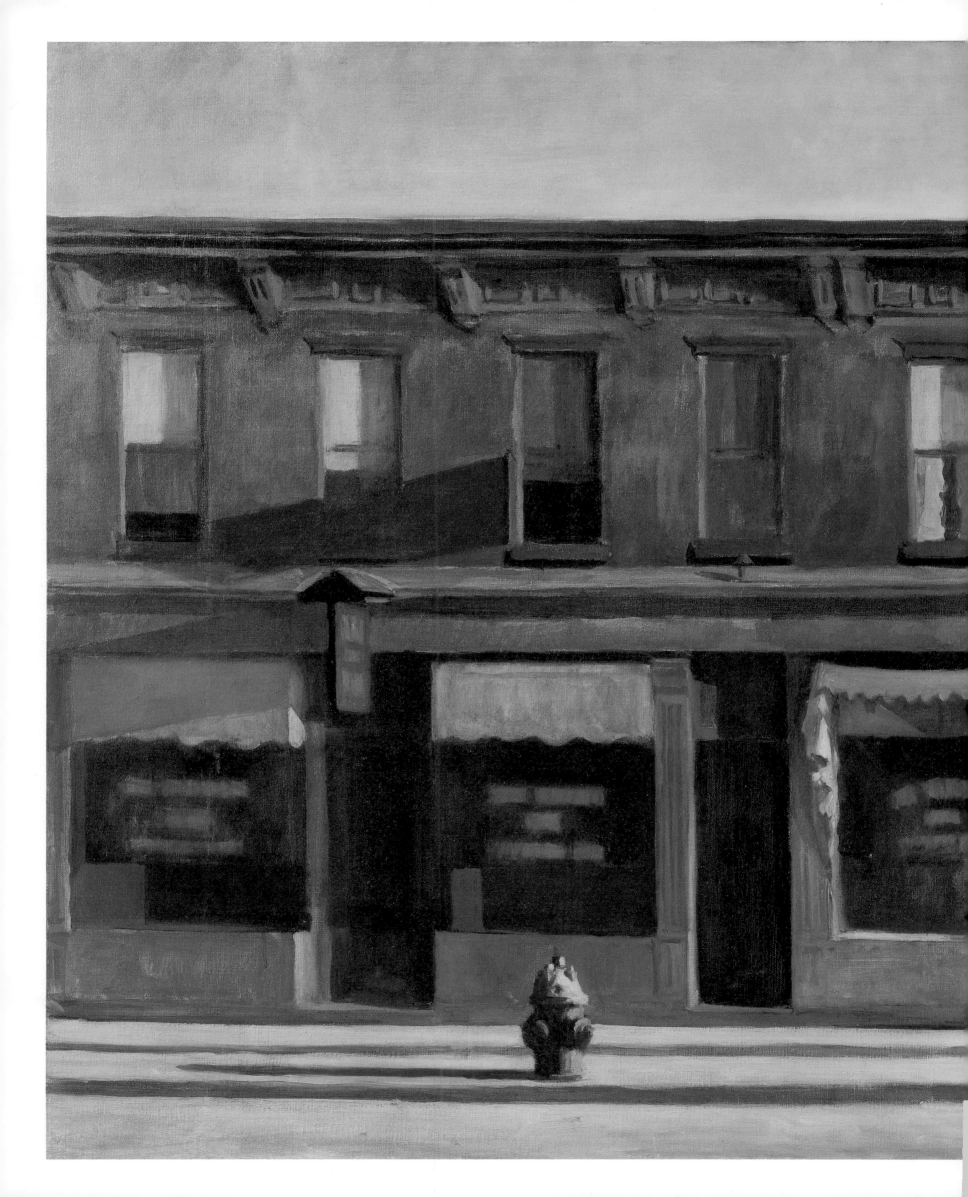

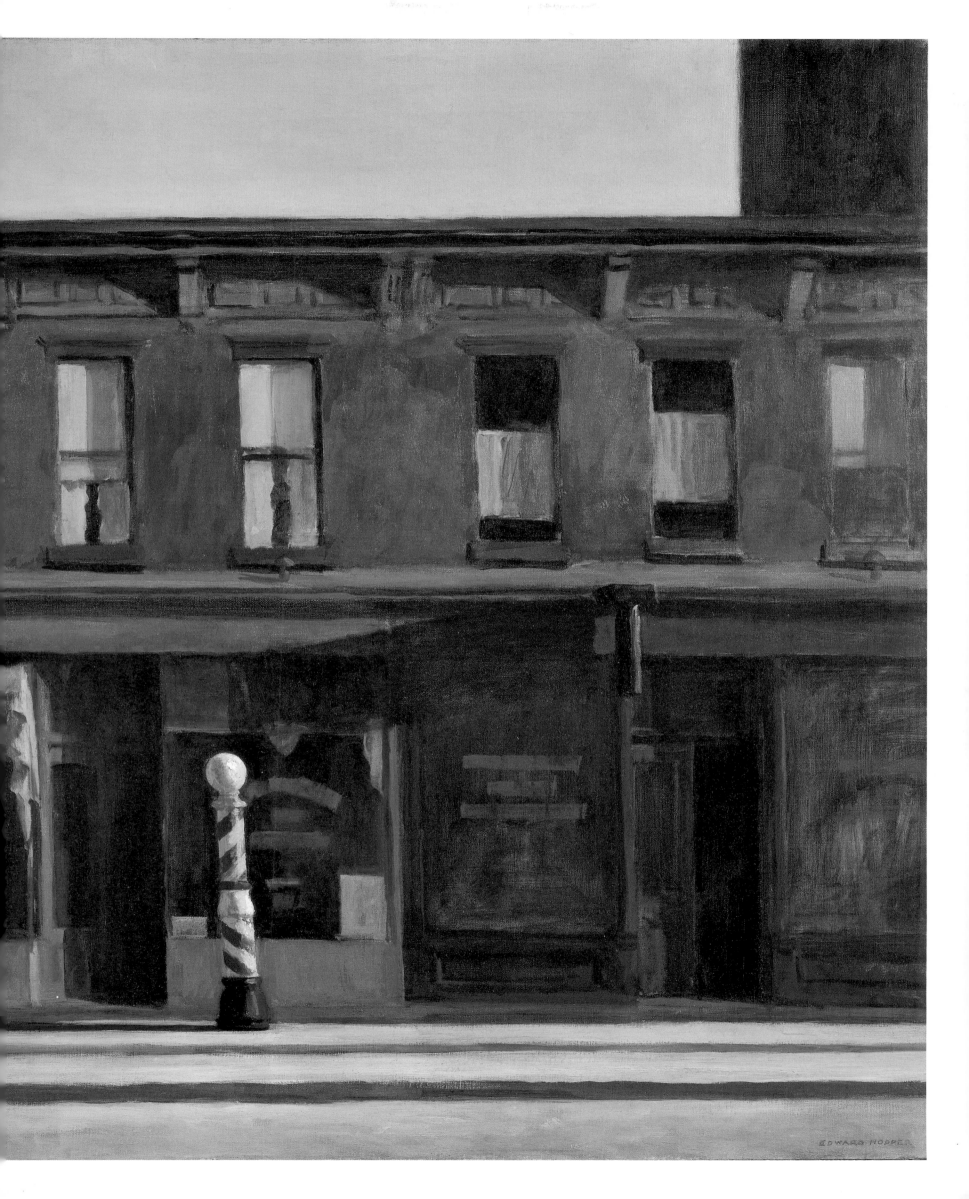

at the Whitney. Though he was grateful for the opportunity, Hopper's disdain for talking about himself and his work had to be managed as writers and critics sought to invade his privacy. Josephine tried to be helpful by stepping up to handle the details for his shows and free him to continue his work. His output for 1933 had been dismal due to the rain and driving about to find new material and now they were committed to the new house construction.

During the winter of 1934, when their summerhouse design was in gestation, Hopper pinned up a watercolour, *Prospect Street, Gloucester* (p.100), *1928* and made an oil of it. He also made ferry trips across to Weehawken, New Jersey to make sketches for what became *East Wind over Weehawken*. This painting shows a curiously mismatched collection of four houses whose entrances roll down to the pavement and street kerb. Their very dissimilarities create a warm charm beneath a chilly sky. Dominant in the foreground, the forward stamp of progress is represented by a white "For Sale" sign. These four old ladies seem doomed to the wrecking ball. Though similar in subject matter, the Prospect Street houses appear more secure, more ready to adapt to change, sitting back behind their front lawn moats.

Hopper personally designed the Truro house and built a model while Jo struggled to engage a contractor for a reasonable price. Their departure for Truro to be there during construction was accompanied by the usual screaming, biting and slapping war, but once on the way, Edward's spirits seemed to rise in anticipation as his wounds healed.

The resulting house had the convenience of running water instead of an outdoor pump and a spacious interior made up of a large room looking out at the oceanfront through a thirty-six-pane window. There was a bedroom, kitchen, bathroom and cellar. The studio sported a red brick fireplace and chimney that stood stark against the white walls, relieved only by the light grey scheme in the bedroom. North light flooded Hopper's studio, which was a practical godsend as well since the house had no electricity due to a lack of easement to reach the distant utility poles. Oil and kerosene lamps would have to do once the sun had set. As with their new larger apartment back in New York, Jo was required to use the back bedroom for her painting. She grumbled to Bee Blanchard:

> *"Not my idea of a house. This is E. Hopper's house. His and the dear dead uncle whose money is paying for it."* [51]

She also wrote of Edward's "…determined opposition to every breath I draw… I live in constant expectation of his prohibition… He complains of my rages as he goes about invoking them. And he objects to being called a sadist."[52]

When seen together by visitors to their new home, the claws were retracted, the barbs were sheathed and the Hoppers were reasonably gracious hosts – though Edward usually made himself scarce if they were Jo's lady artist friends or chatty neighbour women. By November they finally had to return to New York with a few watercolours. What with the search for new subjects, the building of their new house and hosting an endless stream of well-wishers, Hopper's income had plummeted to $3,550.

The year 1935 saw an even further decline in Hopper fortunes. Elizabeth Hopper, Edward's mother, died at the age of eight-one on 20 March. He spent his whole life trying to please her and she hadn't yet seen their new house. Her death at the time when he had achieved his overdue recognition shook him deeply. His moody painting *House at Dusk* was finished during her health setbacks. It shows a grey stone-corniced apartment building on the edge of a park at dusk after the sun has set and lights have come on in the rooms A single figure's head and shoulders are visible in one of the top-floor windows. Separating the apartment roof from the yellow-grey sky is a thick stand of trees and foliage. The feeling is melancholy. An inevitable conclusion to everything that had gone before. Two other significant paintings in 1935 were *Clam Digger* and *The Long Leg*. *Clam Digger* is interesting in that

99. **John Sloan**, *Haymarket, Sixth Avenue*, 1907.

Oil on canvas, 66.3 x 88.5 cm.

The Brooklyn Museum, New York,

gift of Mrs. Harry Payne Whitney.

100. *Drug Store*, 1927.

Oil on canvas, 73.6 x 101.9 cm.

The Museum of Fine Arts, Boston,

Massachusetts, John T. Spaulding Bequest.

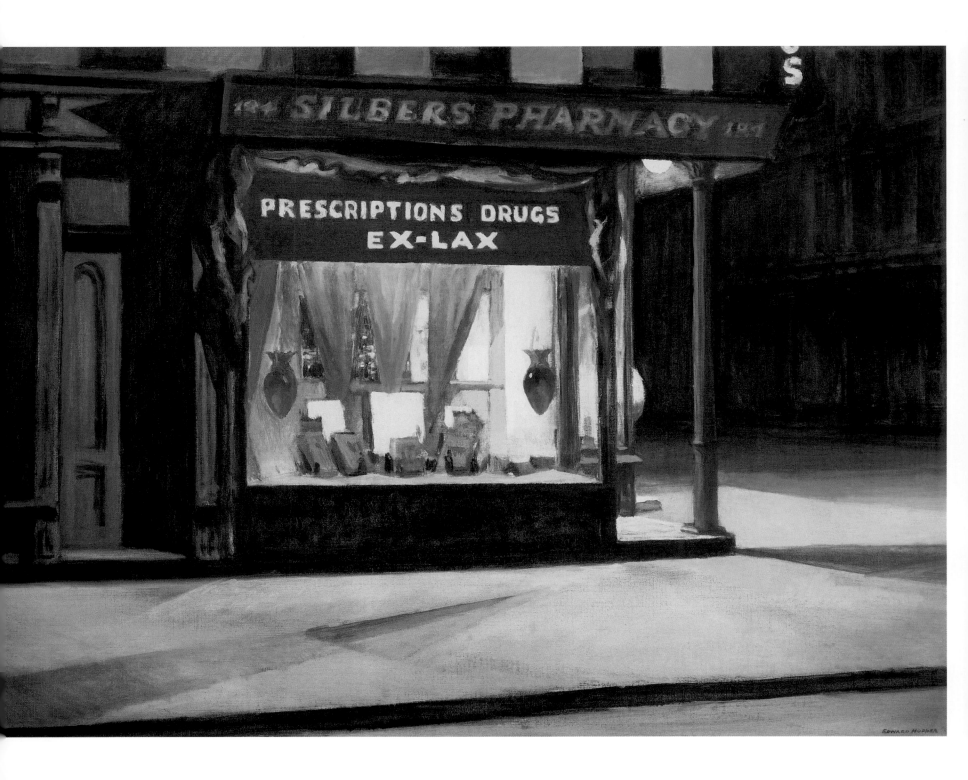

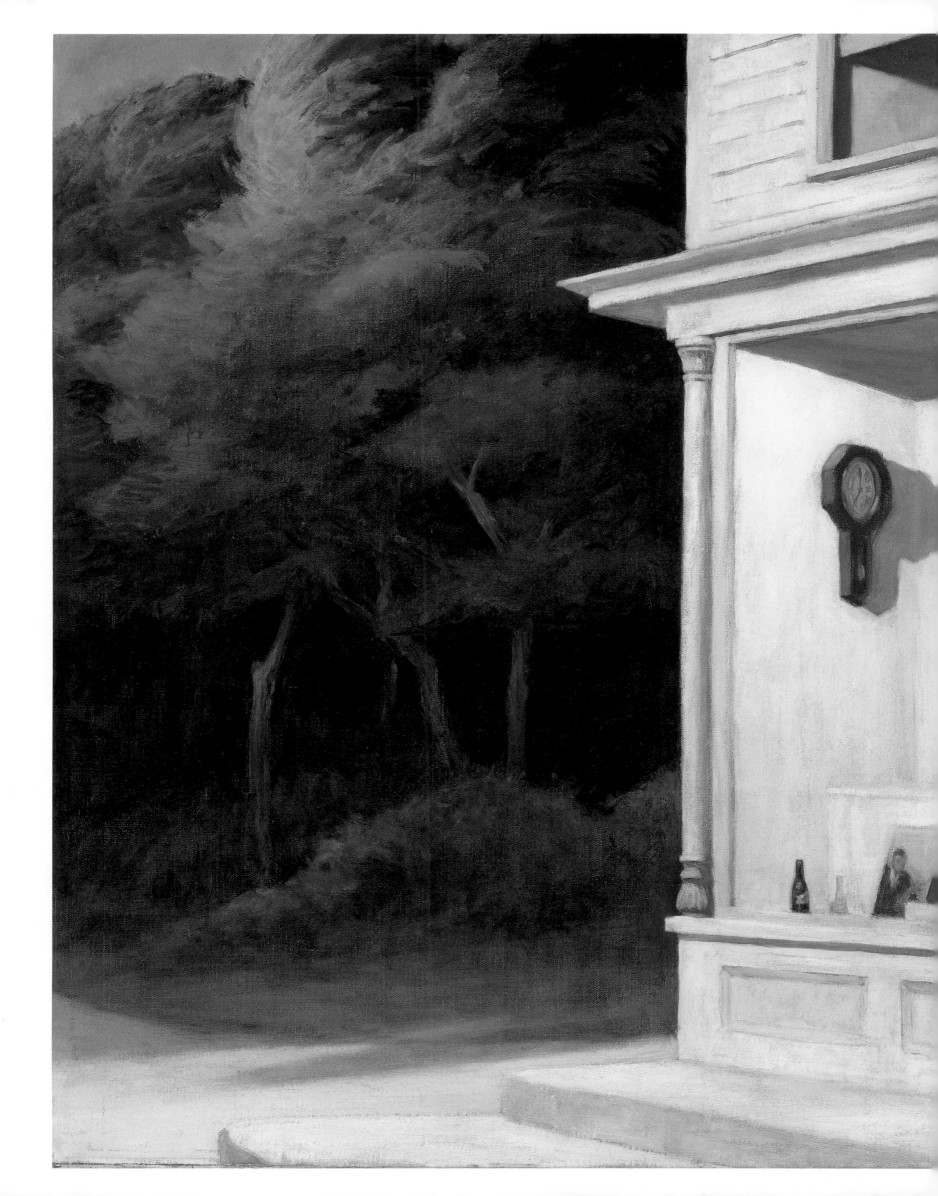

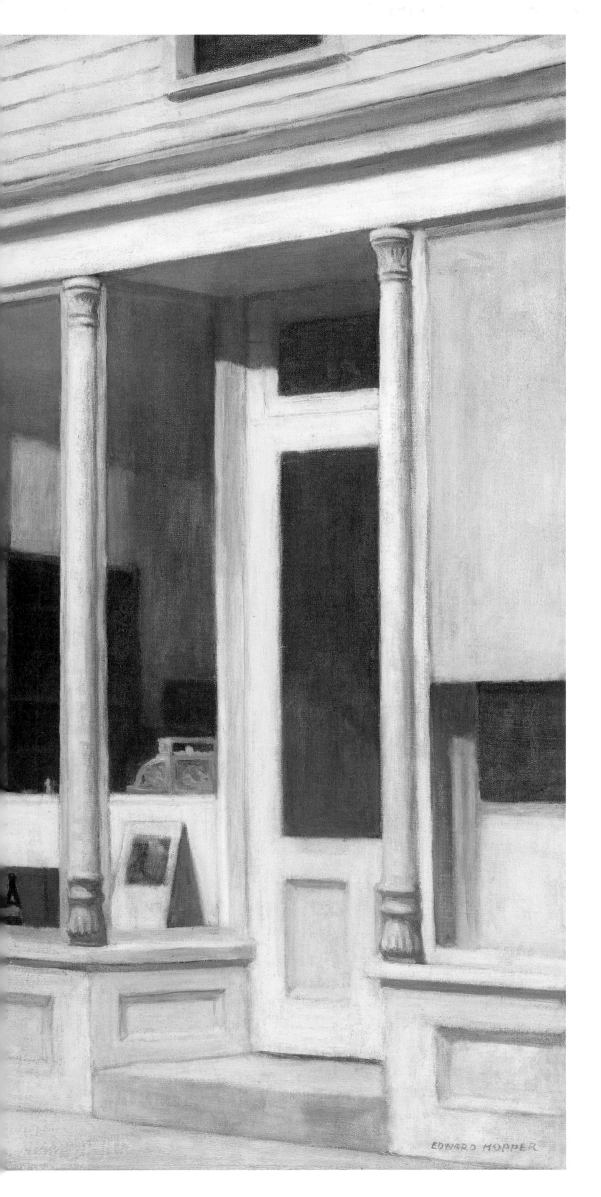

101. *Seven A.M.*, 1948.

Oil on canvas, 76.7 x 101.9 cm.

Whitney Museum of American Art, New York.

Hopper couldn't make it work and abandoned the canvas, and *The Long Leg* (p.141) is one of his sailing pictures. A small gaff-rigged sailing boat drawing full tacks into an off-shore wind. A lighthouse and outbuildings look on from the shore. The view was the same from the Hoppers' huge window on the north side of their house. Despite these canvases, a few watercolours and a prize, Edward's sales totalled $2,250 while Jo sold nothing.

For all the drop in monetary reward, Hopper's work appeared in twenty-three exhibitions and he became keenly aware of his new status in the contemporary art world. To that end, he felt compelled to dash off a letter to Nathaniel J. Pousette-Dart, editor of *Art of Today* magazine to counter an article that claimed Hopper's "direction and bent" had been strongly influenced by his friend, Charles Burchfield. Hopper seethed:

> *"It is not quite clear in my mind as to what you mean exactly by direction and bent, but you probably mean choice of subject matter. It is known by the painters who have known me well for a long time that from that point of view my bent was established long ago. Twenty-five years ago, or perhaps more, before Burchfield had been heard of and perhaps before he had painted at all, I had used the kind of subjects that to some seemed to predominate in the American scene: homes of the Garfield era, railroad stations, telegraph poles, factories, small town streets, etc.*
>
> *If by direction and bent you mean the kind of vision or method of working, it is obvious I am unlike him in almost every respect.*
>
> *In every artist's development the germ of the later work is always found in the earlier. The nucleus around which the artist's intellect builds his work is himself; the central ego, personality or whatever it may be called and this changes little from birth to death. What he was once, he always is, with slight modifications. Changing fashions in methods or subject matter alter him little or not at all.*
>
> *You can see by my letter that I am peeved and I know that Burchfield has felt the same about loose and unjust criticisms of a similar kind that have accused his work of a too great likeness to mine. Think it over."*[53]

This public pummelling of Pousette-Dart, a former fellow student of Robert Henri in 1907 who rose to become a major art director in the advertising world must have been a delicious moment considering Hopper's odium for the artistic poseurs of the commercial art world. Pousette-Dart harrumphed and sputtered a lame reply, but the day clearly went to Hopper.

Fame, Honour and Tears

As the 1930s wound down, the Great Depression's grip on the American and world economy eased. Franklin Roosevelt had seized the reins as President and used bold – "socialist" according to his critics – programmes such as the Works Progress Administration, The National Recovery Act and the Civilian Conservation Corps to create jobs and opportunities for all levels of the unemployed. Also, a war in Europe was on the boil and America's industrial capacity was being called upon by her European Allies, France and Great Britain. Hopper, a hide-bound Republican, despised Roosevelt and was angry he couldn't register in time to vote for Wendell Wilkie in the 1936 election.

That year was also one of emancipation for Josephine. While in New York, she managed to sneak off and get driving lessons that allowed her to obtain her licence. This, she thought, would put her one more step closer to independence when they travelled in search of subject matter.

102. *August in the City*, 1945.

Oil on canvas, 58.4 x 76.2 cm.

Norton Museum of Art, West Palm Beach, Florida,

bequest of R.H. Norton.

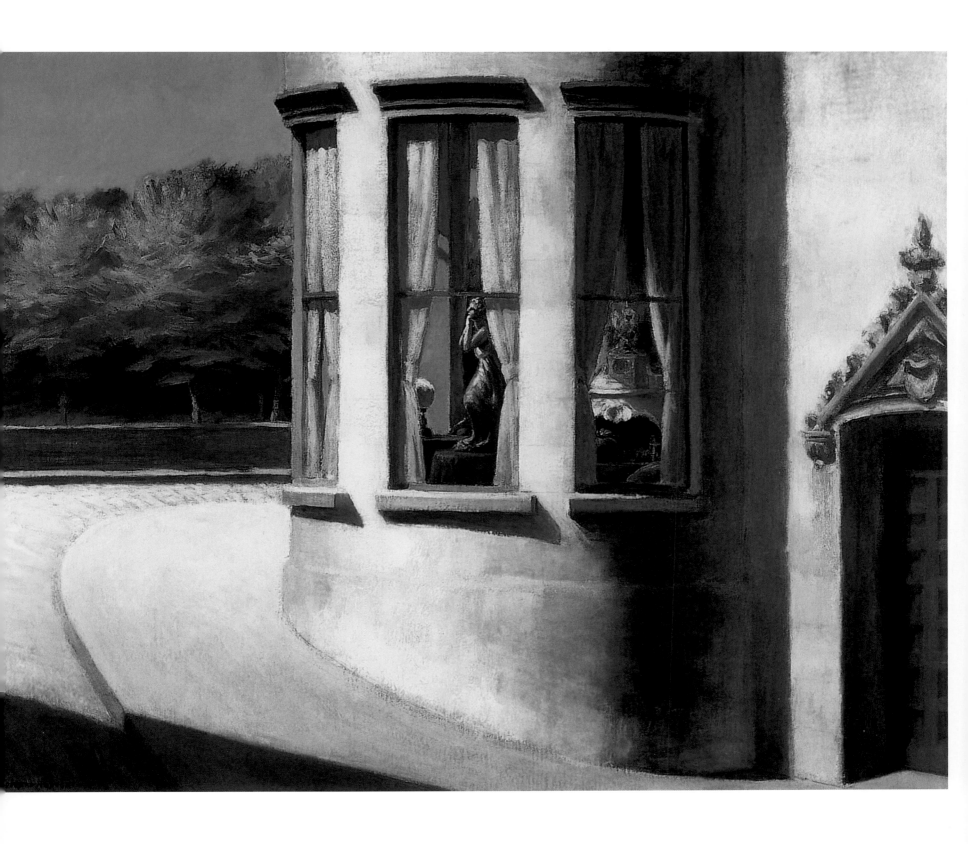

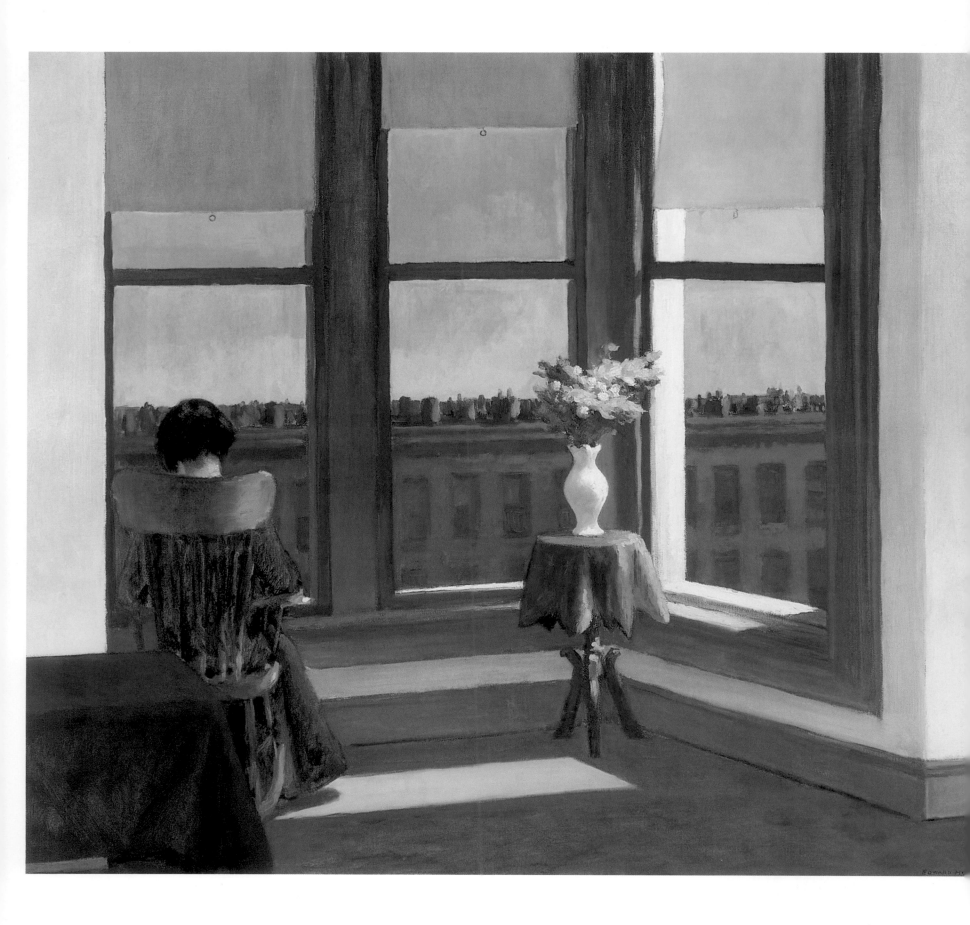

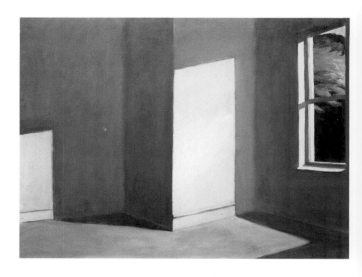

For Hopper, 1936 brought on another wave of despair over having nothing left to paint during their summer retreat to Truro. They tried Vermont again with no results. At the same time, his sister Marion finally arrived in her brother's house and was sent up to the attic to sleep on a cot. During dinner one night, Marion unloaded virtually twenty years of pent-up wrath all over Jo with Hopper in the middle trying to eat his chicken fricassee. If all that wasn't enough hell for 1936, Jo was turned loose with the automobile one afternoon to dine with Edward at a local restaurant. Though he compromised to sit rigidly by her side when she drove, he insisted on doing the parking. On this occasion, however, she rebelled and in a rage Hopper,

"...hauled me out by the legs while I clutched the wheel – but he clawed my bare arms and I all but sprawled in the road. Then he blames me that the audience inside (the restaurant) peered out through the windows."[54]

Two weeks after the battle of the steering wheel, Hopper's birthday present from Jo arrived. She had bought him a ten-volume library on the Civil War illustrated by photographer Matthew Brady. Its arrival caused her to groan because now he had another excuse not to paint.

The painting drought continued with only three oils and a handful of watercolours produced for the year. *Jo Painting* (p.9) was the only portrait he ever painted of his wife. Her hair, having just been washed, bushes out behind her as she works on an unseen canvas. She hoped he'd show it to give her back some of her professional identity. Another work was *Cape Cod Afternoon* (p.109), a house and dilapidated outbuildings painted from their shady side against an ever-changing sky that caused him much trouble. It also won W. A. Clark Prize and the Corcoran Gold Medal at the Corcoran's 15th Biennial in 1937.

An odd signature Hopper emerged from the slow year – an architectural study of New York shops, a subway entrance and the façade of the *Circle Theatre*. Only the C and E of CIRCLE can be read on the theatre roof, because the subway entrance blocks everything else. A lone figure reads the coming attractions billboard. It is a picture of pale greens and pastels surrounding the hot orange C and E, an assembly of planes that is both real and abstract – all occurring behind a stop-light in the foreground showing red.

Frank Rehn noted that the Hopper pipeline was running dry as the 1940s approached and the gallery inventory was very low.

In the catalogue to his 1933 Museum of Modern Art Retrospective Exhibition, Hopper had written:

> *"I have tried to present my sensations in what is the most congenial and impressive form possible to me. The technical obstacles of painting perhaps dictate this form. It derives also from the limitations of personality. Of such may be the simplifications that I have attempted.*
>
> *I find, in working, always the disturbing intrusion of elements not a part of my most interested vision, and the inevitable obliteration and replacement of this vision by the work itself as it proceeds. The struggle to prevent this decay is, I think, the common lot of all painters to whom the invention of arbitrary forms has a lesser interest.*
>
> *I believe that the great painters, with their intellect as master, have attempted to force this unwilling medium of paint and canvas into a record of their emotions. I find any digression from this large aim leads me to boredom."*[55]

At the end of summer 1937, Hopper abandoned Truro for a drive through Vermont in search of subject matter. He managed some watercolours, but Jo wrote of his frustration recalling his earlier words:

103. *Room in Brooklyn*, 1932.

Oil on canvas, 73.9 x 86.3 cm.

Museum of Fine Arts, Boston, Massachusetts,

The Hayden Collection-Charles Henry Hayden Fund.

104. *Sun in an Empty Room*, 1963.

Oil on canvas, 73 x 100 cm.

Private collection.

"…the impossibility of rendering the vision of a scene – that each stroke on the paper destroys it more and more, commits him to something else – not what he wanted."[56]

They returned to New York without an oil painting to show for all their travels. As 1938 began, Edward found himself invited to serve on juries for shows in Philadelphia at the Pennsylvania Academy of Fine Arts and at the Virginia Museum of Fine Arts in Richmond. Josephine saw an opportunity and elbowed her way onto Edward's coat-tails to have her watercolour, *Cape Cod Hills* exhibited in the 133rd Annual Exhibition of Oils in Philadelphia. Complementing her painting, Edward hung his oil, *Jo Painting* in the same show. She saw that as re-establishing her identity as an artist instead of its value as an attention-grabber.

Jo quickly dispatched her watercolour *Dauphinée House* to the Richmond, Virginia show where it was just as quickly rejected. Jurist Hopper never acknowledged that it was his wife's painting that had been bounced. Jo was desolate that her name had not even come up in the judging. Her rage was compounded by a reoccurrence of colitis, an inflammation of the colon causing abdominal pain, diarrhoea and rectal bleeding she had succumbed to a year earlier. Then, Edward had been working on his oil, *The Sheridan Theatre* (p.233), and had nursed her through it. This time he left her to recover while he travelled to Richmond for their exhibition and then out to Indianapolis to help judge another show at the John Heron Art Institute. Left to fend for herself for the longest time since they had been married, Jo lapsed into a depression, struggling to keep warm feeding coal to their antique stove. When he finally returned, he took to their bed with a fever.

A year had passed since Hopper's last oil painting, *Five A.M.* (p.149), a harbour entrance with an island lighthouse created from his imagination after he had visited a show, *Fantastic Art, Dada and Surrealism*. He drew on his memory again and recalled his recent jury travels. Jo posed as a young lady riding alone in a passenger train, reading as an evening sunset was framed by her window. Hopper wrapped up *Compartment C, Car 293* in twelve days and shipped it off to Rehn's gallery.

As the world faced another European war in 1939, Edward Hopper unconsciously launched what would become his *magnum opus* – a series of paintings, linked not by their themes, which spread across all his interests, but by their intensity and final achievement of that personal "vision" he had so long pursued. Age and infirmity began exacting their due, cutting his output to as few as two oils per year. Josephine clung to him, railing to anyone who would listen about the unfairness of the art world, about his hogging the spotlight, about her ruined career. She annoyed him, cursed him, inspired and nursed him as Hopper's art lifted him above what he had become as a person. The creative run lasting two decades began with *New York Movie*.

For movies, the year 1939 was magic: *Gone with the Wind, Wuthering Heights, Gunga Din, Dark Victory, Stagecoach, Of Mice and Men, Goodbye Mr. Chips, Ninotchka, Intermezzo, Mr. Smith Goes to Washington* and *The Wizard of Oz* all became American film classics. Edward Hopper began his painting *New York Movie* in December 1938 with the first of some fifty sketches. Gail Levin suggests he used Degas' *Interior* (or *Rape*) (p.231) which had been on view at the Metropolitan Museum as a compositional model, with its receding diagonal perspective thrust and standing figure at the far right.

Hopper chose many New York movie houses including the Strand, Globe and Republic to copy architectural bits and effects to assemble the final composition. For the usherette leaning against the alcove wall, he used Jo shivering in the unheated hallway, giving her long golden hair and a younger face. He wrestled with the interior lighting coming from many different sources both warm and cool, edge-lighting brass railings and vaguely distinguished patrons seated in the muted gloom. A surreal staircase leads up and away from Jo's alcove, but she is lost in thought or boredom having heard and seen the film over and over until it no longer has any meaning.

105. *Summer in the City,* 1949.

Oil on canvas, 50.8 x 76.2 cm.

Berry-Hill Galleries, Inc., New York.

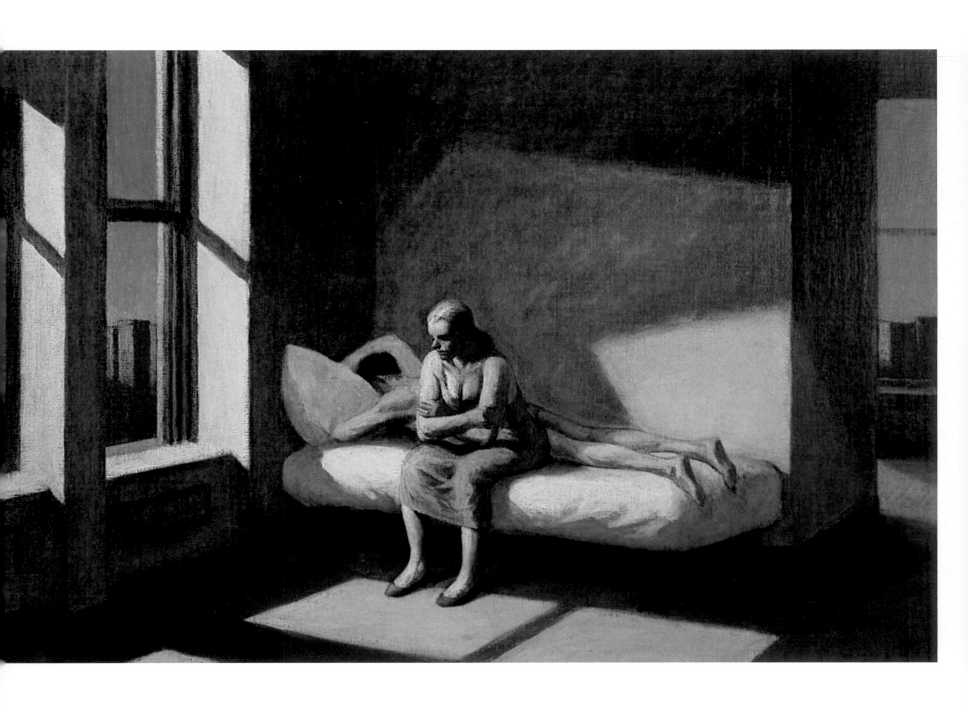

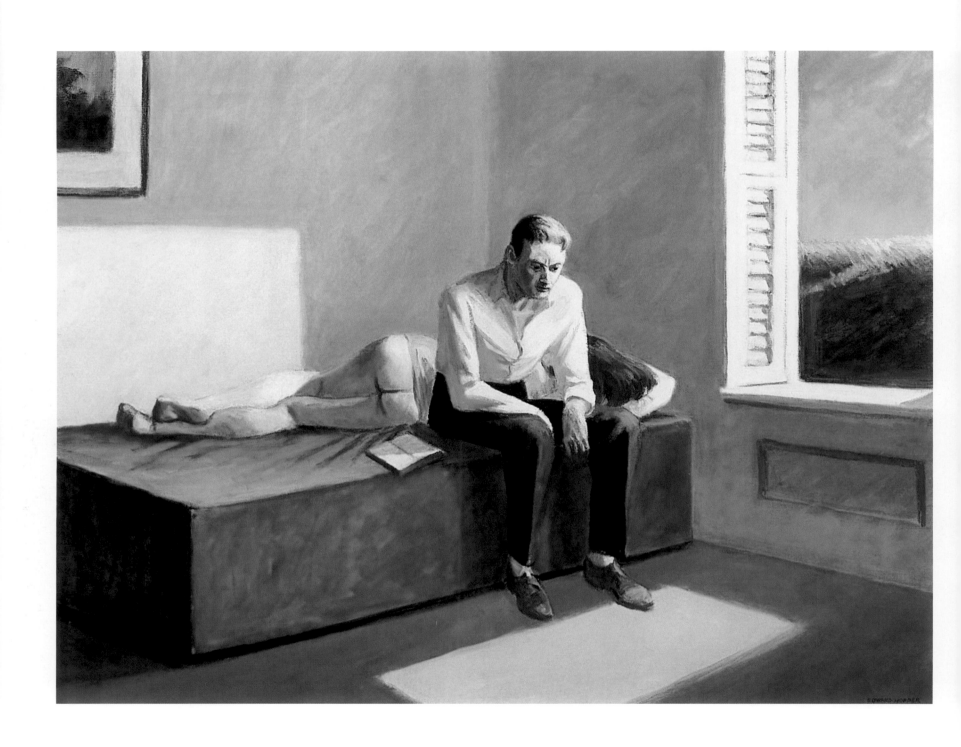

106. *Excursion into Philosophy*, 1959.

Oil on canvas, 76.2 x 101.6 cm.

Private collection.

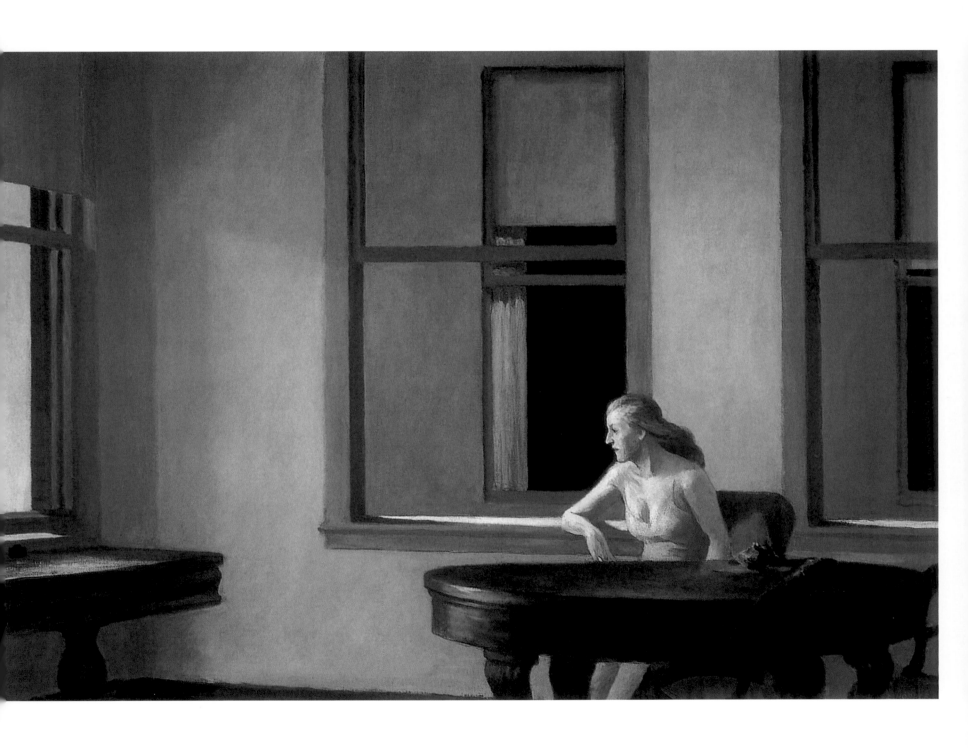

107. *City Sunlight*, 1954.

Oil on canvas, 71.6 x 101.9 cm.

Hirshhorn Museum and Sculpture Garden, Washington, D.C.,

gift of the Joseph H. Hirshhorn Foundation.

Near the end of the work, Hopper once again fell into his morbid reverie that every brushstroke was carrying him further from his original concept. Jo kept herself shut away in the bedroom so as not to be a distraction. Finally, Frank Rehn saw the painting on 2 February 1939, six weeks after Hopper began sketching. It was the first of five exceptional works that year.

Jo's birthday on 18 March was marked with a sweetly-presented gift from Edward, a small French dictionary decorated with hand-cut coloured paper roses and a verse in French that roughly translated as "Day of Birth, March 1939, The toes of Josie are pink and she will have French wherever she goes." Besides the sentiment, the gift included $15 for her to buy a new dress.

Never a great action painter, Hopper's next choice of subject startled everyone. *Bridle Path* depicts three riders galloping their horses on a Central Park bridle path, just about to enter one of the park's many tunnels amid the rocky landscaping. High-rise apartment buildings look down on the woodsy scene. He had to do a lot of homework for this painting, especially for the horses and riding tack. He made a number of visits to the location to get the colours and textures right, requiring eighteen preparatory sketches. Still, the horses seem to be straight out of nineteenth-century Currier & Ives' chromolithographs, but the exactness of their environment and the stygian darkness of that yawning tunnel lift the scene from a genre painting to a truly Hopperesque visualisation. Feeling pressured to give Rehn something more to work with, he rushed the result to the gallery on 27 April.

That burst of energy ended their spring in New York and soon they left for Cape Cod. Feeling he had drained Truro and its immediate environs of interesting subject matter, Hopper began driving with Jo across the countryside. He found a doorway here, a bit of a wood there, here a cornice, there an eave, and began constructing a composition featuring the corner of a house with a bay window, a man seated on a step and a woman with her arms folded, both with their thoughts turned inwards.

He wanted a collie dog in the foreground. Hopper struggled with library book pictures of the dog. Then during a drive, at the side of the road a parked car's door opened and out jumped a collie. Hopper stopped and while Jo introduced herself to the dog and his owners, Edward made his crayon sketches. Back at the Truro studio, after laying in a cloud-like field of golden blowing grass around the collie dog, who looks away from man, woman and house, Hopper had organised his disparate elements into *Cape Cod Evening* (pp.134-135).

Almost without a break, he began sketching for his next work. At once, Jo saw he had returned to sailboats and the sea and she was very happy.

"Ed is doing a fine large canvas in studio – sailboat, boys nude to the waist, bodies all tanned, lots of sea and sky. It ought to be a beauty. Frank Rehn will be delighted. Everyone has wanted Ed to do sailboats,"[57] she wrote to Marion Hopper.

The sailboat with its young crew rounds a bell buoy through a *Ground Swell* (p.144) caused by a sandbar's shallow water. A golden light permeates the scene against a high overcast sky. All eyes are on the buoy as it rolls and clangs abeam of the boat. Hopper finished the painting on 15 September and soon he and Jo were on the road back to New York a month earlier than usual with two oils and no watercolours produced.

Back in the Washington Square studio, the usual rounds began with friends dropping by for one of Jo's informal teas where she could show off her paintings. If Edward chose to show her friends anything after they had viewed her work, as soon as they departed, Jo's hair-trigger temper exploded. Hopper usually fled.

On this occasion, the next day they took a bus to Nyack to visit Marion. While there, they looked at a large white house belonging to playwright Charles MacArthur and his wife, the actress Helen Hayes. The two celebrities had been after Hopper to paint a picture of their house and Frank Rehn had been their ally in the persuasion. Finally, in November, sitting down with the Hoppers the MacArthurs tried to shift Edward's resolve. Helen Hayes wrote:

108. *Hotel Window*, 1956.

Oil on canvas, 101.6 x 139.7 cm.

Thyssen-Bornemisza Collection, Madrid.

109. *Western Motel*, 1957.

Oil on canvas, 76.8 x 128.3 cm.

Yale University Art Gallery, New Haven, Connecticut,

bequest of Stephen Carlton Clark, B.A.

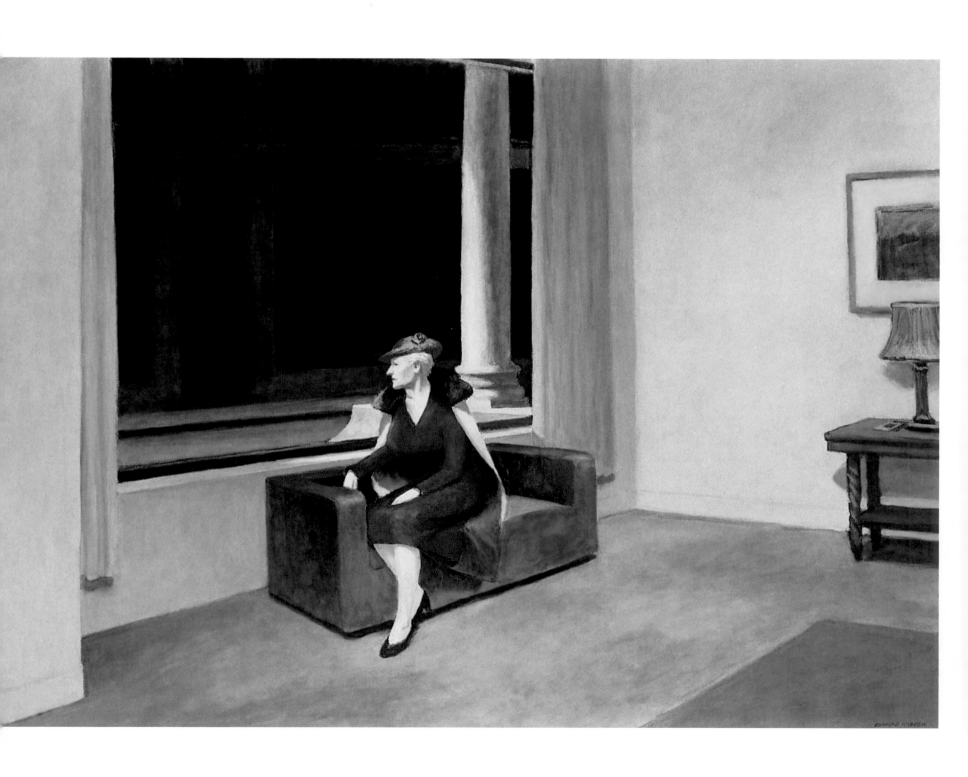

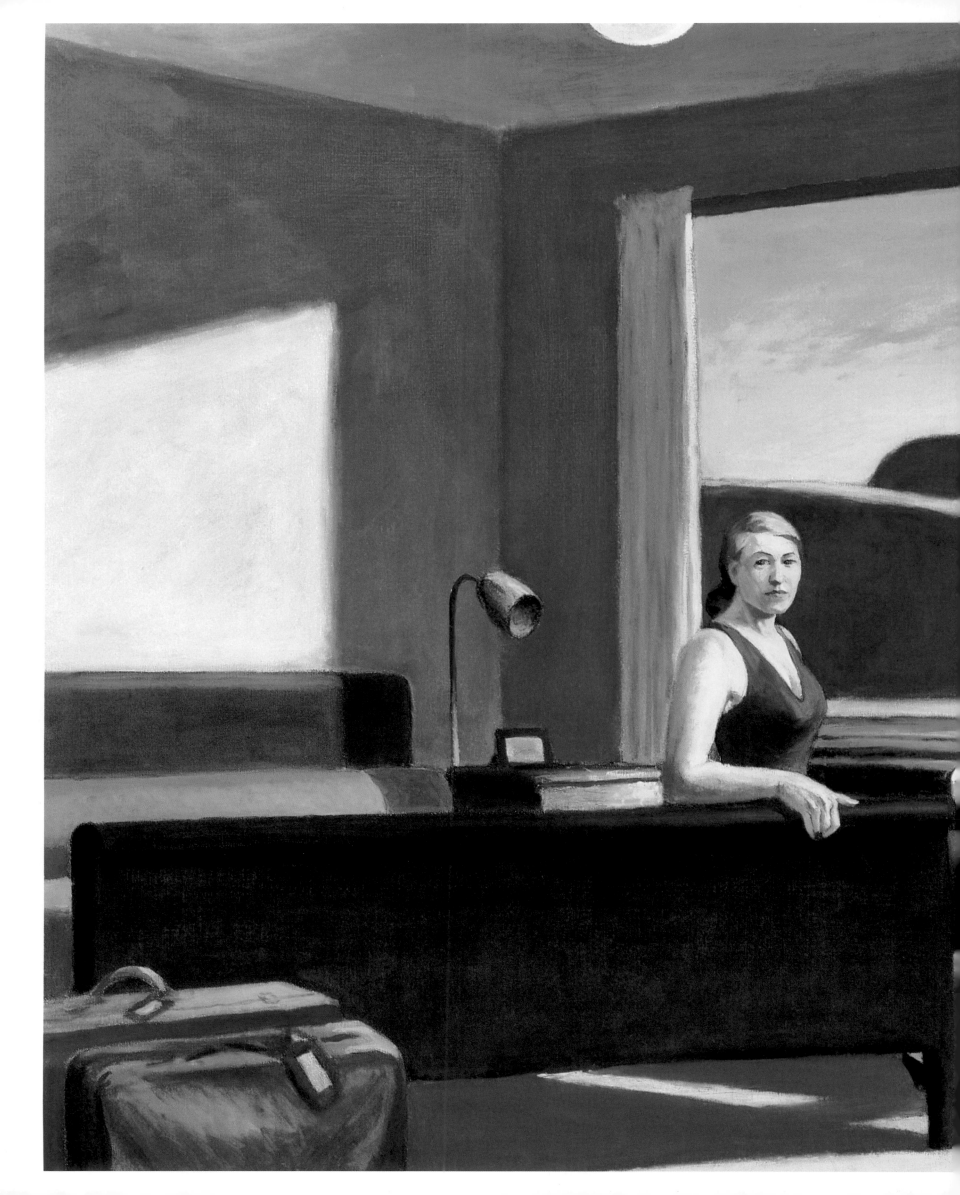

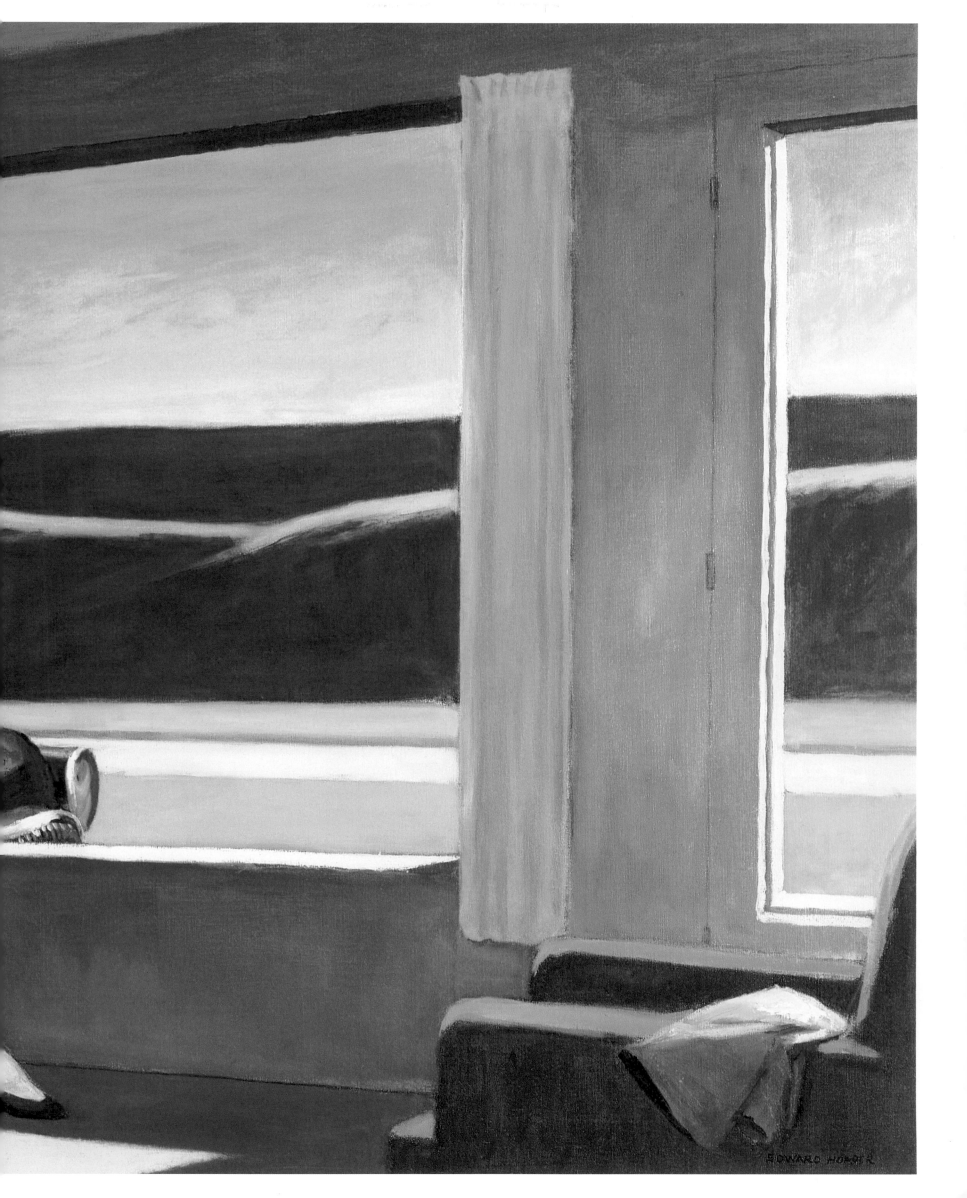

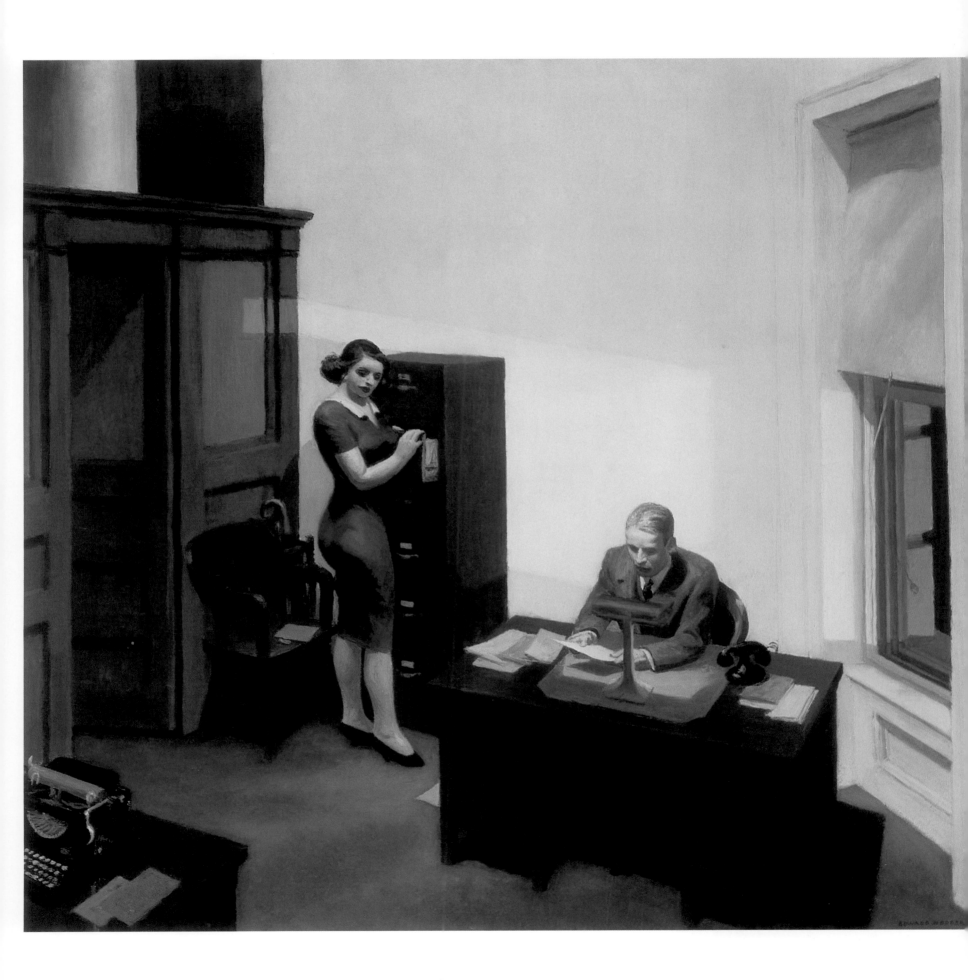

"I had never met such a misanthropic, grumpy, grouchy individual in my life...I just shrivelled under the heat of his disapproval. I backed into a corner and there I stayed in the dark, lost...Really I was utterly unnerved by this man..." She remembered him whining, "I can't do this house. I don't want to paint this house. It does nothing for me...There's no light and there's no air that I can find for that house." [58]

After cajoling by Jo and brow-beating by Frank, Hopper finally showed up one day, planted himself in front of the house and began to sketch. The weather was changing and he was frequently chilled as he groused and searched for some shred of inspiration. From his best sketch, he created a grid and transferred that grid to the larger canvas – a commercial art procedure. Eventually, he laboured into December and finished the painting. When Helen Hayes wanted her daughter and poodle dog in the painting too, Hopper tightly corked the rising steam and simply said no.

The MacArthurs loved the painting and paid Rehn's price, $2,500, which accounted for a large percentage of Hopper's sales total for 1939. The year had produced five oils: *American Movie, Bridle Path, Cape Cod Evening, Ground Swell* and the MacArthurs' commission titled *Pretty Penny*. Each was a departure and preparation for the approaching whirlwind of the 1940s.

Confrontation — 1940s

The Germans hammered their way into Poland on 1st September 1939 and gathered their forces for a *Blitzkrieg* through France in 1940. Those Europeans with any foresight – especially those who remembered the Great War of 1914-18 – were packing bags, liquidating assets and buying steamship tickets. Prominent German Jews, intellectuals, artists, writers and physicists had either left the Fatherland by the time of the French offensive, or were crowding into westbound trains and port cities. Britain was already sending up barrage balloons and stringing barbed wire on its beaches, so the sanctuary of obvious choice was the United States.

The Hoppers were embroiled in their ritual petty squabbles and harangues, and missed most of the international disaster as it brewed up. They were, as usual, involved in the New York art scene and January slipped past with no canvas in sight at the Washington Square studio. However Edward was not idle, roaming the city at night in the El, peering in windows as the railway carriages flashed past. He finally began a charcoal drawing of a secretary and her boss alone in an office at night. Jo was happy to see the first signs of a new painting.

Edward seemed buoyant as well when he left his sketches one night to sweep in and dance Jo through the studio to a Strauss waltz on the radio. He had Jo pose in a short tight dress as he shaped the composition in eight preparatory drawings before transferring to canvas in pale blue brushstrokes. How often he had he drawn a variation of this environment before, bending over his commercial illustrations of desks, filing cabinets and panelled offices for stories in various business magazines. Now the story was his own, as were the actors. Why did she stare at the piece of paper on the floor, blown there by the breeze coming in the window? Was the tight dress supposed to be provocative? Was the boss oblivious to her busty charms? The scenarios were endless as Hopper played out his own after-dark fantasies behind a composition that was uniquely his, and would appear again. His gradual reduction of the scene elements from sketch to sketch is typical and he adds the final story elements only at the end: the window breeze and the fallen paper. *Office at Night* (p.192) joined his repertory of story canvases.

After turning out the last of his Civil War canvases, *Light Battery at Gettysburg* (p.107), in April, he and Jo loaded their "new" 1935 Buick and headed north-east. War news dogged them, but

110. *Office at Night*, 1940.
Oil on canvas, 55.8 x 63.5 cm.
Walker Art Center, Minneapolis, Minnesota,
gift of the T.B. Walker Foundation.

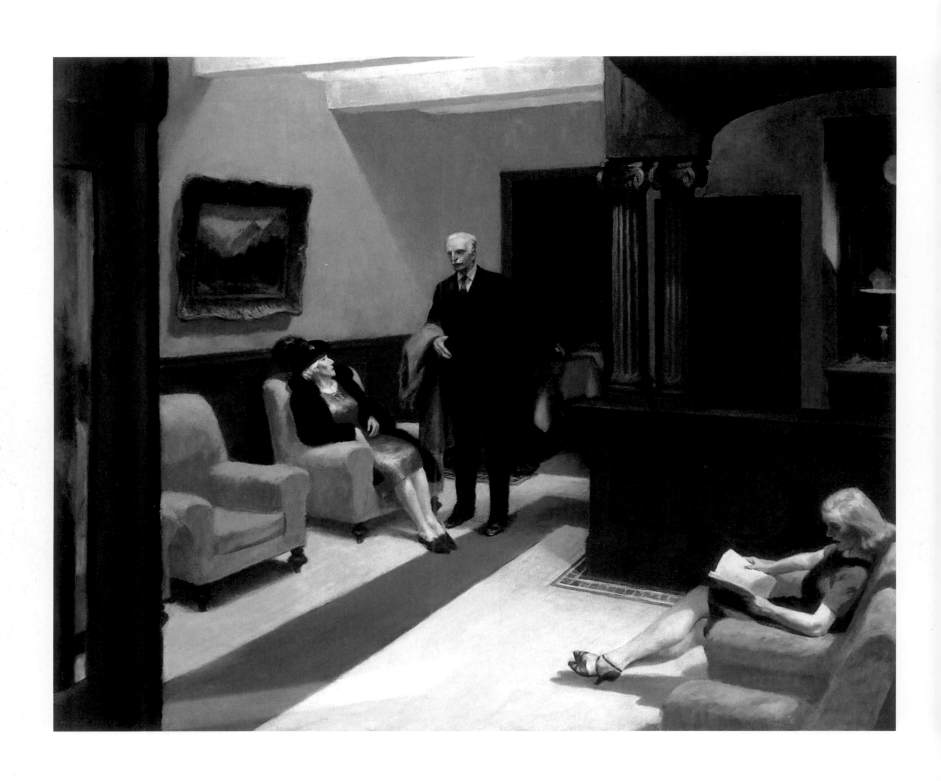

111. *Hotel Lobby*, 1943.

Oil on canvas, 81.3 x 101.6 cm.

Indianapolis Museum of Art, Indianapolis, Indiana.

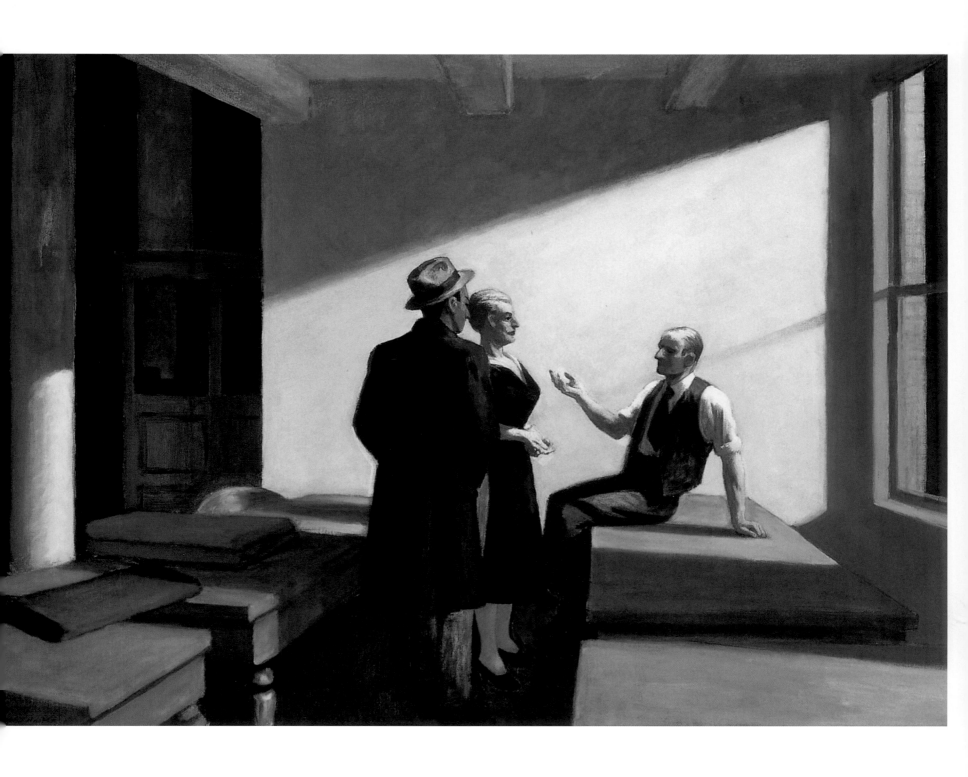

112. *Conference at Night*, 1949.

Oil on canvas, 68.6 x 101.6 cm.

The Wichita Art Museum, Wichita, Kansas.

The Roland P. Murdock Collection.

Hopper strained to find subject matter on the oft-travelled roads. Jo dissolved into tears when she heard that Paris had fallen to the Germans, but was surprised when the locals wondered why she was upset over something happening so far away from their little village. The watercolours remained in their box as Hopper grimly determined to paint another oil. His quest ended at a roadside petrol station and an idea that had been churning for years finally came to the fore. Jo wrote to Marion:

"He's doing a filling station – at twilight with the lights over the pumps lit. And when we go to look at them – around here they aren't lit at all. They're not wasting electricity until it's pitch dark, later than Ed wants." [59]

Titled *Gas* (pp.246-247), the painting is at once familiar and eerie. The lonely filling station at the side of a narrow road across from a dense forbidding forest is too uncluttered, stripped to its essentials by Hopper's reductive method. The pumps are lit – two regular and one "Ethyl" or "hi-test" petrol – and a white light streams from the station interior. A man tinkers with one of the pumps (named by Ed and Jo as the "son of Captain Ed Staples" who had been "killed" in a train crash returning from an art show at the Cleveland Museum – the fate of the original "Staples" canvas in 1929). Hopper visited a few petrol stations in the Truro area, gathering ideas and sketches that contributed to the twelve preparatory drawings, but only one station owner remembers Ed and Jo clearly. Jimmy De Lory recalled Jo was "…a flighty little woman" and Ed "…a terrible driver". [60]

Hopper entered *Gas* in the Whitney's Annual Exhibition of Contemporary American Painting. Painting the oil had been an ordeal and he increasingly complained to his Boston doctor of "feeling tired" and "weak" after long stretches of standing at the easel. Hopper was edging toward sixty years of age and tall, slender men frequently have joint and muscle problems due to their height and poor circulation to the extremities. But when he felt good and full of himself, Hopper often celebrated by informing Jo that her work was no good and if she did give a show, no-one would come. That set her off like a landmine and she ranted and raged. Hopper's "sense of humour" had always involved practical jokes or enjoying others' discomfort, As he aged, this release achieved a sharper and sharper edge, bolstered by his acceptance of the basic inferiority of women, especially as artists.

As 1940 was not a bumper year financially (*Gas* didn't sell to the Museum of Modern Art for $1,800 until 1943) bringing him earnings of $3,866 ($55,400 in 2006 dollars), Hopper fought his way out of the depressing inactivity that heralded 1941 by sketching strippers in burlesque houses. Burlesque had descended from a noble and respectable art-form that had started many famous radio and television comedians and performers on their road to stardom. It had descended from broad comedy and variety performances to a low collection of nude acts. Hopper enjoyed brushing the edge of socially reprehensible behaviour (in others) noting *Soir Bleu* (pp.70-71), his Paris prostitute sketches and the 1925 oil, *Bootleggers* (p.241). His paintings of women exhibiting themselves in windows, out of doors in bright sunshine, or in sexually-charged situations continued throughout his entire career. The fact that almost all were based on poses by Josephine Hopper made it seem natural for him to tell her to take off all her clothes and look like a stripper.

Girlie Show (p.227) is a full-blown flaunting of Hopper's ideal of female charms, turning a short naked lady in her late-fifties into a red-headed knockout with a body good for five shows a day and a face reminiscent of the confident worldly French prostitute in *Soir Bleu*. Poor Jo kept huddled close to the studio stove – burning her leg at one point – while posing as the haughty ecdysiast strutting her stuff for the boys in the front row. She posed and he painted during February and March, and on 8 April 1941 the canvas was delivered to Rehn.

113. **Edouard Manet**, *Plum Brandy* (La Prune), c.1877.

Oil on canvas, 73.6 x 50.2 cm.

National Gallery of Art, Washington, D.C.

114. *Automat,* 1927.

Oil on canvas, 71.1 x 91.4 cm.

Des Moines Art Center, Des Moines, Iowa,

James D. Edmundson Fund, 1958.

115. *Nighthawks,* 1942.

Oil on canvas, 84.1 x 152.4 cm.

The Art Institute of Chicago, Chicago, Illinois.

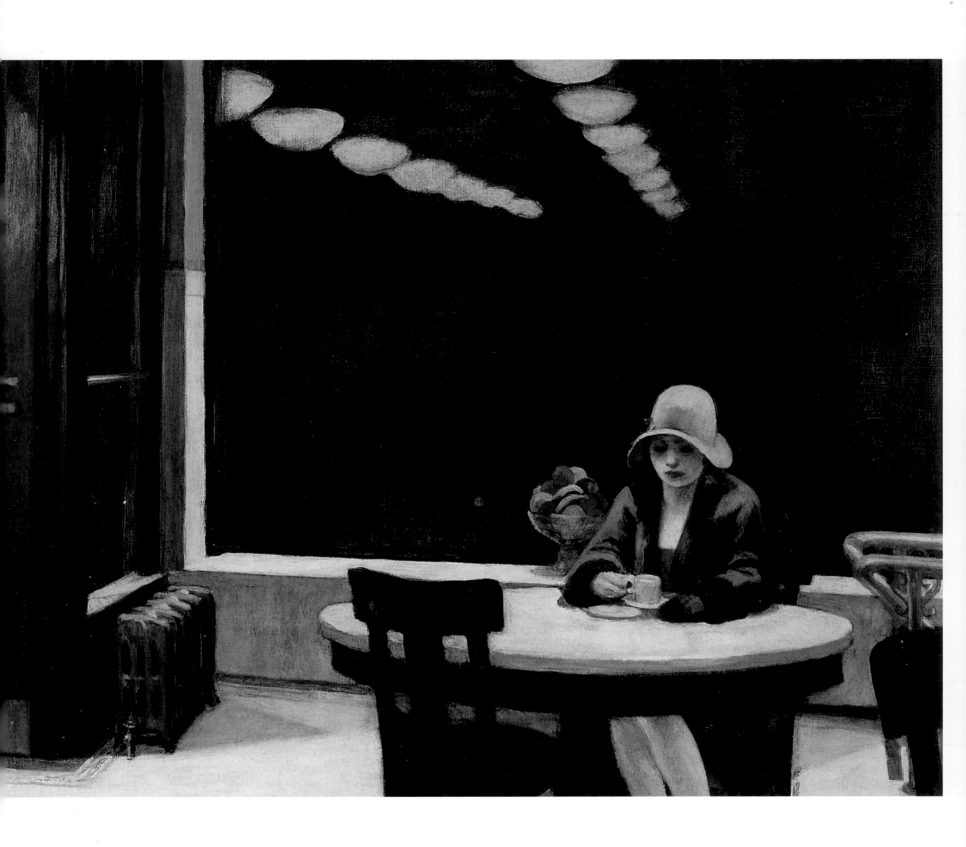

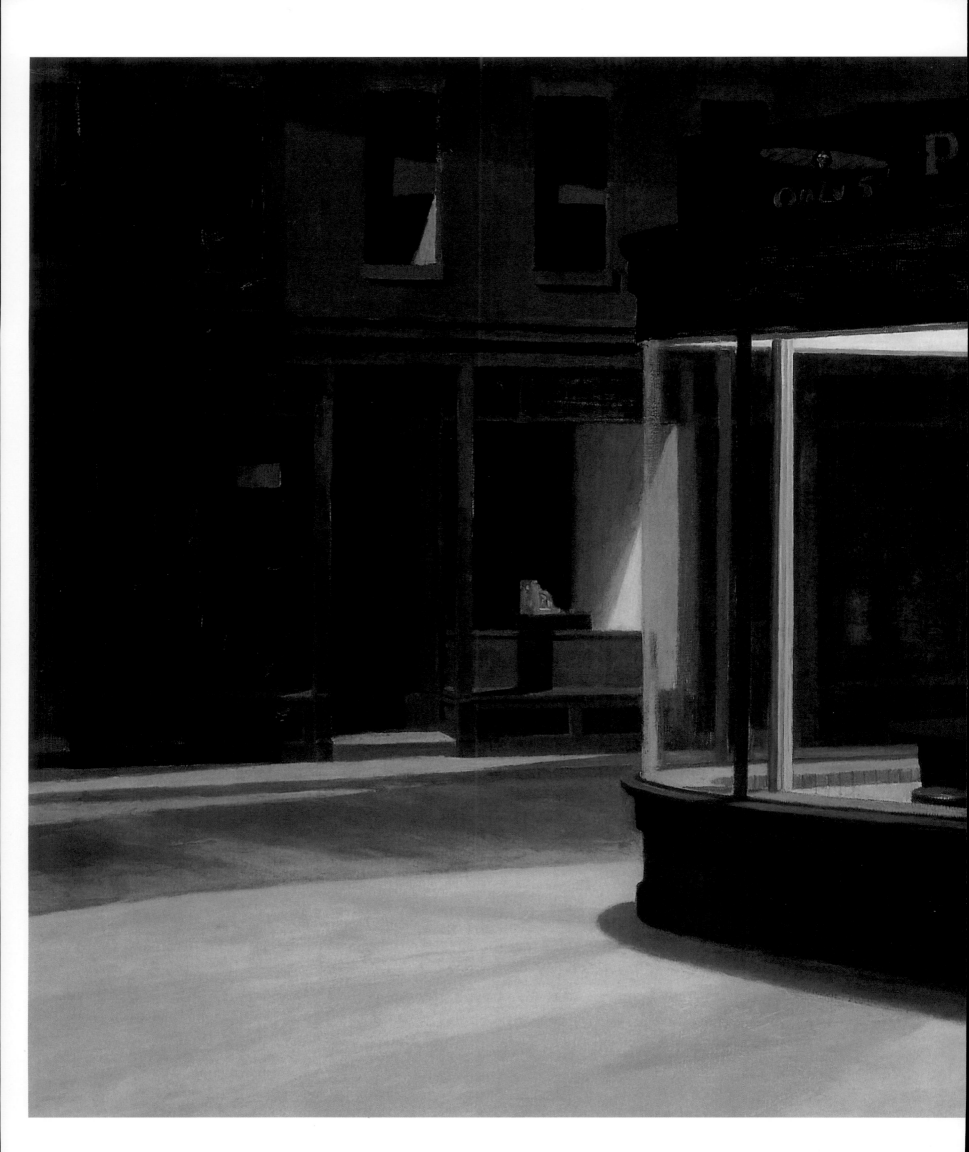

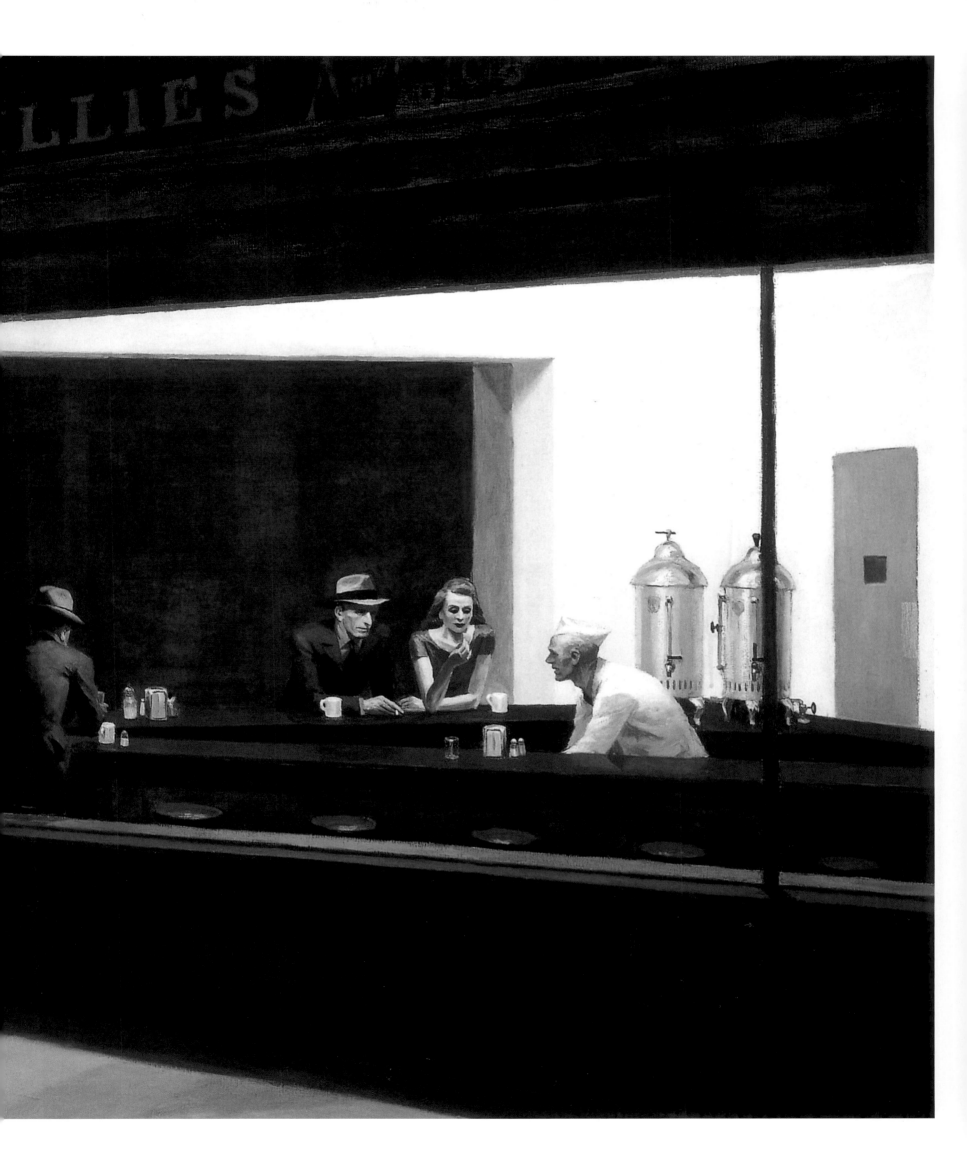

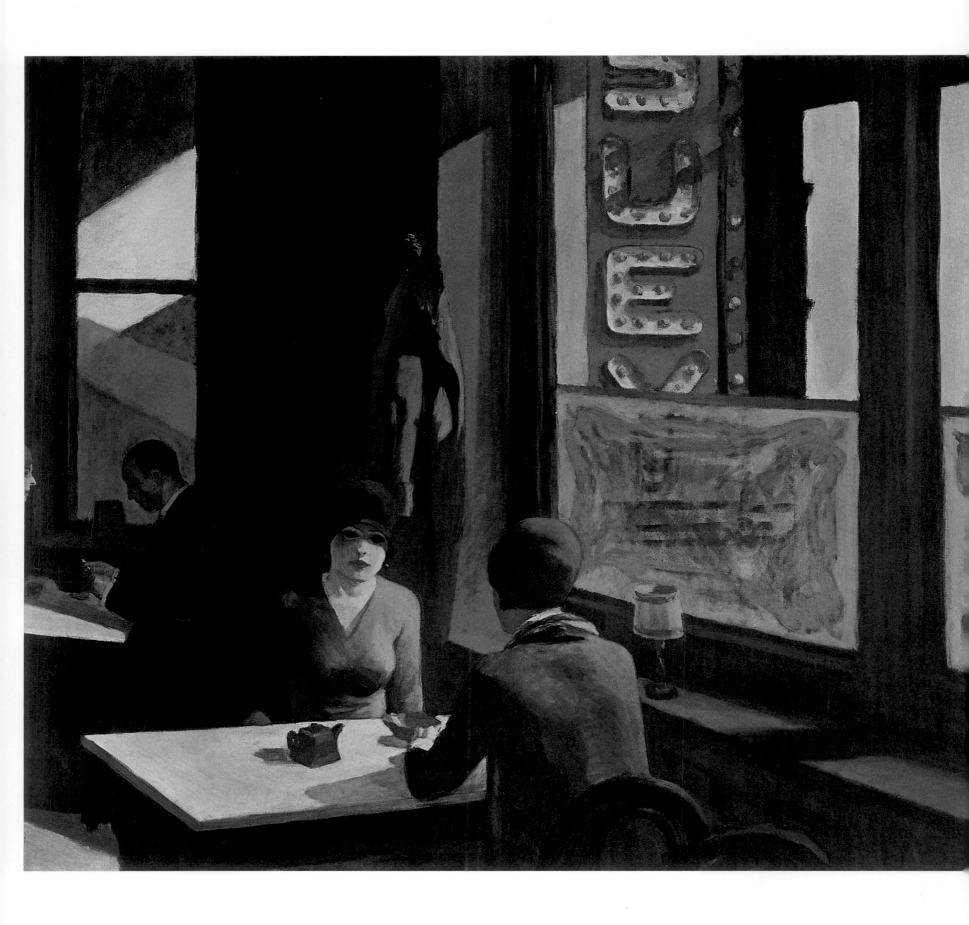

Needing a break, Hopper aimed the Buick west, looking to kindle some fresh material and see new places. Jo dedicated herself to causing no fuss and inspiring him to paint as they viewed the highlights of the western United States from the Garden of the Gods in Colorado to Oregon beaches, Yellowstone Park and vista after vista of breathtaking scenery. Always saving money, they stayed in trailer camps and seedy motor lodges. Finally Hopper ended their trek and, barely stopping, drove straight back to Cape Cod. Near the end of the odyssey, her nagging that he should stop and paint produced shouting, swearing and scalding invective. Josephine's diary pages and letters are pitiful as he ploughed on through Wyoming and South Dakota, cursing his way across Indiana and giving Cleveland a thumbs-down. They remained side-by-side for 10,000 miles covered in sixty days and when they finally rolled to a halt in front of their summerhouse at Truro, they were in a wretched condition. Four passable watercolours resulted.

What saved them was a sailboat picture titled *The Lee Shore* (pp.142-143) that he began in oil on 30 August. During its production, Edward became solicitous towards Jo, helping her paint outside in the chill Cape winds. She was happy that he had begun painting again. The long trip and mental anguish had worn Hopper down and he was ill with no energy. Throughout October he forced himself to finish another oil, *Route 6, Eastham* (p.110), a house and outbuildings alongside a two-lane road in one of the more drab Cape counties.

Fortunately, the time spent painting a very familiar subject and catching up on his reading softened Hopper. By the time they shut up the Truro house in November and headed for New York, their stormy relationship was once again on an even keel.

Frank Rehn's wife, Peggy, had died over the summer. That devastating and obviously distracting event and Hopper's minuscule output brought his earnings down to about $1,560 for the year. Regardless, the muse abandoned him again. As the chill winds of December drove casual walkers from the pavements, Hopper finally began to sketch, either from memory or from direct observation, a Greenwich Avenue intersection. As the world remained fastened to their radios, piecing together reports of the 7 December Japanese raid on the American naval base at Pearl Harbor in the Hawaiian islands, Hopper began to sketch in a brightly-lit island in an unforgiving night.

For *Nighthawks* – the name suggested by Jo in a letter to Marion – Hopper brought his repertory company of characters into a corner coffee shop lit by harsh fluorescent ceiling lights. Like the prow of a brightly lit ship the glass-enclosed counter and its four denizens ploughs on a sharp angle into the darkness. The glare illuminates buildings that look down on the street with dead eyes and shop offerings only dimly seen in the shadows. Not unlike *Drug Store* painted in 1927, the coffee shop is a haven, but its "nighthawks" are clearly seen in their roles like actors in a silent film. Hopper posed for the two men in fedora hats while Jo stood in for the hard-edged redhead. As if taking an order for a refill, "Captain Staples" is again resurrected as the man serving at the counter. Each character, like the design of the stage set, was thought through in many preparatory sketches.

Every detail was researched, including the coffee urns found at the local Dixie Kitchen where Jo often purchased take-away food for dinner.[61] In the details he chose to give the viewer, Hopper brought plausibility to an otherwise implausible scene. As one critic had accused him of including every mundane element in his pictures, whereas great painters were famous for what they left out, Hopper's highly-selective reductive process acted like a magnet. Every generation to come would bring their own tensions, fears, hopes and humorous lampoons to these characters locked forever in this island of light where they can smell the coffee.

To her credit and accumulated wisdom over the years of their rocky, co-dependent relationship, Jo stayed clear of the studio space as Hopper painted *Nighthawks* (pp.198-199). She checked into a hospital for chronic haemorrhoids and Hopper solicitously spent extra money to get her a semi-private room.

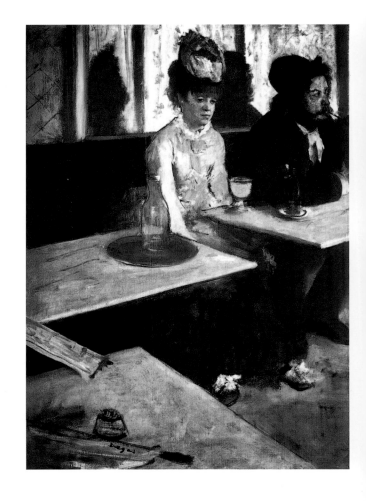

116. *Chop Suey*, 1929.

Oil on canvas, 81.3 x 96.5 cm.

Collection of Barney A. Ebsworth.

117. **Edgar Degas**, *Au Café (In a Café)*, 1875-1876.

Oil on canvas, 92 x 68 cm.

Musée d'Orsay, Paris.

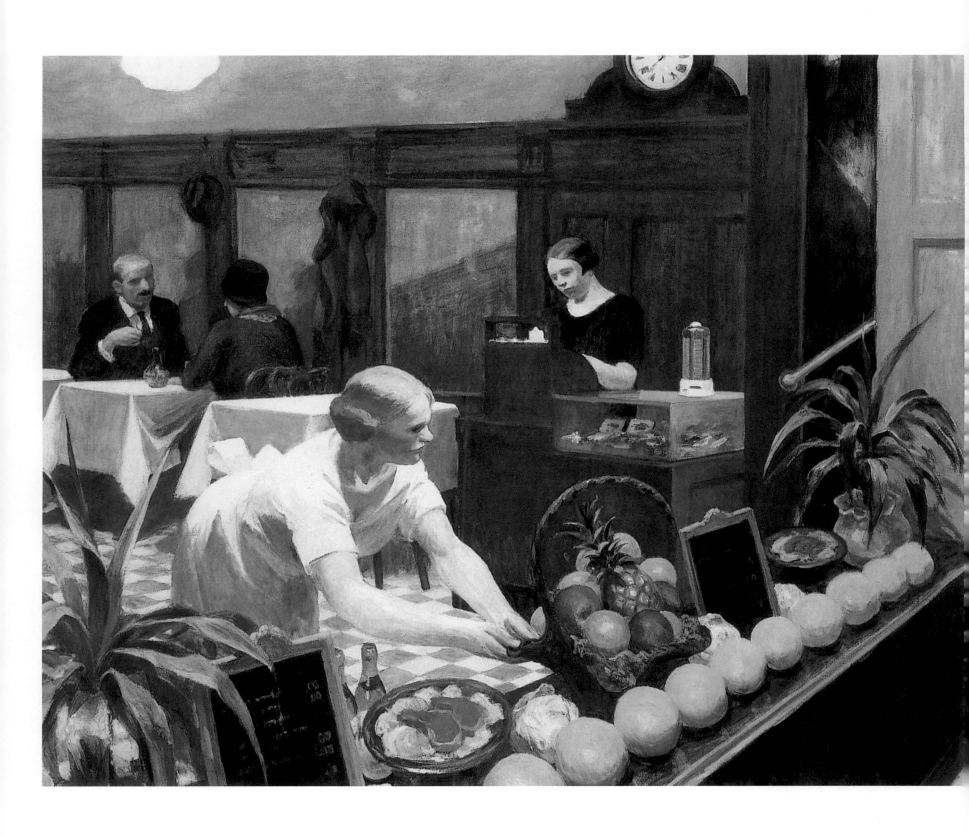

118. *Table for Ladies*, 1930.

Oil on canvas, 121.9 x 152.4 cm.

The Metropolitan Museum of Art, New York,

George A. Hearn Fund, 1931.

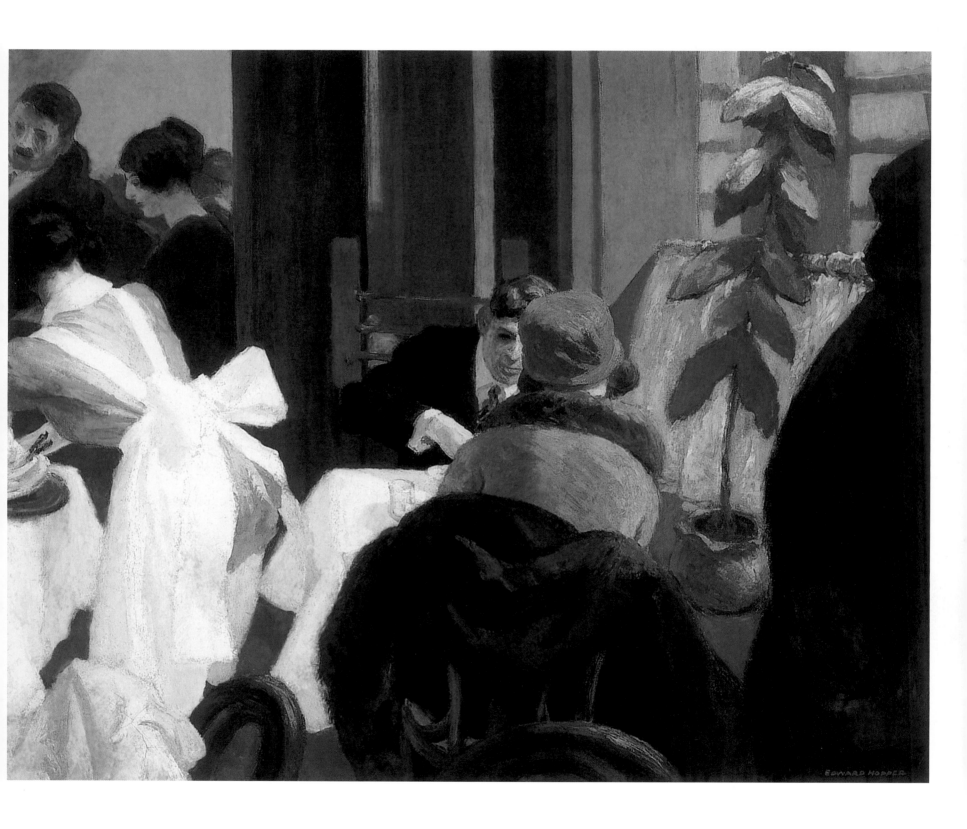

119. *New York Restaurant*, c.1922.

Oil on canvas, 61 x 76.2 cm.

Muskegon Museum of Art, Muskegon,

Michigan, Hackley Picture Fund purchase.

When she returned so did the normal chaos, resulting in yet another shouting match over the poor quality of her paintings which ended with Jo getting slapped around and banging her head on a shelf.

Hopper later offered up a fifty-ninth birthday surprise to Jo and another handmade card with a sentiment in French to help heal the bruises. With his energy and good nature renewed, he painted another oil, a haunting railway station platform with industrial buildings in the background, titled *Dawn in Pennsylvania* (p.172). The oddly menacing rear of a passenger coach with a bronze-like sheen squats dark and empty next to the platform. In May, the Chicago Art Institute purchased *Nighthawks* – the painting that would become his masterpiece.

They returned to familiar Truro and found the war had made an impression on the small populace with beachside observation towers watching for German submarines and bombers. Petrol rationing cut into Hopper's jaunts hunting for subject matter as well as attendance by the female neighbours at Josephine's tea parties. She was left alone at night when he donned his Air Raid Warden helmet and wandered the streets during blackout drills. After falling in and out of recurring depression, he managed a couple of watercolours, but they came back to Washington Square in October bringing all their clothes with them, fearing a government takeover of their bayside property to use as a military base.

The painting *Hotel Lobby* (p.194) started out 1943 for the Rehn Gallery. Edward delivered the painting on 4 January and surprised followers of his work by upgrading the composition's setting from his usual lower-to-middle class environment – such as *Nighthawks* or any of his voyeuristic window peeping – to an elegantly-appointed lobby peopled with well-dressed guests. Painted in shades of blue and green with gold touches on a picture frame and in the blonde hair of a young lady reading a magazine, the setting bespeaks a certain dusty silence. An elderly couple converse. She, dressed in a bright pink dress beneath a black fur coat, looks up at him from an overstuffed mauve chair. He stands on a Kelly green runner that leads to a suggested wood-framed revolving door in the foreground. Dark wood wainscotting and a matching registration alcove finish the room while a dark green curtained doorway hints at the white linen tablecloths of the dining room. That it's an elderly hotel is suggested by the fluted columns flanking the registration desk and the antique brass-door elevator next to the dining room entrance. The mail pigeon holes are empty, indicating that there are few guests. Maybe this hotel isn't as prosperous as it first appears.

Here again, Hopper has offered up an open palette for the viewer to fill in the story details. He must have seen many hotels of this calibre as he visited cities to judge art shows. As usual, Jo modelled for both women and used her own black fur coat for the seated matron.

The Hopper household at Washington Square was busy as Jo hung some of her work in her studio space and invited friends over to see her latest efforts. For once, Edward left her alone and worked on a second oil painting in his studio as her guests came and went. Between invasions, Jo modelled for a young girl in Hopper's favourite sensual mould: busty, long red hair and curves she didn't mind showing off. This *Summertime* (pp.236-237) princess in a yellow straw hat exudes the possibilities of a warm summer day – maybe the dream date of a soldier home on leave. She stands on the front steps of an old but respectable apartment building with its vestibule door ajar as a warm summer breeze stirs a curtain in a first-floor window.

With *Summertime* in Frank Rehn's hands, the Hoppers made the astounding decision to return to Mexico by train for the summer because Truro was so preoccupied with the war, and restrictive petrol rationing limited their travel options. The trip turned into a fiasco fuelled by the Mexicans' sense of *mañana* – anything and everything can wait until "tomorrow". Train schedules trapped them and food problems starved and infuriated them. Hopper returned with six watercolours that Rehn added to a watercolour show and they received critical acclaim.

Sales for 1943 were poor, even though *Gas* was purchased by the Museum of Modern Art. Hopper failed to paint anything for the last three months of the year.

120. *Apartment Houses*, 1923.

Oil on canvas, 61 x 73.5 cm.

Pennsylvania Academy of Fine Arts, Philadelphia,

Pennsylvania, purchased through the John Lambert Fund.

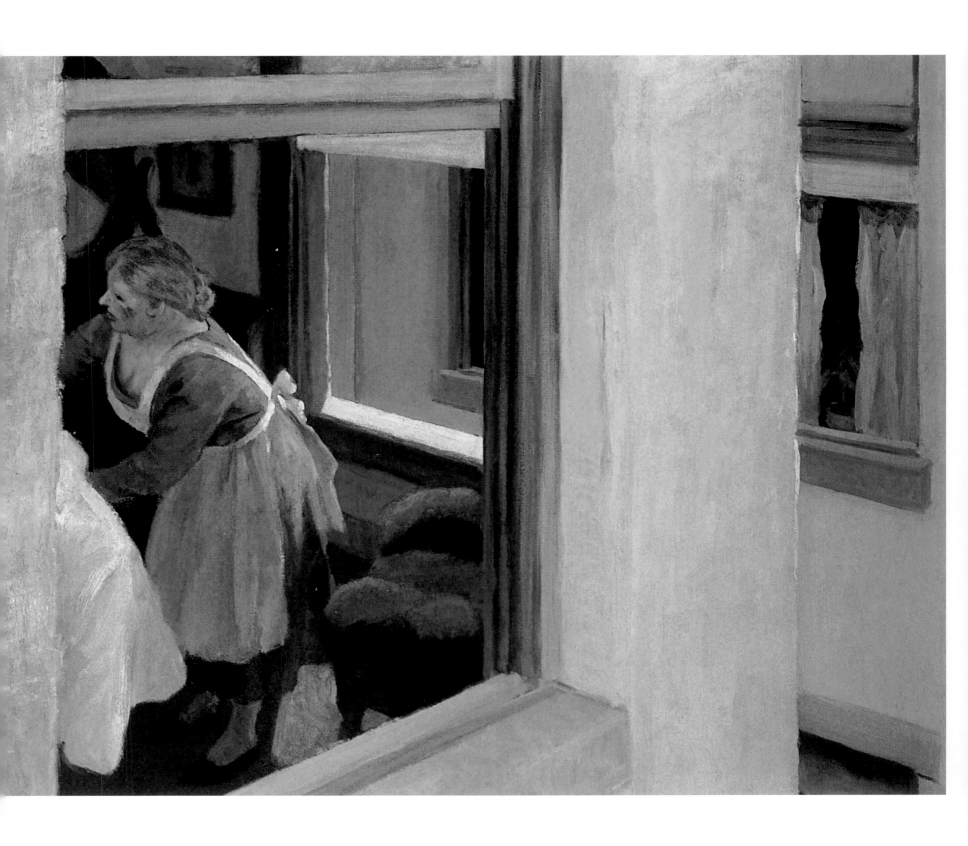

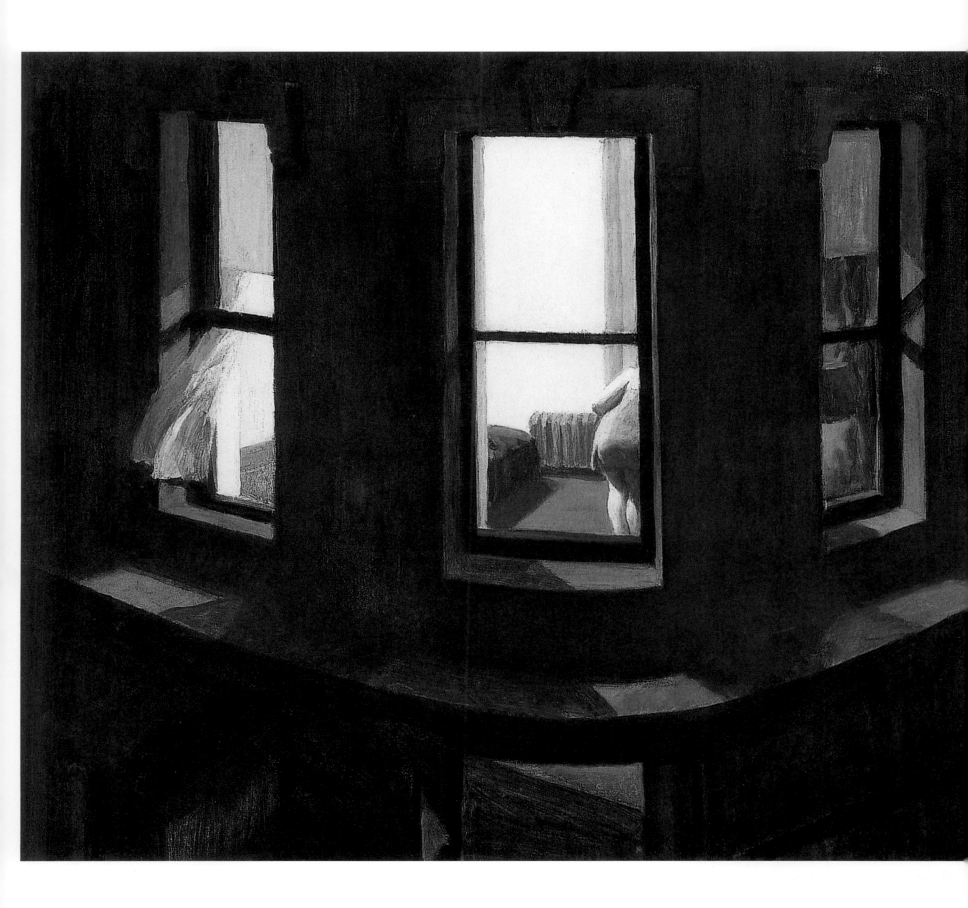

Hostilities were in the air for 1944 and Jo made no effort to celebrate their twentieth wedding anniversary. Edward suffered from health problems and struggled to finish two oils for the season. A nude Josephine became yet another of Hopper's naked young women facing an open urban window and streaming light in *Morning in a City* (p.209). The other oil represents a sandbar studded with seagulls being passed by a gaff-rigged weekend sailer with a bowsprit and jib. The painting's title, *The Martha McKeen of Wellfleet*, suggests the name of the boat, but actually refers to a young lady who had taken them sailing. Even this effort was a struggle for Hopper and had to wait until December to be finished in the New York studio.

Jo had retreated to the bedroom while Edward worked. Soon, his struggles and her confinement combined like sulphur and saltpetre to produce yet another explosion resurrecting ancient and familiar demons from beneath layers of scar tissue. The verbal lashing escalated into the usual physical turmoil and soon, after a slapping and kicking match, Hopper chased his wife across the dunes with a pointed wooden stake. Her stake was shorter than his so she parried his attempts to skewer her by screaming a reminder that her inherited money had built the Truro house. This reminder seemed to mollify him and later he praised four of her watercolours making Jo, once again, Edward Hopper's biggest fan.

A third oil of a house by the side of a deserted Cape Cod road titled *Solitude #56* (p.113) also returned to New York with the scarred Hoppers, where Edward discovered he had been elected to the Institute of Arts and Letters. He was not impressed by the "purely honorary" title.

The last year of the war found Hopper wandering among the apartment buildings that face onto the woodsy Riverside Drive. He discovered an odd architectural detail – a turret-like rounded bay that followed the contour of a driveway off the main street. To its right was a small panelled doorway with an elaborate moulding cap looking like a castle postern or escape exit. *Objets d'art* clutter the room behind the three windows' parted curtains, and among the artefacts is the focus of the painting, a bronze sculpture of an expectant Greek or Roman woman. *August in the City* (p.181) started a series of discomfiting paintings that continued on into the 1950s.

Meanwhile, even the sanctimonious walls of the grand old Salmagundi Club were breached by Hopper's work. Frank Rehn entered *Office at Night* (p.192) in the club's 75th anniversary exhibition. Long a client of Rehn's, the Salmagundi was a haven for New York's academic Realists who had huffed and puffed at the 1913 Armory Show and decried the European modernists (grouped with other "DPs" – Displaced Persons) who had fled to the United States ahead of the Germans. In the club environs where Hopper wouldn't have been offered a cup of coffee in 1921 when he was selling his Paris oils, now in 1945 his *Office at Night* walked off with their $1,000 top prize. Like turning down the Design Academy's membership offer, the prize must have been a sweet reward.

He did accept induction into the National Institute of Arts and Letters and exhibited fourteen of his works as a "Newly Elected Member." Later that same month, his watercolours hung with those painted by Winslow Homer at the Brooklyn Museum. Another show in June at the Museum of Modern Art featured his work in their permanent collection. But still his easel remained empty and the migration to Truro sparked no new ideas. He failed to be roused to paint outdoors and forbade Jo solo use of the car for her own excursions.

Imprisoned in a prolonged lassitude, Hopper listened to President Truman on the radio as he announced victory in the war with Japan. "So glad not to have heard it from the voice of Roosevelt,"[62] huffed Josephine.

Finally, at the end of August, Hopper hauled out the roll of canvas, stretchers and keys and assembled a surface on which he worked in charcoal and then thinned blue oil until the bones of *Rooms for Tourists* took shape. This night painting of a white 1880s private house front lit by floodlights reveals the warm interior glow of a bed and breakfast. Awnings hang at virtually all the windows. Lighting must come

121. *Night Windows,* 1928.

Oil on canvas, 73.7 x 86.4 cm.

The Museum of Modern Art, New York.

from a pole or tree just off the right side of the frame, but inside the shrubbery. He spent time travelling to Provincetown, Massachusetts to sketch in some of the eight preparatory drawings he made. One can only wonder about what the residents thought of the strange tall man lurking in the shadows across the street. He finished the painting in mid-September and was moved to start another in October: two white houses side by side behind three bare tree trunks against a bald sky.

The Two Puritans, a title possibly drawn from several sources, for example Edward and Jo's "puritan" approach to life, or the purity of the setting. If the former, the big house is Edward with the all-seeing windows and the little house is Jo: all front door (mouth) and two dark (dead) eyes. Again, Hopper's vision leaves behind a delightful *tabla rasa* for interpretation.

Back in New York in October, they discovered Hopper's painting *Hotel Lobby* had won the Logan Institute Medal given by the Chicago Art Institute and a $500 prize. They also discovered the Whitney Annual Exhibition had relegated the regular contributors to the building's second floor while "abstract painters" had commandeered the choice first-floor space. The shunting aside of the "American Scene" Realist painters was less a wound to Josephine than the news of the Century Club holding a show of former Robert Henri students and none of his female students were included.

In her sixties with more life behind her than ahead, Josephine Hopper faced 1946 from her sickbed. With time on her hands, she wrote to the painter, Carl Sprinchorn, one of her male allies, a long, eight-page letter bemoaning her lot, her career and Hopper's indifference to both.

> *"I've been laid up with grippe, flue, whatever and it settled in my eyes so no reading for nearly two weeks. So one just lay there festering, stock taking on the brink of the grave, one foot in it. Not the flue – just dull passage of years, such a lot of them and what done with them?*
>
> *"…(Hopper) didn't want me to have any spark, urge, what the hell call it – however feeble, pubescent, insignificant, etc. etc. and it's about killing me. As we all know there has to be some loophole, some inkling where things are brewing, who's gathering them in….E.H. has been in the thick of everything, but he'd see me dead before he'd want to let me in. And this is God's truth – I can't bear to go on living with the bone of one's bone, etc. acting that way. Guy du Bois gets people there and out come Yvonne's pictures – very nice pictures too. E.H says 'but she's his blood, she's born du Bois'. I only married a Hopper. A loathsome breed they are too."*

Later she observed, "Those lighthouses are self portraits. At 2 lights, Cape Elizabeth it was pitiful to see all the poor dead birds that had run into them on a dark night. I know just how they felt. The bright light on top had deceived them – and no way they could think of to wring its neck."[63]

As Jo poured out her misery to Sprinchorn, Edward worked away on a canvas he had begun in January. For all its simplicity, *Approaching a City* is a very visceral painting foretelling a claustrophobic anxiety. Railway tracks drive diagonally into this black maw of a tunnel beneath the dead eyes of buildings that appear crowded against a concrete retaining wall, witnesses to whatever is being sucked below. The terrible reality of almost photographic details such as the sleepers and gravel beneath the rails, the smudges of exhaust soot staining the tunnel entry arch, the symmetry of the building windows and their individual details create the feeling of a Hieronymus Bosch menu of hell's awaiting delights.

As Edward worked, Jo entered two watercolours in a show produced by the Pen and Brush Club, an all-female organisation with whom she felt a natural bond. They rejected her work. Having been shot down by her own gender mates, she began to reconsider her privileged position as the wife of a great and much-honoured painter. Yet she wondered what Edward saw in her. Besides keeping up the

122. *Morning in a City*, 1944.
Oil on canvas, 112 x 153 cm.
Williams College Museum of Art, Williamstown, Massachusetts.

123. *A Woman in the Sun*, 1961.
Oil on canvas, 101.9 x 155.5 cm.
Whitney Museum of American Art, New York, 50th Anniversary gift of Mr. and Mrs. Albert Hackett in honour of Edith and Lloyd Goodrich.

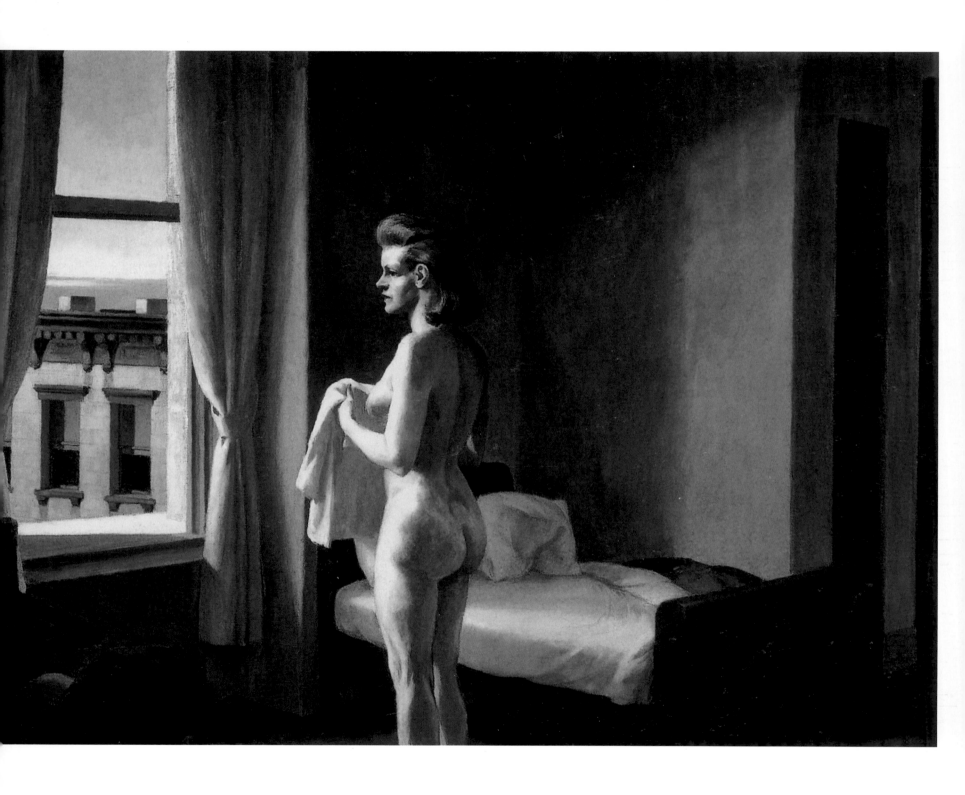

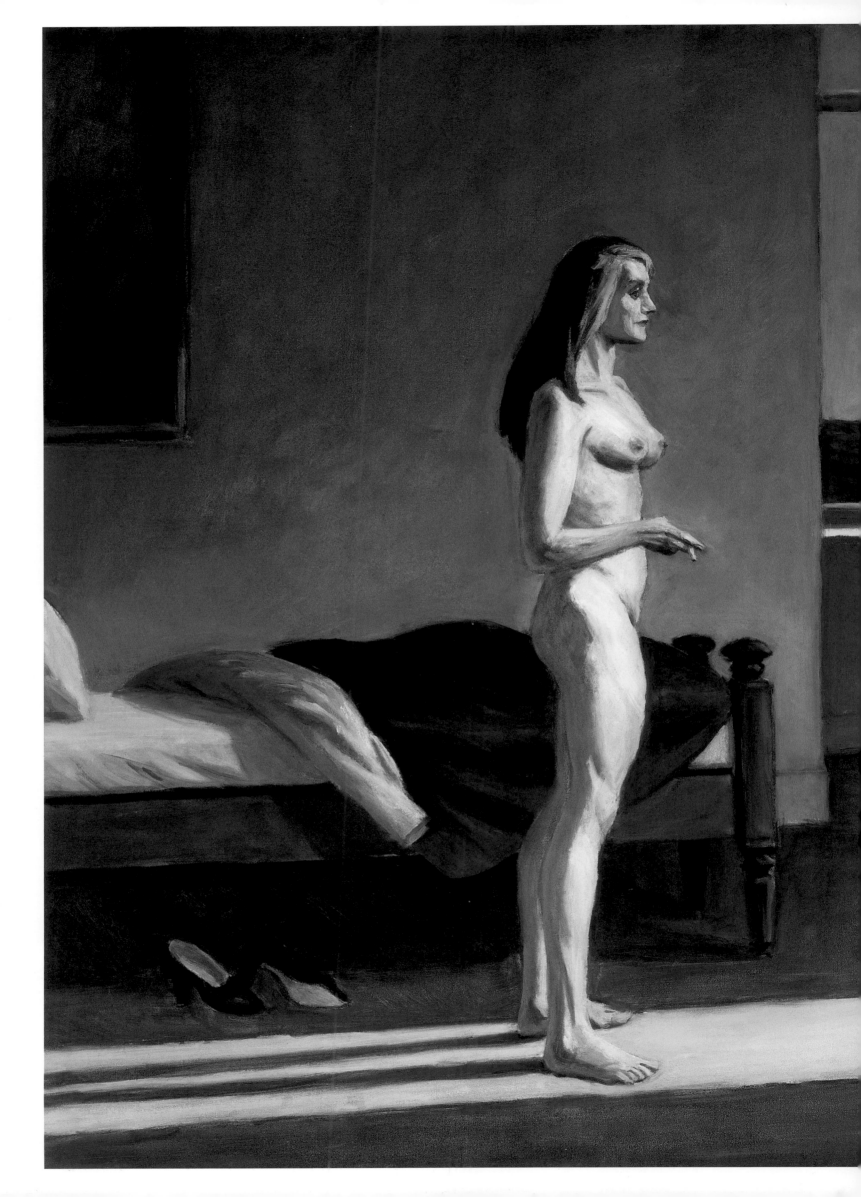

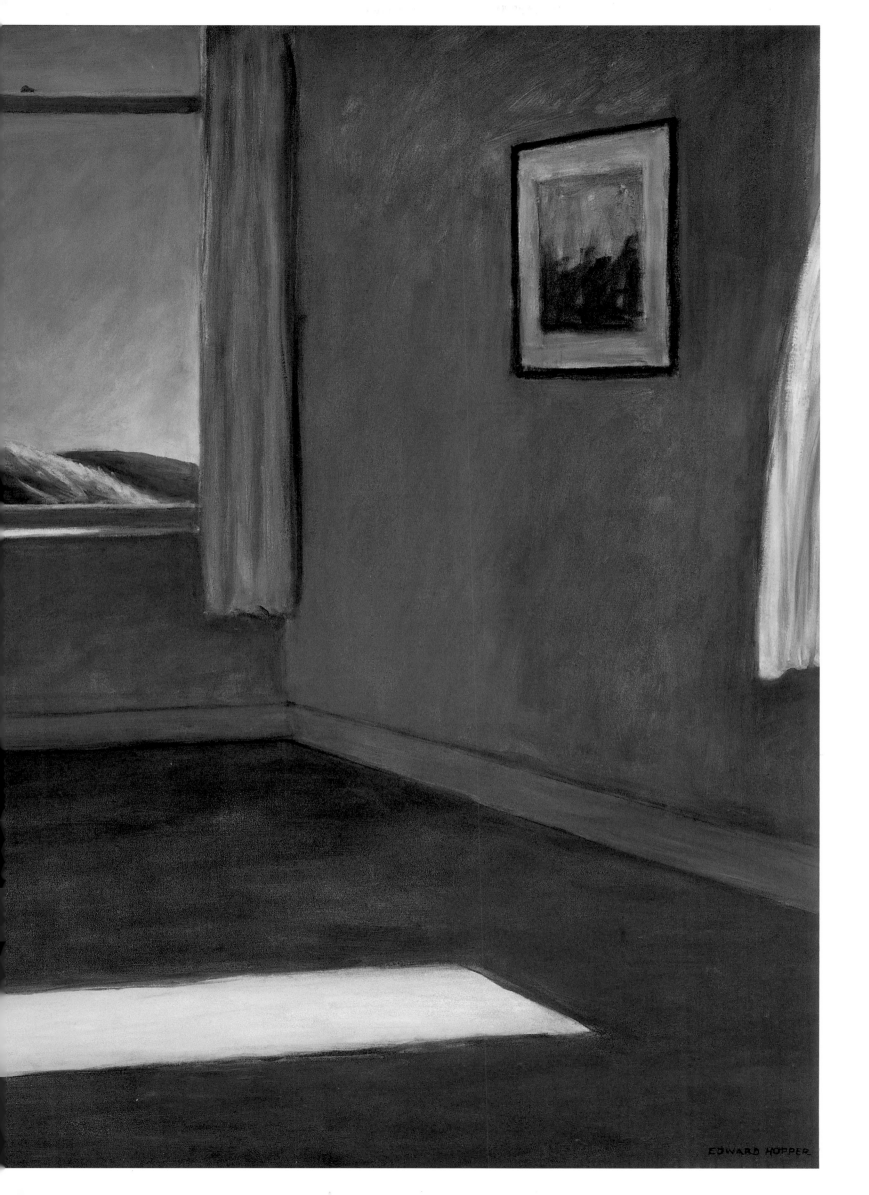

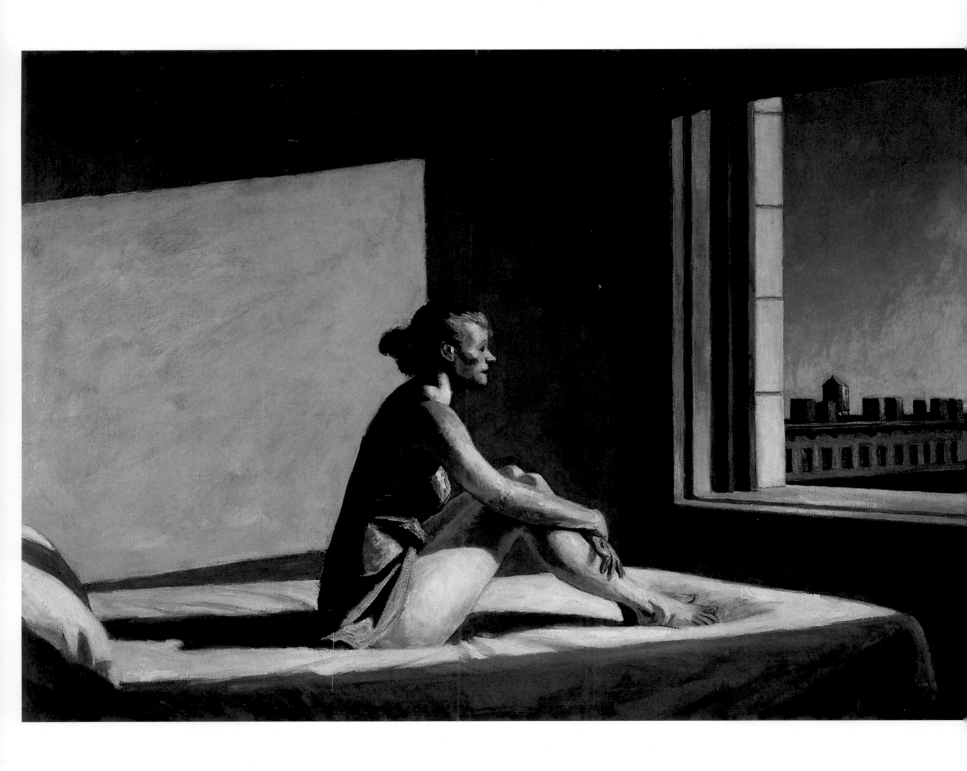

ledger, cooking and domestic chores (except laundry, which was Edward's province) and accompanying him on their trips and to social events he could not avoid, what was her function in his life?

"Any talk with me sends his eye to the clock…He will listen long enough to make pronouncements, then willingly he would end that. Reopening the matter bores him."

Her conversations with Hopper were like "…taking the time of an expensive specialist".[64]

The mood of patient acquiescence lasted only until they began packing for their 1946 summer return to Mexico, this time by car. Over a trivial dispute about unpacking something that had already been packed, another slapping, kicking, biting fight broke out. This time, while being dragged squalling across the floor, Jo managed to inflict a deep bite on his hand. When they were through, they finished packing and set off for Mexico with Edward's hand swathed in a bandage. Jo wrote in her diary: "…No one who sees him so patient so saintly could realise what straights he could drive a person like me thru." [65]

The trip to Mexico was, no surprise, another disaster as they fought and sniped endlessly. Eventually, sick of the smells, the food, the people and the architecture, Hopper overruled her desire to drive south to Oaxaca and steered north for the border. They drove through the western states adding to the few watercolours they managed to paint in Mexico, and arrived in Truro in time for another of Hopper's slides into grim depression over Cape Cod's paucity of subject matter.

Eventually he managed an oil of an isolated white house and a separate garage in need of whitewash in a field of dead grass in front of a wall of dark forest. *October on Cape Cod* (p.112) is a quiet, silent, desolate work to which Jo compared in her ledger one of Hopper's favourite poems that he often read aloud, Johann von Goethe's *Wanderer's Nightsong*:

O'er all the hilltops
Is quiet now,
In all the treetops
Hearest thou
Hardly a breath;
The birds are asleep in the trees:
Wait: soon like these
Thou too shalt rest.

At the age of sixty-five, Edward Hopper's vision of life, like Josephine's, had begun to include his mortality; he could see fewer years stretching before him and could feel the gathering infirmities of age. Surrogates for his moods and fantasies would become more prevalent in his elusive landscapes.

The return to New York saw the Hoppers plunged into a battle to save their home as New York University, owner of the building at Three Washington Square sought to remodel the space into offices and classrooms. Former residents came forward to fight the remodelling and attendant eviction notices. The building was deemed to be a creative shrine, considering its past and current illustrious tenants and the works of art that had been and continued to be created there. The university's plans were finally squelched by the uproar, but Hopper's output was shut down until January 1947.

Of note as the year ended was the continued respectable presence of the abstract Expressionists in the Whitney Museum of American Art Annual Show. In advance of De Kooning and Rothko, Jackson Pollock had begun studying at the Art Students League in 1929 and then under regionalist painter and muralist Thomas Hart Benton. After working in the realist manner of the Mexican muralists Rivera, Orozco and Siqueiros, he abandoned realism for completely abstract non-representation that was about to erupt in his drip and splash works begun in 1947. Critics were already circling the 1946 Whitney Annual with questions about the American Realists' legitimacy, and praising the ascendancy of the raw emotions of the Expressionists.

124. *Morning Sun*, 1952.

Oil on canvas, 71.4 x 101.9 cm.

Columbus Museum of Art, Columbus, Ohio.

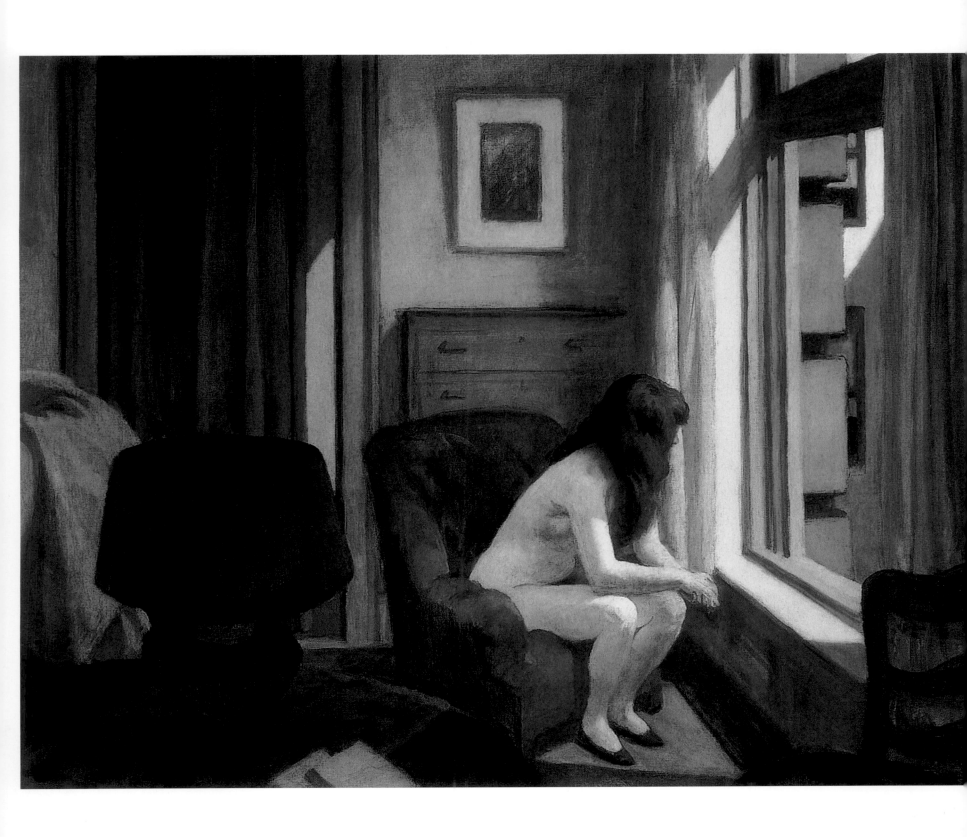

125. *Eleven A.M.*, 1926.

Oil on canvas, 73.3 x 91.6 cm.

Hirshhorn Museum and Sculpture Garden,

Washington, D.C., gift of the Joseph

H. Hirshhorn Foundation.

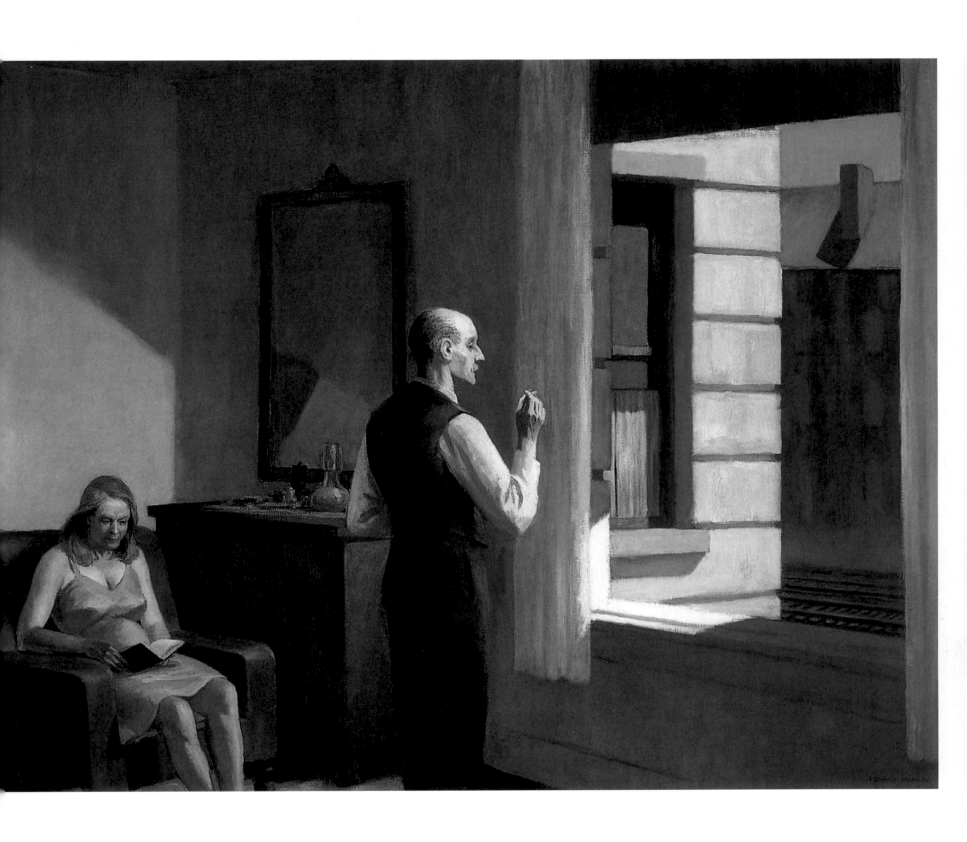

126. *Hotel by a Railroad*, 1952.

Oil on canvas, 79.4 x 101.9 cm.

Hirshhorn Museum and Sculpture Garden,

Washington, D.C., gift of the Joseph

H. Hirshhorn Foundation.

The abstract Expressionists failed to move Hopper from his pronouncement that they painted colour, line and design for their own sakes. Hopper powered into January 1947 with a "mini-*Nighthawks*" painting of a hot-dog stand in an un-named Midwest city. Totally the opposite of the edgy *noir* treatment of *Nighthawks,* this could be dawn at the river's edge with two patrons waiting for the waiter to pour their first cup of coffee of the day. Its location makes it an anglers' diner upstream from the bridge that leads into the still silent downtown with its low-profile buildings. Every middle-sized riverfront town (such as Nyack) has a *Jimmy's*. The diner's bright light has the same effect as *Nighthawks*, but it is welcoming rather than defensive.

Hopper's brilliant use of light as a story-telling tool is nowhere more evident than in *Pennsylvania Coal Town*, the painting he finished in April. A man rakes a patch of lawn between two family houses as a late summer sun blasts down between them. The shirt he wears is old-fashioned for the mid-1940s when all shirts had collars. His matching waistcoat and trousers also make this appear to be a period piece. With its comical frizz of green, the terra cotta pot lightens the otherwise solid, heavy industrial town scene. Jo called the raker a "Pole," going for the displaced person (DP) label attached to many post-war refugees from Europe. If so, that could explain the antique clothes. If he is a coal miner, watching the sunset would have special meaning to someone who worked all day underground.

As the battle over the future of the Washington Square building raged, Jo and Edward fled to Truro. Once ensconced there, Edward pulled forward an old memory of his sister Marion's courting days in Nyack. *Summer Evening* portrays a young couple on a warm evening beneath the glare of a lamp washing over the back porch of a white clapboard house. The girl frowns while the boy explains. Whatever he is selling, she isn't buying and the harshness of the porch lighting adds to the boy's rejection. Marion never married and now lived alone in the Nyack house. That painting was the only product of their Truro summer.

A show of Hopper's work at the Rehn Gallery marked the beginning of 1948. It drew critics eager to compare his mature realism to the early experiments of the growing number of abstract Expressionists beginning to line gallery walls. Besides this early development of "New American Painting", New York had attracted a clutch of European Surrealists. André Breton had assumed the *de facto* mantle of spokesman, and tried to expand the Surrealist movement by claiming various painters were actually closet Surrealists. Off-mainstream painters not linked to any "school", such as Diego Rivera's wife Frida Kahlo and Edward Hopper, were embraced as Surrealists because of the strange deeply personal evocations of their paintings. Both artists rejected this label.

Hopper had explained his position on non-representational art back in April 1945 when he answered a letter from a psychologist, Dr. Roe, to explain his work. Hopper said about his critics, in part,

"They believe me to be not much of a colourist, which I think is true if you consider colour for its own sake alone. They believe me to be not much of a designer and this too I think is true if you consider design for its own sake. However, these last criticisms do not disturb me, as my intention in painting is far from giving form, colour and design a place in my art as an end in themselves."[66]

He remained constant in his views when asked his opinion of the "New American Painting." He answered that these painters attempt to create "…'pure painting' that is, an art which will use form, colour, and design for their own sakes and independent of man's experience of life and his association with nature. I don't believe such an aim can be achieved by a human being…We would be leaving out a great deal that I consider worth while expressing in painting, and it cannot be expressed in literature."[67]

Hopper waved the Expressionists from his mind as a passing phase in art as he and Jo motored to Truro in the summer of 1948. Once there he occupied the main studio, shutting out all light except that which fell on his canvas of a shopfront next to a dark wood. Jo took up residence in the kitchen where the light was "all wrong" and painted watercolours, as her various agendas of slights, being ignored, being demeaned, etc. churned inside her, onto diary pages and into letters to friends.

127. *Sunlight in a Cafeteria*, 1958.

Oil on canvas, 102.1 x 152.7 cm.

Yale University Art Gallery, New Haven, Connecticut,

bequest of Stephen Carlton Clark.

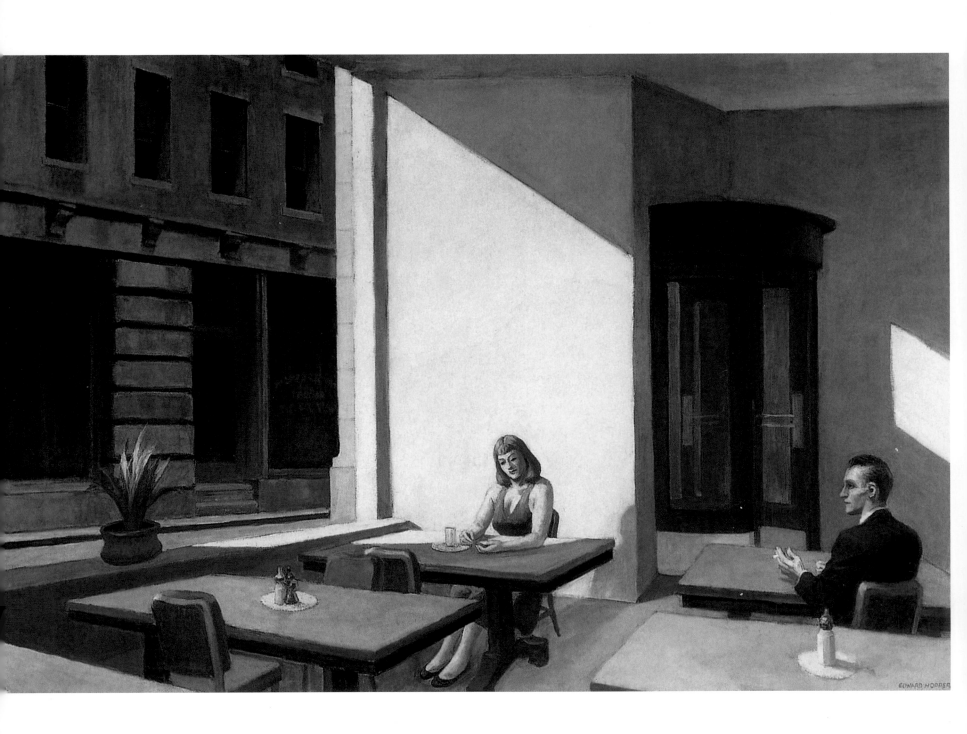

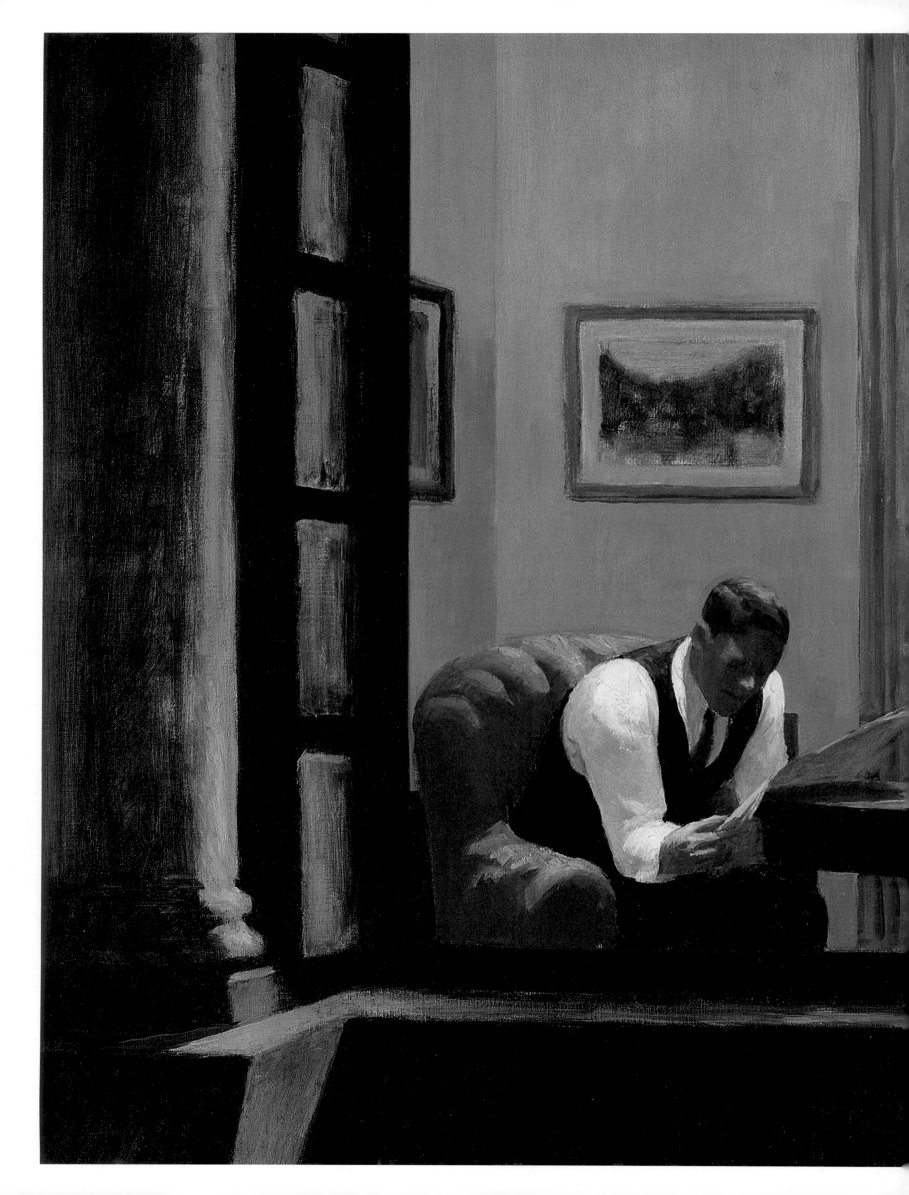

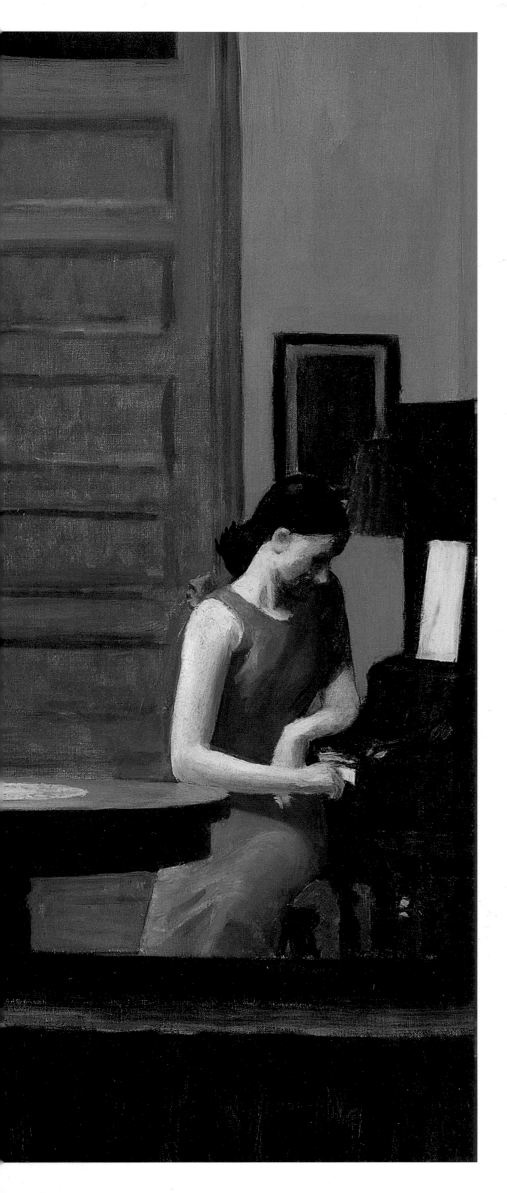

128. *Room in New York,* 1932.

Oil on canvas, 73.7 x 91.4 cm.

Sheldon Memorial Art Gallery,

University of Nebraska-Lincoln, Lincoln, Nebraska.

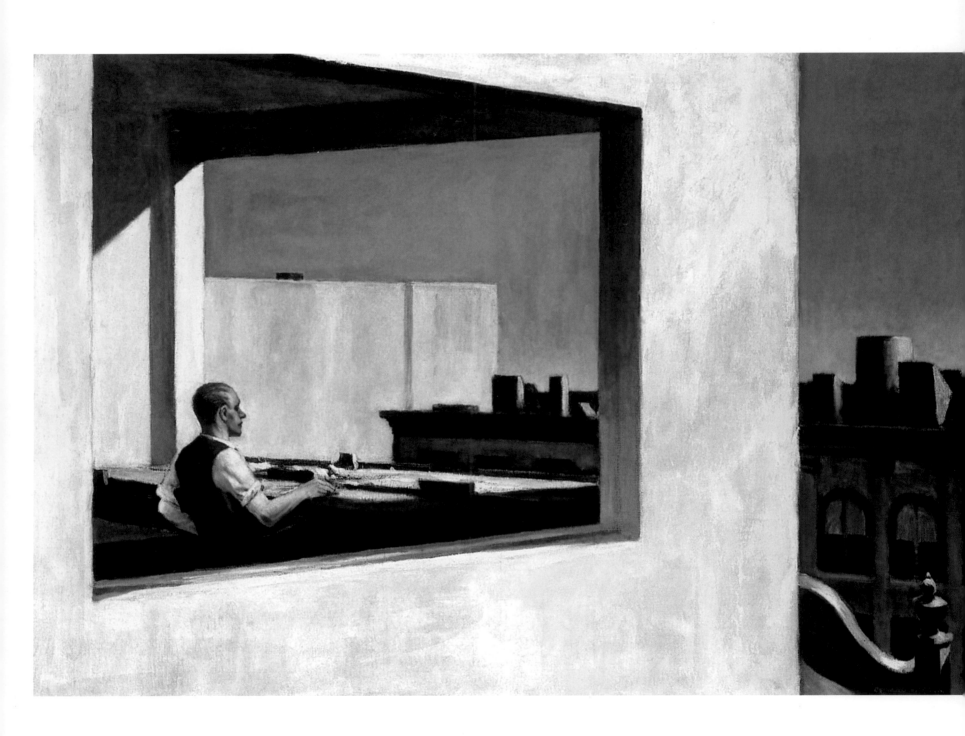

The painting, *Seven A.M.*, is of a white shopfront. An old regulator clock indicating seven o'clock shares the window with a few bottles and pictures, none of which gives a clue to the shop's products or services. A cash register is visible in the dark interior. Upstairs, over the shop, a window is open revealing a wedge of pale blue wall. Beyond the shop a dark, menacing wood with twisted tree trunks sulks in the shade. There is something wrong with the perspective of the wall on which the clock is hung. It is an unsettling painting, but Hopper thought it very good.

As they ranged about the Cape in search of subjects, they thought of many friends who had recently passed away, including John Dos Passos' wife, Katy, who had been kind to Jo, and Frank Crowninshield, former editor of *Vanity Fair*, who had supported Hopper's work since 1929. Edward began feeling the stress, the need to find something to paint. On 23 October he awoke with chest pains. They subsided, but frightened the Hoppers. Anxiety over Jo's recent illness and Edward's previous health and depression problems combined with heavy rains that kept them shut inside. They gave up their work and packed for New York.

As though his creativity was governed by the phases of the moon or the changing of the calendar page, Hopper found himself at his easel in January 1949 turning out another vision from his storehouse of ideas rather than painting directly from life. *Conference at Night* (p.195) could have been done as one of his drive-by sketchings from a moving El train, but the viewer is in the barren office with the three actors in the scene. Light streams in through undraped windows. Empty work-tables fill an alcove as the window light slashes across the wall. Roles for the three in discussion include a modification of the hawk-nosed "Staples", who appears to be the office manager with an unbuttoned waistcoat and rolled-up sleeves. Jo had named the imposing blonde woman with the severe expression "Deborah – a queen in her own right". The third man in top-coat and fedora hat could be her son and second-in-command of the new business that has just moved in. Collector Stephen Clark bought the painting from Rehn and promptly returned it. He claimed his wife said it looked like a Communist cell meeting. The Cold War with the Soviet Union had replaced the shooting war and Americans were seeing Communists hiding under every bush.

A great hue and cry arose among Hopper and his colleagues when the Institute of Arts and Letters elected Georgia O'Keeffe to membership. This cavalier chauvinism sent Jo into a small rage over women's lot that became a full whirlwind when uninspired boredom caused Edward to shoot home a few taunts. Out poured the entire shopworn catalogue of repression and negation that she kept regularly topped up as new slights and insensitive cuts razored their way into her needy existence.

Instead of perking up after verbally crushing Jo yet again, Hopper slid into a deeper depression as he faced prostate surgery. His only remedy for the Black Dog moods was a steady diet of movies, but these depressed Josephine, who needed to paint for her therapy.

With a resurgence of energy, Hopper managed to drive to Truro. After the usual hunt for subject matter, in August he began a canvas, figures in the doorway of a house with dormer windows. But his weakness and general malaise rendered him unable to drive, so Jo was behind the wheel on a trip to Wellfleet when there was a skid, a crunch and the wing was dented.

Edward exploded in a towering rage. It was the end, the end of everything, he babbled. She raged back that she would sell the Truro house – her money had paid for it – but there would be no divorce. Hopper drove to Hyannis and found the cost to repair the dent was $25. Once again the Truro house settled down and he finished the canvas, *High Noon* (p.133).

It is an odd painting – very surreal in its setting beneath a blue sky and raked by strong sunlight – of a white house with a grey shingle roof sporting two dormers. In the doorway a blonde girl wearing only an open blue robe stares wistfully across what appears to be an empty plain. Hopper even built a heavy paper model to study the fall of light across the roof eaves. The

129. *Office in a Small City*, 1953.
Oil on canvas, 71.1 x 101.6 cm.
The Metropolitan Museum of Art, New York,
George A. Hearn Fund.

house is more of a stage set than real because the roof is too low. If the girl is of average height, she could not stand upright on the second floor. It is more of a house of the imagination, a dream house.

Back in New York, Hopper planned a retrospective show with Lloyd Goodrich, curator at the Whitney while Jo hunted about for somewhere to hang her work. Her hunt was interrupted when Edward asked her to pose for a painting of a woman sitting on the edge of a bed while a man lies nude face down behind her. Light streams in through uncovered windows. There is no furniture in the apartment besides the mattress and the bed frame. Jo turned out to be wrong for the husky woman Hopper had in mind so she ended up posing for the skinny man's pale legs. He delivered *Summer in the City* (p.185) to Rehn on 13 December. Ten years later, he would paint the reverse of this painting, shifting the morose burden and the environment in *Excursion into Philosophy* (p.186).

The year 1949 ended with peace in the house. The 1950s looked promising with Edward's retrospective and Josephine's *San Esteban* painting to hang in the National Arts Club.

Personal Vision

The 1950s was a watershed decade for Edward Hopper who had arrived at the pinnacle of his art and his fame in time to defend it and other Realist painters against the onslaught of the "New American Painting" that began to pour from New York. He was coming into his 70s, his health continued to challenge him and his work fell into an even more deeply introspective pattern. He and his work had truly become one.

Curiously, his last painting of the 1950s was a mirror image of his last painting of the 1940s. *Excursion into Philosophy*, however, showed the half-naked woman on the bed asleep and the man sitting on its edge fully clothed down to his shoes and socks. The room is bare except for a painting on the wall. Through a shuttered window, the setting is bucolic, not urban. Next to the man on the bed is an open book as though he has just put it down and is contemplating what he has read (Jo claimed it was "Plato" in her record book of his sales). Quickly painted in just eleven days, *Excursion into Philosophy* seems to be a breath taken after what has come before and what lies in the truncated future.

Just before Hopper's big retrospective at the Whitney on 9 February 1950, Edward entered the New York Hospital with diverticulitis, a disease of the bowel and large intestine. While he was laid up Jo previewed the Whitney's Hopper Retrospective. She was aghast. Too many works were crammed into the space and their chronology caused some boring stretches. She wrote in her diary, "He (Lloyd Goodrich) is dull and has no taste – scholastic, hardworking, but that's not enough for the impresario he fancies himself."[68]

By the time the retrospective closed on 26 March, about 24,000 people had trooped past Hopper's paintings and etchings. He was happy, the critics were kind and everyone who was anyone had paid their respects to his talent. *Time* magazine proclaimed him a virtually peerless painter of the "American Scene", a title that irritated Hopper, and compared him to Charles Burchfield. Burchfield, in turn, compared the classic quality of his work to Winslow Homer and Charles Eakins. Burchfield rhapsodised further:

"Contrary to the case of many famous artists, it is unnecessary, or even impossible, to ignore Hopper the man in studying his art. With Hopper, the whole fabric of his art seems to be completely interwoven with his personal character and manner of living….Hopper… suffers agony during his dormant periods, so important to him is the need to paint."[69]

130. *New York Office*, 1962.

Oil on canvas, 101.6 x 139.7 cm.

Collection of Montgomery Museum of Fine Arts,

The Blount Collection, Montgomery, Alabama.

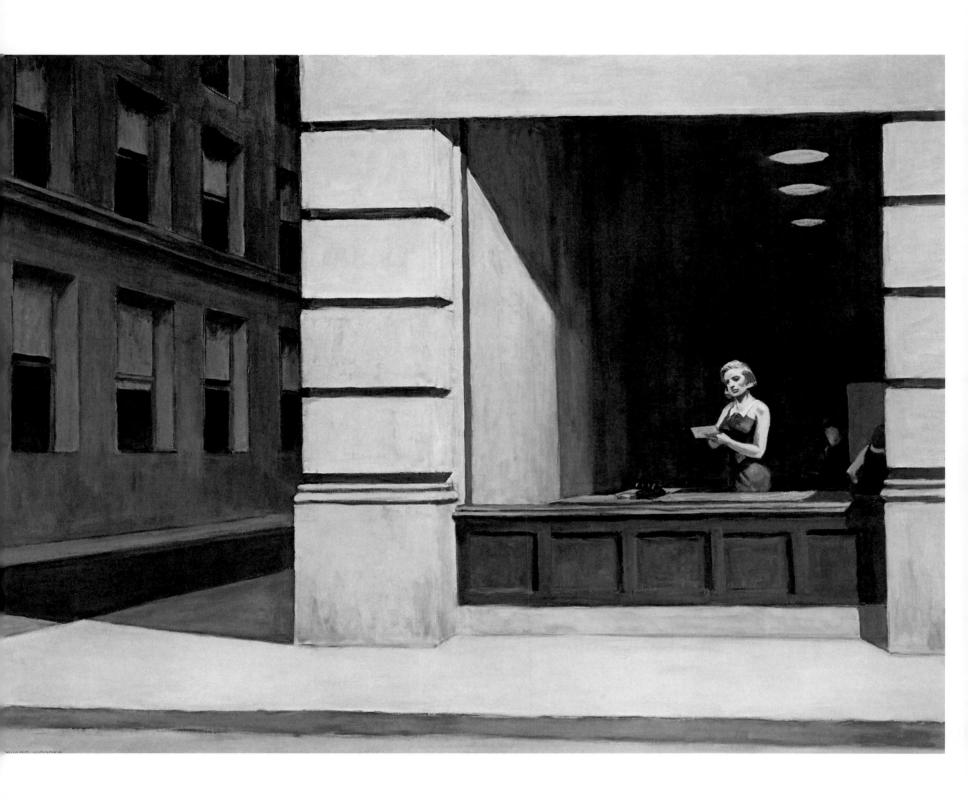

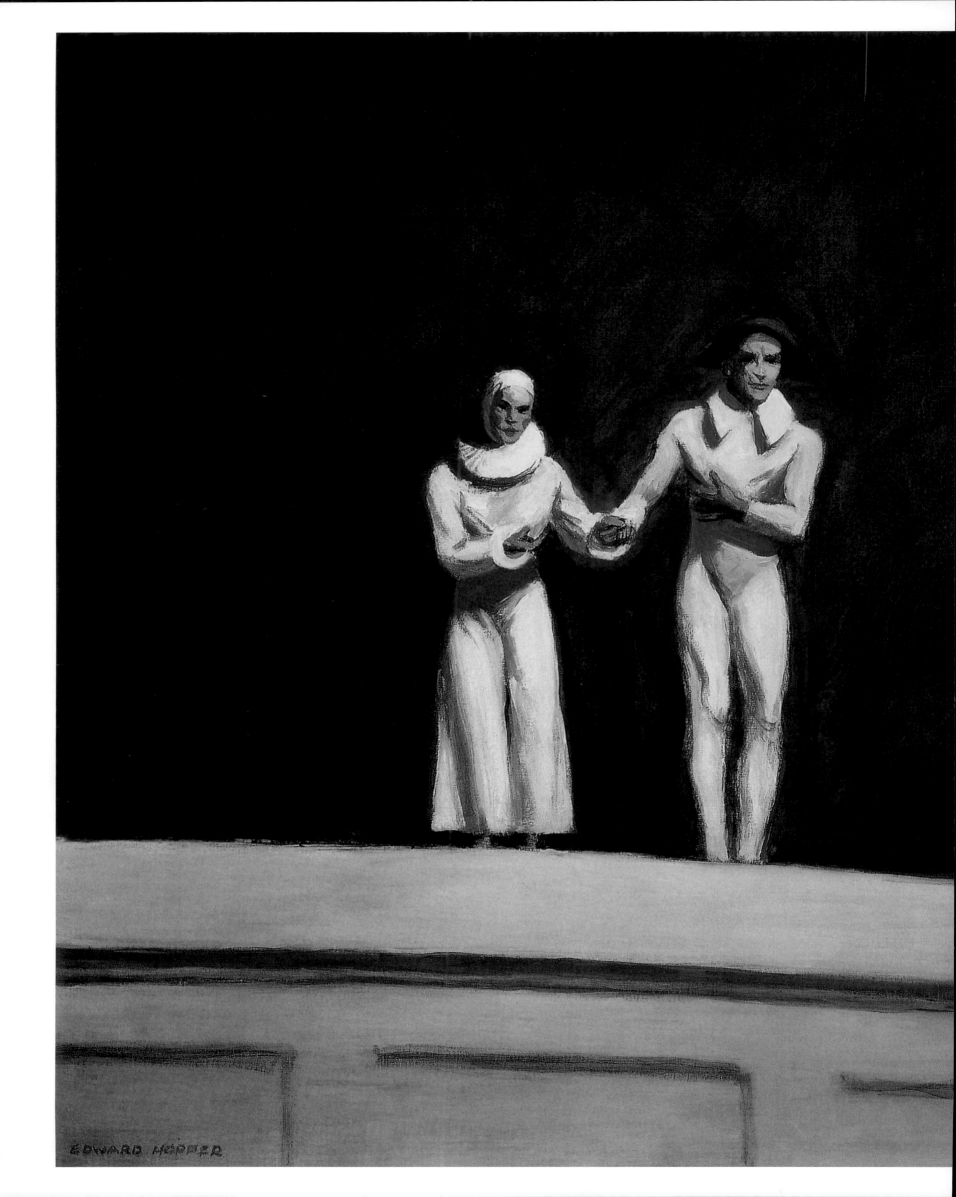

131. *Two Comedians*, 1965.

Oil on canvas, 73.7 x 101.6 cm.

Collection Mr. and Mrs. Frank Sinatra.

Jo bathed in Edward's glow, hanging on his arm at receptions and – to the annoyance of many – doing most of the talking for him. She might have recalled Lucy Bayard's comment while visiting at Truro the previous year about how Jo was blessed to have a husband so faithful and famous. But Jo had "the memory of an elephant," she often wrote, remembering every cut, every slight, every unkind word, every threat, every slap. With her self-esteem barely hanging on, she played her part in public.

As a result of the show, *Life* magazine did a feature spread on Hopper and its praise sent Jo into rage of envy and self-pity that rumbled below the surface as every honour came his way, concluding with an honorary doctorate bestowed by the Chicago Art Institute.

Eventually, they continued their yearly routine and arrived in Truro for the summer. As he aged, Edward's energy was more difficult to maintain, so once on the Cape he relented and let Jo drive with greater frequency. Then one day, she swerved to miss an oncoming car, he grabbed the wheel and they hammered the aged Buick into a post. In a frenzy, Hopper dragged her thrashing and braying from behind the wheel on the public street and stuffed her into the passenger seat. Locals made a note that the Hoppers had arrived for the summer.

Hopper worked on what would be his swan song to straight architectural views done in oil on the Cape as he finished *Portrait of Orleans* (p.248), a small Cape Cod town. While its composition is just about perfect in an academic sense, the buildings (and one lone inhabitant) have the feeling of something impermanent as if found under a Christmas tree or decorating a circle of toy train track. He would paint watercolours during their trips to Mexico, but his oils settled into a pattern of figures searching beyond the frame for something. The purged landscape, urban or rural, acted only as an environment for this cast of characters brewed up in Hopper's mind. There was an uneasy hum of sameness about them, not physically, but all are deep in thought or concentration. This collective sameness is all the more uncomfortable when one considers the upheavals occurring around Hopper at the time they were created.

Cold War tensions with China and the Soviet Union helped create the Korean War in 1950 that came and went to drag on at the Paris and Panmunjom peace talks. But that war was less important to Hopper and other American Realist painters than the battle against being marginalised by the surge of popularity surrounding non-objective art, the abstract Expressionists and the new figurative expressionist painters blossoming in New York and California. The art of "style" using colour and design applied in gestural stabs, trickles, thrusts and slashes on fluctuating planes had suddenly trumped the craft of actualities rendered by Bellows, Sloan, Luks, Davies, Sheeler, Du Bois, Krohl, Glackens, Prendergast and Robert Henri. This "revolutionary black gang", the "apostles of ugliness" christened by the critics had reduced pedantic academic painters, still rooted in the nineteenth-century, to a footnote in American art history. The critics themselves were also at a loss to interpret these new artists who "no longer stayed within the lines." Some critics were reduced to gibbering pronouncements such as the "…impossibility of desapercibirsing (sic) a manifestation such as this…genesiacal (sic) incandescence…"[70] A code decrypting book was needed.

Of all the fading Realists, Hopper was the most secure. His mature, reductive method distilled his paintings into impossible renditions of reality – creations of a fevered egoist driven to succeed all his life – that poured from his brush to the canvas. Hopper's images of the 1950s and 1960s, in their internalised version of reality, were no less fevered than the conjuring of the most explosive abstract Expressionist.

Hopper was bulletproof. He rose above the linked arms and circled wagons of the archeological remains of the Ash Can crowd, and sidestepped the splashy Expressionists weighed down with their manifestos and endless explanations. The Surrealists who embraced him hugged only vapour in the air. He joined that coterie of über-artists who defy labelling: Rene Magritte, H.C. Westermann, Ivan Albright, Alexander Calder, Antoni Gaudí, Edward Weston and Georgia O'Keeffe. Each made their chosen medium their own.

132. *Girlie Show,* 1941.

Oil on canvas, 81.3 x 96.5 cm.

Private collection.

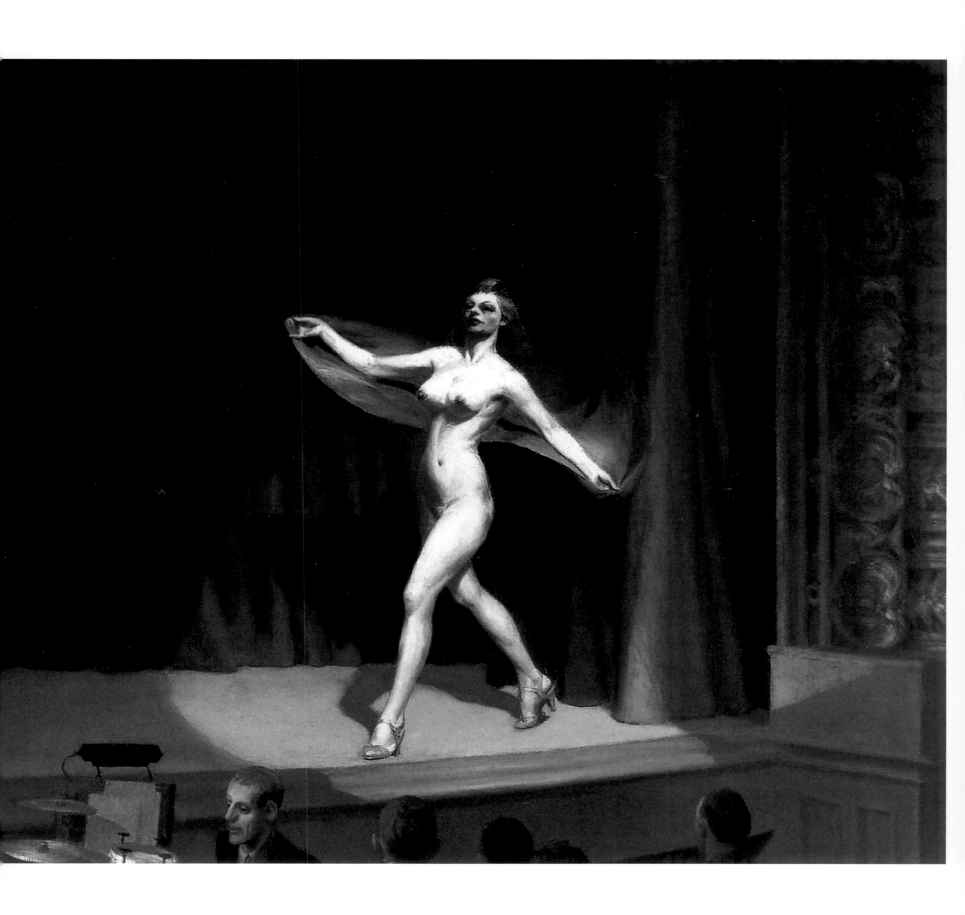

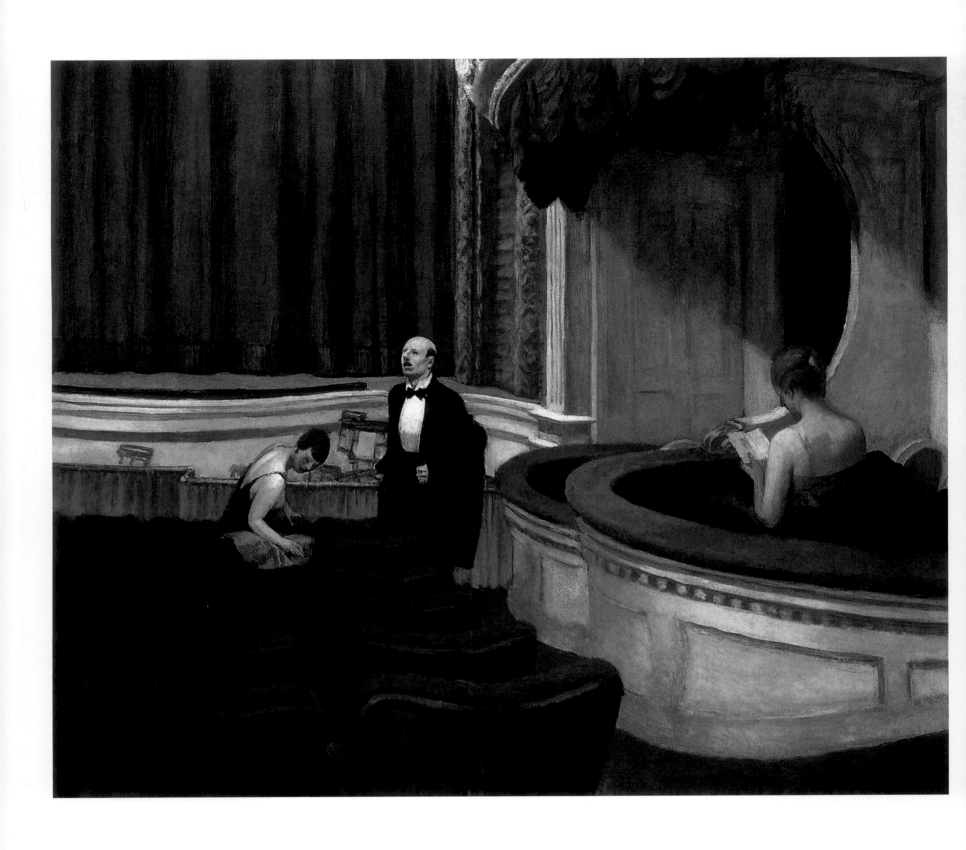

133. *Two on the Aisle*, 1927.

Oil on canvas, 101.6 x 121.9 cm.

The Toledo Museum of Art, Toledo, Ohio,

gift of Edward Drummond Libbey.

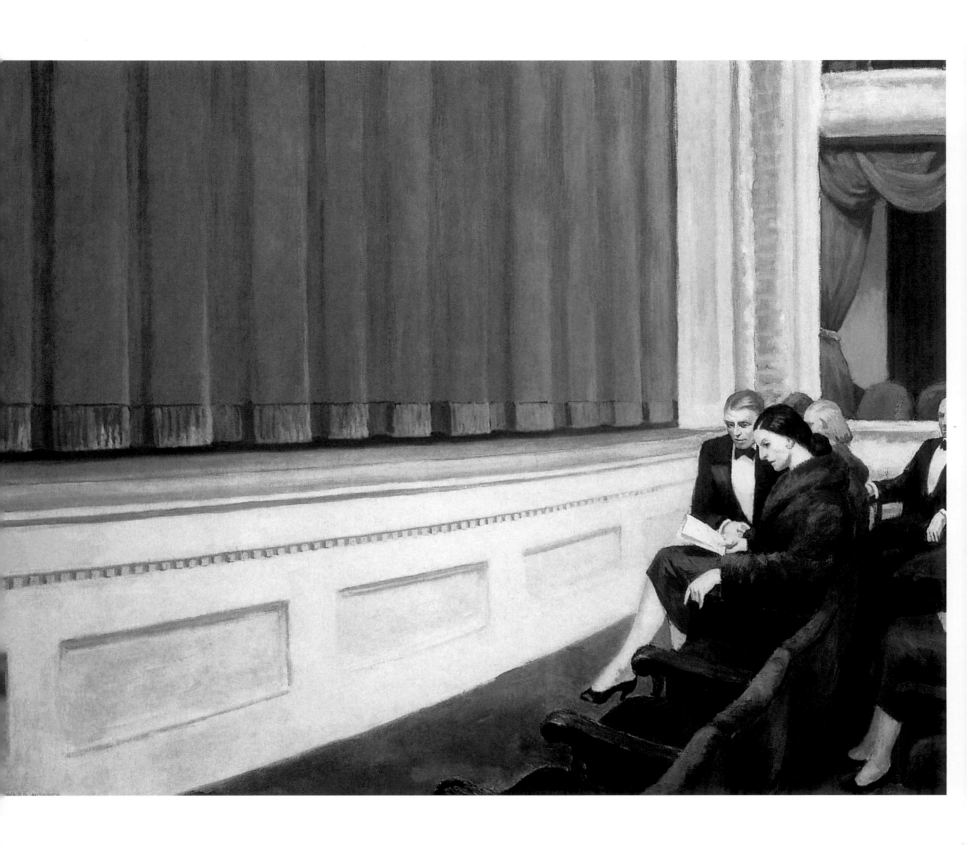

134. *First Row Orchestra*, 1951.

Oil on canvas, 79 x 101.9 cm.

Hirshhorn Museum and Sculpture Garden, Washington, D.C.,

gift of the Joseph H. Hirshhorn Foundation.

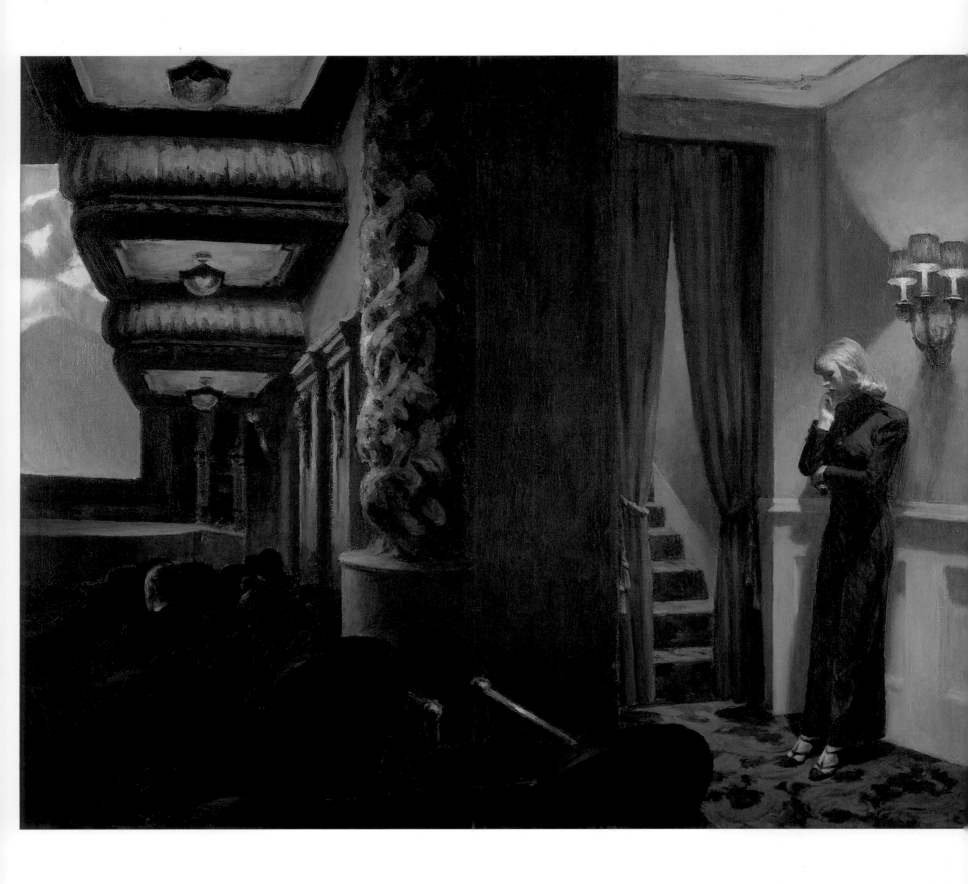

Mark Strand, Poet Laureate to the Library of Congress and Pulitzer Prize winner in poetry wrote of Hopper's paintings:

> *"Hopper's paintings are short, isolated moments of figuration that suggest the tone of what will follow just as they carry forward the tone of what preceded them. The tone but not the content. The implication but not the evidence. They are saturated with suggestion. The more theatrical or staged they are, the more they urge us to wonder what will happen next; the more lifelike, the more they urge us to construct a narrative of what came before…They are all that can be gleaned from a vacancy that is shaded not so much by the events of a life lived as by the time before life and the time after. The shadow of dark hangs over them, making whatever narratives we construct around them seem sentimental and beside the point."[71]*

Hopper's painting, *Cape Cod Morning* (p.124), typifies his later work with figures in timeless suspension. Painted in Truro during October 1950, a woman stands framed in a bay window peering intently at something beyond the frame. Light streams into the room across golden grass and touches the trees of the background forest. The bay's architecture is impossible; the side facing the light is too narrow. It is more like the bow of a ship bursting from the clapboard wall of the house. The bay is only a device to contain the woman's anxiety.

Hopper's output suffered again the following year as he produced the oil, *First Row Orchestra* (p.229). He and Jo had been fortunate to enjoy these expensive seats offered by a friend and the oil celebrated their good fortune with a grouchy collection of theatregoers dressed to the nines awaiting curtain up. As so often, Hopper explores the anticipation of an event, the periphery, never the event itself and, as usual, joyful expectation is not part of the experience.

Ever forgetful (or hopeful), Edward and Josephine motored down to Mexico once again in search of inspiration only to discover a raging heat wave baking the country. Unable to endure the heat, Edward headed straight north to visit Santa Fe again after twenty-five years. It had changed for the worse to Hopper's eye. On they went, staying in run-down tourist motels and trailer camps until finally arriving back on the Cape.

In the Truro studio Hopper painted *Rooms by the Sea* (p.157), a view out of their back door and of the entry to their bedroom. Light streams in through the open doorway that reveals nothing but the sea and its orderly march of waves. Though it was possible to see this phenomenon at the house – the sharp drop of a sandy cliff being not visible through the door – as shown in the painting, the view appears impossible as though the sea was at their doorstep. Hopper made an extremely rare visual joke.

There was no joke, however, when Hopper found out that the Art Institute of Chicago had awarded Willem de Kooning the Logan Prize and purchased his mural-scale painting, *Excavation*. Hopper had won that same prize in 1923 ($25) for one of his etchings. De Kooning represented everything Hopper disliked about the abstract Expressionists. Hopper labelled non-objective work "a passing phase" on every occasion. Willem de Kooning developed gestural paintings, figure paintings and abstract urban landscapes throughout the 1950s.

When they arrived back in New York, Edward learned about a group that was forming made up of "objective painters trying to defend themselves" who targeted the Museum of Modern Art. The museum of late had seemed to embrace the non-objective art movements to the dismay of the apparently *passé* Realists.

As Christmas rolled around, once again Hopper tried to make light of the warfare between him and Jo. He gave her a copy of Rimbaud's poetry and inscribed it in French that translated as "To the little cat who bares her claws almost every day".

135. *New York Movie*, 1939.
Oil on canvas, 81.9 x 101.9 cm.
The Museum of Modern Art,
New York, anonymous gift.

136. **Edgar Degas**, *Interior (The Rape)* (Intérieur (Le Viol)),
c.1868-1869.
Oil on canvas, 81 x 116 cm.
Philadelphia Museum of Art,
Philadelphia, Pennsylvania.

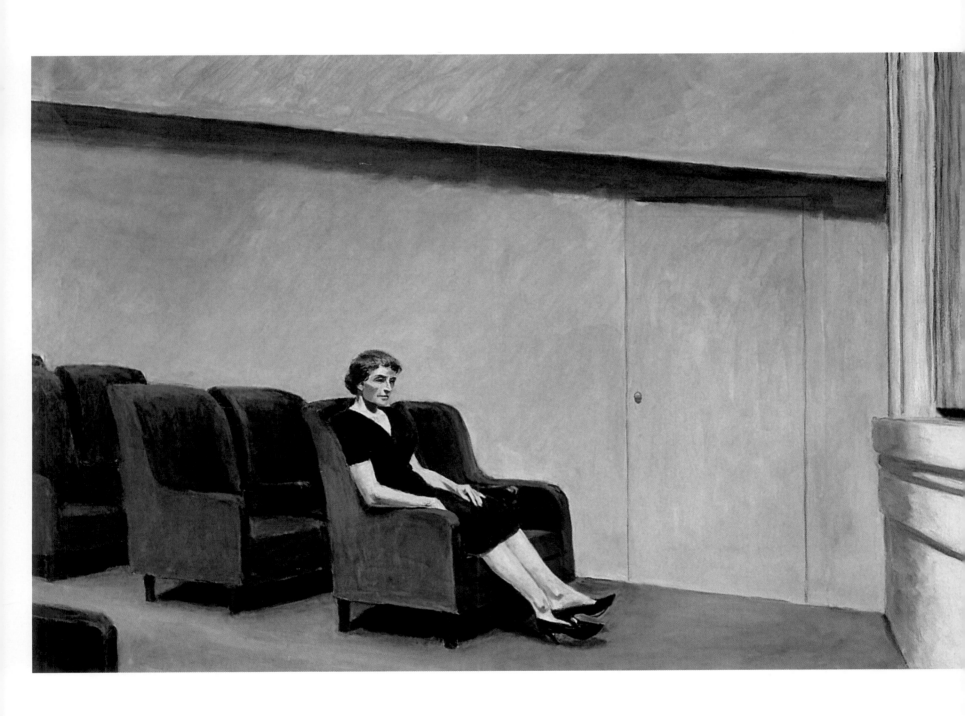

137. *Intermission*, 1963.

Oil on canvas, 101.6 x 152.4 cm.

Collection of Mr. and Mrs. Crosby Kemper.

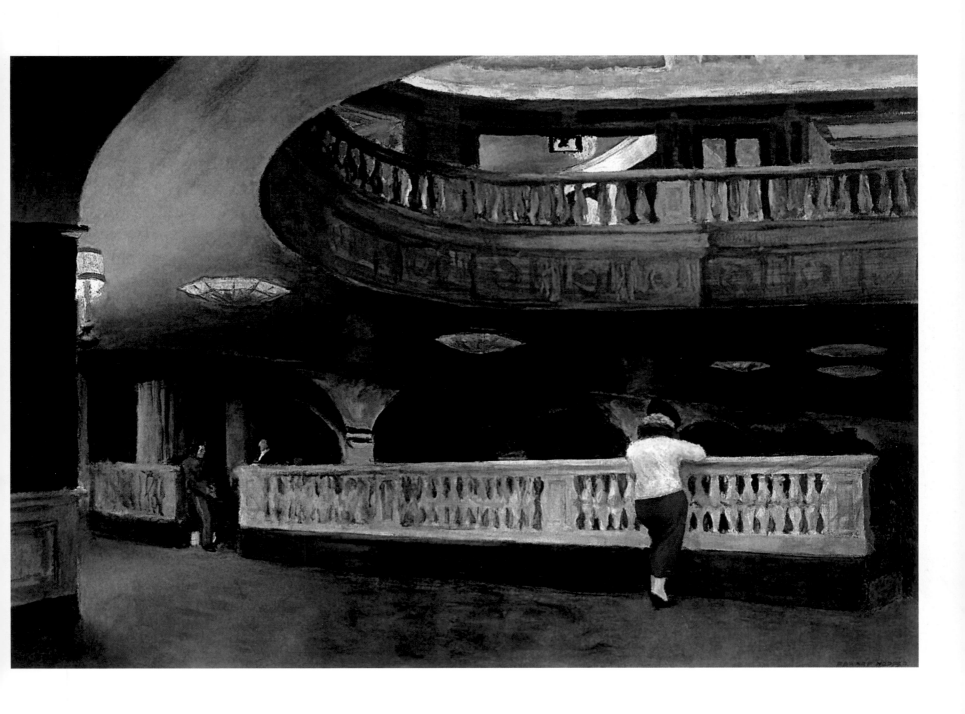

138. *The Sheridan Theater*, 1937.

Oil on canvas, 43.1 x 63.5 cm.

The Newark Museum, Newark, New Jersey,

Felix Fuld Bequest Fund.

Josephine had noticed that her eyesight had weakened; she continued to battle colitis due to stress and had become so vocal in her constant rant against Edward's treatment and repression that friends and casual acquaintances she met at shows began to notice. The façade of the dutiful wife was beginning to peel away. Hopper managed to get her to pose for *Morning Sun* in New York – yet another female, in a pink slip this time – on a bed, peering out an urban window. The woman is less important than the light that strikes her and the wall next to the bed. This preoccupation with light and light sources becomes a recurring theme within these figurative paintings.

Also painted in 1952 was *Hotel by a Railroad* (p.215). An older couple sits in a small room, probably in a residential hotel. She is in her slip reading a book and he wears Hopper's middle class uniform of white shirt, black trousers and matching waistcoat. The man seems to be speaking and gesturing, but she is paying no attention. She has heard it all before. Beyond the window are familiar urban textures of granite and window glass, while a pair of railway lines suggest escape if only it were not too late. The reverse of this painting would come in 1956 in *Four Lane Road* (p.245).

Seawatchers (p.163) filled out Hopper's 1952 canvases. Painted in October at Truro, a middle-aged couple in bathing suits stare out to sea from the deck of their modest beach house. Laundry flaps on its clothes-line. They face the sea as though some great crippling event had stricken them mute. Jo named them in the record book, as she did with many of Edward's characters:

"Sheila and Adam; Irish girl, gentle, sweet, large and Yankee clam digger – very fine people – on New England for late swim. People inventions of E.H."[72]

In New York, the war against the abstract Expressionists had heated up. A new magazine, *Reality: A Journal of Artists' Opinions* was in the planning stages to become the mouthpiece for those realist and objective painters who felt particularly threatened by the "action painters'" encroachment on their traditional turf, the Whitney Museum of American Art and the Museum of Modern Art. Galleries around town were also hanging the works of Jackson Pollock, Willem de Kooning, Clyfford Still, Adolph Gottlieb, Franz Kline, Robert Motherwell, Barnett Newman, Ad Reinhardt and Mark Rothko. These "New York School" artists raised Hopper's hackles as well. When asked to attend editorial meetings and contribute to *Reality*, he willingly complied. While they planned the first issue to be published in 1953, he wrote:

> *"Great Art is the outward expression of an inner life in the artist, and this inner life will result in his personal vision of the world. No amount of skilful invention can replace the essential element of imagination. One of the weaknesses of much abstract painting is the attempt to substitute the inventions of the intellect for a pristine imaginative conception.*
>
> *"The inner life of a human being is a vast and varied realm and does not concern itself alone with stimulating arrangements of color, form and design.*
>
> *"The term 'life' as used in art is something not to be held in contempt, for it implies all of existence, and the province of art is to react to it and not to shun it.*
>
> *"Painting will have to deal more fully and less obliquely with life and nature's phenomena before it can again become great."* [73]

Hopper's championing of the realist painters put him in touch with a younger crowd as his own contemporaries were dying off. Kenneth Hayes Miller, one of his earliest instructors, had recently died. John Sloan, another contemporary and member of Henri's original "Eight" passed away in 1951. Hopper continued to attend these artists' meetings and to them, his laconic silence was seen as quietly approving wisdom.

139. *New York Pavements*, 1924.

Oil on canvas, 61 x 73.7 cm.

The Chrysler Museum of Art, Norfolk, Virginia,

on loan from the collection of Walter P. Chrysler, Jr.

140. *Summertime*, 1943.

Oil on canvas, 73.6 x 111.8 cm.

Delaware Art museum, Wilmington, Delaware,

gift of Dora Sexton Brown.

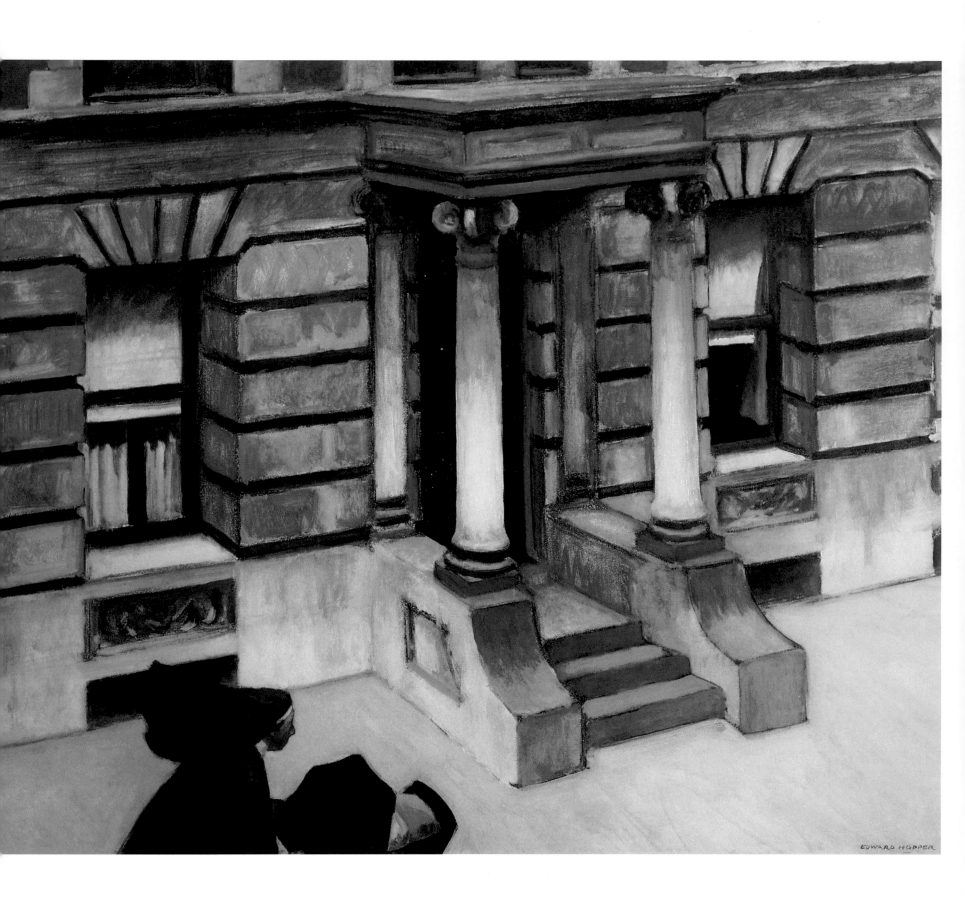

235

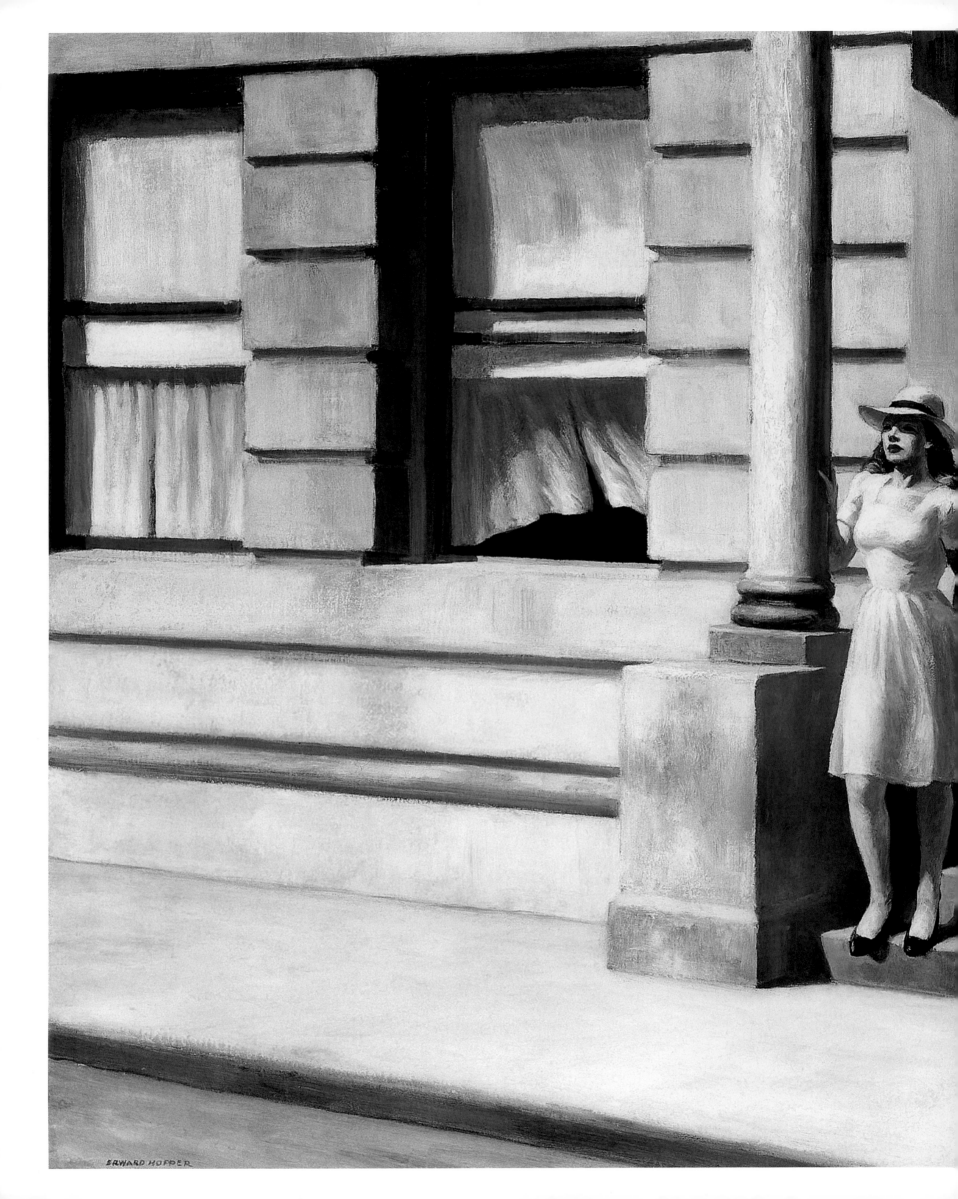

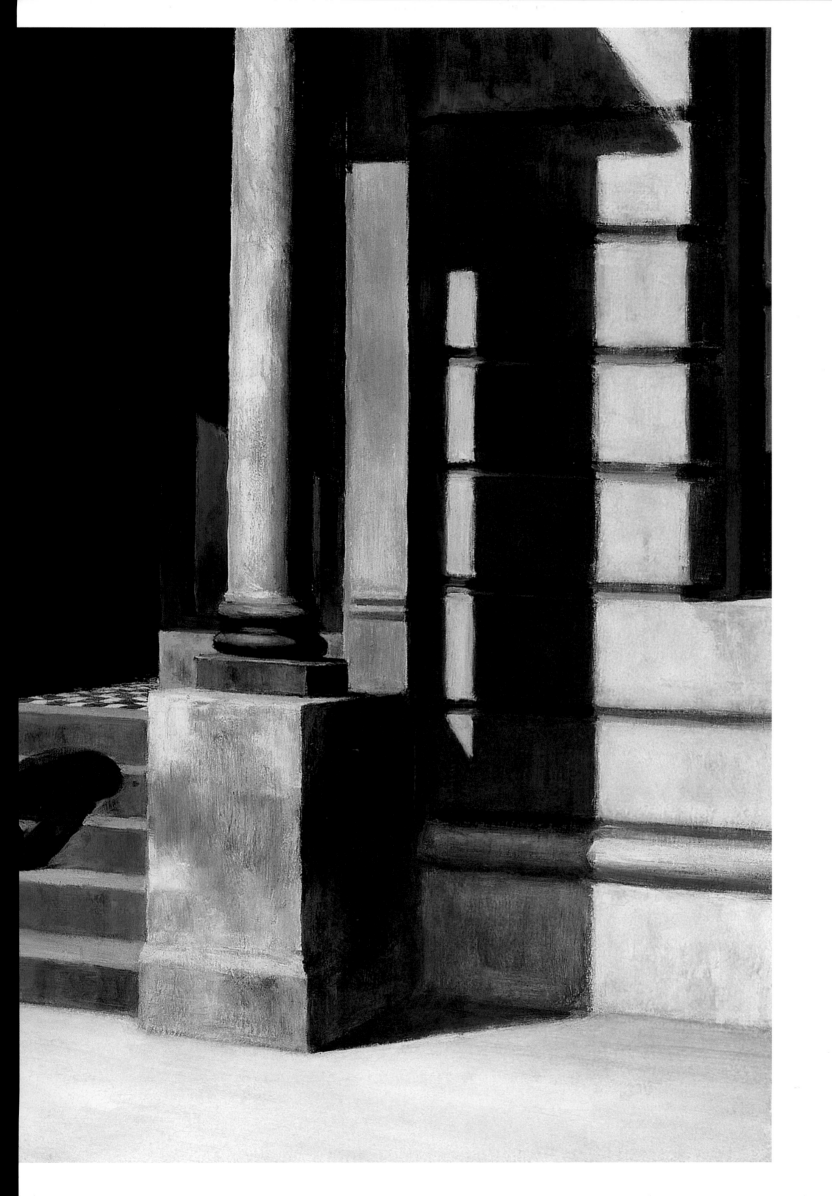

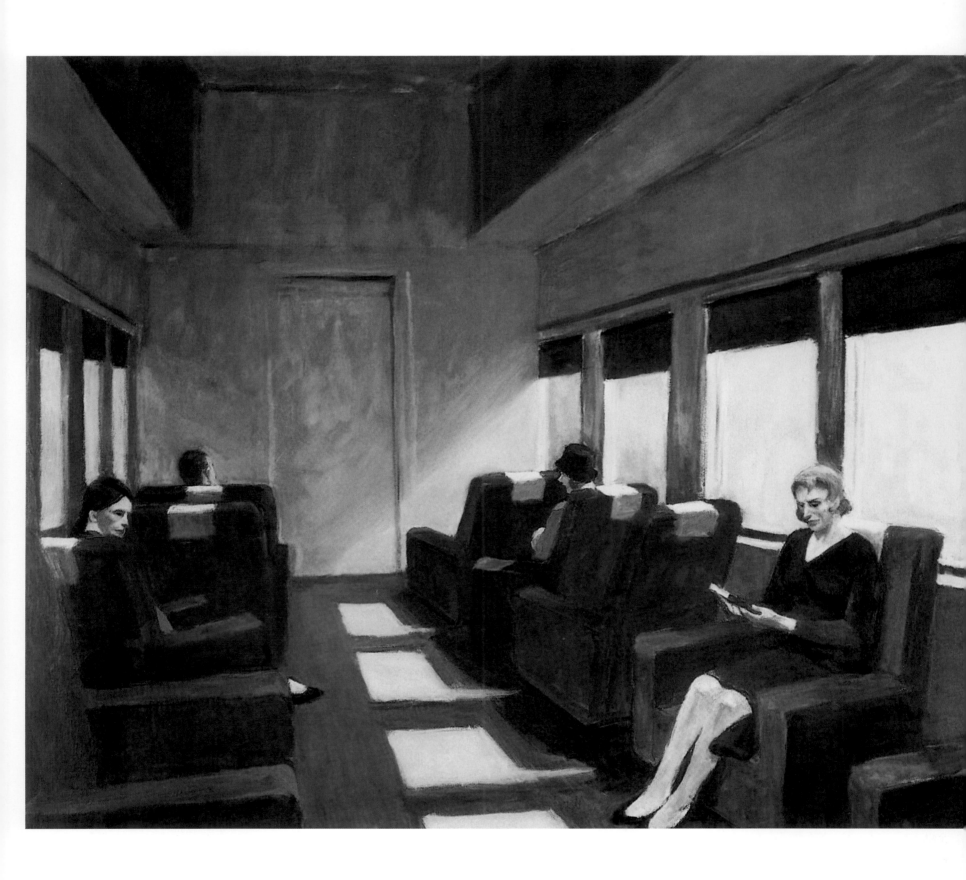

Another Hopper Mexican sortie began 1953. It was the usual roller-coaster of good times, good food, bad food, car breakdowns, health breakdowns ending with a final run for the US border. And, as usual, very little productivity resulted. The big art event of the year was the launching of *Reality* and its positive response in the Realist artistic community.

Josephine's inferiority complex was further fuelled by a lame apology from Lloyd Goodrich, curator at the Whitney, for not including her in the last Annual Show. She retorted with a snide letter to Goodrich in which she stated,

"Over the years I've learned that my poor little bastards – are little bastards and their very existence unmentionable."[74]

But her churning feelings of rejection were removed when the Whitney's 1953 Annual Show opened on 14 October. Hopper's *Hotel by a Railroad* had been hung and next to it was Josephine Hopper's oil, *Convent across the Square through Fire Escape*. The next day *New Yorker* magazine's Robert Coates singled out Edward Hopper, Jo Hopper and Henry Varnum Poor as three Realists he found acceptable. One of her little bastards had found a home.

Office in a Small City (p.220) was Edward Hopper's only oil in 1953. He gives us another voyeuristic peep show peering into the office of an architect or artist in some mechanical drawing field pausing at his drawing board. The man is Hopper's *Everyman* in white shirt and dark waistcoat with the pale skin of a city dweller. He stares ahead and down at the building across the street, an elderly pile with a ventilator-studded roof. Next to that building is the blank white side of another taller building that is either a warehouse or the standing half of what was once two buildings. Directly in front and just below the artist's view is what appears to be the back of a sign in an antique frame not appropriate to the severe concrete walls of his office. Was Hopper feeling besieged in his bunker in the small New York Art community? Was he an old-fashioned artist trapped in a modern world?

When *Office in a Small City* was completed on 8 October 1953, it was delivered to the Rehn Gallery. Frank Rehn had suffered a stroke and his assistant John Clancy now managed the gallery. Hopper was concerned. He had never had another agent, but Clancy seemed competent and now that Hopper's fame had been established, the sales and shows were easier to arrange.

From 1954 until 1960, the Hoppers continued their seasonal meanderings to Truro, Mexico and the West. They returned to New York each autumn to shake their figurative fists at the Expressionists; Edward spent time on show juries while Jo began to have some success in finding wall space for her paintings. Unfortunately, incipient cataracts and colitis continued to weaken her, while Edward was in and out of hospital for hernia and prostate surgery. Electricity finally arrived at their Truro summerhouse in 1954 and a dumb waiter took over the coal hauling chore in their Washington Square apartment and studios.

The figurative paintings continued through this period. *City Sunlight* (1954) (p.187) featured the red-headed girl (ageing noticeably) looking out of a daylight window dressed in her pink slip. Curious double windows on either side of a thick exterior look into the dark interior of the apartment behind her as though the room she occupies was added onto the finished building. Its earthy colours and single Rembrandt-type light source give it a Dutch look.

Carolina Morning (1955) breaks with Hopper's formula for characters. "Dina" (as named by Jo), a Mulatto girl, looks directly out at viewers of the painting. She wears a pink dress, matching wide-brimmed hat and high-heeled shoes. Her arms are folded and her gaze is direct as though she is soliciting business in the improbable shuttered grey house in the middle of a grassy prairie.

Completed in New York in December 1955, *Hotel Window* (p.189) puts us back in a cheap hotel lobby as an elderly, but well-dressed and dignified matron appears to wait for a taxi. She seems isolated from her surroundings. The concept apparently came from Hopper's ramblings from

141. *Chair Car*, 1965.
Oil on canvas, 101.6 x 127 cm.
Private collection.

Broadway to Fifth Avenue, where he noted the number of second-class hotels catering to transients, salesmen and residents on a pension. Her well-coiffed and well-dressed gentility undermines the vulnerability of being alone. Though the spaces around her are large and empty she seems unconcerned. 1955 seems to have been Hopper's year for forceful women.

Of his next five oil paintings completed between 1956 and 1959: *Sunlight on Brownstones* (1956), *Four Lane Road* (1956), *Western Motel* (1957), *Sunlight in a Cafeteria* and, finally, *Excursion in Philosophy* (1959), his gender reversal on *Summer in the City* painted back in 1949, Hopper's wonderful comment on his own life in *Four Lane Road* probably turned the most heads among his contemporaries.

Pictorially, *Four Lane Road* is very successful. The strips of stratus clouds, strip of dense forest, strips of green parkway and strips of concrete roadway down to the strip of blue shade all race past the petrol station with its red pumps – like the station in Hopper's *Gas*. Here, the rush of horizontal strips only emphasises the implacable immobility of the station owner, seated in the sunshine, smoking a small cigar. Hanging out of the window to his right, like the figurehead on a sailing ship, a woman (his wife?) berates him for his apparent sloth. According to the written record book and diary notes, it took some time for Jo to realise the painting's implications concerning their relationship.

She had little time to brood however, since Edward had won the 1956-57 Huntington Hartford Foundation award of $1,000 and a six-month stay at the Frank Lloyd Wright-designed Foundation art "colony" in California. They revelled in the hot showers, good food and cavernous studio space – with even a large studio for Josephine. Meals were communal, which delighted Jo but sent Edward grumping down to the far end of the table. While he was hiding from his fellow art colonials, Hopper learned that *Four Lane Road* had been sold for $6,000.

As 1959 closed a defining decade for Hopper's secure hold on the title of Dean of American Realist Painters, abstract expressionism and variations of non-objective art now constantly lined the walls of the major museums and galleries. The Museum of Modern Art sent out a travelling show of the big paintings. Their impact reached back into Europe and the bastions of good taste to engage the Spanish, arouse the Germans, puzzle the Soviet Union and really bother the French, who had not had a top grade painter since Dubuffet, who was now in his sixties.

At home, the scales were falling from the eyes of some American critics. John Canaday took over as art editor of the *New York Times* and fired off his first editorial: *An American Dissent: "We've Been Had."*

"There can be no objection to abstract expressionism as one manifestation of this complicated time of ours. The best abstract Expressionists are as good as they ever were – a statement not meant to carry a concealed edge. But as for the freaks, the charlatans and the misled who surround this handful of serious and talented artists, let us admit at least that the nature of abstract expressionism allows exceptional tolerance for incompetence and deception…

"Recognising a Frankenstein monster when they see it – and lately they can't miss it – some critics and teachers wail, 'But what are we going to do? We can't go back to those old Grant Woods again.' Of course it is not a matter of going backward, but forward – somewhere. That we will go forward from abstract expressionism seems unlikely, since it is more and more evident that these artists have either reached the end of a blind alley or painted themselves into a corner. In either case they are milling around in a very small area – which, come to think of it, may explain why they are increasingly under a compulsion to paint such very large canvases…

"We have been had. In the most wonderful and terrible time of our history, the abstract Expressionists have responded with the narrowest and most lopsided art on record. Never before have painters found so little in so much."[75]

142. *The Bootleggers*, 1925.

Oil on canvas, 76.5 x 96.5 cm.

The Currier Museum of Art, Manchester, New Hampshire.

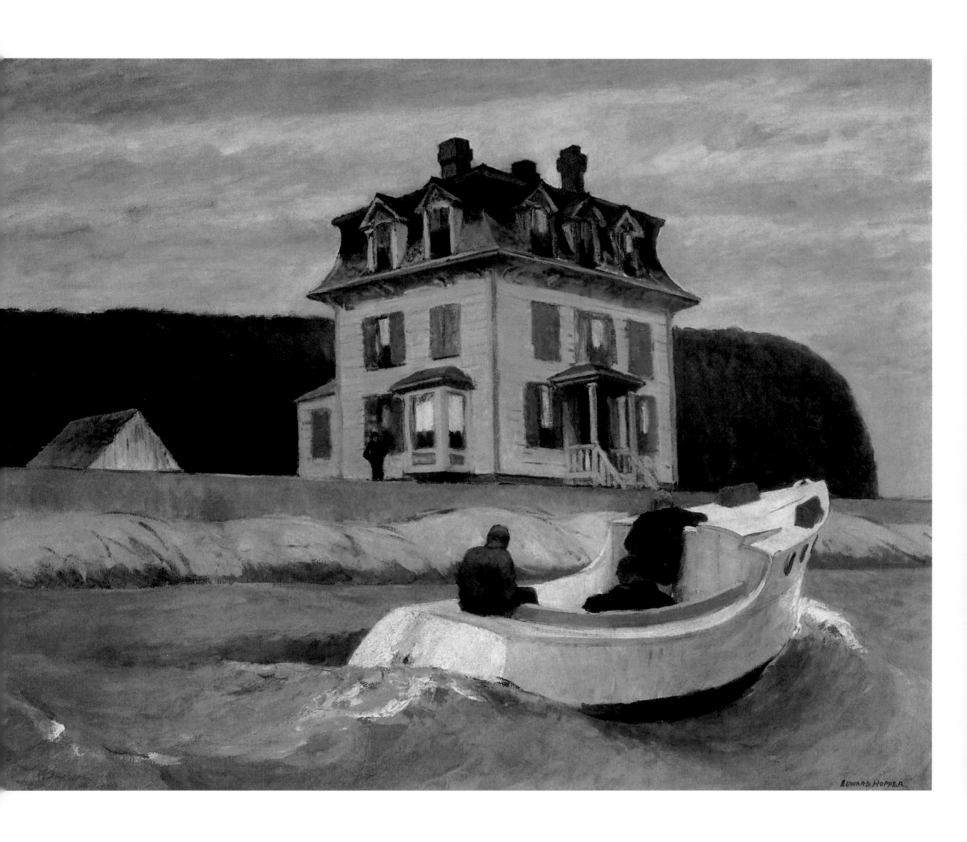

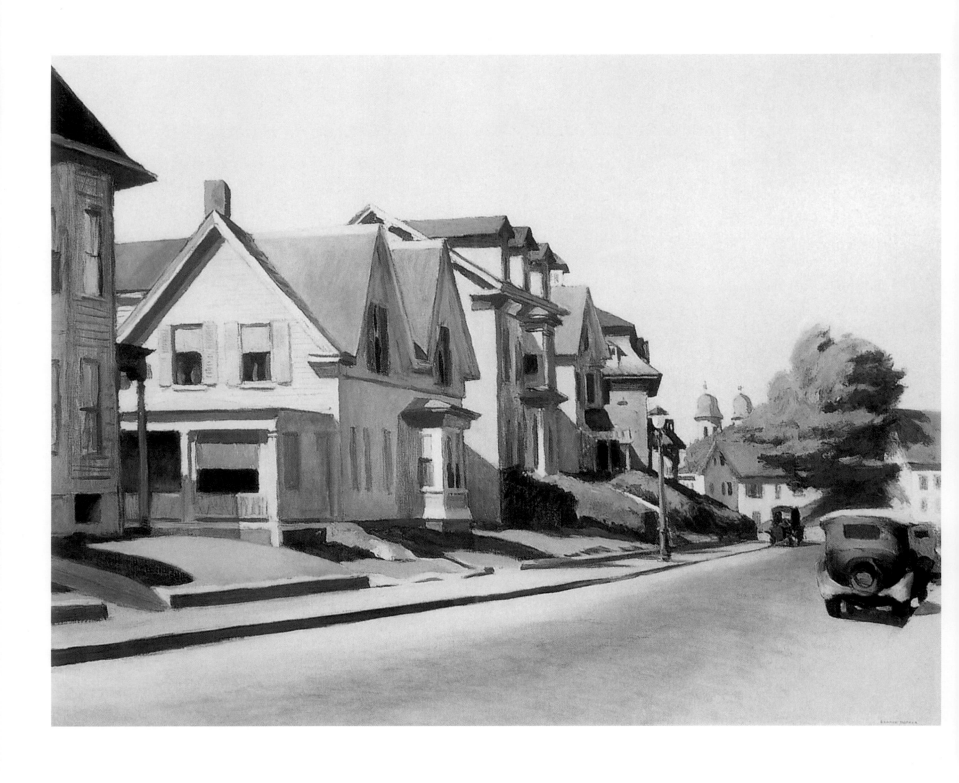

The Comedians

People in the Sun (pp.160-161) was a large canvas and an ambitious project for the seventy-eight year old Hopper as his twilight entered the 1960s. Jo continued to keep an eye on their affairs. New York University had decided to install central heating originally selecting gas – which frightened Jo – but settled on steam safely enclosed in three radiators. The lugging of coal and ashes from their studio would finally end. When rain clouds loomed above their skylight, spoiling the quality of painting light, they went to the movies, but when sunlight – Hopper's obsession – flooded the room, he took up the canvas again.

The painting depicts five fully-dressed people sitting in camp chairs on concrete gratefully absorbing the rays of a low sun. Part of a concrete building with familiar gold-coloured curtains anchors the upper left corner. A distant mountain range lies beyond a prairie plain of golden grass. The work is strangely dreamlike, as if the people are waiting for an event to occur. The mountains are saw-toothed, peaks evenly spaced and the colour of waves at sea. Again, the inclusion of certain details in the clothes, the folding chairs, the pleated curtains combine to suggest a frightening reality. Hopper claimed the idea came from seeing people enjoying the sun in New York's Washington Park, but his extrapolation of these city sun worshippers to a western prairie turns the simple concept on its head.

Jo and Edward continued their support of the anti-abstraction faction of New York artists. He signed his name to a joint letter of protest to the Whitney Museum as younger artists demonstrated in front of the Museum of Modern Art which had completely embraced the expressionist movement. Edward was a reluctant protester against the Whitney since his career had started there back in the 1920s. The museum had been his champion for forty years and now Jo's work hung on their walls in every Annual Show. But his dismissal of the expressionist "gobbledegook" required his support of the protesters.

A loss struck Jo as the one gallery, owned and run by Herman Gulack, that had accepted her paintings went broke and her work was returned. Gulack had been her admirer and saviour when he opened his gallery, and now she retreated again to her own studio for shows, a difficult venue with its draining seventy-four stair climb.

Their sojourn in Truro introduced a phonograph to the isolated location, and Edward was so moved by Strauss waltzes that he swept up Jo and they danced about the studio on their aching joints. Two other events marked the summer. In Provincetown, not that far away from Truro, a school for loathsome abstract painting opened and Hopper finished a large canvas, *Second Story Sunlight* (pp.138-139).

On the second-storey balcony of a white house, a grey-haired grandmother reads her newspaper while a blonde girl (her granddaughter?) poses on the railing in a two-piece sun suit that announces her busty charms to the neighbourhood. Jo – who posed for both characters – named the girl "Toots" and decided she meant no harm: "...a lamb in wolf's clothing".[76]

One of the highlights of Hopper's 1961-62 seasons was the rekindling of his relationship with print curator Carl Zigrosser who wanted to open a complete retrospective of Hopper's etchings at the Philadelphia Museum of Art. Rather than have the aged Hopper pull new prints from the antique press that still sat in the New York studio, Zigrosser introduced Hopper to Edward Colker, a Philadelphia printmaker. The resurrection of Hopper's plates that were protected with coatings of beeswax, from cleaning to the final prints, navigated around Hopper's micro-managing of Colker's work (Umbria paper, Frankfurt black ink available in the 1920s, special "trick" ink-wiping techniques, etc.).[77] The final "toll gate", according to Colker, was Jo's critical eye when the prints were delivered. She basically aped Hopper's original concerns, but the prints passed Hopper's review. Colker's visit to the studio was punctuated with the requisite tour of Jo's paintings, which Colker dismissed as "...second-rate Hoppers".[78]

143. *Street Scene, Gloucester*, 1934.
Oil on canvas, 71.7 x 91.4 cm.
Cincinnati Art Museum, Cincinnati,
The Edwin and Virginia Irwin Memorial.

A Woman in the Sun (pp.210-211), painted in Truro in October 1961 is another nude facing a window and dawn sunlight after rising from bed. She smokes a morning cigarette. In Jo's record book, she writes that Hopper called the girl, "a wise tramp".[79]

Two paintings were completed in 1962: *New York Office* (p.223) and *Road and Trees*. It would be difficult to imagine two more opposite works. In New York, Jo continued her voluminous correspondence and diary entries, mostly of their growing list of infirmities and illnesses as well as the depressing list of friends who had died. Hopper struggled with bouts of fatigue to finish *New York Office* during April and May.

A girl in an office stands before a large plate-glass window examining a document. Great granite pillars framing the window suggest a building of substance such as a bank. Sunlight rakes the front of the bank, throwing the alley and the next door building into shadow. This effect results in the shadowed building plane coming forward ahead of the sun-saturated bank façade. The window joins the advanced shadow-building plane in a very un-Realist planar push-pull not unlike the work of Hans Hofmann, considered one of the elder statesman outriders of abstract expressionism.

In *Road and Trees*, painted before they returned from Truro in November 1962, Hopper showed an angry wood waiting in ambush for whatever comes down a road that has been reduced to a simple band of grey. The shape and lightness of the tree trunks spaced along the roadway gives them a curious and hostile humanity against the dark woods behind them. Hopper's gift for evoking a dream-like menace had never been accomplished with so little subject matter.

A unique opportunity to penetrate Hopper's now aged persona came in the form of a portrait requested by Raphael Soyer as part of a group portrait being created as an homage to the painter Thomas Eakins. Hopper had always touted Eakins as a greater painter than Manet and allowed his image to be part of the group collage. Soyer committed his impression of Hopper to his diary after the first session.

"There is a loneliness about him, an habitual moroseness, a sadness to the point of anger. His voice breaks the silence loudly and sepulchrally (sic). He posed still, with hands folded on the table. We hardly conversed."[80]

The portrait brought up resentment in Jo, feeling that Soyer was seeking publicity for himself while exploiting the Eakins' homage. Besides that, Hopper had rarely posed for her. True to form, this self-pity led to a dam bursting as past slights, neglects, abuses and pathetically short reprieves ate at her.

During the spring of 1963 Hopper worked through March and April to finish *Intermission* (p.232), another theatre subject showing a plain woman with short brown hair wearing a black dress and matching heels. She sits alone in a two-seat front row at the far left of the stage. Hopper named her "Nora" in the record book notes. Her lack of jewellery, lack of interest in the "intermission" taking place and the location of her seat all suggest her fish-out-of-water solo approach to this cultural experience.

His final painting of 1963 came, as usual, in October. *Sun in an Empty Room* (p.183) represents the ultimate in his reductive technique. He has left us with the window and sunlight that hits the floor and two walls. Again, as with *New York Office*, these shapes of light and dark values create shifting planes pushing forward and back in space with only the window and tree foliage beyond to anchor the painting in reality. These experiments with the sun on surfaces endeared Hopper to those abstractionists who knew their business, as he employed spatial relationships in their purest form. As noted by *New York Times* critic, John Canaday, during the 1964 occasion of Hopper's first retrospective exhibition at the Whitney Museum since the 1950s:

"He has remained in the good graces of even the abstract painters, because, alone among American Realists, he works in a way easily connectable with abstraction in the careful disposition, the inventive purity of his surface patterns."

144. *Four Lane Road*, 1956.

Oil on canvas, 68.6 x 104.1 cm.

Private collection.

145. *Gas*, 1940.

Oil on canvas, 66.7 x 102.2 cm.

The Museum of Modern Art, New York,

Mrs. Simon Guggenheim Fund.

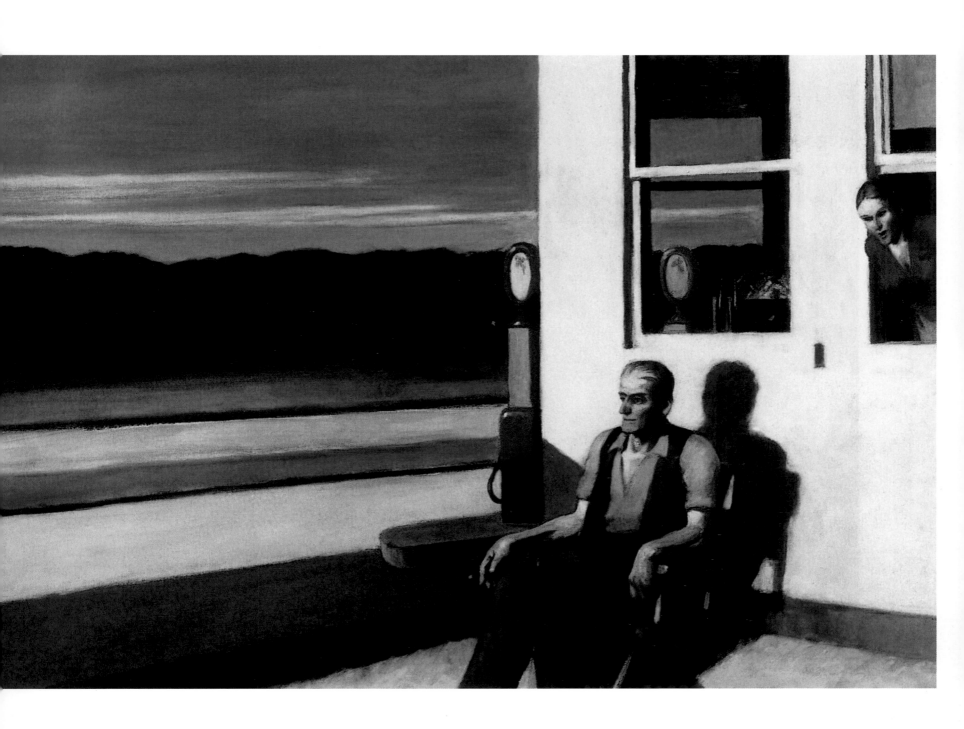

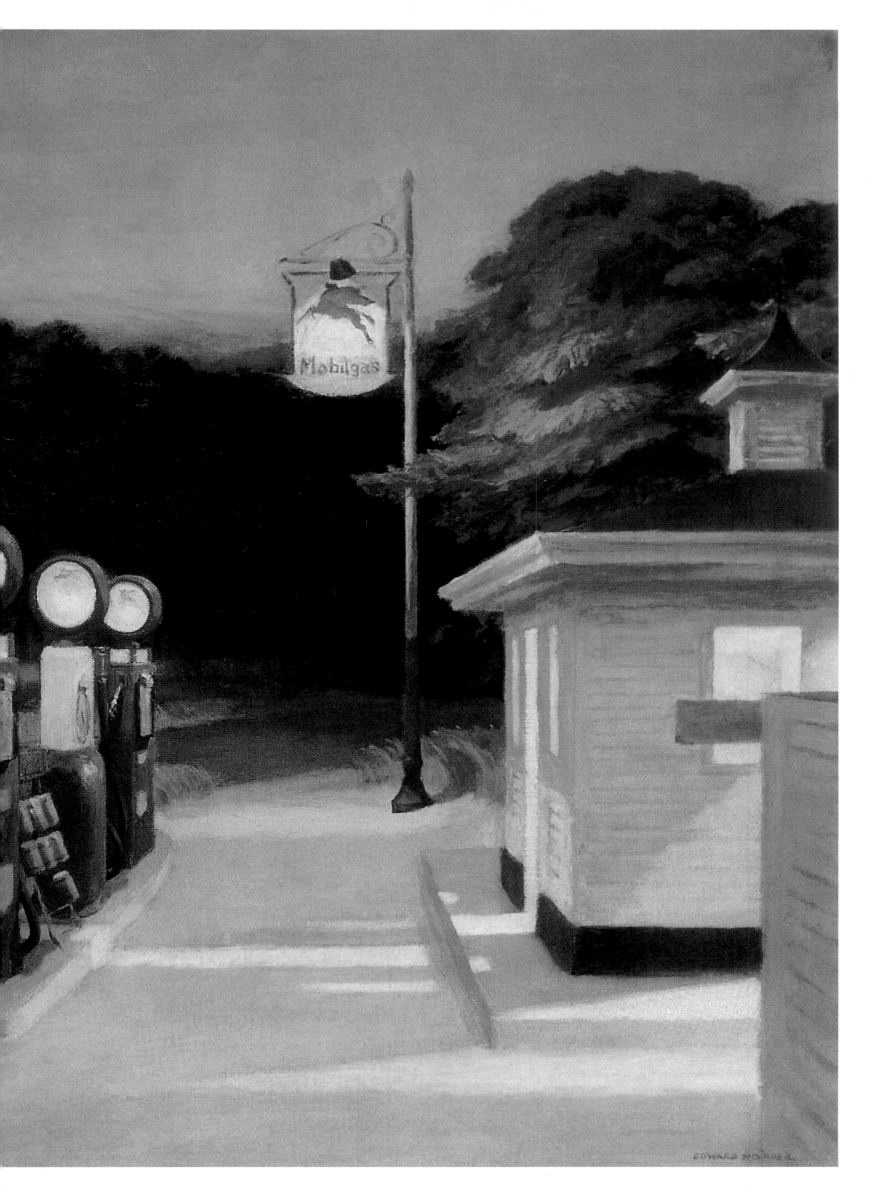

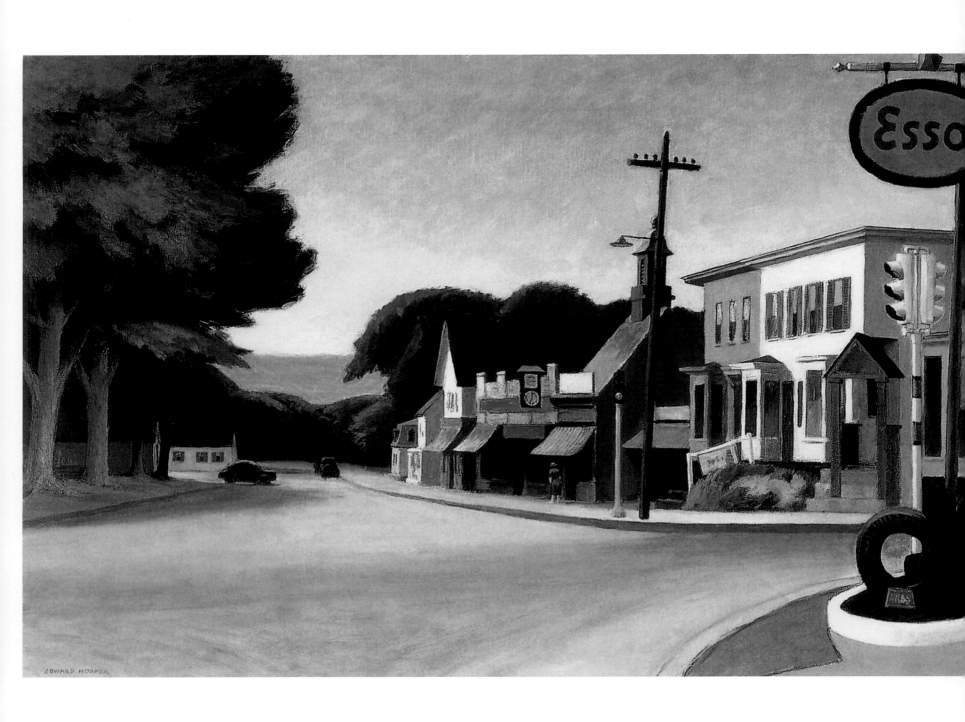

That retrospective had made Hopper nervous. Would he be deemed passé? Had he outlived the value of his vision? At the age of eighty-three, these questions still troubled him. He moved slowly with a cane, suffered bouts of fatigue and depended to an even greater degree upon Josephine to act as gatekeeper to his privacy. And still they quibbled and fought, but the edge was off the invective. Their collective infirmities ruled out the physical abuse. At the slightest criticism or imagined slight on her husband's talent or place in art history, Jo rounded on the offender like a lioness protecting her cubs. According to Josephine, 70,000 people passed through Hopper's retrospective before it travelled across the country. Not bad for an old Realist.

In December 1964 he began a new canvas in New York. It traced back to his love of trains and he titled it *Chair Car* (p.238). The interior of the car and the chairs are impossibly large. The outside passes by as ethereal light drenching the vast interior space and leaving *impasto*-thick pads of yellow on the carpet. While the chairs cast shadows onto these yellow squares, the passengers do not as if they don't really exist. All are engrossed in their own pursuits in this cathedral on wheels. And where does the blank door at the end of the car lead?

Being true to their Republican roots, the Hoppers declined an invitation to Lyndon Johnson's inauguration in January 1965. His sister Marion, the final link with Edward's past, passed away on 17 July after he and Jo had nursed her for a week in Nyack. Jo found ample time to gripe about being saddled with the settling of Marion's affairs as Edward backed away from the emotional stress of the work. They had made the trips back and forth to Nyack by bus because Edward could no longer drive and Jo's weak eyesight prevented her from taking the wheel.

After the ordeal, they arrived in Truro in August, being driven by their handyman, Eddy Brady. There they remained until October with no new paintings in sight. Finally, Edward roughed in some crayon drawings and then fetched his brushes and began sketching in blue. A stage emerged with scenery hinted in the wings. At centre stage, viewed from the audience angle, two white-garbed clowns appeared, tall Pierrot and his faithful Pierrette, hand in hand for a final bow. He titled it *Two Comedians* (pp.224-225).

There was no mistaking the inference, the identity of the couple.

On returning to New York Edward suffered a severe pain and entered hospital. A week later, Jo joined him after breaking her hip and leg from slipping on some wax. Her cataracts were now complicated by glaucoma. It was December 1966 when they left the hospital and returned to their eyrie atop Three Washington Square. Edward was weak and required Jo's help. She managed as best she could with her diminished eyesight.

Hopper's health continued its downhill slide after yet another hernia operation. Josephine wrote to a friend, Catherine Rogers, about coming into the studio on 15 May 1967:

"And when the hour struck he was home, here in his big chair in big studio – and took one minute to die. No pain, no sound and eyes sere (sic) and even happy and very beautiful in death, like an El Greco....We were alone there in the late afternoon and he in his chair. No struggle, no pain, even gladly, and looked so beautiful."[81]

Hopper was buried in the family plot on 17 May 1967 in a very private service. Jo lingered long enough to bequeath Edward Hopper's paintings, sketches and etchings to the Whitney Museum of American Art. She also gave them her diaries, record books, letters and her entire body of work. Jo lasted ten months until 6 March 1968, just before her eighty-fifth birthday. After forty-three years, they were together again.

Edward Hopper's work is a national treasure, revived from time to time for future generations and is perpetually on display at the Whitney. For the most part, Josephine Nivison Hopper's bequeathed body of work was discarded as having no value at all.

146. *Portrait of Orleans*, 1950.

Oil on canvas, 66 x 101.5 cm.

Private collection.

BIBLIOGRAPHY

Edward Hopper
by Sheena Wagstaff, David Anfam, Brian O'Doherty
Tate Gallery (1 August 2004)

The Paintings of Edward Hopper
by Edward Hopper (Editor),
Gail Levin, Whitney Museum of American Art
W. W. Norton & Company (15 January 2001)

Hopper: Mark Strand, Knopf; Revised edition
(13 November 2001)

Edward Hopper: The Art and the Artist
by Gail Levin
W. W. Norton & Company; Reprint edition (October 1996)

Edward Hopper: A Journal of His Work
by Edward Hopper, Deborah Lyons, Brian O'Doherty
W. W. Norton & Company; 1st edition (November 1997)

Edward Hopper's New York
by Avis Berman, Edward Hopper
Pomegranate Communications (February 2005)

Edward Hopper: An Intimate Biography
by Gail Levin
University of California Press; 1st edition (10 April 1998)

Edward Hopper: The Watercolours
by Virginia M. Mecklenburg, Edward Hopper, Margaret Lynne
Ausfeld, National Museum of American Art (U. S.),
Montgomery Museum of Fine Arts
W. W. Norton & Company (1 September 1999)

Edward Hopper: An American Master (Great Masters)
by Ita G. Berkow
New Line Books (30 September 2005)

Edward Hopper as Illustrator
by Gail Levin
W .W. Norton & Co Inc; New edition (January 1984)

Hopper's Places:
by Gail Levin, University of California Press; 1st edition
(10 December 1998)

Notes

1 Edward Hopper, *Notes on Painting*, "Edward Hopper Retrospective Exhibition", catalogue, Museum of Modern Art, 1933, courtesy: Frances Mulhall Achilles Library, Whitney Museum of American Art

2 http://butlerart.com/book/ Kenneth Hayes Miller, Nannette v. Maciejunes

3 Vachel Lindsay, Letter to his Father, 10 December 1903

4 Edward Hopper, *American Masters*, p.14

5 Patricia Wells, *Where to Sit to See and be Seen*, *New York Times*, 6 June 1982

6 Edward Hopper, Letter to his Mother, 29 December 1906

7 Enid M. Saies to Edward Hopper, letter, Derby, England, 1907

8 http://www.bidingtons.com Pedigree and Provenance, *Ash Can School*, Margaret Morse

9 Gail Levin, *Edward Hopper, An Intimate Biography*, University of California Press, Berkeley, California, 1995

10 *Ibid.*

11 Gail Levin, *Edward Hopper as Illustrator*, Whitney Museum of American Art, New York, 1979

12 James MacNeil Whistler, Mark Harden, www.glyphs/art/com

13 American Institute of Economic Research calculation, http://www.aier.org/index.html

14 Gail Levin, *Edward Hopper – An Intimate Biography, op. cit.*

15 Guy Pène du Bois, "Exhibitions in the Galleries", *Arts and Decoration*, 15 April 1915, p.238

16 Gail Levin, *Edward Hopper – An Intimate Biography, op. cit.*

17 *Ibid.*

18 *Ibid.*

19 www.intaglio-fine-art.com/etching-info-about.php

20 Henri at MacDowell Club, *American Art News*, 17 February 1917, p.3

21 http://www.artnet.com/johnmarin

22 Gail Levin, *Edward Hopper – An Intimate Biography, op. cit.*

23 Edward Hopper to Marian Ragan, letter, 10 February 1956, Montclair Art Museum, New Jersey

24 Rembrandt, *The Three Crosses*, 1653, Rijksprentenkabinet, Amsterdam

25 Gail Levin, *Edward Hopper – An Intimate Biography, op. cit.*

26 Josephine Hopper diary, January 10, 1956

27 William Johnson, unpublished interview with Edward and Jo Hopper, Oct. 30, 1956

28 Gail Levin, *Edward Hopper – An Intimate Biography, op. cit.*

29 Josephine Hopper diary, 12 October 1944

30 Henry McBride, *Edward Hopper's Watercolors Prove Interesting – Also Sell*, *New York Sun*, 25 October 1924

31 *Edward Hopper – The Watercolors*, Virginia M. Mecklenburg, National Museum of American Art, W.W. Norton & Company, New York, 1999

32 The Ten Best English-language Noirs, Steven Murray, (San Francisco Noir), 2005, p.8

33 Gail Levin, *Edward Hopper – An Intimate Biography, op. cit.*

34 Kingwood College Library, American Cultural History 1920-1929 kclibrary.nhmccd.edu/decade20.html

35 "The New Society is Arranging Its Exhibit", *New York Sunday World*, 3 January 1926, p.7

36 Lloyd Goodrich, New York Exhibitions, *The Arts*, 9 February, 1926, p.68

37 Lloyd Goodrich, *Edward Hopper*, Harry N. Abrams, Inc. New York, 1989

38 (Gathered by Gail Levin, *Edward Hopper – An Intimate Biography*): Elizabeth Luther Cary, "Many Types of Art are Now on Exhibition", *New York Times*, 28 February 1926, sec 8, p.12. Margaret Breuning, "Exhibitions of Contemporary American Artists Feature Lenten Week in Local Galleries", *New York Evening Post*, 27 February 1926, p.9

39 "America Today", *Brooklyn Daily Eagle*, 7 March 1926, p. E7

40 Garrett McCoy, "Charles Burchfield and Edward Hopper", *Journal of the Archives of American Art*, 7, July-October, 1967

41 Edward Hopper, "John Sloan", *The Arts*, 9 March 1926, pp.172-178

42 Gail Levin, *Edward Hopper – An Intimate Biography, op. cit.*

43 Josephine Hopper diary, 11 August 1954

44 Hopper to Charles H. Sawyer, Letter, 19 October 1939, Lloyd Goodrich, Edward Hopper, New York, Harry S. Abrams, 1971

45 Edward W. Root, "To the Editor of the Press", *Utica Daily Press*, 3 March 1928, p.9

46 Edward Hopper quote from Brian O'Doherty, *American Masters: "The Voice and the Myth"*, Universe Books, New York, 1988, p.14

47 Edward Hopper to Forbes Watson, 29 April 1930

48 Guy du Bois, *Edward Hopper*, monograph

49 Royal Cortissoz, "Some Modern Paintings from American and French Hands", *New York Herald Tribune*, 27 November 1932, p.10

50 Jo Hopper, Letter to Bee Blanchard, 18 July 1932

51 Jo Hopper, Letter to Bee Blanchard, 14 June 1934

52 Jo Hopper, Undated Diary Entry, 1934

53 Edward Hopper, Letter to *The Art of Today*, vol. 6, no. 2, February 1935, p.11, (Frances Mulhall Achilles Library, Whitney Museum of American Art)

54 Jo Hopper, Diary, 11 August 1937

55 Edward Hopper, *Notes on Painting*, Museum of Modern Art catalogue, "Edward Hopper Retrospective Exhibition", 1933, p.17 (Frances Mulhall Achilles Library, Whitney Museum of American Art)

56 Jo Hopper, Diary, 14 November 1937

57 Jo Hopper, Letter to Marion Hopper, August, 1939

58 Helen Hayes, interview with Gail Levin, 27 October 1980, Gail Levin, ed., *Edward Hopper Symposium at the Whitney Museum of American Art*, "Six Who Knew Hopper," *Art Journal*, 41, summer, 1981, p.129

59 Jo Hopper, Letter to Marion Hopper, 13 September 1940

60 Jimmy De Lory, interview by Gail Levin, 29 July 1991, *Edward Hopper, An Intimate Biography*, Gail Levin, University of California Press, Berkeley, California, 1995

61 Jo Hopper, Diary, 14 March 1959

62 Jo Hopper, Diary, 15 August 1945

63 Jo Hopper, Letter to Carl Sprinchorn, 10 February 1946, Frances Mulhall Achilles Library, Whitney Museum of American Art

64 Jo Hopper, Diary, 8 April 1946

65 Jo Hopper, quote, Brian O'Doherty interview, American Masters, p.25

66 Edward Hopper, Letter to "Dr. Roe", 20 April 1945, Frances Mulhall Achilles Library, Whitney Museum of American Art

67 Edward Hopper, Letter to Mrs. Frank B. Davidson of Richmond, Indiana, 22 January 1947

68 Jo Hopper, Diary, 8 February 1950

69 Charles Burchfield: "Hopper, Career of Silent Poetry," *Art News*, March 1950, p.63

70 *The "New American Painting" Captures Europe*, John Russell, critic, *Sunday Times* (London), Horizon Magazine, November, 1959, vol. 11, no. 2, p.42

71 Mark Strand, *Edward Hopper*, Ecco Press, Hopewell, NJ: c.1994, p.23

72 Edward Hopper Record Book, p.47, Frances Mulhall Achilles Library, Whitney Museum of American Art

73 Edward Hopper, *Reality: A Journal of Artists' Opinions*, June, 1952, courtesy: Frances Mulhall Achilles Library, Whitney Museum of American Art

74 Jo Hopper, Letter to Lloyd Goodrich, 23 March 1953, Frances Mulhall Achilles Library, Whitney Museum of American Art

75 John Canaday, New York Times, 1959, quoted in *Horizon Magazine*, "New American Painting," November, 1959, Vol. 11, No.2, p.121

76 Jo Hopper, Letter to Mrs. Malcolm Chase, 18 January 1961

77 Gail Levin, *Edward Hopper – An Intimate Biography, op. cit.*

78 *Ibid.*

79 Jo Hopper, Record book III, p.75, October, 1961

80 Edward Hopper, quoted in Soyer, *Diary of an Artist*, pp.71-72, from Levin, *Edward Hopper – An Intimate Biography*, p.555

81 Jo Hopper, Letter to Catherine Rogers, 4 June 1967

LIST OF ILLUSTRATIONS